ANNUS

ART IN TH

D0725888

CONTENTS

Author's Biography viii
Acknowledgements ix

Introduction I

NEW ART 23
Audible Light 26 January 2000 24
The British Art Show 5 12 April 2000 27
Steve McQueen: Cold Breath 17 May 2000 31
Richard Billingham 9 June 2000 35
Douglas Gordon: Black Spot 28 June 2000 39
Intelligence: New British Art 2000 5 July 2000 43
A Shot in the Head 26 July 2000 47
The Turner Prize 2000 25 October 2000 52
Glenn Brown and Science Fiction 28 November 2000 57
Aernout Mik 20 December 2000 59
The Citibank Photography Prize 2000 4 November 2000 63
Rineke Dijkstra, Ugo Rondinone
 and Juan Uslé 12 January 2000 67
Shirin Neshat I August 2000 71
Ant Noises 2 6 September 2000 75
Apocalypse 20 September 2000 80
Gillian Wearing and Shirazeh Houshiary 27 September 2000 84
Tony Oursler 29 March 2000 88
Dream Machines 4 October 2000 92
Anish Kapoor's Blood 31 May 2000 96
Tony Bevan 23 August 2000 99
Rodney Graham: City Self/Country Self 3 January 2001 103
Protest & Survive 11 October 2000 107
Tony Cragg at Liverpool 23 March 2000 III
Carl Andre 12 July 2000 115
Encounters: New Art From Old 14 June 2000 119
Panamarenko 15 February 2000 123

Francisco Toledo	24 May 2000	128
Yayoi Kusama	2 February 2000	132
The Merians Collection	25 November 2000	136
Felix Gonzalez-Torres	21 June 2000	142

GALLERIES RENEWED, TRANSFORMED, CREATED — 147

The New Pompidou	5 January 2000	148
The New Art Gallery, Walsall	16 February 2000	152
Tate Britain's Inaugural Shows	27 March 2000	157
White Cube² and Ant Noises	19 April 2000	161
A New Wing for the National Portrait Gallery	5 May 2000	166
Tate Modern Opens	10 May 2000	170
The Holocaust Exhibition	7 June 2000	176
Transforming the Wallace Collection	19 June 2000	182
The Renewal of Somerset House	22 November 2000	187
The British Museum's Great Court	6 December 2000	192

TALKING TO TATE — 199

Tate Britain: Interview with Stephen Deuchar	20 March 2000	200
Tate Modern: Interview with Lars Nittve	1 May 2000	205
'Who's Afraid of Modern Art?': Interview with Nicholas Serota	20 November 2000	209

BEYOND THE GALLERY — 215

Alex Hartley's Pavilion	29 December 1999	216
Noriaki Maeda at Yorkshire	26 January 2000	219
James Turrell	March 2000	223
Bill Woodrow on the Plinth	15 March 2000	227
Jan Fabre: A Consilience	19 January 2000	232
Modern Sculpture at Gloucester Cathedral	5 June 2000	236
A Mysterious Rush of Voices: Two Artangel Commissions	3 May and 10 November 2000	240
Filling the Empty Plinth	3 July 2000	244
Michael Landy: Planning Break Down	16 October 2000	249

REASSESSING THE PAST 253
Golden Deer in New York,
 Van Gogh in Philadelphia 27 November 2000 254
Seeing Salvation 1 March 2000 258
Tilman Riemenschneider
 and Nam June Paik in New York March 2000 263
Rome Renewed 13 September 2000 267
The Artist and the Garden 23 August 2000 272
Chardin 10 March 2000 275
William Blake 8 November 2000 279
Turner's Watercolours 18 November 2000 284
Ruskin, Turner and the
 Pre-Raphaelites 8 March 2000 288
Impression 1 November 2000 293
Paris Exhibitions: The Riviera, Manet
 and Guston 15 November 2000 296
Art Nouveau 5 April 2000 300
1900: Art at the Crossroads 14 January 2000 304
Painting the Century 1 November 2000 308
The Scottish Colourists 11 July 2000 312
Bauhaus Dessau 23 February 2000 316
Picasso the Sculptor 30 August 2000 320
Weegee 3 May 2000 325
Force Fields 19 July 2000 329

TWO NEW BIOGRAPHIES 333
Caravaggio January 2000 334
Wyndham Lewis October 2000 341

AFTERWORD 351
Goodbye to All That 26 December 2000 352

Index 358
Credits 367

All these articles were originally written for *The Times*, apart from 'James Turrell', published in *Orient-Express Magazine,* and 'Caravaggio' and Wyndham Lewis', both commissioned for broadcast on BBC Radio 3.

AUTHOR'S BIOGRAPHY

Richard Cork is an art critic, historian, broadcaster and exhibition organiser. He read art history at Cambridge, where he was awarded a Doctorate in 1978. He has been Art Critic of the London *Evening Standard*, Editor of *Studio International*, Art Critic of *The Listener* and Chief Art Critic of *The Times*. In 1989–90 he was the Slade Professor of Fine Art at Cambridge, and from 1992–5 the Henry Moore Senior Fellow at the Courtauld Institute. He then served as Chair of the Visual Arts Panel at the Arts Council of England until 1998. He was recently appointed a Syndic of the Fitzwilliam Museum, Cambridge, and a member of the Advisory Council for the Paul Mellon Centre.

A frequent broadcaster on radio and television, he has organised major contemporary and historical exhibitions at the Tate Gallery, the Royal Academy, the Hayward Gallery and elsewhere in Europe. His international exhibition on Art and the First World War, held in Berlin and London, won a National Art Collections Fund Award in 1995. His books include a two-volume study of Vorticism, awarded the John Llewelyn Rhys Prize in 1976; *Art Beyond the Gallery*, winner of the Banister Fletcher Award for the best art book in 1985; *David Bomberg*, 1987; *A Bitter Truth: Avant-garde Art and the Great War*, 1994; and *Jacob Epstein*, 1999. The present book is part of a four-volume collection of his critical writings on modern art, all published in 2003.

ACKNOWLEDGEMENTS

I am grateful to Robert Thomson, Editor of *The Times*, for granting me permission to publish material that originally appeared in the newspaper. I would also like to thank all the artists, galleries and museums who so kindly provided photographs for this book.

My gratitude extends as well to Greg Dyke and Alison Booth for permission to publish material originally broadcast by the BBC and commissioned for *Orient-Express Magazine*.

At Yale, Ruth Applin and Beatrix McIntyre deserve an accolade for handling with such skill and patience all the complexities of publishing four books at once. My thanks also go, as ever, to my publisher John Nicoll. His enthusiasm for this project was invaluable, and I am fortunate indeed to benefit once again from his wisdom.

Each of these books is dedicated to one of my four children. Adam, Polly, Katy and Joe can never know how much they have sustained and delighted me, while my wife Vena has always given me a limitless amount of encouragement, friendship and love.

INTRODUCTION

An astounding number of people wanted to explore the Tate's new powerhouse of art at Bankside during its first six months. Before the modernist temple opened its immense doors in May 2000, official predictions about visitors during the first year were doubled to four million. But the reality confounded even the most optimistic forecasts. The initial surge, which proved too much for Norman Foster's elegant yet surprisingly shaky Millennium Bridge arching across the river to St Paul's Cathedral on the opposite side, was prodigious. Most members of the new museum's staff felt euphoric. They could have been forgiven for imagining that a revolutionary change was underway, ousting for ever the once-notorious British hostility to modern art.

By outlining such a heady future for the Bankside Tate, they may of course have been indulging in shameless and unfounded wish-fulfilment. After all, over the last hundred years Britain's attitude to adventurous contemporary work has been bedevilled by suspicion, ignorance and hatred. The very fact that London had to wait so long for Tate Modern to emerge beside the Thames testifies to the scale of the problem. Too many people were quick to scorn experimental art, and vandalism destroyed many outstanding achievements. The melancholy list of mutilated or demolished victims reflects an enduring sense of public rage. Because the appetite for knocking innovative developments knew no bounds, it prevented the British from establishing a fully fledged museum of modern art long before the twentieth century had itself expired.

Why, then, should I foresee a more positive future for modern art in the century ahead, now that the schizophrenia of struggling to house two conflicting collections at Millbank has at last been brought to an end? However welcome the new Tate may be, we can hardly expect it to bring about the wholesale conversion of a nation whose prejudices seem so ingrained. I do nevertheless believe that the advent of the Bankside building is symptomatic of, and coincides with, the beginning of a profound shift in national attitudes. Tabloid headlines may continue to ridicule the Turner Prize shortlists, while commentators vilify the winners without bothering to visit their exhibitions. But the public at large

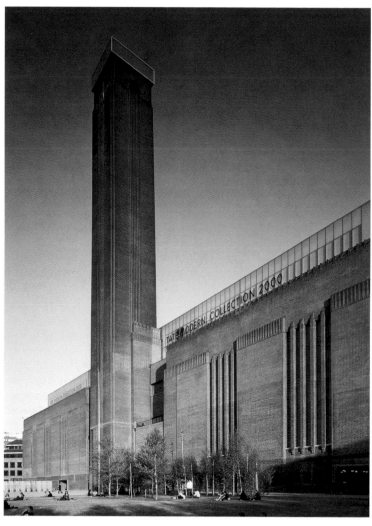

1. Tate Modern

show no such reluctance. They are prepared to join long queues and, once inside, arrive at their own unhackneyed conclusions about the work on display there. Indeed, the Turner Prize exhibition held in the winter of 1999–2000 became the best-attended so far. It was more popular, even,

than the scandalous show when Damien Hirst won the prize with his sliced cow and calf suspended in formaldehyde.

Far from spurning the most extreme manifestations of current art, the British are fast developing an appetite for unpredictable experiences. Young visitors in particular appear unencumbered by the dreary antagonism of their elders. They have shaken off the automatic impulse to condemn experimental initiatives out of hand. And they no longer insist that art should be limited to painting and sculpture. They realise that the rapidly expanding range of visual resources must inevitably be explored in the work artists produce. The possibilities continually offered by technological discoveries are bound, in the new millennium, to have a radical effect on contemporary practice. They offer alternative ways of understanding the world and our volatile place within it. Those who so loudly deplore the use of video, film, installation and computer-based approaches in modern art have seen nothing yet. Just as the Renaissance brought about a galvanic upheaval 600 years ago, so the twenty-first century may well witness a thorough-going transformation of what the word 'art' means.

Do not misunderstand me. Artists should never be expected blindly to follow every visual invention thrown up by the new millennium. They must view each fresh development with an appraising eye, deciding for themselves the difference between the fruitful and the meretricious. Latching on to the latest seasonal craze may produce short-term amusement, but such a policy leads in the long term to superficiality and obsolescence. Nothing looks more stale than last year's gimmick, in art as in fashion. The true artist should be motivated by more profound and lasting aims, far removed from the incessant urge to appear up-to-date at all costs.

Even so, there is no point in ignoring the essential pulse of your own time. Little can be gained from pretending that you are immune to the world's ever-shifting dynamic. Artists who cling to such a belief, in order to console themselves with nostalgic affection for an irrecoverable past, will end up consigning their work to a state of paralysis. Railing against anyone who explores alternative strategies and new media, they start denying the legitimacy of everything except their own narrow area. As a result, blinkered defensiveness sets in. Stagnation soon ensues, along with a mounting intolerance of artists who still succeed in remaining alive to the essential energy of their era.

The momentousness of the modern period in art is at last reflected in the work displayed by the Tate's Bankside colossus. From now on, the inventive turbulence charted there will become far less easy to ignore or deride. The vitality of the exhibits is bound to win an increasing number of converts, making them appreciate just how arrestingly the finest

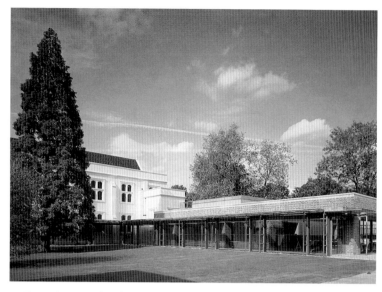

2. Extension at Dulwich Picture Gallery, London, by Rick Mather Architects, 2000

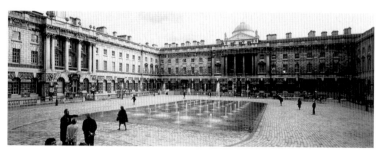

3. Somerset House, with Edmond J. Safra Fountain Court

contemporary art reflects the pace of life experienced by everyone as the new century moves into action. Painting will certainly survive, responding as it always has done to challenges thrown up by fresh sources of imagery, wherever they may appear. But its practitioners must accept that making marks on canvas will henceforth be only one option among many available to the artist of the future.

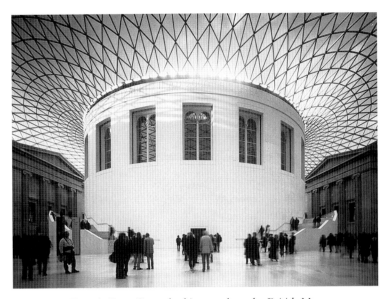

4. Norman Foster's Great Court, looking north, at the British Museum, London

Video installations of increasing technical sophistication are bound to play an important role, and so will computer animation and the Internet. Digital techniques are already generating an increasing interest in deceptive manipulation. Even the most gritty of documentary images will be subject to alteration, at the artist's whim. Nothing is safe. The more 'authentic' a picture may seem in future, the less it should be trusted. Visual distortions of the most devious yet persuasive kind will soon become commonplace. And as technology grows more sophisticated, art will be able to conjure astonishingly convincing worlds into being. They may come to seem more real, paradoxically, than reality itself. We can only guess at the battery of devices that might become available as the 21st century proceeds. But one thing is beyond doubt. The continuing thrust of technological innovation will provide a multitude of intoxicating possibilities for the artist to explore. The term 'art' will grow ever broader in meaning, to encompass the continually expanding array of alternative avenues worth investigating.

Sensing the need for different, dramatically expanded methods of presenting art, museums are undergoing a revolution. Tate Modern was only the most spectacular of the new buildings that opened, across the nation,

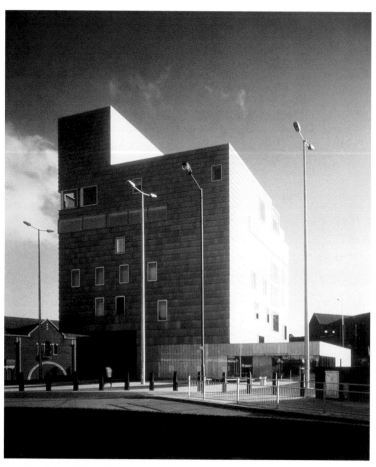

5. Walsall Art Gallery, by Caruso St John

in a £400 million initiative. It amounted to the biggest museum expansion that Britain has ever witnessed. In London alone, a major new space at the National Portrait Gallery, extensions at the Wallace Collection and Dulwich Picture Gallery, the Imperial War Museum's new wing and the conversion of the River Terrace frontage at Somerset House were the most prominent of the enterprises unveiled in the spring and summer of this *annus mirabilis*. Then, in the winter, the British Museum launched its ambitious transformation of the Great Court. Increasing public space in

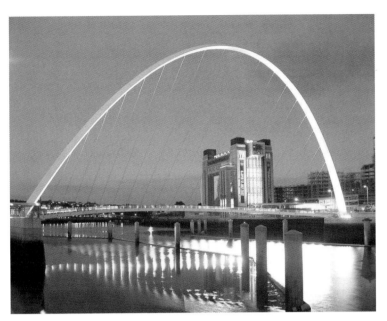

6. Baltic, Gateshead

the museum by 50 per cent, it boasted the largest covered public square in Europe underneath Norman Foster's immense steel and glass roof. Nor was the spirit of boldness limited to London. An audacious new gallery also opened in Walsall, dominated now by Caruso St John's soaring and expansive cubic monolith. Its calm, spacious rooms compared well with the Lowry Centre in Manchester, where Michael Wilford's swaggering, highly sculptural building on the waterfront at Salford Quays devoted too little of its jarringly coloured interior to the display of art.

Far from exhausting itself by the end of 2000, the drive for larger, more versatile and inviting museums is likely to intensify as the century proceeds. A mounting number of regional cities are furnishing themselves with buildings that escape, at last, from the old, depressing stereotype of the municipal art gallery. In 2002 the monumental Baltic, converted from old flour mills, opens at Gateshead on the banks of the River Tyne as a grand showcase for contemporary art. And the desire to commission bold structures, revolutionizing everyone's ideas about what a gallery can be, will quicken when, as I still hope, the full amount of money is eventually raised for Daniel Libeskind's eruptive *Spiral* at the

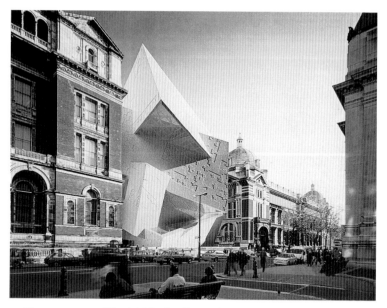

7. Photomontage of Daniel Libeskind's *Spiral*, at the Victoria & Albert Museum, London

Victoria & Albert Museum. This uninhibited yet rigorously designed new wing promises to be as arresting, albeit in a smaller and more cramped setting, as Frank Gehry's convulsive Guggenheim Museum in Bilbao. Libeskind has also produced a flamboyant building for the Imperial War Museum in Manchester, and the provocative precedent he sets there will surely be emulated by other, equally stimulating regional projects later on.

Across the world, a similar appetite for renewal galvanised the millennium year. Appropriately enough, 2000 began with the reopening of the extensively remodelled Pompidou Centre, the great forerunner of recent modern art museums elsewhere. At the same time, the restlessly expansive Guggenheim Museum unveiled its swashbuckling plans for an unlikely outpost in Las Vegas and a typically headlong Gehry building in New York, exploding on the banks of the East River with even more chutzpah and restless dynamism than its seismic forerunner had displayed in northern Spain. Not to be outdone, the Museum of Modern Art revealed the full extent of its even more expensive major redevelopment

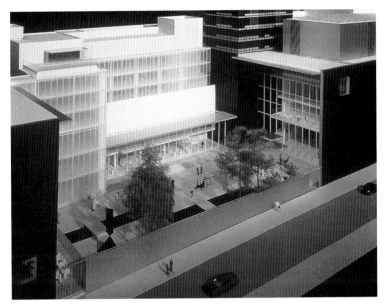

8. Yoshio Taniguchi, model of Museum of Modern Art, West 54th Street, New York, showing renovation of the Abby Aldrich Rockefeller Sculpture Garden

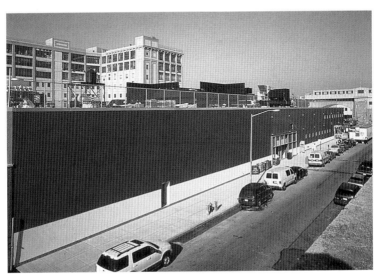

9. Museum of Modern Art, Queens, Exterior view, 33rd Street

in Manhattan. Involving the closure for three years of its building on West 53rd Street, so that Yoshio Taniguchi's construction and reconstruction project can be carried out, the scheme also embraces the acquisition of an industrial space in Long Island City, Queens. Remodelled by Cooper Robertson & Partners with Michael Maltzan, it will be the temporary home for MoMA until the newly transformed Manhattan museum reopens in 2005. By far the most ambitious building initiative in the museum's history, it aims at fulfilling Director Glenn D. Lowry's bullish promise to 'showcase our world-class collection like it has never been seen before'.

The Royal Academy, which harbours its own expansion plans in the old Museum of Mankind building behind Burlington House, produced the noisiest advance publicity of the year for a show of international contemporary art called *Apocalypse*. In the event, visitor numbers did not match expectations, and by no means all the exhibits possessed the millennial impact of the exhibition's rousing title. Some would-be viewers may have felt deterred by the prospect of crawling through the opening exhibit, Gregor Schneider's intensely claustrophobic interior of his own reconstructed house. And once inside, images as powerful as Maurizio Cattelan's stricken Pope, or Jake and Dinos Chapman's swastika-shaped vitrines pullulating with figures mired in combat, torture and genocide, referred back to the past rather than forward to the 21st century. Although plenty of new art was displayed during 2000, and is discussed in the rest of this book, scant sign could be detected of a definably fresh momentum in contemporary work. Some outstanding solo shows were staged, by artists as various as Tony Bevan, Richard Billingham, Rineke Dijkstra, Douglas Gordon, Rodney Graham, Yayoi Kusama, Steve McQueen, Aernout Mik and Shirin Neshat. Quite understandably, however, there was a general tendency to be retrospective instead of searching for emergent artists who have yet to define their singularity.

When the increasingly powerful Jay Jopling opened his handsome new White Cube[2] gallery in East London, the inaugural show amounted to a résumé of British artists who had established themselves in the previous decade. Dominated by Damien Hirst, Tracey Emin and other members of their generation, along with a few older artists like Gilbert & George and Antony Gormley, it contained no surprising new names. Nor did the large exhibition simultaneously mounted at the Saatchi Gallery over in west London. It concentrated on several of the most prominent artists in *Sensation*, a show whose initial notoriety at the Royal Academy was later compounded by a high-profile international tour culminating in a publicity-drenched, stridently attacked appearance

10. Shirin Neshat, *Fervor*, 2000

at the Brooklyn Museum in New York. Now, however, one of the organisers of the 2000 *British Art Show*, Matthew Higgs, felt that the euphoric period had passed. He pointed out that the 1995 *British Art Show* 'took place at the absolute epicentre, the fever-pitch moment, of interest in young British art.' But Higgs considered that there was now 'a genuine international suspicion in relation to British art.' He and his fellow-selectors of the show's 2000 instalment opted instead for a cross-generational selection, from David Hockney's painstaking 'camera lucida' portrait drawings to Martin Creed's joyful yet threatening balloon-filled room.

The sense of hiatus may have been inevitable during a year when everyone seemed more conscious, in millennial terms, of endings rather than beginnings. Perhaps the future appeared far too full of uncertainties to be contemplated for long. The prevailing emphasis in major exhibitions across the world rested on reassessing the past. In Paris, the discovery of the idyllic Mediterranean coast by French painters filled the Grand Palais with sensuous radiance, while Manet's still-life images were explored at the Musée d'Orsay and Philip Guston's career re-examined at the Pompidou Centre. On a previous Paris trip, I was even more fortunate to

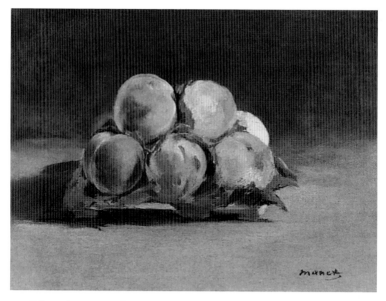

11. Edouard Manet, *Still Life with Peaches*, 1880, Musée d'Orsay, Paris

view the Pompidou's monumental survey of Picasso's prodigious achievements as a sculptor. The Metropolitan Museum in New York went much further back, reassembling the hoard of golden deer deposited in a south Russian burial site between the fifth and fourth centuries BC. I remember being still more impressed when, on another visit to New York earlier in the year, I encountered the same museum's dramatically staged retrospective of Tilman Riemenschneider's eloquent limewood carvings. Quite by chance, I also caught another highlight of the year in the US when a great touring exhibition of Van Gogh's portraits arrived at the Philadelphia Museum of Art. Maybe the advent of 2000 prompted institutions everywhere to be exceptionally wide-ranging in their exploration of history. But the recent past was not forgotten. Nam June Paik's pioneering contribution to video art was celebrated in a spectacular survey at the Guggenheim Museum in New York, and contemporary British paintings acquired by Elaine and Melvin Merians were displayed with great panache at the Yale Center for British Art in New Haven. I was delighted to write the catalogue essay for the latter show, and realise how much London-based painters from Lucian Freud to Peter Doig are now cherished by discerning US collectors.

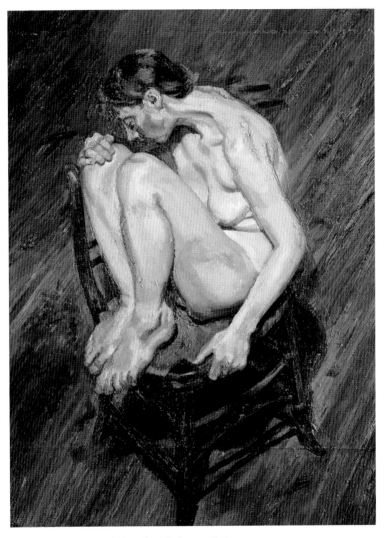

12. Lucian Freud, *Naked Girl Perched on a Chair*, 1994

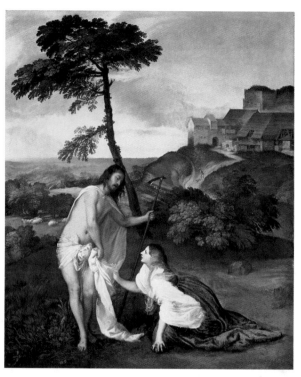

13. Titian, *Noli me Tangere*, 1510–11, exhibited at *Seeing Salvation*, National Gallery, London

The best-attended show of historic art in London was held at the National Gallery, where Neil MacGregor's *Seeing Salvation* looked at the development of Christ's image in Western art. Roaming from the funerary slabs in Roman catacombs to Stanley Spencer's ecstatic multi-racial *Resurrection* in Cookham churchyard, the show proved overwhelmingly popular. At a time when the future of Christianity looked beleaguered throughout Europe and elsewhere in the world, visitors appeared to find enormous solace in this illuminating survey of redemptive images from an era when art was at its most devout. But the highlight of my own rediscovery of the past in 2000 occurred during a summer trip to Rome, where the arrival of Jubilee Year coincided with a revelatory amount of restoration and renewal throughout the city. After a protracted period of neglect, buildings and their contents were once again revealed in a near-

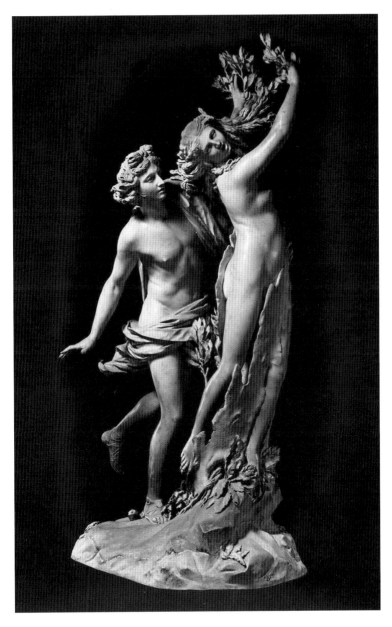

14. Bernini, *Apollo and Daphne*, 1622–4, Villa Borghese, Rome

pristine state. Carlo Maderna's newly cleaned facade of St Peter's looked resplendent, and so on a far smaller scale did Bramante's extensively renovated, exquisite Tempietto. The vaulted immensity of the newly opened Tabularium, its full Roman grandeur still preserved inside the Palazzo Senatorio, proved as impressive as the Villa Borghese where Cardinal Scipio Borghese's collection at last emerged from decades of inexcusable closure. Two of the works that impressed me most forcibly as a student are housed here: Titian's *Sacred and Profane Love* and Bernini's *Apollo and Daphne*. Seeing them again, over thirty years later, was intensely moving, and I was also elated to rediscover Raphael's exuberant *Galatea* fresco leaping out of its wall at the newly transformed Villa Farnesina.

Back in London, the year 2000 as a whole proved an excellent moment to renegotiate our relationship with the art of the past. The Royal Academy unearthed a host of forgotten names in its stimulating re-examination of *1900: Art at the Crossroads,* while the Victoria & Albert Museum brought the Art Nouveau movement back to sinuous, undulating life. Ruskin, Turner and the Pre-Raphaelites were scrutinised by the Tate and, in apparent riposte, the stern modernist rigour of *Bauhaus Dessau* was celebrated at the Design Museum. Above all, though, a remarkably diverse array of living painters, sculptors and artists working with photography and video responded with alacrity when the National Gallery invited them to make work inspired by images in its collection. The whole idea would have incensed Constable, who wrote an angry letter to his friend Archdeacon Fisher in 1824 predicting that, 'should there be a National Gallery (which is talked of), there will be an end of the art in poor old England.' Committed to studying landscape in the open air, Constable feared that his freshness of observation would be ousted by a sterile worship of approved, traditional masters. 'The manufacturers of pictures are then made the criterions of perfection', he stormed, 'instead of nature.' To a certain extent, Constable's fear may have been justified. Copying great paintings at the National Gallery rapidly won favour, and often encouraged a timid, slavish devotion to academic ideals. But the truth is that the National Gallery could also inspire the most innovative artists. Monet found himself captivated by Turner when he visited the collection in Trafalgar Square. And David Bomberg, who helped to revolutionise British art before the First World War, took his wife to the National Gallery in 1914 and explained to her, in front of Michelangelo's *The Entombment*, that modern artists 'had their beginnings with the Old Masters.' Just over half a century later Frank Auerbach, once a pupil of Bomberg's, painted an overt tribute to one of the National Gallery's greatest masterpieces, Titian's *Bacchus and Ariadne*.

15. Frank Auerbach, *Bacchus and Ariadne*, 1971

As part of its millennium celebrations, the same collection devised a fascinating tribute to its continuing influence. By inviting twenty-four artists to make new work inspired by National Gallery paintings, it aimed at revealing the debt owed by the present to the past. Richard Morphet, who had retired the previous year as Keeper of the Tate Gallery's Modern Collection, was well-placed to act as the exhibition's curator. And he admitted that plenty more artists, especially from the younger generation, could easily have been added to the list of participants. At the same time, though, there was nothing predictable about the show, and some of the artists' choices were very surprising. Who could have guessed that Louise Bourgeois, obsessed by dark, traumatic memories of her father's infidelity, would plump for Turner's lyrical *Sun rising through Vapour: Fishermen cleaning and selling Fish?* But her sculpture *Cell XV*, made in honour of Turner's painting, was a shimmering affair, containing within its aluminium structure two white cones flowing with blue liquid. It paralleled Turner's fascination with incessant change and radiant luminosity. Equally unlikely was Anselm Kiefer's decision to select

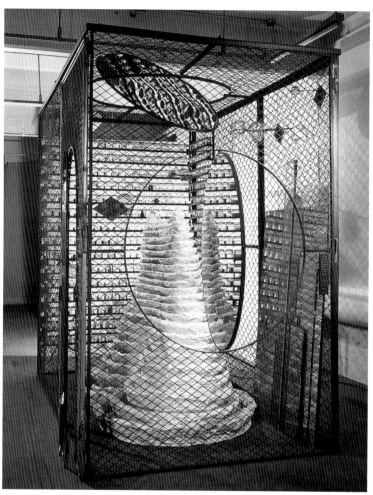

16. Louise Bourgeois, *Cell XV (For Turner)*, 2000

Tintoretto's *The Origin of the Milky Way*. After all, Kiefer made his repu-
tation as an artist haunted by Germany's past, and in particular by the ter-
rible legacy of Fascism. So why was he now drawn to ancient mythology,
and the story of Hera's spilt breast-milk creating a galaxy of stars? The
answer lay in Kiefer's more recent involvement with the firmament. His
exhibit, *Light Trap*, was an almost diagrammatic view of the night sky,

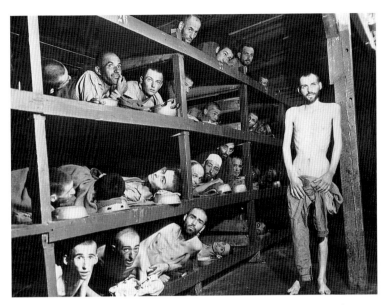

17. Jews in Buchenwald concentration camp, after liberation on 11 April 1945

reflecting his fascination with astrology, alchemy, Mayan temples and much else besides.

If the *Encounters* show summed up contemporary artists' continuing involvement with history as the old millennium gave way to its successor, one particular aspect of the past would not go away. Apart from the Chapman brothers' hellish *tour de force* in the *Apocalypse* show, several other contributors to the same exhibition made open or veiled references to the Holocaust. In Berlin, Daniel Libeskind's new Jewish Museum encapsulated the horror we still feel about the Nazis' annihilation of the Jews. And he did so without relying on exhibits of any kind. The architectural forcefulness of his uninhabited building, where voids proved even more telling than solid forms, was potent enough in its own right. But the Imperial War Museum's new Holocaust exhibition in London also proved that the judicious use of historical exhibits could convey a haunting notion of the unimaginable atrocities committed by Hitler and his followers. By deploying photographs, film, documents, objects and eyewitness testimony, an almost unbearable reconstruction of the twentieth century's most barbarous moment was convincingly achieved. While the show admitted all the way through that the Holocaust was 'beyond

describing', its cumulative effect delivered, as one witness hoped, 'a warning to future generations'. So did Rachel Whiteread's much-delayed *Holocaust Memorial*, completed by 2000 but not finally unveiled until the following year. For too long, the project had looked doomed. Endlessly postponed, and paralysed by the murky strife of Austrian politics, her monumental steel and concrete sculpture was intended from the start to relate to a highly sensitive context: the Judenplatz in Vienna, the ancient heart of the city's beleaguered Jewish community and the place where their medieval synagogue was destroyed as early as 1421. Maquettes and photomontages of the Memorial *in situ* showed an austere, sealed-up building, its rigidly ordered sides resembling library walls facing out-wards. Memories were triggered of the highly publicised book-burnings undertaken by the Nazis, who knew only too well how to distort and erase history. Despite everything achieved by computer technology and the Internet in recent years, books are still the prime repository of human knowledge. They tell us about ourselves, and the sight of

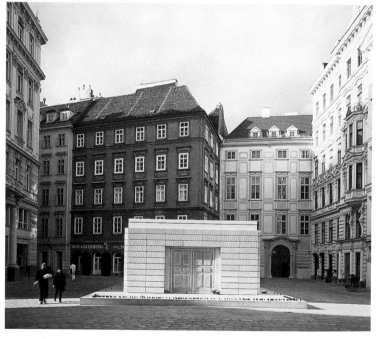

18. Rachel Whiteread, *Holocaust Memorial*, Judenplatz, Vienna

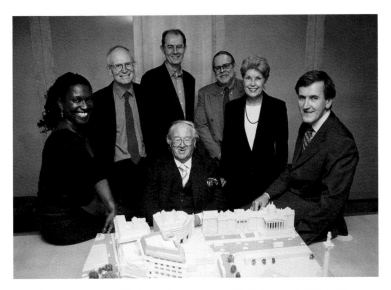

19. The Empty Plinth Advisory Group, 2000, with (left to right) Elsie Owusu, Professor Peter Clarke, Richard Cork, Sir John Mortimer, Councillor Bob Harris, Baroness Rendell and Neil MacGregor

Whiteread's glacial shelves provoked in the viewer an instinctive, even indignant, sense of loss.

Whiteread also contributed a site-specific work to a remarkable new setting for sculpture in London: the empty plinth in Trafalgar Square. Largely ignored ever since Sir Charles Barry designed it in the early Victorian period, the plinth was originally intended to be crowned by an equestrian statue to match the bronze of George IV on horseback at the north-east corner of the square. But the proposed effigy was never erected, and the plinth lay empty until the Royal Society of Arts held a meeting to discuss the possibility of a 'millennial sculpture display.' I attended that initial discussion, and strongly supported the idea of commissioning three artists to produce new work for the site. London has far too little memorable modern sculpture in its public spaces, and the empty plinth occupies a prominent position at the city's heart. The scheme obtained planning permission, secured the necessary funding and went ahead. All three commissions provoked widespread fascination. They could hardly have been more diverse, ranging from Mark Wallinger's small

marble Christ-figure *Ecce Homo* and Bill Woodrow's mighty allegorical bronze *Regardless of History* to Whiteread's inverted cast of the plinth in water-clear resin. Contemporary sculpture secured an enormous new audience, but the plinth's long-term future remained uncertain.

So an Advisory Group was set up under the chairmanship of Sir John Mortimer, and soon after joining it I discovered that the entire nation had decisive, wholly contradictory views about the kind of image best suited to fill the vacant site. Some wanted a statue of Princess Diana riding in a jeep, others a colossal handbag in memory of Lady Thatcher, while a well-organised lobby pressed for a memorial to the Women of World War II. But the Advisory Group decided, after extensive consultation, to recommend that the plinth continue to be used as a showcase for specially commissioned sculpture, expanding the initial scheme so that artists across the world could submit proposals. Our report was welcomed by the new Mayor of London, Ken Livingstone, who has so far proved disappointingly slow in implementing the project. But the plan to pedestrianise the north side of Trafalgar Square is going ahead, and I hope that the plinth sculpture scheme will play an audacious role in revitalising this much-polluted part of the metropolis.

I also trust that the urge to work outside the boundaries of galleries and museums, in unpredictable spaces where fresh approaches are generated, will expand elsewhere during the present century. New audiences for art can be nurtured in the most unlikely settings, and artists often benefit from the chance to make more ambitious work, whether temporary or permanent, in public places. Such ventures carry dangers, especially in exposed locations vulnerable to attack. But they can result in landmark achievements, which help to define the emergent identity of a new age.

In the end, though, everything depends on the quality of the experience provided by art. No amount of expansion, whether inside galleries or beyond, can guarantee the viewer a memorable and satisfying encounter with a work. Growing popularity could even militate against it, attracting crowds that allow only frustrating glimpses of the exhibits. Steady, sustained looking is the only way to deepen our understanding of how art can illuminate human existence. The impatient glance is no substitute for the searching gaze. If we truly learn how to scrutinise, with the passion and attentiveness that great artists repay many times over, then our future lives will be enriched beyond all expectation.

NEW ART

AUDIBLE LIGHT
26 January 2000

Brace yourself for a sensory assault-course at Oxford. *Audible Light*, an international show at the Museum of Modern Art, ends up bombarding retina and ear-drum with equal relish. The reverential silence normally associated with art galleries is swept aside. We are subjected to aural and visual invasions of mounting intensity, until they reach such a pitch that our natural reaction is to head for the street. This is the work of artists reared on amplified sound-blasts and hectic light shows in clubs and rock concerts. Several of the exhibitors also have track-records in music, performance and DJ-ing. They belong to a cross-over generation that moves with ease between areas once regarded as culturally separate. And the finest of their installations at MoMA benefit from this appetite for boundary-breaking.

The show starts in a deceptively quiet way. Carl Michael von Hausswolff, a Swedish polymath who works in publishing and music production as well as making experimental art, presents a new piece called *Domestic Grid Flow*. A continuous buzz is transmitted from his darkened space. It seems at first to come from half-way up the wall, where a television set emits a fuzzy redness. A slow-building mood of tension is generated here, reinforced by the television's proximity to an industrial cooker emanating heat. Nobody can be detected in this gloomy interior, but everything installed there seems to have been left on by a recent, careless occupant. A thin vertical heater juts from the wall, its orange bar blazing angrily. We can feel its warmth, even though a wire barrier prevents us from going any nearer. Von Hausswolff provides a row of four chairs, where viewers can sit and contemplate the menacing spectacle. But I still felt irritatingly shut out from the electro-magnetic flow coursing beyond the wire, and aware above all of the pent-up danger it posed.

In this respect, von Hausswolff's ominous offering is untypical of the show as a whole. Most of the exhibits invite us to come as close as we like, and some allow the viewer to play a decisive role in activating the installation. The only British artists on view, Bruce Gilbert and Graham Lewis, set up a tall metal container in the centre of their space. Towards the top, a glass window allows us to look inside. The light bulb suspended there gives off an almost blinding brightness, painful to look at for more than a few seconds. But it enables you to detect a tomato-red metal device positioned behind the bulb. Reminded of an alarm, I stopped and waited for

it to go off. Nothing happened. Only when I gave up and walked past did the alarm start ringing, and even then it sounded strangely muted. Since Gilbert and Lewis are also musicians, and belong to the influential band Wire, the softness of their alarm seems still more baffling. But our ability to trigger it serves as a warning for the experiences ahead, waiting to ambush us upstairs.

Here, the German artist Carsten Nicolai has, like von Hausswolff, transformed his room into an arena for live electronic sound. Unlike von Hausswolff, though, he does not bar us from walking freely around the space. No signs of danger can be detected here, and we soon discover that our presence plays a vital part in the work. Eight black, circular speakers are embedded in the grey, platform-like floor. They give out sampled pulses, but their low sound has a far less dramatic impact on our ears than on our feet, legs and arms. As we move towards two glass containers, reminiscent of the laboratory flasks favoured by Tony Cragg, the pulses from the floor vibrate through our limbs. Tingling, we notice that the water in both flasks is shaking with the impact as well. Sound is made visible through the water's agitation, and the vibrations now seem to surround us, bouncing off all the white walls. We might be witnessing the preliminary tremors of an earthquake. But Nicolai, who performs on the club scene under the name Noto, stops well short of subjecting us to a more alarming sonic turbulence.

Ann Veronica Janssens, on the other hand, shows no such restraint. Her *Untitled (Cyberlight)*, the most impressive work in the exhibition, assails us with a battery of constantly changing colours. The last time I encountered this Belgian artist's work, at the 1999 Venice Biennale, she filled her country's pavilion with a dense mist. I felt like a traveller lost in a winter landscape, suddenly hearing a child's voice or finding a cluster of bulging water-bags about to burst. It was an oddly soothing experience, but her room at Oxford is more akin to a disco light-show at its most aggressive. The powerful theatrical spotlight lurking in a far corner gives no respite. Every few seconds, it saturates the entire space with a different colour. The light-beam changes from lime-green to pale blue, puce to orange, yellow to purple. And within each overall hue, a circle or oval of the same colour flashes on to the floor, wall, ceiling or overlaps between one of these surfaces and another. It is a fierce experience: our eyes are perpetually adjusting to the contrast between darkness and sudden, dazzling radiance. But I found it invigorating rather than alarming, as long as my eyes avoided getting directly in the line of fire from the relentless machine. No sound distracts us from this sensuous extravaganza, which initially seems so opposed to the mist-enveloping pavilion at

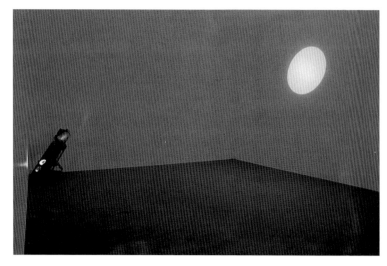

20. Ann Veronica Janssens, *Untitled (Cyberlight)*, 1997

Venice. After a while, though, I realised that both these memorable instal-
lations are united by the same vision-cleansing impulse.

Ann Lislegaard is far more baffling. Moving into her room, we are
rebuffed by a large white structure stretching like a temporary wall across
the centre of the space. Flashes of bright light erupt around its edges,
along with the sound of a young woman's voice. But when we walk past
the wall, nothing else is visible beyond it. The other side is just as blank,
apart from speakers lodged in the wall's four corners. Lislegaard, among
the most internationally celebrated of younger Danish artists, is in no
mood to make things easy. As the light continues to flash on and off,
revealing nothing except the wall's pristine bareness, we listen to the
voice telling a mundane story about a man's movements inside a house.
At one point there is a brief, throwaway reference to a scream outside. It
prompted me to wonder if the woman is really describing the scene of
a crime. But she concerns herself otherwise with a matter-of-fact
account of the man's letter-writing, phoning and pacing around, backed
up sometimes by the sounds he might be making. Occasionally the
woman's voice converges with another one, making their words inco-
herent. At these moments, confronted by the tantalising blankness of the
wall, I found Lislegaard's tactics alienated my sympathies altogether.

Walking into the vastness of the final room, where the Finnish artists

Tommi Gronlund and Petteri Nisunen have set up a highly interactive work, is like stumbling across an early-warning radar station. On every side, large white dishes seem to monitor your movements. Each of these eight hissing saucers is attached by cable to a bank of tape recorders on the floor, where tapes are continually played on a loop. But the sounds we make, moving across the immense space, trigger the installation. The white dishes relay our sonic presence around the gallery, and if we cry out or clap, the noise sets off a startling sequence of echoes. If we retreat to the side of the room, though, the sound in the centre builds up to a high, loud and near-unbearable pitch. Although the saucers remain as motionless as before, they now appear to be mounting an assault. Our senses quickly feel threatened, as if by an instrument of torture. The sound can be stopped if we move back to the middle of the room, thereby blocking the transmission. But it might be more sensible to jam fingers in our ears, locate the nearest exit and escape.

THE BRITISH ART SHOW 5

12 April 2000

After the prolonged adrenalin rush of the 1990s, British art finds itself pausing for breath. The generation who enjoyed so much heady international success has become older, now, and more established. Younger artists are emerging, and yet there is little coherent sense of a boisterous 'new wave' sweeping the YBAs of yesterday to one side. Matthew Higgs, a co-curator of the enormous *British Art Show* 5 filling eight galleries across Edinburgh, is acutely aware of the change. Looking back at the last *British Art Show*, staged half-way through the 1990s, he stresses that it 'took place at the absolute epicentre, the fever-pitch moment, of interest in young British art'. Now, by contrast, he detects 'a genuine international suspicion in relation to British art', and a strange feeling of uncertainty prevails.

As a co-curator of the last *British Art Show*, I can testify to the accuracy of Higgs's remarks. The excitement involved in organizing that survey was intense. Huge vitality abounded everywhere, women artists easily outnumbered men in the exhibition, and it attracted record-breaking attendances on a national tour. It marked a moment of exceptional vigour in British art, and many of its youngest exhibitors have since developed into outstanding individual talents.

Several strong members of the YBA generation are included in the latest *British Art Show*. Tracey Emin has a roomful of spidery monoprints, all exploring her own messy life with emotional candour. Ruefulness mixes with anger and vulnerability in these confessional images, their fragility contrasting with the multicoloured blatancy of her appliqué blanket covered in teenage memories as acrid as 'pissing pure cider until it rains'. No photographs or video images of Emin herself are displayed, whereas Sarah Lucas's contribution relies solely on self-portraits taken with a camera. They chart her 'bad girl' development over the last decade, from the long-haired ex-student who posed in 1994 next to a washing-line full of knickers. Whether flaunting her notorious T-shirt smeared with two breast-shaped fried eggs, or carrying a salmon on her shoulder outside a public lavatory, Lucas scowls at the lens. She only allows herself a reluctant smile in 1997, squatting on the floor with a skull between her legs.

On the whole, though, the *British Art Show* 5 steers away from YBA territory. The organisers, who also include Pippa Coles and Jacqui Poncelet, have opted for an open-minded, cross-generational approach. Unlike the last *British Art Show*, with its concentration on twenty-six predominantly young participants, this new male-dominated exhibition embraces fifty-six artists of widely differing ages. David Hockney makes a surprise appearance, in a row of careful pencil portraits made with assistance from a camera lucida. Although it helps him produce a faithful representation, Hockney is too good a draughtsman to need aid from any instruments. Ranging here from Alan Bennett to Damien Hirst, his sitters are all easily recognisable. But I prefer Hockney when he is more freewheeling, and there are no discernible links between his drawings and work by younger exhibitors.

Paula Rego, by contrast, does have attitudes in common with artists who are half her age. In a powerful pastel triptych, she explores the predicament of women forced to undergo illegal abortions. Rego feels so passionately about this issue that she is supporting the political fight to change abortion laws in her native Portugal. But there is nothing agit-prop about her triptych. In each section, a young woman is seen alone and humiliated. Whether lying in bed or perched on a bucket, she looks fearful. A terrible sense of helplessness hangs over her, and Rego's willingness to tackle such a harrowing subject made me appreciate her unsuspected links with Tracey Emin. Rego's style, based on rigorous study of the posed model, has nothing to do with Emin's scratchy expressionism. But both artists are prepared to confront the most painful aspects of female life, and the exhibition offers other opportunities to make surprising connections between the generations.

Nothing, at first, might seem to bind the fifty-year-old conceptualist John Stezaker with Michael Raedecker, a young Dutch artist now based in London. Stezaker uses computer prints and Raedecker works with acrylic, thread and sequins on linen canvases. But the results turn out to have similarities in subject and mood alike. Stezaker's panoramic images, both called *Overworld*, baffle the eye with city views and landscapes poised half-way between reality and reflection. He presents us with a puzzling, semi-inverted world where nothing can be taken for granted. So does Raedecker, even though his haunting *Mirage* appears to concentrate on a deserted stretch of arid countryside. Woven trees cast painted reflections, perspective is asserted only to be denied, and at one point Raedecker twists the entire image on its head.

Disorientation is also an important theme elsewhere in the show. It reaches a spectacular point in Martin Creed's *Half the Air in a Given Space*. His room, at Inverleith House in the seductive Royal Botanic Gardens, is a brilliant *coup de théâtre*. No less than 15,000 balloons are packed inside. We can only enter with difficulty, pushing hard against them to force the door open. Once inside, we soon find the balloons engulfing our vision in an astonishingly aggressive way. As we stagger blindly through the room, the multicoloured orbs press against us on

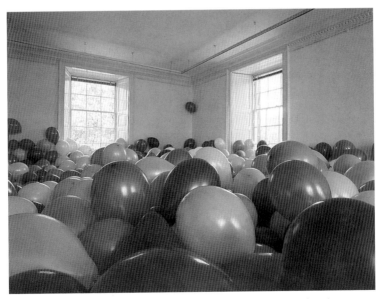

21. Martin Creed's balloon installation at Inverleith House, Edinburgh, 2000

every side. Although empty space above can be glimpsed at times, we are mainly obliged to inhabit a world that baffles and bombards our senses. On one level, it offers an exhilarating experience: children will probably treat Creed's room as an excuse for a riotous party. But there may be moments when adults feel trapped by the balloons, and find themselves longing to escape from the incessant, claustrophobic barrage.

Susan Hiller's video installation, powerfully occupying a darkened room at the Fruitmarket Gallery, is even more unsettling. She makes no attempt to hide her reliance on clips from film and television, all featuring children and teenagers with special powers. But the cumulative effect is mesmeric. Watching these 'possessed' figures forcing crockery to slide across a table, or make objects fly through the air and strike their opponents, we gradually find ourselves transported into a hallucinatory realm.

Some of the younger artists, among them a strong contingent from Northern Ireland, prefer to deal with contemporary life in a more raw, direct way. Born in Belfast, Paul Seawright uses large colour photographs to explore an uncompromising vision of urban confinement and destruction. Rusty cages dominate some of his strongest images, their emptiness in no way diminishing their potential as instruments of oppression. Other images show the aftermath of calamitous fires, their origins unspecified. But Graham Fagen, in the captions accompanying his photographs, is prepared to spell out exactly how damaging home-made weapons can be. Training his camera with clinical precision, he turns a petrol bomb, a flame-thrower or a finger-sling into deceptively quiet still-life images. They look pristine, and yet Fagen emphasises the weapons' effectiveness by revealing all their lethal elements.

Derry-born Padraig Timoney is no less bleak, in his panoramic painting called *Fungus Rules the Brazen Cars*. He presents a deserted housing estate where one end wall is disfigured by a scrawled drawing of a building on fire. The ground between the blocks is strewn with broken fragments of machinery and, most nightmarish of all, plaster mushrooms sprout from windows and roofs where television aerials might normally be found. The threat of violence recurs in *Disclaimer*, an installation by another Derry artist, Conor McFeely. On one wall, a large painting reminiscent of Frank Stella's early minimalist canvases strikes a dour note. It seems to be made from insulating tape, which reinforces the feeling of sealed-up oppression. So do the resin-splattered blankets ranged across the floor, flanked by another wall where baseball bats are paraded, as if waiting to be wielded on the streets.

But images of urban desolation are not confined to Northern Ireland. Michael Landy's epic installation, *The Consuming Paradox*, refers to a

more universal sense of social malaise. He makes us wander through a maze-like sequence of high walls, each constructed from plastic milk crates. Their jaunty colours fail to mask Landy's underlying seriousness, which finds more feverish expression in his crowded ink drawings displayed on the walls. They dramatise a world overwhelmed by the strident imperatives of consumerism at its most unbridled.

Consolation seems to be offered by Chad McCail, whose frieze-like gouaches relate to a project for billboard images. Executed with the clarity of Chinese propaganda cartoons from the Mao era, they show a world of social harmony where people burn money in bonfires, strip off their business suits to bathe, and wander into the woods for 'relaxing orgasms'. But it is all impossibly idealistic, and the gap between fantasy and reality gives McCail's tableaux a strange, dream-haunted melancholy.

STEVE McQUEEN: COLD BREATH

17 May 2000

Steve McQueen has never been afraid of exposing himself in his own art. When he won the Turner Prize last year, his most substantial exhibit showed the deadpan artist standing utterly still and unconcerned as a timber house falls on to him. And in *Bear*, his powerful early film now on view at Tate Modern, he appears naked, eyeing another young black man as they circle warily round each other. They might be preparing for a fight. The plumper of the two, McQueen looks more nervous and sweaty than his cooler, more sinewy companion. But he grins as well. The film swings between pent-up conflict and a more playful mood. At one point, the two men embrace and seem to enjoy homoerotic affection. Then they are viewed from below, panting as their arms lock in a wrestling hold. Pain is stressed, even fear. But *Bear* is a mercurial film, constantly shifting from aggression to sensuality and back again. McQueen teases the viewer with ambiguities throughout this deft, subtle and highly dramatic work, astonishingly assured for a twenty-four-year-old artist.

Still a student when he made the film in 1993, McQueen subverts all the old racial stereotypes about the black aggressor. He emphasises instead the hesitancy of the two men, especially in lingering shots of their faces as they veer between hostility, suspicion and tenderness. Shot

with arresting visual flair, *Bear* ends as the two men break into a slow-motion, surprisingly lyrical dance. The sequence concentrates on their legs alone, and throughout the film McQueen favours close-ups of different body-parts. He appears enthralled by every aspect of the human figure, particularly when its actions confound lazy expectations and offer tantalizing alternatives to clichéd notions about the male capacity for violence.

Even so, nothing can prepare us for the experience offered by McQueen's latest film, *Cold Breath*. Installed in the Delfina's new project space, a cavernous Southwark building only a brief walk away from Tate Modern, it presents us at first with a journey down a narrow, dark corridor. With characteristic precision, McQueen specified the width of this passageway. He was equally careful to insist on the exact height of the television monitor positioned in the corridor. We find ourselves physically confronted by it, and pushed unexpectedly near to the screen. It becomes an intimate encounter, and the closeness is reinforced when we realise that a man's nipple occupies the centre of the image. It appears motionless to begin with, like a black-and-white photograph. We have time to register the goosebumps peppering the flesh around the nipple, and notice that the skin is entirely hairless. Soon enough, however, our eyes begin to detect motion. The nipple swells gently and then recedes, in response to its owner's breathing. No hint of agitation can be detected, but there is a growing air of expectation. The nipple appears to be waiting, almost in a state of suspense.

Before long, two fingertips invade the screen. Without ado, they get to work. Somewhat paler than the nipple, they feel at liberty to play with it at will. They brush the nipple, in an affectionate yet taunting gesture. They tweak it, pinching so hard that we can feel the pressure in our own bodies. They glide over the nipple, as if about to say farewell and move on. But this initial dalliance is only the beginning. For the fingers turn out to be extraordinarily flirtatious. After leaving the nipple alone for a while, they return with even more seductive energy than before. The nipple is confined to a passive role, playing the part of defenceless target for whatever the fingers feel like inflicting on it. They refuse to let go, and we gradually realise that the ritual enacted here is as ambiguous as the struggle between the two amorous men in *Bear*. This time, though, only one person is involved: McQueen himself. And we see nothing of his body apart from nipple and hand. Everything is focused on the interplay between them. The effect is as tightly concentrated and reductive as in a late Beckett play, where an otherwise dark stage is alleviated by a spotlit fragment of the actor's face.

22. Steve McQueen, *Cold Breath*, 2000

Not that McQueen is as relentless or depressing as Beckett. The fingers are insouciant at times, pretending that they can hardly be bothered with the nipple at all. A wry humour is at work here: McQueen seems unafraid of light-heartedness, and is surely aware that *Cold Breath* could be seen in an absurdist light. He does nevertheless explore the possibility that the fingers are launching an attack. At one instant, they close hard on the nipple and twist it brutally, wrenching it to one side and then the other. The film is difficult to watch at such times, for we feel like voyeurs witnessing the private frenzy of someone intent on pleasuring himself through hurt.

But those moments are brief, and McQueen stops well short of emulating the punishment that Paul McCarthy inflicts on his body in a manic 1976 video called *Rocky*. Now on view at the Lisson Gallery's excellent survey of international video work in Covent Garden, *Rocky* takes as its springboard Sylvester Stallone's movie of the same name. After seeing it at the cinema, McCarthy decided to strip off, don boxing gloves and disguise his face with a repellent mask. Then, filmed in his own dingy kitchen, he started beating himself around the head with frequency, force

and remorseless relish. At once disturbing and grotesquely funny, especially when he pauses to squirt ketchup and mustard all over his genitals and buttocks, the video only terminates when McCarthy slumps on the floor. Beneath all the clownish exaggeration, the pummelled figure appears to savour this prolonged assault on his own flesh. He looks like a punch-drunk pugilist finally unhinged by too many brain-battering bouts in the ring.

Compared with this outrageous performance, *Cold Breath* seems restrained indeed. If the nipple occasionally looks threatened by the fingers, it more often responds with pleasure. Arousal is the principle theme of this fundamentally erotic film. In *Bear*, the two men reach out to each other, impelled by the desire to touch or stroke. But their gestures are fleeting, whereas *Cold Breath* never allows us to escape from an encounter so close that we feel embarrassed by our proximity to the event.

When McQueen won the Turner Prize, he explained that the silence in his film of the falling house was intended to make viewers 'become very much aware of themselves, of their own breathing . . . I want to put people in a situation where they're sensitive to themselves watching the piece.' His words apply even more to *Cold Breath*, where McQueen pushes us so near his own body that we register each rise and fall of his increasingly excited breathing rhythm. By the time the film nears its end, we feel completely caught up in the cycle of sensations explored here. They lend fresh meaning to the tired word 'tactile', and McQueen administers a shock when he sends his own spit dribbling down to the nipple. Its arrival prompts the fingers to indulge in an even greater flurry of activity. They run over the nipple again and again, so fast that everything dissolves in a blur. The camera seems to go completely out of focus at this ecstatic point, as if its unknown operator had become overheated by the frenzy visible through the lens.

Then, quite suddenly, the orgiastic motion subsides. The fingers vanish, leaving the dazed nipple as solitary as it was at the beginning of the film. Although a little lonely, it lingers on the screen and appears to find relief in these closing moments of quietness. The fingers return for a last caress, but it lasts no more than a second or two before the film finally blacks out.

Anyone who welcomes this cessation is in for another surprise, however. At the end of the corridor, we turn left and discover a giant projector mounted on a stand in an immense room. At the far end *Cold Breath* reappears, this time on a wall larger than most cinema screens. The former intimacy has disappeared. We stare at the distant image in a far more removed way, realising now that it looks oddly like a crater

marooned on the surface of the moon. Each minuscule crease in McQueen's skin here resembles a mighty fissure, scored deep in the lunar landscape. So when the fingers arrive, they appear infinitely larger and more invasive than before. Projected on this scale, *Cold Breath* becomes an almost abstract affair. No longer so bound up with intimate disclosure, it triggers a more detached and analytical reaction. We become conscious of McQueen's desire to explore film as an agent of invasion. The nipple seems curiously helpless now, at the mercy of manipulation by fingers and camera alike. But right at the end, when left alone on the screen, it assumes the appearance of an outsized eye. Even as we continue staring, engrossed in this strange spectacle, the nipple now seems to return our gaze with disarming, insolent directness.

RICHARD BILLINGHAM

9 June 2000

At the end of Richard Billingham's impressive show at the Ikon Gallery, a large photograph of an electric heater glares on the wall. Seen in uncomfortable close-up, its orange bars burn so fiercely that we can almost feel their dry, relentless heat. The image makes us want to recoil, while at the same time arousing our most avid attention. At once unbearable and irresistible, Billingham's work ends up disclosing a remarkable array of insights into the home where this heater blazes. Inhabited by his family, in a town only a few miles outside Birmingham, it became the focus for a sustained, obsessive investigation by the camera's lens. When he started taking photographs of his father, mother and younger brother in 1990, they were intended only as raw material for paintings. But they soon took on a self-sufficient power, and the images at the Ikon add up to an outstandingly frank, painful, humorous, affectionate and above all humane exploration of family life near the century's end.

Billingham was only twenty when he embarked on this risky project. From the outset he valued informality, going beyond all notion of 'setting up' in order to get at a truly unfettered vision. His father, the alcoholic Ray, must have helped simply by being himself. An early black-and-white picture catches him reflected in an oval dressing-table mirror, mouth open and convulsed by a toothless cackle. He looks the embodiment of mischief, and his role as domestic clown is reinforced when he

puts on an absurd woolly hat. This time, Ray stares straight at the camera with a defiance enhanced by his stubbornly folded arms. But his wife Liz, slumped beside him, does the laughing now. When seen together, they offer a superb study in physical contrasts. In one unforgettable colour photograph, the ample Liz offers her wizened husband two boiled eggs on a plate. Flanked by enigmatic Venetian masks on the wall behind, she looks monumental and even imperious. But Ray refuses to take her seriously. Hunched on the sofa, he grins and extends his slender hands to grasp the meal with a theatrical flourish, half mocking and half grateful.

More often than not, though, humour gives way to melancholy. Liz, stretched out on the same sofa with arms raised like a latter-day odalisque by Matisse, reveals a sadness poignantly at odds with the brazen gaiety of her flower-spattered dress. As for Ray, he frowns while holding the cat on his lap as warily as a soldier clasping a weapon. Life in the Billingham household can degenerate into a battlefield, especially when he drinks too much and Liz grows angry. One of the most disconcerting images shows Ray pitching over as he attempts to get off his chair. Although he rests one hand on the carpet, nothing will prevent this vulnerable old man from collapsing flat on the floor.

It is a relief, at such moments, to find Billingham swinging away from the claustrophobia and training his lens out of a window. One such shot, so dim and grainy that it resembles a speckled Seurat roofscape at dusk, seems filled with yearning for a world beyond the confines of home. But the indistinctness of the view serves to show how remote it really is. The frustration increases in a far brighter photograph of a wide window, almost filling the picture-space. Hints of green growth can be detected outside, but it is largely veiled by a net curtain smothering both the glass and the wooden frame.

For the moment, at least, all thoughts of escape appear to be snuffed out. So Billingham turns back to scrutinise his relatives again. Sometimes he views them as the inmates of a prison. In one extraordinary photograph, Ray and his teenage son Jason stand stiffly against a wall. Side by side, and both naked above the waist, they seem to be waiting for inspection. Jason's combed hair and puffy teenage flesh contrast with Ray's unruly wisps and thinner, lavishly tattooed body. Bizarrely, the old man holds a plastic jug brimming with home-brew beer. He looks impish enough to down it in one gulp, whereas Jason's deadpan face appears oblivious of everything around him. Funny, tender and disconcerting, this image is an excellent example of Billingham's ability to make apparently simple photographs resonate with ambiguities. Jason looks even

more detached in a picture where he tilts sideways in a dressing-gown, a cigarette burning down between his fingers. But this languor is replaced by a more menacing alternative in a photograph of Jason's bare back, standing at a window and leaning forward. His body is so tense, now, that veins and sinews stand out with sharp definition. He could be struggling to see out, sharing his brother's longing for a different world.

Another photograph, however, shows Jason deep in a chair and holding his own baby. His hand, rather alarmingly, has positioned itself near the infant's throat. Although the macabre mood is heightened by the skeletons cavorting on Jason's black T-shirt, his paternal feeling for the child is also clear. So Billingham leaves us pondering the complexity of feeling, just as we wonder about the picture of Jason's girlfriend pinioned beneath his outflung legs next to the unconcerned family dog. She looks content enough in a dazed sort of way, but may feel trapped as well.

A similar sense of confinement surely led Billingham, between 1992 and 1997, to take his camera out of the family home and study the streets in Cradley Heath. Familiar to him since boyhood, they form the subjects of the most surprising pictures in the show. For Billingham's overriding preoccupation with people deserts him here. Apart from one shot, where a solitary passer-by can be detected in the distance, no figures invade these scenes. He deliberately waited until nobody was around. As a result, all these images have an air of expectancy. The empty path leading up a hill towards a grey shed seems to be waiting for someone to use it. So does the decaying roundabout in a dismal, litter-strewn playground. Plenty of houses stand beyond, but they all look shut away from the open grassland. Hence, perhaps, the dereliction afflicting both the roundabout and a near-by climbing-frame. Billingham doubtless relished them both when he was young. Now, however, they seem shunned, and paralysed by disuse.

The only proof that Cradley Heath itself is still inhabited lies in the cars. One is parked outside an RSPCA shop with grim, shuttered windows. Another, sliced off by the end wall of a brick-built house, looks oddly furtive. A third is half-buried by bushes in an otherwise deserted parking lot. The only car with a forceful, foreground presence is positioned in shadows at the edge of an open, green space. The sunlit landscape seems unreal, divorced completely from the urban darkness occupied by the car. Billingham views all these eerily becalmed scenes in the same elegiac spirit. They look inert, drained of the significance he once found in them. Their emptiness could be seen as an acknowledgement, on his part, that the life he led there is now irrecoverable. It would explain the mournfulness discovered in these roads, alleys and patches of

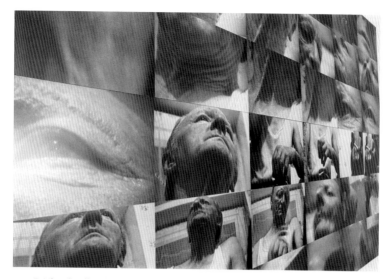

23. Richard Billingham, installation at Ikon Gallery, Birmingham, 2000

waste ground. They must remind Billingham of how much time has passed since he walked beside the row of battered bollards, or first saw the white May blossom foaming on the foliage skirting an otherwise bleak stretch of parkland.

Hence, perhaps, the strangely stunned, dreamlike feeling in his most recent exhibits. Working with video, he returns to the family. But we no longer see Ray, Liz and Jason in the clutter of their habitual settings. Now the lens goes in very, very close. Billingham concentrates on the remarkably red-lipped, open mouth of Jason's friend Tony, blowing out smoke-rings that seem, through reverse projection, to be sucked back inside him. After a while the repetition becomes mesmeric, and reminiscent in its lingering sensuality of Steve McQueen's nipple-fixated film, *Cold Breath*. But the mood grows more manic when Billingham turns his video camera on Jason's hand. We watch it manipulating a Playstation's remote-control buttons with fantastic speed, exterminating the warriors on an invisible screen. It should convey a high-spirited sense of enjoyment. By focusing so much on Jason's pressing fingers, though, Billingham makes us notice his deeply bitten nails. They give the entire activity a more nervous urgency, suggesting that Playstation is an addiction rather than a harmless game.

The most outstanding video projection, however, is *Ray in Bed*. He looks either groggy or asleep as his son's camera roams restlessly around the room, passing chaotic possessions piled on the floor and tracing the contours of his body beneath the counterpane. Liz comes in at one point, mutters and then vanishes. Ray's head is left marooned on the pillow, erupting in a sudden cough and then reverting once more to silence. The lens travels greedily over his features, staring up his nostrils and revealing every fissure and furrow in his pallid skin. Billingham seems driven by the need to get as near as possible to his father, but the urge is thwarted when the camera's focus mechanism breaks down. Unable to cope with such extreme proximity, it lapses into a blur. Billingham keeps on filming, and produces images as soft and lyrical as the most tender of abstract paintings. But the desire to gain a greater degree of closeness to Ray remains unfulfilled. We are left, at the end, with his profound filial longing for an intimacy he can never attain.

DOUGLAS GORDON: BLACK SPOT

28 June 2000

Like a tormented character from a Jacobean tragedy, Douglas Gordon is much possessed by an awareness of mortality. But rather than succumbing to dejection, he is fascinated by the infinite complexity of human existence. His haunting exhibition at Tate Liverpool is constructed like a labyrinth, and its sequence of chambers propel us into experiences that even encompass the pre-natal stage of life.

The room where Gordon tries to imagine his earliest months of consciousness looks nothing like a womb. As an artist dedicated to deploying the simplest of means, he would never attempt a literal recreation of his mother's uterus. Most of the long, low-ceilinged oblong space is empty, and only at the far end do we find a cassette player and speakers positioned informally on the floor. They are relaying jazz pieces, among them music by John Coltrane, that Gordon's mother might have heard while he was growing inside her. There is, of course, no way of knowing what she really did listen to on radio or records in 1966, the year of his birth. But Gordon does not strive for autobiographical accuracy. After all, in an earlier version of this work he confined the music to pop songs by The Who, The Kinks and other, less familiar groups of the

period. The room then was suffused with blue, whereas now a warm yellow spreads out from a rectangle of light glowing like an aperture on the wall beyond the speakers. At once playful and plaintive, the jazz combines with the colour to evoke a sense of germination. The luminosity is akin to the heat in a conservatory where growth is fostered, and the yellow rectangle makes the baby's passage to future life seem charged with a mystical feeling of optimism.

Maybe Gordon looks back on his time in the womb as a golden age, when even the most mournful jazz could not seriously impair his overall mood of well-being. If so, those nine months compare well with the buffeting he has since endured. In another space at the Tate, a colossal photograph showing an open hand is punctured at the centre of the palm by a black spot. As well as resembling a marksman's target or a Christ-like nail wound, it calls to mind the deathly portent in Robert Louis Stevenson's *Treasure Island*. Gordon has given his whole exhibition the ominous title *Black Spot*, as if to emphasise that its contents are overshadowed by the inevitability of extinction.

Nearby, he appears to counter negation in a work called *Never, never*, where eight framed photographs present digital images of an outstretched, naked forearm. Although it terminates in an empty hand tilting forlornly downwards, the inside of the arm bears a tattoo of the word 'forever'. While some of the photographs show the forearm imprinted with black letters, others are tattooed in white with a mirror-image of the same word. The promise of eternity becomes far more sinister, and encourages us to see the word's meaning in a different light. After all, 'forever' could easily be viewed as a branded mark, burnt into a criminal's flesh as a reminder of guilt. Viewed in this way, the permanence of the word seems more like a curse than a blessing. The unidentified owner of the forearm could regard 'forever' as an affliction, from which he will never be able to recover.

Gordon is preoccupied with the notion of a disabling, psychic blight. Enter the room containing *From God to Nothing*, and you realise immediately that something has gone wrong. Lit by only three naked bulbs, this large and deserted space is unrelieved in its bleakness. And the words running around the dark walls like an extended SOS from hell chart the omnipresence of anguish. Everything, in this relentless verbal bombardment, turns out to be capable of provoking fear. Both friends and enemies, failure and success, can trigger it. Nothing and nobody are exempt. Parents, siblings and children are all equally likely to be the cause. As the panic-stricken roll-call proceeds, some potential sources of distress seem understandable enough. The prospect of broken bones, disfiguration or

psychological pain all appear legitimate causes for alarm. Other possibilities, however, are less rational. 'Fear of exhumation' sounds excessive, and 'fear of tenderness' borders on the hysterical.

Gordon refuses to stop there. 'Bodily functions' in general are soon cited, along with nature, reality and 'loss of reality'. As the barrage finally nears its close, the words become still more all-embracing. 'Fear of the future' is succeeded by fear of the past and then the present. 'Time passing' becomes a cause of anxiety, along with 'fear of the end of the world'. Apocalyptic terror formed an unavoidable part of Gordon's own childhood, dominated as it was by the urge to be a good Jehovah's Witness. But he ends with 'fear of nothing', a deeply ambiguous phrase which could either mean a horror of the void or an impatience with the whole idea of dread. The probability is that Gordon's outlook refuses to settle, moving restlessly between these two drastic alternatives.

In a similar way, he makes sure that the work occupying another room shifts constantly from lightness to dark and back again. Illuminated this time by a solitary bulb, the text is confined to a single wall. It offers a terse summary of a French experiment conducted in 1905 between Dr Baurieux and the condemned criminal Languille, who was decapitated by the guillotine. Immediately after the execution, Baurieux noticed that the eyelids and lips of the severed head contracted briefly, then relaxed. But when the doctor shouted 'Languille', he noticed that the dead man's eyes slowly opened. They fixed him with a clear gaze before steadily closing. Baurieux addressed him again, and the eyelids duly rose. 'Two undoubtedly alive eyes looked at me attentively,' the doctor recorded, 'with an expression even more piercing than the first time.' When he tried once more, though, the severed head did not respond. The whole macabre encounter only lasted between twenty-five and thirty seconds, the time Gordon reckons that, on average, we should take to read the wall-text. That is why the light bulb constantly switches on and off, controlled by a timing device that cuts between visibility and the dark with startling abruptness.

His fascination with the pivotal tension between life and death finds its most dramatic and absorbing expression in a major new work called *Déjà-vu*. Gordon is always at his most powerful when working with cinematic material, and this three-screen video installation takes as its springboard a 1949 movie called *D.O.A.* Nothing more than a workmanlike thriller in the film-noir tradition, it begins with a man reporting his own murder at the police station. Although clearly not quite Dead On Arrival, he declares that his life is almost at an end. The rest of the film employs extended flashbacks to show how he arrived at such a

stricken state. It seems to involve poisoning, duplicity and mistaken identities, but Gordon ensures that the dialogue is frustratingly indistinct. The musical soundtrack plays a more potent role than the actors' words, lending the tight, action-dominated plot a sense of incessant, driving urgency.

Gordon's decision to run the movie at three different speeds ought, in theory, to generate intolerable confusion. In practice, however, the rival versions deepen and enrich what would otherwise be an efficient yet routine exercise in violent, erotic betrayal. We instinctively favour the fastest version projected on the left-hand screen, in order to view the unfolding of the plot as quickly as possible. But our eyes constantly find themselves straying over to the other screens, where sequences we have already witnessed reappear like fragments from an oppressive, inescapable dream. As a result, the hapless man at the centre of the film's machinations seems to become enmeshed in a mazelike complexity. He is condemned to repeat his own actions, without benefiting from their reappearance in any way.

They grow increasingly remorseless as the film proceeds. While he entangles himself with bewilderingly similar blonde women in a jazz club, undergoes traumatic medical tests and changes from dupe to avenger, the overriding notion of an implacable fate is reinforced at every

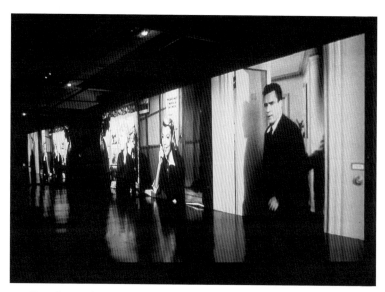

24. Douglas Gordon, *Déjà-Vu*, 2000

turn. The original film remains intact, just as Hitchcock's *Psycho* stayed essentially unaltered when Gordon slowed it down to a twenty-four-hour duration. In every other respect, though, *D.O.A.* is transformed into a far more troubling, hallucinatory and claustrophobic experience than it must initially have been. The three screens trap us in a nightmare of obsessive reiteration, advancing towards its close with the bleak inevitability of a Greek tragedy. When the poisoned man eventually completes his testimony and dies, an anonymous policeman's hand stamps his file with the D.O.A. capital letters in thick, black ink. Nothing, apparently, could be more terminal. And yet, soon after the final credits roll and the screens have all gone dark, Gordon ensures that the film returns and its victim's gruesome, tripartite ordeal commences all over again.

INTELLIGENCE: NEW BRITISH ART 2000
5 July 2000

Before you reach the first room of *Intelligence: New British Art 2000*, Martin Creed's neon sign on the corridor wall offers some advice: 'DON'T WORRY'. It reads like a message of reassurance to anyone who might think the show's title forbidding. After all, the word 'intelligence' has a cerebral ring. And the British, with their notorious mistrust of intellectuals, could easily suspect that the exhibition will be too clever by half. By counselling us not to worry, Creed's neon piece may also run the risk of implying that the show is as bland as a tranquillizer. But the capital letters flash on and off in a distinctly nervous way. Their staccato rhythm promotes a feeling of instability, as if to hint at an unpredictable set of experiences in the rooms beyond.

So indeed it proves. *Intelligence*, the largest loan show ever held at Tate Britain, inaugurates a new series of major contemporary art surveys to be staged here every three years. This opening instalment is curated by Charles Esche and the Tate's Virginia Button. They want to highlight the role of investigation, exploring how twenty-two artists set about information-gathering with the zeal and cunning of private detectives or secret agents. But they have no desire to suggest that art should come up with 'a final conclusion in which everything is revealed'. Instead, they rightly stress the part played by the viewer encountering the work. In their view,

Intelligence tries to provide a space where 'viewers and artists meet on fairly equal terms. They are both attempting to come to terms with, and make sense of, material that is by its nature slippery and imprecise.'

Underlining the importance of an audience, Julian Opie makes sure the first room contains several sculptures of viewers scrutinizing the paintings on the walls. These bold, digitally generated images provide examples of the subjects most often found in museum collections: a sumptuous still life, a languorous reclining nude and several flamboyant portrait heads. By placing metallic, digitised figures on the floor, Opie indicates that the experience offered in the paintings is incomplete without the onlookers' response.

This issue becomes frankly problematic in the contribution by Douglas Gordon, where lists of names run in vertical columns across three vast walls. They include everyone he can remember meeting, and the lists will mean little to people who fail to identify the international art world's current players. Informed viewers stand to gain far more, but Bob and Roberta Smith would like to involve all visitors in their contribution. No specialised knowledge is required to accept their invitation to write down a protest on paper and slip it, like a voting card at an election, into a black box. Every Sunday, Bob Smith promises to select his favourite protest and sign-paint it on the walls, where it will join political complaints as dismissive as 'Sack Straw' and 'All They Do Is Nothing'.

None of the other exhibits in the show approach this level of audience participation. Susan Hiller's haunting *Witness*, restaged here after its recent airing at a derelict Baptist chapel in Notting Hill, only requires us to listen to first-hand accounts of UFO sightings. As for Michael Craig-Martin's room, it appears to hide away from view beyond a low doorway. Once inside, though, we suddenly find that this strategy magnifies the impact of his installation. Immense, floor-to-ceiling images surround us on the walls, defined in strong black contours. Partially coloured, they transform the square space with their spare, interlocking linear lucidity. Craig-Martin has never looked stronger. Although references abound to Duchamp, Man Ray and others, especially in the bottle-rack and steam-iron studded with tacks, his colossal still life is eminently accessible and superbly articulated. By concentrating on objects like a fire extinguisher or a household drill, Craig-Martin is in tune with the spirit of a show fascinated by everyday existence. But Gillian Wearing, who has recently been working with a community of street drinkers in South London, is a far more collaborative artist. Concentrating here on the story of one particular alcoholic pummelled by the vicissitudes of life, she produces a work at once compassionate, disconcerting and poignant. Wearing's

approach is openly indebted to the television documentary tradition, and depends to a crucial extent on the strength of her rapport with the people she films.

Oladele Ajiboye Bamgboye goes further in terms of autobiographical revelation. His space has been turned into a living-room, with carpet, glass table and leather furniture. On the television set we see an unscripted filmed conversation between him and his Scottish girlfriend Anne Rome Elliot, as they attempt to examine why their affair has ended. Their painful exchanges are interspersed with shots of Elliot isolated outside in the snow, or Bamgboye climbing into a bath. The position of a black, Nigeria-born British artist in an overwhelmingly white Scottish society is explored, but the film stresses particular experience rather than racist issues in the abstract. Yinka Shonibare, who grew up in Lagos and London, is also fascinated by cultural multiplicity. In *Vacation*, he shows a family of four space tourists dressed in cosmonauts' suits as they step out on another planet. The pale platform supporting them is suspended several feet above the ground, thereby reinforcing their sensation of floating. One small child rushes forward, entranced by this spellbinding new world. But the others look more guarded, and the exuberant fabrics swathing their suits contain ironic echoes of cultural colonialism in Africa.

Britain's imperial past also plays a role in Brighid Lowe's intriguing exhibit, where 225 battered paperbacks culled from car-boot sales, second-hand bookshops and charity stalls are displayed on a wall in neat rows. They range from classic sociological studies, like Vance Packard's *The Hidden Persuaders*, to lurid thrillers and soft-porn love stories. Their cover-images add up to a nostalgic feast in themselves, and reveal a great deal about the contradictory obsessions of the post-war period. But Lowe ambushes us on the opposite wall with a text work drawn entirely from the books' titles. Against all the odds, these disparate words form a headlong prose poem filled with anger, ironic humour and despair about the state of our society today. 'You've got it coming Britain,' declares one alarming passage, describing how 'on borrowed time, the empty hours swimming in cold blood, anxiety and neurosis, this animal is mischievous'.

In Sarah Lucas's sculpture, the warning issued by Lowe already seems to have resulted in catastrophe of the most violent kind. Two smashed and burned-out cars, a Ford Sierra and a Buick Sable, dominate the space with their blackened metal carcasses. The hideously charred chaos of their interiors makes a jolting contrast with the clean, ordered rows of filter cigarettes applied to the outside of one car, and the front seats of the other. But there is something neurotic about the obsessive care Lucas

25. Sarah Lucas, *Life's a Drag Organs*, 1998

has devoted to the cigarettes' display. Their presence here prompts us to see the cars' insides as damaged and diseased lungs. She implies that addiction to smoking is as fundamentally suicidal as the reckless impulse behind so many fatal car accidents.

By no means all the contributors adopt Lucas's dramatic, visceral approach. Alan Johnston goes to another extreme, restricting himself to subtle, intricate pencil marks that hover on the periphery of our vision. Running round the edges of large white walls, his drawings could hardly be more discreet. But the spaces they enclose are monumental, and often resemble cinema screens at their most panoramic. By emptying them out, he seems to offer a therapeutic alternative to all the clamorous images that so often threaten to saturate our vision. We can pause here, and maybe project our own dreams and fantasies on to the calming expanses that Johnston provides.

But *Intelligence* does not leave us becalmed for long. In the space beyond, Hilary Lloyd places video monitors at different angles and relays images of figures engrossed in humdrum activities. Two grave young men, Darren and Darren, unaccountably spend their time crawling through each other's parted legs. An equally solemn young woman, seen in close-up, struggles to assemble a house of cards. As for the other fig-

ure, he sprawls on the floor, rips images from glossy magazines and spreads them around him with coolly sensual deliberation. Their absorption seems so private that Lloyd places herself in a voyeuristic role as she films them. But the people who made the work assembled in Jeremy Deller and Alan Kane's *An Introduction to Folk Archive* are all eagerly committed to public display. To find the Women's Institute flower arrangement, visitors must go back to the Tate foyer. But the cornucopia of other folk art specimens is displayed in a single, delirious room. A Jimmy Saville scarecrow complete with rings and cigar shares the space with a grotesque Red Riding Hood-style predator whose skull protrudes from a hood. Garishly painted fingernail attachments are brandished near mugs scribbled with inscriptions as furious as 'England Are Shit!' Deller and Kane cherish the boisterousness of folk art, seeing it as an act of native resistance against our ever more standardised, consumerist culture.

The final room is dedicated to all the artists in this stimulating show. Bill Furlong has ranged sixteen grey boxes around the floor. Some are placed together like benches, encouraging us to sit on them while we listen to the men and women talking on every side. For the boxes are all speakers, relaying Furlong's interviews with the artists. He has edited them with a composer's flair. Sometimes a single voice as distinctive as Susan Hiller's American accent emerges from the general hum. Then they lapse into babble, before separating out again with the aid of insistent, chant-like repetition. After a while it amounts to a mesmeric experience, enabling us to share the artists' ideas and hopes for their work. Furlong manages to convey the thoughtfulness of all these individual voices, united by their commitment to the fundamental necessity of an alert and enquiring art.

A SHOT IN THE HEAD
26 July 2000

With August only a few days away, even the most frenetic young artists might be forgiven for lapsing into a high-summer torpor. But the contributors to the Lisson Gallery's new show have gone into overdrive. More than forty artists from across the world are exhibiting in this crowded, unpredictable and provocative survey. Nicholas Logsdail, the Lisson's chairman, has called it *A Shot in the Head*, after hearing the phrase in a

World Service news bulletin during a sleepless night. But the show's overall impact is more akin to an excitable cocktail, fizzing with bizarre ingredients and threatening to destabilise everyone who samples it.

Anything seems possible once you start exploring these uninhibited offerings. Simon Wood announces, on a deceptively sober printed card, that 'I want to make myself into an industrial diamond'. Elsewhere in the same room, a pair of blue flip-flops lie discarded on the floor. Above them, projecting from the upper half of the wall, Stefan Nikolaev's shower unit seems suspended in space. White plastic curtains are drawn defensively around it, and they resist attempts to open them. But the hiss of water can be heard behind, combined with a young man's voice tunelessly singing *Space Oddity* and *Perfect Day*. Peer through a slit in the curtains, and you will discover that the shower is an illusion: totally dry, and inhabited only by recording equipment. But the sound of spray and singing fills the rest of the room so convincingly that the man's self-absorbed presence can be felt in an intimate, almost palpable way.

Pierre Bismuth adopts a more elusive tactic. He confines himself to the ground-floor window, with words stuck on the glass describing an event outside the gallery altogether: 'Every two hours, in the pub on the corner of Bell Street and Lisson Street, an actor will order a pint of lager, while at the same moment, an actress pretending to work in the gallery will answer the telephone.' It all sounds too removed from anything we are likely to experience, and nobody can be in the pub and the gallery's office at the same time. Bismuth's teasing statement has to be taken on trust, whereas Jemima Stehli leaves no doubt in our minds about the events in her work. Six rows of colour photographs hang above each other on a wall, documenting encounters between Stehli herself and six male artists, critics and curators. Invited to a studio, they had to sit and watch her strip off. They were also asked to take photographs, by triggering a hand-held switch attached by cable to a nearby camera.

But Stehli cleverly ensured that the images show the observers as well as the observed. Moreover, the men are viewed from the front while she is seen from behind. Cast in the role of voyeurs, they display hugely varied reactions. Matthew Collings, unshaven and resting his left leg jauntily on his right knee, starts by grinning and treating the whole spectacle as an uproarious joke. As Stehli discards her black top, jeans, bra and pants, however, he sobers up. By the end, when she stands before him wearing only a pair of black high-heel shoes, his legs are apart and he stares up at her with a concentrated frown. Matthew Higgs, by contrast, tries to subvert the entire ritual by gazing resolutely at the camera. Pale and rigidly upright in his chair, he avoids looking at Stehli and remains deadpan

26. Jemima Stehli, *Strip No. 4 Curator*, 1999

throughout. But he ends up appearing embarrassed, like a classic English puritan unable to cope with such a brazen display of female flesh.

Male visitors staring at Stehli's images also find themselves implicated in the voyeurism. While I was viewing her work, a young man came up to enquire if he could take a photograph of me. When I asked why, he replied: 'Because you're a critic.' Only afterwards did I realise that he must have wanted to show me hovering, like a peeping Tom, next to Stehli's exhibit.

Not that *A Shot in the Head* is preoccupied with sex. True, John Murphy displays a white parrot, crowned with extravagant yellow head-feathers, sitting on a perch as if thunderstruck by a reproduction of Courbet's notorious painting of a naked woman's crotch. In the main, though, the artists on show here pursue less lusty concerns. Ceal Floyer's large, bleached photograph of a half-full (or, depending on your mood, half-empty) glass could hardly be more austere, even though she challenges us to interpret it either in a hopeful or gloomy way. As for Douglas Gordon, he takes understatement to an extreme. Having raised expectations by placing a video screen in the far corner of a room, he allows it to stay blank until interrupted, at brief intervals, by a single, mournful sentence: 'A moment's silence (for someone close to you).' After another period of blankness, the same words reappear in negative, white against the surrounding dark. But Gordon, so often the most cinematic of artists, does not permit anything else to invade the empty screen.

Verbal messages, in fact, play an important part in a surprising number of exhibits. Above one doorway, a glowing blue neon piece by Gary Rough consists of two dangerously complacent words: 'VERY INTERESTING'. The fact that the word 'VERY' flashes on and off makes the work seem all the more pleased with itself. But it also suggests that Rough has a saving sense of irony. Martin Boyce, on the other hand, places a sampler-style prayer at the centre of his large wall. Painted in white on a pale grey ground, it asks God to 'bless the corners of this house' before hoping that He will 'bless the crystal windowpane that lets the starlight in'. All this pious optimism is undermined, however, by diagonal white lines lancing across the wall. They resemble fissures, and slice through the prayer with such aggression that the prospect of domestic benediction suddenly seems remote.

The words deployed by Jonathan Monk are painted in gold, and easily missed. He has inscribed them round the sides of a skylight, thereby forcing us to change position several times in order to read the entire sentence: 'The Mount Fuji Weather Station (the south western edge of the crater) Japan 14th July 2010 dawn.' This terse, enigmatic message appears to hold out the promise of an assignation. Perhaps Monk hopes that whoever buys this piece will agree to meet him at this remote locale in ten years' time, and thereby bring the work to completion. If so, the straightforward simplicity of the words is misleading, and masks the prospect of a strange, arduous encounter.

Francis Alÿs, by contrast, produces photographic evidence of unplanned assemblies in Mexico City. Five black-and-white images, each carefully annotated with details of the date, time of day and much else besides, chart

the spontaneous movements of pedestrians in an enormous civic square. The space is dominated by an immense flagpole. Every passer-by ignores it in one or two of the photographs. But when the sun's intensity makes the flagpole cast an elongated shadow, Mexicans stand in its dark, comforting coolness to protect themselves from the heat. They form a line, and take on a near-ceremonial formality. Although they are only sheltering for a while, these motionless figures seem to be participating in a grave, ancient drama bound up with the need to acknowledge the sun's overwhelming power.

Jane and Louise Wilson go to the other extreme, displaying a large, sumptuous colour photograph of an entirely deserted casino interior. All crimson and gilded kitsch, with an absurdly ostentatious staircase curving through the centre, this palatial space is determined to impress. But the absence of customers makes it look oddly forlorn, and even futile. A similar melancholy hangs over Jeroen Offerman's contribution, a minuscule silver-plated wire cage where a fly called Henry is supposed to live. By the time I inspected his claustrophobic quarters, the hapless Henry must have fled or died. I could see no sign of him, and only a curling piece of miniature toast on the cage floor testified to his former existence.

The three piranhas swimming round John Latham's fish tank still seemed vigorous enough. He has given them submerged texts to read, but the piranhas appeared far too caught up in their predatory fantasies to notice the cerebral words installed in the water. They talk of The Incidental Person, a long-standing Latham obsession, and declare that 'during the past year cosmological theory has begun to affirm the primacy of Event'. He goes on to wonder if such a development will aid 'human self-understanding'. Upstairs, though, scepticism gives way to purposeful experimentation with the natural world. A whole room is given over to an elaborate exercise in genetic engineering. Koen Vanmechelen, a young artist who rears chickens in the Belgian countryside, confronts us with a loudly crowing cockerel and three hens in a carefully constructed coop. By extensive breeding between nations, he aims to produce a truly 'Cosmopolitan Chicken'. The genealogy of his experiments is disclosed in words and photographs on the walls, but the real focus of his complicated, noisy installation is surely the incubator. Here, the definitive European chicken may soon be hatched, bringing art and genetics into a closer, more edible alliance than ever before.

THE TURNER PRIZE 2000

25 October 2000

Everyone knew where to look when entering last year's Turner Prize show, dominated from the outset by Tracey Emin's soiled and rumpled bed. But the new instalment starts in a far more unfocused way. Wolfgang Tillmans adopts a scatter-gun strategy. All four of his walls are riddled with photographs, and we have no idea what to study first. Both colossal and minuscule, colour and black-and-white, intimate and panoramic, framed and unframed, alone and in clusters, the barrage of images ranges restlessly from one extreme to another. Some are displayed near the ceiling, some near the skirting-board. And another fusillade is aimed at us from four showcases, positioned like white blocks of minimal sculpture on the centre of the floor. Containing spreads from Tillmans' publications, they show how his concerns roam freely between the political and the personal.

One, devoted to *Soldiers – The Nineties*, concentrates on photographs culled from newspapers and magazines. Deliberately anti-heroic, it favours images like the *Time* cover where a haunted soldier's face is juxtaposed with the headline 'Is Bosnia Worth Dying For?' But Tillmans' other publications shy away from the mass-circulation media altogether. He takes pictures with snapshot immediacy of Concorde surging over his head, as if the arrival of the plane had taken him by surprise. He likes to be ambushed by people as well, especially in his guest-edited *Big Issue* where passengers on crowded tube journeys reveal their bodies with unsettling frankness. Nothing could be more exposed than his close-up of a strap-hanger's armpit. And yet another publication, called *Total Solar Eclipse*, proves that he is equally adept at photographing nature at her most immense and engulfing.

Tillmans, born in Germany but based in London ever since he studied at Bournemouth and Poole College of Art during the early 1990s, is impossible to pin down. He typifies the spirit of a Turner shortlist no longer overshadowed by the Young British Artist generation. They have all but disappeared, in an exhibition where three out of four contenders turn out to be foreign. Their inclusion here shows how much of an international centre London has become in recent years, attracting young artists from across the world as a vital place to live and work. Tillmans includes photographs taken in locations as disparate as Las Vegas, Hong Kong, Puerto Rico and New York. But his main emphasis rests on the English scene, viewed with the freshness and unpredictability of an outsider. He

27. Wolfgang Tillmans, *Lutz in sand dunes*, 2000

never forgets the importance of private moments, catching his naked friend Lutz rolling in a sand-dune, or the moment when a breast-feeding mother suddenly spurts milk into the air from her nipple.

Glenn Brown, the only exhibitor who hails from England, is utterly removed from Tillmans. His medium is traditional oil paint on canvas, and he handles his materials with consummate skill. He also allies himself with the past in a very open way, taking as his springboard anyone from the nineteenth-century visionary John Martin to Salvador Dalí. But Brown does not simply copy the painters he admires. He brings them together in unlikely fusions. Although the starting-point for his most full-blooded picture is Martin, he calls the picture *The Tragic Conversion of Salvador Dalí (after John Martin)*. By referring to Dalí's adoption of Catholicism in later life, Brown implies that it was an event calamitous enough to ruin Dalí's work. And another, unexpected dimension is added to the painting by Brown's decision to place a grandiose city on a distant cliff-top. It adds a futuristic note to the scene, and helps prepare us for Brown's enthusiastic use of science-fiction illustrations in other work.

One of his largest and most bombastic paintings takes its cue from just such a comic-book source. Mysteriously called *The Loves of Shepherds*, it shows hollow spacecraft hurtling through the cosmos near a shimmering planet. Brown treats this 'low art' subject with as much reverence as his 'high art' quotations. The handling of paint is equally meticulous, testifying to weeks of painstaking work by a perfectionist who has a horror of leaving anything sketchy, loose or unfinished. In this respect, Brown could hardly be more opposed to the impetuous approach of Frank Auerbach, another painter who inspires him. From a distance, Brown's female heads bear an uncanny resemblance to faithful reproductions of Auerbach's work. Near-to, though, the heaped paint and agitated brushmarks all turn out to be an illusion. Brown's pigment is thin and flat, giving the surface of his work the repellent air of a colour print.

While respecting his deftness, I derive scant pleasure from Brown's way with oil-paint. Its sheer technical proficiency promotes a sense of coldness, even when he twists Dalí's *Autumn Cannibalism* into a widescreen image that echoes the proportions of Picasso's *Guernica*. That is why Brown's sculpture offers such surprising relief. For he builds thick coils and tongues of pigment into bulky, glistening masses quite removed from the thinness of his paintings. One of them, unaccountably called *The Shepherdess*, looks like a craggy meteorite capable of crashing into planet Earth and causing a cataclysm as disastrous as a Martin apocalypse.

Tokyo-born Tomoko Takahashi, who occupies the next room, shares this interest in pulverizing. Her junk-filled installation resembles the aftermath of a road-smash, with fragments strewn across the floor and broken objects suspended in the air. The dangers of learning how to drive a car run through her exhibit like seismic tremors. Looking up, I noticed a wheelbarrow, a cracked table, a fire extinguisher and an old tyre hanging far above me. They appear ready to drop, and a printed sign on a nearby wall adds to the mood of anxiety with the words 'Warning Fragile Roof.'

Wherever you turn in this heaped, labyrinthine space, Takahashi promotes the feeling that something has gone fundamentally awry. A few lamps have been left switched on, suggesting that the people who once occupied this room were forced to leave very quickly. Chairs, desks, heavy wooden chests and other office equipment are stacked pell-mell in storage units, as though waiting to be moved to a safer destination. Yellow tubes sprout like exotic plants near traffic cones and road signs, while abandoned television sets lie dead on piles of discarded lumber. Takahashi is a born accumulator, scavenging her waste material from anywhere she can find it. A small red school blazer dangles inexplicably from a shelf, unclaimed by its owner. The overall mood is akin to the melancholy of a lost-property office, and Takahashi has probably taken part of her cue from the atmosphere of the Tate's own storerooms. But despite the inclusion of objects as startling as an axe, jutting out from an open drawer, the installation lacks the memorable impact of its forerunner at the Saatchi Gallery last year. There, sound and flickering lights played a potent role, whereas here silence prevails and too much of the work looks merely additive, confused and cluttered.

Michael Raedecker, on the other hand, has never seemed more impressive. He shares with Brown and Takahashi an end-of-the-world preoccupation, but the images on the walls belong to him alone. Because this Amsterdam-born artist uses needle and thread on his canvases as well as paint, commentators often point to his apprenticeship in the late 1980s with the fashion designer Martin Margiela. But Raedecker's current work has everything to do with art and nothing with clothes. Landscapes predominate, and they are all devoid of comfort. Desolate, grey-green plains are punctuated only by stripped trees with clotted bunches of thread masquerading as dead foliage. Although Raedecker makes no attempt to disguise the artificiality of these dreamlike scenes, they begin to haunt the imagination,

A low wooden house appears in one of the finest paintings, and pale light fills a window as wide as a cinema screen. But the radiance fails to

enliven the stricken and deserted terrain outside, while the blankness beyond the window promotes a suspicion that the room within is empty as well. When Raedecker takes us inside one of these interiors, our misgivings are confirmed. In a powerful work called *Radiate*, we find ourselves gazing across a floor covered with curling pieces of light brown wool. Far from promoting an aura of well-being, they look jarring. And the window beyond is clogged with a thick, cloying expanse of creamy paint.

Another interior resembles a motel, with a double bed and wardrobe suggesting recent use. But worm-like threads appear to be infesting the room and crawling across its surfaces. Knots of wool grow out of the walls and floor like fungus, indicating that the entire bedroom has long since become abandoned and derelict. Raedecker stops short of explaining the catastrophe that seems to have overcome the blighted world he depicts with such conviction. He prefers to explore this uncompromising territory, and confronts us in one painting with a clotted white lake bordered by rotting green trees. The perspective here is crazily inverted. We can no longer tell how to situate ourselves in relation to an ambiguous landscape, where the ground appears to lurch, bend back and then roll over like a wave.

Sometimes Raedecker increases our bewilderment by adopting an aerial vantage, looking down on an arid region studded with rocks and blighted bushes. Everywhere we look, tiny white creatures emerge from the parched soil like slugs illuminated by an unknown source of brightness. They appear to be the only form of life sustainable here, but in a painting called *Echo* even these rudimentary inhabitants have disappeared. This time, we appear to be gazing through a cave-like aperture towards a mountain-fringed desert beyond. Although dark patches of water and a solitary tree are visible, the view is partially obscured by tangled brown skeins. They hang down over the cave's mouth like the bedraggled remnants of an ancient, threadbare curtain. But the frustration they generate only makes us even more eager to look, spellbound by the work of an artist who deserves, surely, to carry off this year's prize.

GLENN BROWN AND SCIENCE FICTION
28 November 2000

The closeness of Glenn Brown's reliance on his source raises uncomfortable questions about the whole notion of art and originality. People are understandably disturbed when they realise how heavily reliant Brown has been on Anthony Roberts's cover for the Robert Heinlein science-fiction book *Double Star*. Brown has spent his entire career basing his paintings on existing images. Apart from Salvador Dalí, he often takes as his starting-point the apocalyptic visions of John Martin or the powerfully distorted heads painted by Frank Auerbach. In each of these instances, the difference between Brown and his source is still easily understood. But no such gap appears to separate Brown's painting *The Loves of Shepherds* from Anthony Roberts's illustration. They are exceedingly close, and bring to a new extreme a dialogue that can be traced back across the centuries.

Throughout the entire history of Western art, painters have fed voraciously off each other's work. When Raphael was executing his wall frescoes in the Vatican apartments, he sneaked into the Sistine Chapel and discovered what Michelangelo was painting. The impact was so overwhelming that Raphael immediately changed his own approach, incorporating muscular figures clearly related to their source of inspiration on the Sistine ceiling. Whenever artists are venerated like gods, references to their work abound in countless paintings by their admirers. Turner, whose watercolour exhibition opens this week at the Royal Academy, admired Claude so much that he tried to emulate the French artist's work. Turner's paintings are riddled with Claudian quotations, sometimes to an embarrassing extent. But the whole process reached far more controversial heights during the twentieth century.

Picasso, in his later years, became so preoccupied with particular paintings from the past that he produced hundreds of variations. Delacroix, Manet and Velázquez were the targets for this obsessive activity, but Picasso always managed to transform his sources and stamp them with his own robust identity. So did Francis Bacon, whose infatuation with Velázquez's portrait of Pope Innocent led him to paint many disturbing images of a screaming, imprisoned Pontiff. The Pope in Velázquez's painting reminded Bacon of his father, with whom he had a highly disturbed relationship. So Bacon's popes reflected this psychic turbulence, and there was no question of the outcome merely copying Velázquez's original.

Some modern artists have poked fun at the old masters. The arch-icon-oclast, Marcel Duchamp, even drew a moustache on a reproduction of the *Mona Lisa*, claiming the result as his own work. Then, at the age of seventy-seven, Duchamp produced another image of the *Mona Lisa* without the moustache, inscribing it with a single cheeky word: *rasée!* Duchamp had a love-hate fascination with Leonardo's portrait, and plenty of other modern artists have incorporated equally irreverent quotations in their paintings and collages. During the 1960s, Roy Lichtenstein enraged several comic-book illustrators when he took their work and turned it into monumental Pop Art paintings. Lichtenstein was accused of brazenly ripping off the comics, but the truth is that a genuine transformation did still occur in his work. More recently, Damien Hirst found himself attacked when he displayed a titanic bronze statue called *Hymn* at the Saatchi Gallery. It was an exact copy, albeit massively enlarged, of a small Humbrol toy costing £14.99. The fact that Charles Saatchi had paid £1 million for Hirst's colossus further incensed Norman Emms, who designed the original toy and declared that Hirst owed him a fee. But in my view, Hirst's *Hymn* has been turned into a work dramatically removed from its source.

Similarly, if the Heinlein book cover were displayed next to Glenn Brown's offending painting, significant differences would become very clear. Brown's handling of paint is highly individual, and the enormous size of *The Loves of Shepherds* ensures that it ends up, against the odds, as a personal achievement. It pays tribute with considerable swashbuckling aplomb to Brown's love of science-fiction images, and in no sense deserves to be dismissed as bad art. But it offers, at the same time, a disconcerting reminder of artists' dependence on each other. And it poses, above all, one overriding question: when does inspiration become plagiarism? In my view, *The Loves of Shepherds* goes spectacularly beyond its source and stops well short of rip-off. But if Brown's work is anything to go by, that nagging question will be asked again and again as the art of the twenty-first century gathers pace.

AERNOUT MIK

20 December 2000

In order to reach *Lumber*, the most impressive and haunting installation in Aernout Mik's ICA show, we have to walk through a narrow passage flanked by pale rubber walls. At one point, a circular surface on the right swells and deflates like a breathing organism. Its rhythm slows us down, and our movements are further hampered when we negotiate the rest of the labyrinthine pathway beyond. But nothing can prepare us for the mysterious, worrying torpor of the bodies that await us at the centre of *Lumber*. We arrive at a clearing where five screens, all set at different angles to each other, surround us. The only way to absorb the silent video images projected on their surfaces is to sit or even sprawl on mats scattered across the floor. And by lowering ourselves, we reach the level of the figures on the screens. They resemble, initially, a crowd at an outdoor rock festival. Whether seated or reclining on rumpled blankets, they seem in thrall to something we can neither see nor hear. Some of them clap, as if responding to music. But their hands meet in a spasmodic, tired way, as if they were filmed in slow motion or about to succumb to terminal exhaustion.

Then, with an accelerating sense of unease, we notice the mud. Churned and punctuated with pools of water, it must have long since seeped into the blankets and made them disgustingly damp. Even the dogs who sit, loll or wander in a trance, gaze with apparent disbelief at the sodden scene. But their glumness is eclipsed by the humans who, even when they lean against one another, seem unaware of anyone else's existence. No interaction between people can be detected in this despondent panorama. Each figure seems marooned in a state of psychological isolation. Weirdly oblivious, they do not even notice the smoke escaping from an inexplicable hole in the mud. Although it could be caused by some volcanic disturbance far beneath the ground, nobody bothers to examine the emission. Nor are they surprised by the man in the wheelchair, who moves round in endless circles as though hypnotised by his own futile movements.

Aernout Mik's cameras never stop travelling over the mudscape, and their purposeful scanning contrasts ironically with the pointlessness of the mired bodies. The more we stare at them, the less connection they have with the whole notion of a festival. Enjoyment is nowhere to be seen. A few figures trudge disconsolately across the furrowed, soaking land, but they are aimless. One man tosses from side to side on a yellow

28. Aernout Mik, *Lumber*, 2000

sheet, seemingly in thrall to a nightmare. And gradually, the entire dazed
ensemble appears to be stranded in the aftermath of some unknown yet
catastrophic event. Far from revelling in a rock concert, they look like sur-
vivors. One woman, sitting next to an especially boggy stretch of ground,
moves back and forward like a mute mourner. Although inconsolable, she
is at least conscious – unlike the man with blonde hair who lies face
downwards, prone and helpless. He seems to need help, but the camera
glides past him without a pause. It also moves past a standing man who
struggles in vain to clap his hands, past a cushion marooned on a crum-
pled sheet, past an empty mattress, abandoned paper cups and pummelled
plastic bottles, past a long-haired man with a paunch who clutches his legs,
past heaps of abandoned clothes, dirty lilos, a discarded toy animal, a stick
thrusting out of the mud and a tipped-over picnic box.

By keeping his lens on the move, and forever fixed on these stunned
figures, Mik ensures that we are offered no respite from their plight. The
camera pushes on relentlessly, impelled for no apparent reason by the
urge to keep on surveying a place where nothing really happens. Despite
the air of lassitude, *Lumber* is oddly compulsive. And after a while, even

the most inert bodies appear to be affected by an inexplicable, almost imperceptible motion. They tilt and arch their backs, rise a surprisingly long way from their bedding and then sink down again, as if worn out by the effort involved. Unseen pressures beneath the mud must be forcing them to react, and I discovered afterwards that Mik installed people in pits below the ground who pushed upwards, unsettling the figures above them. But we cannot tell, simply from watching the screens, why these strange spasms and undulations occur. They could be after-shocks, running like isolated tremors through a landscape still striving to recover from a recent cataclysm.

They are not, however, violent enough to cause panic, or rouse an individual permanently from the passivity afflicting everyone. Some figures still walk through the mud, lifting their blackened feet and splashing across the water with as little concern as sunbathers on a beach. But this is no holiday affair. Although pallid light can be detected here, it does not appear to be generating much warmth. A loudly patterned umbrella flaunts its orange, yellow and white flowers with festive relish. A sudden wind makes it shudder, though, and the garish fabric does nothing to make the rest of the scene resemble a pleasure-ground. Indeed, the umbrella's flamboyance seems grotesquely misplaced in such a dour, dejected context.

After a while, I found myself remembering the still more mud-filled battlefields of the First World War, where relentless shelling and equally persistent storms conspired to wound the earth with rain-filled craters. Mik gives no hint of any specific interest in the Great War or any other conflict, and none of the people in *Lumber* could be described as soldiers. Their jeans, ponchos, checked shirts and sweaters look contemporary enough, and nobody is suffering from injuries or bleeding. All the same, the denatured state of this dismal locale does hint at a world *in extremis*, blighted by forces that have made it almost uninhabitable. We cannot imagine anyone continuing to stay here much longer, and their willingness to linger in the dirt already seems hard to understand. Mik, who created the entire location in his native Holland, appears fascinated above all by humanity's willingness to withstand such atrocious conditions without complaint. No suggestion of protest, fury or despair can be found here. A spirit of stoicism prevails, along with a tacit acknowledgement that these forlorn figures, like characters in a Beckett play, are waiting for the end.

Making my way out of the labyrinth, I passed walls covered this time with glinting fabric as creased as the sheets in *Lumber's* video. They might have been hung out to dry, hinting perhaps at the possibility of escape from the dampness. But hope soon evaporated when I encountered the

installations upstairs. In one room, a pair of screens stand together like sculptural blocks near the centre of the floor. Although cushions invite us to sit and watch, no reassurance is provided by the projected video images. They take us into a stark room, where two young men are joining forces to smash a chair. One, stripped to the waist, presses down on his companion's head as they both try to wreck its metal leg. They fail, and yet their energy remains formidable. So does their pent-up aggression. Soon afterwards, a fight breaks out between them while they both struggle to tear a cardboard box apart. They succeed, and their fury is contrasted with the patience of an auburn-haired woman who grimaces and puffs out her cheeks as she rips a wicker seat into pieces, strand by separate strand.

Occasionally, without any warning, a dark brown substance is poured on to them from an invisible source above. But they do not even notice, and it never distracts the destroyers from their lust for annihilation. A man in a dark red shirt goes into a frenzy, as he smashes flesh-coloured foam blocks with a metal weapon. His rage compares poorly with the deliberation of a grey-haired woman seated on the right, who stabs methodically at another foam block and seems unaware of everything else. But the madness all around eventually makes her resolve appear just as fanatical as the man's. After a while, the whole room looks like a cell occupied by lunatics, each of whom indulges in bouts of obliteration as a form of crude, desperate therapy. The vandalism becomes most alarming when the half-naked man throws himself into an orgy of indiscriminate smashing, and we notice that the target is a baby-buggy. The random nature of his fury makes us realise how he might behave outside the room, and how street life in the year 2000 is increasingly defiled by irrational assaults on the most vulnerable inhabitants of our cities.

Approaching Mik's third installation, down a narrow white corridor, I feared at first that it would be just as gruesome. After all, the screen at the far end was filled with the face of a crop-haired young man whose mouth stayed open in a silent yell. Gradually, though, the camera pulled back, and disclosed that he was a sculpture on the wall of a room occupied by mercifully peaceful young women. One sat eating an apple, nodding in automatic assent at her companion who lay on the floor, talking incessantly and playing with a glitter-ball. The discarded equipment of a pop band surrounded them, but the rehearsal seemed to be over. A mood of languor prevailed, and the images seemed humdrum until I realised that the garrulous woman's voice could be heard, indistinctly yet live, behind the right-hand wall. So a camera must have been relaying a real-time event occurring elsewhere in the room. I felt uncomfortably

voyeuristic, wondering whether to call out and ask them how it felt to have their activities filmed and projected on-screen for public consumption. But something stopped me: such an act would only have compounded the intrusion. Besides, the memory of *Lumber* still nagged at my mind, as I attempted to decide if its stunned and weary victims belonged in the past century or prophesied, with unsettling plausibility, the shape of traumas to come.

THE CITIBANK PHOTOGRAPHY PRIZE 2000
4 November 2000

The extraordinarily high profile commanded by the Turner Prize reflects ever-mounting interest in contemporary art. But photography, despite its increasing vitality and ability to play a powerful part in many young artists' work, lacks the same level of public recognition. Until the Citibank Photography Prize was initiated in the mid-1990s, no substantial award in Britain honoured a body of work for making a distinguished contribution to photographic art. That is why the Citibank Prize is so welcome. Open to the entire spectrum of photographic image-making, so that everyone is eligible, from professional photographers to artists using the camera as an integral part of their work, it refuses to follow the Turner Prize by imposing restrictions on age or nationality. It also helps break down the persistent divide between photographers working in a documentary tradition and artists using lens-based images.

The latest shortlist for the Citibank award is as lively as ever. Women outnumber men, and most of the contenders explore visions preoccupied with death, decay and alienation. Nobody more unnervingly than Roni Horn. Although based in New York, she has become obsessed with the Thames. Her photographs of the water reveal just how sinister and potentially lethal London's great river can be. The water's surface seethes with treacherous currents, ready to defeat anyone rash enough to take a plunge. Dark, swirling and filled with menace, the Thames in Horn's photographs is utterly removed from a picturesque idyll. Rather is it a place associated with irrational fear, and the absence of people from these desolate images serves only to increase the overwhelming mood of loneliness.

In the mid-1990s, Horn became fascinated by the amount of corpses found there. She researched the *Reports of Deaths in the River* compiled

29. Hellen van Meene, *Untitled # 61*, 1999

by the Metropolitan Police's Thames Division. It made gruesome read-
ing, and she began writing her own fictionalised reports inspired by these
melancholy case-histories. Then, in 1999, she made two trips on a work-
ing riverboat, photographing the Thames with a sustained attention to
closely observed detail. The results bring us uncomfortably near to the
oily, restless and brooding reality of the river, escaping entirely from
tourist-brochure clichés. No glib reassurance can be found here, only an
inescapable sense of murky foreboding.

Hellen van Meene is far less gruesome. Staying very close to the peo-
ple she knows best, van Meene concentrates on photographing the
inhabitants of her hometown, Alkmaar in The Netherlands. And she
restricts herself still further by portraying, for the most part, adolescent
girls on the verge of adulthood. The pictures are all carefully staged and

lit, making no attempt to pretend that they are spontaneous snapshots. Nor do they disguise the physical imperfections of the girls who pose for van Meene's lens. Braces, spots, scratches and clumsy hair-styles are all in evidence, but these images are not simply the product of a desire for harsh realism.

Some stir memories of familiar paintings by Dante Gabriel Rossetti or even Vermeer. Others are more akin to advertising shots, or fashion pictures where the elongated models all look disconcertingly young. Van Meene has no intention of playing safe in her work. She is aware of how easily photographers can manipulate their sitters, and her preference for friends and neighbours shows how much she values a trusting relation-ship between artist and subject. Beguiling, sometimes disturbing and occasionally flirtatious, the girls in these haunting pictures seem to hover between childhood and maturity with a dream-like intensity.

Like van Meene, Boris Mikhailov still works in the town where he was born: Kharkov in the Ukraine. Trained as a technical engineer, he lost his job after the KGB discovered some photographs Mikhailov had taken of his naked wife. But he remained defiant, and his subsequent work with the camera took a provocative, often fiercely critical look at life in the former Soviet Union. The results were deeply disquieting. He contrasted the humdrum reality of Russian existence with the propaganda symbols and heroic statues of the discredited regime. He photographed the private, often messy lives of his fellow-countrymen and women, revealing a social disorder that gave the lie to the old, official views of Soviet existence.

More recently, Mikhailov embarked on his toughest and most discon-certing project. He decided to explore the victims of homelessness, and in nearly 500 colour photographs built up a relentless indictment of a society where so many citizens live in degrading conditions. Many of the people in this gruelling series, tersely entitled 'Case History', seem doomed. They live rough in an appallingly severe climate, and some of the bleakest pictures show homeless bodies abandoned in the snow. Mikhailov is a courageous photographer, determined that his uncom-promising images disclose a bitter truth.

At first sight, the landscapes photographed by Jem Southam may look seductive. Over the last decade he has focused on the English coun-tryside at its most peaceful. Travelling from Cornwall to East Sussex, Southam sees southern England as a largely uninhabited terrain where water often plays a potent, decisive role. But the more we examine these deceptively restful images, the less beguiling they become.

Southam is fascinated by rockfalls, and studies the often alarming deposits heaped at the base of a cliff. They show how unstable our seemingly

redoubtable coastline can be, where nobody is able to forecast when the next collapse will occur. All we do know is that even the most serene landscape is subject to a startling, continual process of alteration and decay. The rivermouths and ponds in Southam's other work may look placid, and induce a feeling of calmness in the viewer. But they can cause erosion as severe as on a cliff-edge, and Southam's photographs gradually make us aware of water's ability to bring about astonishing alterations in the most tranquil scene. His work delivers a warning about flux, and its predominant mood is melancholy.

Hannah Starkey explores disquieting territory as well. Although she only graduated from the Royal College of Art as recently as 1997, Starkey has already defined her own distinctive vision. Her territory is the contemporary city, and the people who move through it are invariably women. Young and often uncertain, they gaze into mirrors and out of windows in a strange, absent-minded way. Starkey, however, is the very opposite of a photographer who catches life on the wing. She employs professional actresses for her pictures, and asks them to perform particular roles like actors in a film or play.

But the outcome is far from theatrical. Starkey favours down-to-earth locations, like the dismal upper floor of a bus at night. The 'action' recorded there may be confined to a glance, from one passenger to another. Nothing overtly dramatic happens in a Starkey picture. Her women are usually seen in repose, pausing by a wash-basin or meditating over a cup of tea. They can easily look listless, as if unsure about what to do next. Many of her figures appear adrift, dislocated. One young woman sits hunched on a bench, resting a head wearily on her arm. Urban life is seen as oppressive, and sadness afflicts many of the people who occupy these impersonal public spaces.

RINEKE DIJKSTRA, UGO RONDINONE
AND JUAN USLÉ

12 January 2000

Walking into the Saatchi Gallery's pristine space, we find ourselves ambushed by a fusillade of angry headlines from the New York press. 'ART ATTACK' screams one tabloid front page, while another yells 'DUNG HO!'. Scattered across a wide, white wall, scores of framed cuttings testify to the furore generated by *Sensation* and Chris Ofili's elephant-assisted paintings at the Brooklyn Museum last year. Mayor Giuliani's absurd and futile attempt to censor the show ignited a frenzy of debate, catapulting Charles Saatchi's favourite British artists into a notoriety they had never encountered in America before. Now, however, the same prodigious collector kicks off the twenty-first century with a show of new continental work. And the first exhibit to confront us, by the Swiss artist Ugo Rondinone, suggests that painting is now the priority. A large round canvas, fuzzy with concentric circles of high-keyed colour, hangs on the end wall like a colossal target. Recalling Kenneth Noland's celebrated paintings of the early 1960s, its whirling force seems to suck us back into an era where pure abstraction was regarded by many as the ultimate goal.

But there is nothing remotely pure about the outrageous, shameless Rondinone. Moving downstairs into his big arena is like being transported forward again, to a fashion extravaganza in Milan. More circular paintings seem to rotate like Catherine wheels on the walls, and their candy-sweet hues now appear to swell out and pulsate from a distance. They could almost be reacting to the rhythm of heady music accompanying a glamorous catwalk parade. Rondinone may well see them as fantasy décor for just such an event. His own fascination with the fashion world is disclosed in a bizarre series of appropriately glossy photographs. They look, to begin with, like the product of sessions with models posing for lavish magazine spreads. The mood appears brazen, especially when a pale figure flaunts a bra brandishing the stars and stripes of the US flag. But then we realise that many of these women are oddly gaunt and stubbly. Rondinone has manipulated the images, superimposing his own enigmatic features on the models' faces. His make-up varies in each shot, ensuring that he blends uncannily well with the bodies he has invaded.

At the same time, though, he makes no attempt to hide his five o'clock shadow. So the 'woman' in every picture is left stranded in a no-man's land, half-way between cool professional poise and gender-bending ambiguity. At first lightweight, the results grow more unsettling as

you ponder their purpose. For the series is called *I Don't Live Here Anymore*, and some show the model standing or meditating against a backdrop of glum suburban houses. The contrast between figure and location shows how divorced he/she must feel from the former childhood home. The disparity should ideally be liberating, but the models' blank, wan expressions suggest instead a state of despondency. Seen in this light, the target paintings take on a more ominous appearance. While I was there, the winter afternoon suddenly darkened and each phosphorescent canvas began to glow like the rings on an electric cooker. Rondinone disorients us still further by displaying near the targets some panoramic ink landscapes. They could have been executed by a completely different hand. White against dark skies, the trees and land alike seem to have been caught in the flash of an explosion. It reinforced my earlier feeling that the glazed fashion models seem marooned, in an alien world they no longer recognise.

The confusion intensifies when we move on to Juan Uslé's room. Unlike Rondinone, he confines himself exclusively to painting. And he is in no danger of presenting himself as three weirdly disparate artists. A strong, coherent grasp of style runs through all these flamboyant canvases. They have a deceptively spontaneous air, as if executed all in a rush by an artist who thrives on quick, adrenalin-powered bursts of energy. True to his Spanish origins, he produces fiercely emotional images. They engulf the viewer in a flurry of agitated mark-making. Thick, undulating brushstrokes gather in convoluted masses, like intestines convulsed by a nervous seizure. But they are forced to coexist with vertical and horizontal stripes, painted as sternly as the stakes in a forbidding perimeter fence.

There is a feeling of constriction in these paintings, and it fights for supremacy with far more freewheeling elements. The catalogue describes Uslé as a romantic, but he seems to me a pessimist bent on diagnosing the sickness of contemporary urban life. Ostensibly abstract, he leads us through the interstices of cities dominated by snaking conduits, technological systems, tunnels, electronic circuitry and other, more renegade components. They writhe, blink, collide or rush past each other in a blur of hyper-activity. Are we on the inside looking out, or vice versa? Uslé does not tell us. He thrives on bafflement, and implies that the hybrid contents of his tangled metropolis might at any instant succumb to chaos. However much hectic dynamism may be generated by the seeming expansiveness, it could all easily implode.

In this respect, Uslé could not be more different from the best artist on view here. The adolescents photographed by Rineke Dijkstra seem to

have escaped from the mayhem of big-city existence. Singly, and tentatively, they stand in their swimming costumes on beaches as far apart as Coney Island and Odessa. One, a teenage girl at Kolobrzeg in Poland, seems to have just emerged from the sea: an area of dampness still darkens the lower part of her costume. But she is no Venus newly risen from the waves. Her hair is bedraggled, her pose awkward, and the sand clogging her feet increases her overall air of ungainliness.

Dijkstra's attitude is utterly opposed to Rondinone's as well. He treats the photograph as raw material, fit only for subversive distortion. She, on the other hand, stakes everything on frank, unwavering observation. No digital trickery interferes with her clear-eyed scrutiny. She asks her subjects to stand on pebbles or sand, against simple backgrounds of sea and sky, and look at her viewfinder without resorting to clichéd holiday smiles. These figures are solemn, and a Belgian girl with windblown hair presses both arms rigidly against her sides like a soldier standing to attention. So does a boy in Dubrovnik, but in his case the pose looks less defensive. Despite his short stature, he fixes the camera with a belligerent stare. His tanned, plump body gleams in the sun, detaching him from the surroundings he inhabits with such a show of confidence. He is already striving, without much success, to emulate the macho swagger of his elders.

But at least he is unhampered by the painful elongation of the slender, pale youth from the Ukraine. His body has all the gawkiness of someone growing upwards with phenomenal speed, leaving him bonily self-conscious. He looks stunned by the rapid changes his body is undergoing, whereas the girl who stands on a wet beach at Hilton Head Island in the US is far more aware of her allure. Sporting an orange bikini, she keeps her legs close together. One hand is raised, to prevent her long, streaked tresses from being buffeted by sea breezes. Somehow, though, this essentially practical gesture looks calculated as well. It signifies a desire on her part to look as pert as possible. But she gazes out at us with a hint of sadness, and her tentative attempt to assume a beguiling pose serves only to accentuate her vulnerability.

Dijkstra achieves marvels of quiet, subtle scrutiny with the most pared-down means. Far from striving to catch life on the wing, and benefit from lucky accidents, she asks people to remain motionless in front of her camera and stare. When the subjects are women from her native Holland, all holding new-born babies, she presents the condition of motherhood with a refreshing lack of sentimentality. Positioned starkly against institutional white walls, the women seem dazed by the ordeals they have undergone. One clamps a determined hand right over her baby's face, as if to shield the infant from the camera's intrusive lens. But

30. Rineke Dijkstra, *Tecla, Amsterdam, Netherlands, 16 May, 1994*, 1994

she struggles to retain a grip on her offspring's limbs, which seem bent on wriggling free. The baby grasped by another woman is far more inert, and probably breast-feeding. The naked mother, though, is the opposite of serene. However hard she tries to retain her composure, her face betrays a sense of shock. Pitched into a relationship that carries such unparalleled responsibilities, she looks hesitant, burdened and unprepared. As her hands close tightly on the fragile form of the baby she is learning to love, a thin line of blood runs down her left leg like a vein exposed to the light's clinical harshness.

SHIRIN NESHAT

1 August 2000

Fervor, Rapture, Turbulence. The one-word titles of Shirin Neshat's recent video trilogy are terse enough to herald their stark, unrelenting power. At the same time, though, all three titles are unashamedly emotional. They prepare us for the richness of the experiences to come, switching from alarm and indignation to melancholy, frustration and a yearning lyricism that can grow overwhelmingly impassioned.

The springboard for Neshat's outstanding trilogy, now the centrepiece of a Serpentine Gallery show, is her own complex and profoundly troubled reaction to the turmoil in her native Iran. By the time her country was transformed by the 1979 revolution, she had become an *émigré* art student living in Los Angeles. Neshat waited eleven years to return, and the Iran she eventually explored in 1990 moved her so much that it acted as a catalyst. She took up her work as an artist after a long, fallow period. Although New York was now her base, she commenced a series of black-and-white photographs called *Women of Allah*. Using herself as the model, Neshat produced strong, direct, close-up images of a young Muslim woman. At one moment, she is hidden by the traditional dark chador, baring only a forearm to clutch the hand of a naked boy whose skin is covered with tattoo-like linear patterns. In another photograph, she partially lowers the veil to disclose her eyes. Both hands, inscribed with the calligraphic script of Farsi, still cover the rest of her face. She looks hesitant, and yet her features are fully revealed in other images. The most militant, *Rebellious Silence*, shows her holding a rifle whose vertical barrel travels up past her mouth and nose. With Farsi written this time on her chin, cheeks

and forehead, she stares forward in a frankly militant manner. And a further photograph called *Speechless* zooms in on the right side of her face, where the veil is pulled away to let a gun point directly at us.

This interplay between extremes of conformity and revolt gives *Women of Allah* its nourishing ambiguity. But it is taken much further in Neshat's superb trilogy of video installations. Occupying three large spaces at the Serpentine, they show how her subtlety and resourcefulness as an artist flourished immediately she began working with sound, movement and split-screen structures. The major role played by music throughout the trilogy is announced, with impressive assurance, in the earliest video on view. For *Turbulence* opens with an image on one screen of a man at a microphone, singing an old Persian song based on a Sufi love poem. Surprisingly, he turns his back on the all-male audience assembled in the auditorium beyond. But even more unexpected is the presence on the other screen, positioned at the opposite end of the gallery: a veiled woman, viewed from behind. Sitting in the middle, we are obliged to turn restlessly from one screen to the other and back again. The man sings very commandingly, while the woman remains silent and still. But her refusal to turn round or acknowledge his performance soon takes on a significance of its own.

It begins to look defiant. And when he finishes singing, applauded by his audience, she suddenly starts to sing herself. It is a stunning moment. The auditorium in front of her stays empty, underlining the fact that, in Iran, repressive rules of modesty forbid women from singing in public. So this mysterious performer is flouting a fundamental social code, and Neshat's camera movements emphasise her audacity. When the man sang, the camera remained static. But once the woman's voice takes over on the soundtrack, the camera travels slowly round her to reveal the sensual individual who has earlier been nothing more than an anonymous silhouette. She is a compelling, vibrant personality. The man was very correct, and refused to depart from tradition in his performance. The woman, by contrast, employs eloquent hand gestures and a fluidity that matches the motion of the camera circling her body.

The sounds she makes are equally uninhibited. At one instant lowering her voice to a near-whisper, and then unleashing it in a wail of searing force, she is a mesmeric performer. The absence of an audience is, for her, a liberating factor rather than a discouraging reminder of her social isolation. Indeed, she manages to turn this ostracism into a source of strength. It permits her to sing in whatever way she chooses, experimenting with an innovative range of sounds and a physical mobility that makes the man's performance seem stiff and dutiful. He, in turn, cannot

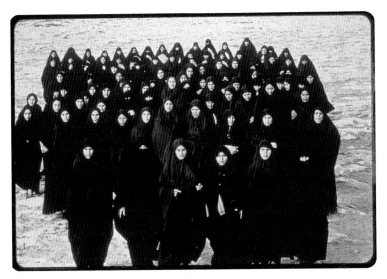

31. Shirin Neshat, *Rapture*, 1999 (detail)

help gazing at the female interloper. All the way through her *tour de force*, he stays as transfixed as the men in their seats beyond. However shocked they may feel by her flagrant flouting of patriarchal rules, their faces show that her magnetism holds them in its thrall.

No such sustained confrontation of individuals runs through Neshat's next video, *Rapture*. But her preoccupation with the gender divide in Muslim societies still predominates. At the outset, an ancient castle by the sea is juxtaposed, on the other screen, with a deserted stretch of rocky terrain. Then, as if in a mirage, a phalanx of white-shirted men appears shimmering in a distant part of the fortifications. They advance towards us, chanting. At the same time, women dressed in black appear in the distance, walking purposefully over the barren land. By removing them from their normal indoor context, Neshat overturns our expectations at once. Rather than staying hidden and private, these robed females could hardly look more exposed. They pause and wait, seen now in close-up. Meanwhile, the men busy themselves putting up ladders against the castle's inner walls, for no apparent reason. The women seem to be watching them, solemn and intent. But when a fight breaks out between an older and a younger man, the women start ululating with their tongues brazenly exposed.

Their howls startle the crowd of men, who stop jostling and stare in astonishment. Although it is unclear where the women are in relation to the castle, the mood of collective confrontation grows intense. They advance again, chanting and raising their hands to display calligraphy on their open palms. It is, Neshat told me, one of her favourite poems about the closeness of women to nature. The men look up, but the women kneel on the ground and bend over, masking their faces. Then the men run forward clapping, their energy reinforced by the cannons projecting from the castle walls. The women, however, advance to the seashore, silhouetted like graceful yet resolute birds against beach and sky. Their movements captivate the men, who stare down in wonderment as the women push a small boat out to sea. The singing choir becomes particularly urgent now, as though affected by the physical strain involved in combating the waves. But they manage to send the vessel on its way with six passengers on board. They look highly vulnerable, floating towards an empty horizon. Their courage, though, is beyond dispute, and they may succeed in enjoying a more emancipated life if their unknown destination is reached. Neshat's ambiguity is at its most poignant here, accentuated by her decision to end with the men standing on the battlements and waving. However much they may disapprove of the boat passengers' recklessness, they cannot stop themselves admiring the women and cheering them on.

Even so, Neshat stops well short of indulging in unqualified optimism. Her most recent video, a new installation called *Fervor*, makes clear at the start that the gulf separating men from women in the Muslim world is still formidable. Nothing could be more uncompromising than the opening sequence. Although the two screens are now set side by side, implying a closure of the gender divide, the man on the left walks away down a long, deserted road while the woman on the right walks towards us. Seen from above, their paths slice through space with bleak, diagonal thrusts. The two figures meet momentarily at a crossing. But they walk past each other. Although the man pauses to look back, the woman simply smiles secretly to herself as she hurries on.

The choral soundtrack changes to heavy organ music while a crowd of men, all dressed in pale Western clothes, join women robed in dark chadors at the entrance to a religious meeting-place. Once inside the building, though, ruthless segregation occurs. A black curtain runs up the centre, splitting males from females as they sit on the floor. Neshat's camera travels across the silent rows of figures, coming to rest on the man and woman who encountered each other in the country. But only for an instant: a bearded authoritarian strides on to a stage at the far end and pulls down a painted scroll illustrating the story of Youssef and Zolikha

from the Koran. He begins to shout, urging his audience with exclamatory, swinging arm-gestures to beware the 'evil' forces that made Zolikha seduce Youssef. The man in the audience looks across at the woman, who returns his glance and smiles. It is a heretical act: Islamic taboos forbid any gazing between the sexes in public. But the knowledge that they are violating social codes heightens the illicit sexual *frisson* they feel.

The bearded instructor rants on, filling both screens with his agitated movements, smacking his hands together and forcing his audience to repeat his phrases. They grow faster and more urgent, and their alarming fervour takes its toll. Although neither the man nor the woman joins in, she looks increasingly blanched and tense. Abruptly, she stands up, forces her way through the startled female crowd and leaves. The man stares after her, upset but apparently unwilling to disrupt the proceedings and follow her. The final sequence of this intensely charged and moving work is far more subdued. With a soft female voice leading the soundtrack, the man and woman approach one another in a narrow street and walk straight past. Not even a glance passes between them, and they both vanish from sight. The ending could hardly be bleaker. But the possibility of a future encounter remains in the air. For we cannot quite believe that their fiercely aroused desire, flaring even as religious condemnation chanted louder around them, will stay repressed for ever.

ANT NOISES 2
6 September 2000

Brace yourself for a gruesome and repellent spectacle at *Ant Noises 2*, the Saatchi Gallery's provocative new exhibition. The smell assails your nostrils long before Damien Hirst's aptly named *Horror at Home* reveals its disgusting contents. But as we approach his colossal white ashtray, the stink becomes atrocious. Staring down at this outsized receptacle is like gazing into a pond long since drained of its putrid water. And there, heaped at the bottom, is a festering deposit of cigarette butts by the thousand, along with empty packs of Marlboro, Benson & Hedges and even Hamlet cigars. Their brand names are often difficult to decipher, for everything is smothered in a heavy layer of ash. But make no mistake: any cigarette manufacturer would be aghast at the throat-wrenching nausea generated by *Horror at Home*.

The smell is so appalling that I was forced to hurry on, and yet Hirst provides no respite. His other work, displayed in the blinding vastness of the Saatchi Gallery's main arena, includes a thirteen-part screenprint series called *The Last Supper*. Despite the pious title, this is a remorselessly secular affair. Rather than depicting images of Christ and his disciples, Hirst turns each tall print into a food package. The meals on offer are traditional English stodge: corned beef, sausages, pies, chips and pasties. The cumulative effect is repulsive, and Hirst makes it still more alarming by designing the prints in the style of pill packets on sale at the chemist's. He even includes references to tablets and capsules, specifying drugs as potentially lethal as morphine. So *The Last Supper* adds up to a suicidal cocktail, fit only for depressives bent on swallowing a final meal before the onset of death.

By now, Hirst's obsession with mortality is familiar enough. But the more I looked at his art here, the stranger it became. In his most imposing exhibit, an elaborate vitrine called *Contemplating a Self-Portrait (as a Pharmacist)*, a spattered easel supports a half-finished painting of a figure in a white coat. Its style is reminiscent of an early work by Francis Bacon, one of Hirst's heroes. But a real white coat hangs on the canvas as well, invading the illusionistic space conjured by the painting. The effect is disconcerting, and Hirst compounds the unease by sealing off the easel inside its own glass-walled cell. In the rest of the vitrine, a palette lies on a table with brushes, knife and paints already squeezed out ready for use. But anyone inhabiting this prison-like space would be denied access to the painting on the easel. So the entire work becomes a curious testament to frustration. Hirst started off wanting to be a painter, and he once showed me a vigorous, Bomberg-like view of Leeds painted when he was only sixteen. Although his subsequent work took a very different course, he still looks back on his youthful paintings with affection. Maybe Hirst feels thwarted, even now, by the unattainability of the artist's studio reconstructed here. But he acknowledges, in the very subject of the canvas on the easel, that his fascination with pharmaceutical imagery led him away from his earlier concerns.

A large recent painting by Hirst, *Zeolite Mixture*, hangs nearby, sending hundreds of multicoloured dots swarming into space. Its title refers to minerals, but these dancing particles could also be seen as deceptively attractive pills dazzling our eyes with their inescapable presence. Drugs permeate Hirst's vision of the contemporary world, and even a work as apparently high-spirited as *Zeolite Mixture* should not blind us to its more ominous implications.

Compared with his mordant toughness, Tracey Emin's exhibits lose

some of their sting. Her notorious *My Bed* reappears here, for the first time since it aroused such extreme responses at last year's Turner Prize show. The rearranged sheets look even more crumpled and stained than before, and the discarded tights now seem to convey a reference to Sarah Lucas's preoccupation with the same underwear. Taken as a whole, though, *My Bed* looks far less raw. With two suitcases chained and roped beside it, the entire work has a highly theatrical air. It could easily be a stage set, the seedy location for an acting-out of scenes from Emin's life. And its artifice is intensified when we find, in the very next space, a real hut transported all the way from Whitstable beach. With Lucas, Emin bought the derelict structure back in 1992. She and her boyfriend frequented the hut, and the anecdotal title may well refer to the final time they visited it together: *The Last Thing I Said To You Is Don't Leave Me Here*. Marooned now in the pristine bareness of a gallery, the hut looks even more dilapidated than it must have done at Whitstable. In contrast with the self-conscious installation of *My Bed*, this gaunt shelter seems untouched by the artist. The rudimentary exterior, its rotting timbers and corrugated iron smeared with peeling paint, looks utterly desolate. Peering in through a rickety open window, I caught a tang of the sea inside. But the hut is deserted, and only in a couple of nearby colour photographs do we find Emin crouching naked within.

Although she appears lonely, her hunched body lacks the outright anguish explored in an appliqué blanket called *I Think It Must Have Been Fear*. Made this year, its blanched surface nevertheless has a faded air. Perhaps it reflects the fact that Emin is undertaking an act of remembrance, looking back on a traumatic school ski trip to Austria in 1974. Her spidery writing spreads across the blanket, relating in often misspelt detail the misery of the expedition's last days. Standing close enough to read the small, faint words, we discover that 'the fear of returning home' prompted Emin to stay in bed 'and wet myself'. Afraid that everyone else would find out, she remained there long enough to feel thoroughly humiliated by her ordeal. In bold letters taking up a substantial part of the blanket, she relates how 'I Lay There For Two Days In My Piss Stain [sic] Sheet.'

At first glance, a new colour photograph of Emin clutching coins and banknotes between her open legs seems more celebratory in mood. But the title, *I've Got It All*, sounds like an ironic comment on all those over-publicised pools winners who ended up miserable after frittering their prize-money away. Then we realise that Emin is still alone here, and that clasping the cash to her body could be seen as a melancholy substitute for human companionship and love.

32. Tracey Emin, *I've Got It All*, 2000

Sarah Lucas, the other 'bad girl' of British art, also relies on self-portraiture in some of her exhibits. Wearing torn jeans and a T-shirt smeared with two breast-shaped fried eggs, she stares out frostily from a 1996 photograph. In recent years, though, she has turned her work away from blatant, Emin-like self-exposure. Lucas is probably still the model for a new photograph called *Chicken Knickers*, where the plucked and headless fowl dangles like a grotesque appendage from a woman's pants. But we no longer know for certain, and another new work entitled *Priere de Toucher* refuses to disclose the identity of the woman whose left nipple pokes through a hole in her white sweatshirt.

Jenny Saville shares this obsession with the female body, even if her paintings have never indulged in the genital references that pepper

Lucas's most brazen work. *Host*, Saville's immense new painting, dominates its long space at the Saatchi Gallery. Displayed at the far end, its cinematic width is filled almost to bursting-point with the exposed belly of a pig. Not that the animal is identified beyond all doubt. Its head is excluded, and there are disconcerting hints that human references may be fused with the porcine elements. Teats project from the belly, and Saville's increasingly assured brushwork animates what might otherwise have become a slack and ponderous work. All the same, we have no way of telling whether the animal is alive or dead. *Host* is a deeply ambiguous painting, relying on source-material as various as illustrations in *National Geographic* magazine and a novel about a girl who is transformed into a pig. We are left, in the end, with a troubling image of mortal flesh, caught helplessly between the sty and the abattoir.

Although Saville's powerful exhibit is displayed with the maximum possible impact, it unfortunately overshadows the other paintings in the room. They are the work of Gary Hume and Richard Patterson, impressive artists whose presence with Saville gives the lie to complaints that Saatchi is not interested in painters. But both of them appear uncomfortably sidelined here compared with *Host*, and I only hope that their work receives the ample representation it deserves in a future showing at the gallery.

Gavin Turk, on the other hand, could not ask for a more generous display. His *Death of Che*, a lifesize waxwork figure of the artist posing as the murdered Che Guevara, is isolated in a room as clinical and chilling as a morgue. The sculpture looks far better than it did in White Cube[2] earlier this year, surrounded by the work of Turk's contemporaries. Despite its intriguing debt to David's *Death of Marat*, though, I still find it uncomfortably close to Madame Tussaud kitsch. And Turk's empty skip in the entrance hall, unaccountably called *Pimp*, failed to sustain my attention for long.

Jake and Dinos Chapman, by contrast, surprised me with their heartfelt eloquence. The eighty-three hand-coloured etchings in their *Disasters of War* cycle are a real, sustained achievement. Far more impressive than the callow titillation of their earlier fibreglass sculpture *D.N.A. Zygotic*, where they indulged in monstrous mutilation for its own sake, these etchings are genuinely impassioned. The Chapmans' long-standing involvement with Goya re-emerges in many of the prints, where images from his *Disasters* series are openly recycled. But they are more than mere pastiche. Goya, in the Chapmans' turbulent and agonised print-sequence, is fused with countless other references, including news photographs of the Holocaust and political caricature at its most savage. Drawn with economy and bite, their *Disasters of War* pulls us into

a relentless vision of the world burdened, above all, by corpses heaped in mass graves. Its despair is powerful enough to make me look forward to seeing the Chapmans' monumental sculpture in the Royal Academy's forthcoming *Apocalypse* show, where they tackle the same theme in an even more harrowing manner.

APOCALYPSE
20 September 2000

If you want to enter *Apocalypse*, be prepared to crawl. An alarmingly small hole greets able-bodied visitors to the Royal Academy's much-hyped exploration of 'beauty and horror in contemporary art'. Being tall, I had to jack-knife my way through. And even then, my twisting limbs only just managed to scramble into Gregor Schneider's gloomy *Cellar* beyond. Inside, it does not get any easier. A labyrinth of narrow, roughly plastered corridors stretches ahead, transplanted from Schneider's own house in Germany. At certain points on the tortuous route, doors swing open to disclose dank, cheerless rooms. Their creepiness made me shudder and hurry on. But no sooner had I escaped than Schneider confronted me with a screen, where a hand-held video camera conducts a journey through the house itself.

He has remodelled it into a nightmarish sequence of uninviting, claustrophobic spaces. The cameraman can be heard breathing heavily, grunting and even groaning as he stumbles up ladders, along tunnel-like cavities and down into a bleak basement. They were depressing enough to make me think of Fred West's corpse-filled home, and wonder why Schneider should submit himself to such a gruelling assault-course. Maybe he is trapped in a self-inflicted version of purgatory, for *Apocalypse* takes its cue from the heaven-and-hell rhetoric of St John the Divine's vision. He prophesied the world's end, and his hallucinatory prose has inspired artists ever since. Every generation, as Norman Rosenthal points out in his curatorial essay, has invented its own version of the Apocalypse. And although the RA show is at pains to include celebration as well as mortification, the most impressive works on show invariably turn out to be the most lacerating.

Maurizio Cattelan goes all out for theatrical impact. Most of his enormous, red-carpeted room is empty, apart from a lifelike painted wax figure

of the Pope. Felled by a meteorite, he lies on the floor and closes his eyes in anguish. Shards of glass are scattered nearby and, looking up, I noticed that a real hole has been smashed through the gallery's skylight. The spectacle falls short of outright horror, though. The gap in the roof looks implausibly small, and the Pope is far from dead. Still gripping his crucifix, he appears capable of pushing the meteorite aside and rising to his feet.

Luc Tuymans, by contrast, rejects showmanship and opts for extreme reticence. His paintings are so bleached and ghostly that they hardly seem to be there at all. Apart from a couple of male heads, their subjects are equally elusive. Without the titles to guide me, I would have hesitated to identify the pillows, embroidery and cosmetics he depicts. They all look faded and bloodless, more shadow than substance and eerily close to extinction. Mariko Mori would spurn such a vision of frailty. Her *Dream Temple*, grandly occupying by far the largest gallery, invites us to don slippers and ascend a transparent staircase before entering a luminous chamber. After the door shuts, we are left alone in a globular space suffused with multicoloured light. Nirvana has been reached, inside a building where ancient Japanese religion is fused with cosmological optimism. But it all seems like wishful thinking compared with the stricken Pope, whose vulnerability is far more persuasive than Mori's confected Eastern bliss.

Mike Kelley's bizarre exhibit is impossible to take seriously on any level. A makeshift living-room takes up most of his space, with a gas oven, a table, a sculpture and a rumpled bed far less seedy than Tracey Emin's. It all looks like an unaccountably deserted stage-set, but behind one wall come the sounds of two men arguing. There, on a modest screen, a grainy black-and-white video relays a performance in the living-room. Both actors utter stilted, over-the-top dialogue caricaturing their gay relationship. They are locked in a mutually destructive cycle, which terminates when one man tempts his partner into the gas-filled oven where he sees Sylvia Plath beckoning him. Although their hysterical acrimony could well be described as 'hellish', I found it impossible to engage with this ludicrously mannered playlet.

My interest revived with the advent of Wolfgang Tillmans's photographs. His three large images of an incandescent sunset, where the clouds resemble a nuclear eruption, have an apocalyptic menace reinforced by cracks, tears and light leaking into the camera. But the overall mood of Tillmans's room is impossible to pin down. He moves from a tender portrait of a bare-chested young man to a pale still life with 'vanitas' undertones. And his most provocative image closes on an anonymous crotch, where Tillmans gives a strong, sensual charge to the texture of jeans and human flesh alike.

Chris Cunningham's film is far more brazenly erotic. At the entrance to his darkened chamber, a notice bans under-eighteens from viewing the work's 'violent and sexually explicit sequences'. After such a warning, the film itself seems oddly inconclusive. Cunningham, a former director of commercials and music videos, offers a slick and stylish vision of two naked figures copulating and fighting in an immense black void. Dramatically lit, like bodies in a Caravaggio painting, they make love and become transformed by shafts of radiance. But lust turns to aggression, and their struggles soon become bloody. Cunningham's soundtrack grows mercilessly loud when the bloodsmeared woman regains consciousness, coughing and retching. Both she and her muscular lover seem addicted to extreme pain, and it is a relief when their over-emphatic exertions give way to a more abstract sequence filled with smoke, light and seminal fluid.

After Cunningham's sado-masochistic orgy, Tim Noble and Sue Webster's *The Undesirables* seems almost innocent. Assembling a monstrous pile of garbage, they make it cast silhouettes of their own heads on to the far wall. It is a clever trick; and since the rubbish is odourless, the whole assemblage becomes oddly romantic. It also serves as an ideal foil for the most powerful work on view: Jake and Dinos Chapman's aptly named *Hell*. Inside a series of vitrines ranged in the shape of a giant swastika, thousands of miniature figures suffer from appalling brutality. Barren landscapes, where dusty trees seem about to die, are transformed into killing fields. At the centre, a volcano belches smoke while butchered figures stagger down its sides like streams of human lava. Wherever you look, bodies are being disembowelled, decapitated, impaled on trees and poles or pushed into ovens. Nazi troops often appear as the persecutors, but the Chapmans also refer to atrocities depicted centuries earlier by Goya and Breugel. The most harrowing scene contains an immense pit heaped with hideously amputated corpses. A few skeletal men stand on the bodies, gesturing helplessly as if to deplore the infinite carnage. But the Chapmans offer no respite or sign of hope.

Their excoriating tableaux make Jeff Koons's final room seem lamentably feeble. Based on his son's toy collection, the space is dominated by a colossal *Balloon Dog* shimmering in high chromium stainless steel. This extravagant, blown-up pet seems unbearably trite after the sustained savagery of the Chapmans' *cri de coeur*. They have gazed straight into the heart of twentieth-century darkness, and provide the show as a whole with a gruelling, relentless masterpiece.

33. Jake and Dinos Chapman, *Hell*, 1998–2000 (detail)

GILLIAN WEARING AND SHIRAZEH HOUSHIARY

27 September 2000

Fascinated by other people's lives, Gillian Wearing decided from the outset to place them at the very centre of her work. During the early 1990s she went up to pedestrians in the street, inviting them to write down on large white cards anything they wanted to say. A surprising number unburdened themselves. And their responses, ranging from baffled aggression to painful vulnerability, were captured in a series of colour photographs where the writers hold up their words like poignant public confessions. With hindsight, we can now see how clearly Wearing caught the spirit of the decade in this early work. Now that people queue up to expose themselves on prime-time television shows like *Big Brother*, the possibilities for turning the private into public entertainment are larger than ever before. But Wearing, to her great credit, has never sought to exploit them. Her concise and lucid mini-retrospective at the Serpentine Gallery enables us to chart the Turner Prize-winner's development. And in her early works, she stops well short of invasive tactics.

A woman with a bandaged face walking down the Walworth Road captivated Wearing. She longed to talk to her but felt, no doubt rightly, that it would 'ruin the mystery'. So instead of filming the unknown figure, Wearing decided to bandage her own face and assume the woman's identity. Or rather, she presented to the camera her notion of what the real bandaged woman was like. A similar idea underpins *Dancing in Peckham*, where Wearing dances on her own, without music, in a shopping centre. Passers-by stare and hurry on, leaving her absorbed in bodily gyrations. This time, she was inspired by a woman dancing 'like some wild banshee' to jazz at the Royal Festival Hall. Wearing's innate reserve prevented her from approaching the woman, and so she decided to perform her own, non-jazz version in far more humdrum surroundings.

Although Wearing was profoundly influenced by her childhood exposure to television documentaries and talk shows, she retains the right to work in a far more free and unpredictable way. *Sacha and Mum*, a 1996 video projection occupying an enormous single screen in the Serpentine's central space, may have been based on a woman's authentic account of her desperate, love–hate relationship with her mother. But Wearing employed actors to assume the roles, filming it in a heightened, neo-expressionist style disturbingly reminiscent of silent cinema. The fierce concentration on close-ups and distorted camera angles reinforces the alarming struggle between the two women. Wearing further removes

it from documentary realism by running the video backwards. Alternating between violent hair-tugging and tearful embraces, the insidious family conflict becomes even more stylised. It resembles some macabre ballet, and the fragmented soundtrack gives the entire work an almost unbearable emotional intensity.

In her more recent work, though, Wearing has consistently entered into direct, lengthy collaborations with the people who excite her interest. The most commanding Serpentine exhibit is a three-screen projection called *Drunk*, the product of her involvement with a group of south London street boozers. At first, they responded with too much enthusiasm, turning her film sessions into a bottle-strewn brawl. Then tragedy intervened: Lindsey, a woman who was in the artist's view 'outspoken, loud and violent, but also had a wicked sense of humour', died soon after Wearing filmed her. Hence, perhaps, the elegiac mood of *Drunk*. Cans and bottles in their hands, young men wander erratically across the three screens. The backdrop is studiously neutral, removed from any attempt to recreate the urban locations where they usually hang out. Sometimes all the screens are empty, sharpening expectations that something is about to happen. And then tension grows, as one swaggering man deliberately

34. Gillian Wearing, *Drunk*, 1999

taunts his mates, goading them into a fight. They tussle and fall to the ground, while someone tries to pacify them. Others look on stunned, unable to do anything except sit and booze. After a while, melancholy comes to predominate. A terrible sense of lassitude hangs over everyone, suggesting that Wearing's view of the drinkers has been overwhelmingly affected by Lindsey's death. They all seem doomed, and at one point the greatly enlarged figure of a solitary young man takes up all the screen. Eyes closed, he has collapsed on the floor with one leg slung over the other as loosely as a doll. His inert posture looks so monumental that it stirs memories of Christ's dead body in a thousand paintings of the *Pietà*. Except that no mother is on hand to grieve over her son. The unconscious drinker remains alone, with nobody to help or even lament his decline.

In *Drunk*, the people filmed by Wearing are subjected to prolonged, painful exposure. But most of the time, she prefers to veil them in disguises. The process began in *Confess All*, one of her landmark works from the mid-1990s. Each confessor wore a grotesque mask, caricatured so much that it suited, in a carnivalesque way, the extreme nature of the stories they told. Now, in a new work called *Trauma*, the people all don masks of relatively uncrazed adolescent faces. Their expressions are deadpan, but underneath we can glimpse a grey beard and sagging chins that disclose the wearers' true ages. They all responded to an ad Wearing published, asking for anyone willing to talk on film about 'negative or traumatic experience in childhood or youth'. So the masks, as well as protecting their anonymity, transport them back to the age when they suffered their pain. Entering a confined room, and straining to hear their muttered recollections, we find our sympathies engaged by one of the most fearless, observant and compassionate artists of our time.

If Wearing's commitment to photography and video is reaffirmed by this survey, Shirazeh Houshiary emerges from her Lisson Gallery show with an altered way of working. It offers a profoundly meditative experience. Houshiary established her reputation in the early 1980s as a sculptor, and only began working on canvas a decade later. The dark, brooding images she produced then seemed closer to drawing than painting. Although they recalled the all-black squares and rectangles of Malevich and Ad Reinhardt, further inspection revealed a fascination with cloudy circles. But there was nothing nebulous about the way Houshiary executed these remarkable works. Minuscule graphic marks were formed into Arabic words, reiterating words like 'truth' or 'I am breath'. Houshiary had succeeded in arriving at a delicate fusion of Western art and her native Iranian culture. The concentration she

required to achieve such poised, meticulous work must have been formidable. It was bound up with her interest in Sufi mysticism, and the belief that the essence can only be approached if your mind is emptied of all everyday thoughts.

A similar feat lies behind the work in the Lisson show. But this time, with one dark exception upstairs, all her exhibits are luminous with whiteness. Most of them are executed on canvas, and rely on a highly personal mixture of aquacryl, silverpoint and graphite. Yellow pigment also plays a part in several works, but the initial impression on entering the gallery is of intense, pure light. At first glance, some look like all-white monochromes, as if Houshiary were exploring the bleached territory pioneered by Robert Ryman. But these images repay prolonged scrutiny, and they gradually impart subtleties that may not be apparent at first.

They evade, for one thing, any attempt to define them as paintings. Viewed near-to, some of their surfaces seem exquisitely etched, as if made with the fine point of a print-maker's needle rather than brush or pencil. The silverpoint clearly plays a vital role in their making, and yet Houshiary does not allow it to give her images an unwanted precision. Everything remains suggested, not stated. We find ourselves tantalised by these infinitely mysterious works, and wonder how on earth Houshiary executed them.

They often appear to have been breathed on to the canvas. Rather than resulting from a process of deliberate mark-making, they hint at more trance-like procedures. Houshiary executes them on the floor, moving round each canvas with steady, contemplative deliberation. Drawing in graphite still provides the foundation, but the words visible before have now vanished altogether. In their place, we find delicate hints of cloud formations enlivening an otherwise pale, empty sky, or thin concentric circles widening out from a still centre. Colour asserts its presence at times, most notably when she employs the yellow pigment. But it remains, for the most part, suppressed by the veil of whiteness washed across the surface.

These are remarkable works, sensitive and resolute in equal measure. Houshiary prefers to whisper her way of looking at the world rather than shout it out loud. But that does not mean her work lacks strength. At a time when our eyes so often feel bombarded by clamorous images wherever we turn, a visit to her limpid exhibition is more necessary than ever. It cleanses our vision, enabling us to leave the gallery purged and invigorated.

TONY OURSLER
29 March 2000

Marooned near the centre of a darkened room at the Lisson Gallery, an elderly woman's face seems to confront us. But she betrays no awareness of our presence. With hooded lids, wandering eyes and an air of permanent disappointment, she begins to speak. 'Monster? Monster? I'm not a monster!' she protests in an unreal, little-girl voice. Tony Oursler has never wasted time as he draws you in to his desolating, weirdly compulsive world. Most of the video installations created by this brilliant and relentless New Yorker address the viewer directly through the mouths of people who seem stranded and alone. They alert you at once to the fact that something has gone wrong. 'Do I know you? Do you know me?' asks the woman, who forgets to answer her own question and then, without warning or explanation, mutters 'dash – dash – dot – dot'. The staccato sound of the Morse code proves prophetic. After her mouth says 'I'm breaking up', she gives a rictus grin and goes into a fast-forward frenzy. Like a convulsive Bacon face gone haywire, her features start fragmenting.

Oursler back-projects the woman's face on to a cluster of transparent boxes, stacked in rows like goods in a supermarket. Their glinting, irregular surfaces splinter her even more, and cast pale white reflections high on the wall behind. But just as she seems about to decompose completely, like a Chuck Close head dissolving in its grid, the woman returns. 'I am, I am not,' she says carefully, repeating the words several times as if they were a mantra. Her eyes roam even more distractedly than before, and she mutters: 'Zero one, zero one. Something, nothing.'

At once terse and wayward, the characters who inhabit Oursler's troubled work are all *in extremis*. Their deadpan expressions do not, however, signal any realization that they need help. Profoundly introverted, they seem unable to do anything except talk to themselves like victims of their own divided psyches. In *Blue Dilemma*, a multi-part installation filling most of the downstairs space, we find ourselves addressed by a man's isolated head sprouting devil's horns and lying, like an overgrown potato, on the bars of an open cage. 'Where are you?' he asks in a playful, sing-song voice, as if acting out the role of a demented killer in a horror movie. But then we realise that he echoes his own question in a high voice, speaking through clenched lips like an amateur ventriloquist. 'What did you say?' he asks, pretending not to understand himself before muttering: 'Everything has its price – price?' Random images play over

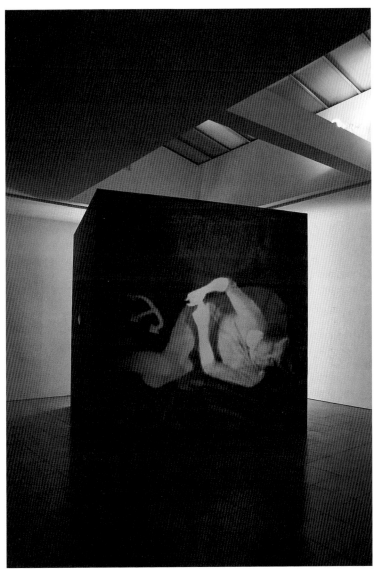

35. Tony Oursler, *Camera Obscura*, 2000

his pallid, stubbly face, like fragments from a dream. He lapses into silence, as if spellbound by the film stars, cartoon characters and weather-forecast charts that flash across his submissive features.

Not all Oursler's work concentrates on talking heads. Nearby, another video projector trains its image on the wall through a bulbous glass vessel. The naked figure writhing there seems trapped in a dark space. Limbs thrust outwards in startling distortion, or else retreat into tight clusters. Oscillating between restlessness and inertia, the body appears unable to escape from its shadowy confinement. Nor can it speak, although Oursler ensures that the voice of the horned man stays naggingly audible as we watch this mute figure writhing without hope of relief.

The sense of entrapment in Oursler's art is acute. It generates, after a while, a claustrophobia that increases when we are invited to step through an open door. Inside, the brightness of a lamp dazzles us from the floor of a small room. But a freestanding window curves down from one corner, providing a surface for a camera to project a tiny image on the lowest pane. In order to see it properly, I had to crouch and peer. The two naked figures visible there made me feel like a voyeur. Involved in silent confrontation, they are psychologically remote from each other. The seated man appears to be dominated by the standing woman. But then he clasps her legs, trying to move them, and her motionless posture suddenly resembles a dummy.

Ever since he first defined his uncompromising vision, Oursler has been fascinated by such images. Many of his earlier figures lay slumped like deflated balloons, alienated from their own bodies. They continued to speak, just as patients struggle to communicate with a therapist. But their attempts to break out of a Beckett-like loneliness only confirmed their inability to overcome it. In the present show, a bust of a woman looks as if it has strayed into the gallery from a shop-window display. Casting a silhouetted shadow on the wall beyond, it suggests that Oursler has inherited the Surrealists' involvement with mannequins. Unlike most of his figures, she has no head. But he compensates for its absence by projecting on to her body a sideways image of a large pair of lips. Mouthing silent words, they look like a wound forever opening and closing in her flesh.

Oursler cannot jettison the head for long, though. Near the violated bust is a large revolving disc where multicoloured faces in yellow, green and red all babble away at each other. Their voices are so subdued that they become impossible to disentangle. But their features are more distinctive, ranging from individual sets of animated features to mask-like forms where everything except a smudgy suggestion of eyes has been

obliterated. Their imminent blankness undermines the rest of the faces, who ignore one another's presence and still seem utterly alone.

For all his interest in voluble, agitated characters, Oursler does not let us forget the stillness of death. At the end of the downstairs installation, we enter a room with a window set in the far wall. Resembling a blue cross, it looks down on a colossal transparent skull occupying the centre of the floor. Whenever a man's voice issues from a speaker in the corner, coloured bulbs flicker within the skull. He sounds as if he is reading extracts from an optician's textbook. In a steady, matter-of-fact tone, difficult to hear unless you sit on the floor and concentrate very hard, he talks about eyesight problems when the retina is assailed by 'amorphous bursts of light'. The more he elaborates, the more sinister his dispassionate observations become. He talks about 'a blind spot, a nearly circular area near the back of the retina' and floaters that 'may appear to drift before your vision'. The bulbs flaring inside the skull take on a new menace when he describes how 'flashes are caused by irregular bloodflow, and may be accompanied by extreme pain'. But the most sinister moments of all occur when he pauses and simply breathes into the microphone, causing the bulbs to react with nervous spasms of colour. The skull's sightless eye-sockets only add to the macabre mood; and the presence of a leering ventriloquist's dummy, propped on a stick in another corner, does nothing to alleviate the air of foreboding.

Alongside this preoccupation with mortality, Oursler meditates on the ever-increasing power of the broadcast image. The voice in the skull room may talk at one point about a camera obscura in its 'dark chamber', but elsewhere references abound to the ever-accelerating impact of new technologies on our ways of seeing. Nowhere more poignantly than in the upstairs installation. A large ball rests on the floor opposite a camera. And as we move into the room, the other side of the ball turns out to be filled with the image of a woman's eye seen in mesmerizing close-up. Bloodshot and prone to blinking, the eye seems mesmerised by a television programme. We can glimpse reflections in her pupil of a man doing press-ups and jogging. The programme's droning soundtrack can also be heard, but only indistinctly. It does not matter a great deal to the woman, whose eyelid begins to droop and, after a while, shuts completely.

She seems disorientated with weariness, or maybe pain. Her lid becomes more torpid and goes momentarily out of focus. She appears unable to comprehend any more of the ceaseless transmission. Like a drug addict suffering from an overdose, her eye looks dazed by media saturation. It goes into fast forward and, like the woman in the downstairs gallery, starts breaking up for a while. The sound vanishes as a

coherent image returns, and we are left with the silent predicament of an irreversibly sated eye – baffled, groggy and incapable of absorbing any more. But the final irony lies in the woman's inability to turn away and liberate herself from televisual exhaustion. The eye remains perversely in thrall to the source of its own unending distress.

DREAM MACHINES
4 October 2000

Once we have mounted the steps leading to the gallery entrance, a strident floor pattern traps our feet and drives them inside. Jim Lambie's jagged, relentlessly coloured stripes, bouncing off the walls and careering in to a crowded centre, dominate every move we make. The onslaught of glossy vinyl tape smothers the Camden Arts Centre's wide foyer, making us feel caught inside a psychedelic whirlpool. Nothing could be more apt as a scene-setter for *Dream Machines*, Susan Hiller's entertaining and provocative selection of hallucinatory art. Altered states of consciousness is the theme running through this continually surprising show, where the exhibits ambush us at every turn. As an artist who has grappled impressively with such haunting themes in her own work, Hiller proves an ideal curator. Setting no limits on the media employed and allowing the wildest obsessions to flourish, she only stops short of violent nightmares. The terror informing Hamlet's 'perchance to dream' finds no place here, and Hiller goes some way towards accounting for the omission by wrily declaring, in her catalogue introduction, that 'I think we have enough mysterious darkness within ourselves and our own culture to be getting on with.'

So if a work in *Dream Machines* looks alarming at first, the impression turns out to be deceptive. When I saw Adam Chodzko's video projection *Night Vision* from a distance, the spectacle of blurred and grainy figures stumbling through a gloomy, rain-sodden wood reminded me of a scene from *The Blair Witch Project*. But in reality, they are all rock-concert designers and technicians, bent on carefully lighting a heavenly scene among the trees. Maybe they would have profited from the fly agaric mushrooms which Carsten Höller unpacks, fries and eats in his hotel room. He lapses into a visionary stupor, and we watch him slump, doze, clutch his head and sing with eyes shut. A revolving mushroom appears

in a wood, changing colour as it spins. But most of the time we are aware that Höller's hallucogenic experiences stay within his head, and cannot be conveyed by his laid-back videos.

In this respect, Rodney Graham's *Halcion Sleep* is more effective. He decided to take a sleeping-pill in a motel on the outskirts of Vancouver. Then, like a child, Graham was placed on the back seat of a car and driven to his apartment. *En route*, he makes no attempt to show us his dreams. But somehow, the sight of this horizontal figure lying so still, with one hand propped neatly under his head, conveys a strange sense of his trance-like state. His body bumps up and down with the car's motion, while the streaked lights of Vancouver flash past the rainy window behind. But he remains imperturbable, his expression serene.

By adopting such a straightforward approach, Graham avoided the frustration experienced by Henri Michaux. Celebrated for his experiments with mescaline, and for the agitated drawings he drew under its influence in the late 1950s, he later collaborated with Eric Duvivier to make a film about the visions induced by this potent drug. A video copy is projected at the gallery, and its black-and-white images return time and again to the close-up of a man reeling as he registers the effects of his own mescaline intake. At one point, he claps hands to eyes, as if attempting to stop the visionary bombardment. But it continues, showing upraised hands in strange clusters, the sun shimmering on an immense, empty sea, candles wavering in woodland and galaxies glittering like a thousand precious stones set in blackness. A heightened obsession with light runs through the entire film, but one critic damned it as 'a documentary on colours filmed by the colour blind'. Michaux himself admitted the film's failings, especially its slowness compared with the incredible speed of the visions he had experienced. And in an evocative passage, expressed with greater eloquence than anything achieved by the film, he insisted that they 'should be more dazzling, more unstable, more subtle, more labile, more ungraspable, more oscillating, more trembling, more torturing'.

In view of Michaux's complaints, artists may be well-advised to avoid simulating the effects of drugs in their work. Jane and Louise Wilson's video, *Routes 1 and 9 North*, benefits from the directness they adopt. Shot in a dingy American motel, it looks at first like a cheap porn film or a police record of a crime documented with hidden cameras. But we soon realise that the Wilsons are being hypnotised, and much of the film's interest lies in the fact that they are twins. Looking uncannily similar, the two women react to the hypnotist's quiet, measured commands in near-identical ways. Their deadpan faces allow us to project our own thoughts

36. Jane and Louise Wilson, *Routes 1 and 9 North*, 1994

on to the proceedings, and identify with the calming effect of the session. At the same time, the shadows flung on the walls behind their heads promote a feeling of eeriness as the Wilsons slump forwards, in thrall to the hypnotist's instructions.

The spoken word plays a conspicuous role throughout the show. Near the entrance, a speaker attached to the wall relays a continuous 1926 recording of Kurt Schwitters's voice performing *The Primordial Sonata* (*Ursonate*). He sounds oracular as his strange, irrepressible chant comes through the crackles. Photographs of the artist performing the Ursonate reveal his expression altering from a vehement, downturned frown to defiant, head-thrown-back glee. 'Uu zee tee wee bee,' he cries, brazenly challenging us to understand his enigmatic score. Schwitters believed that 'listening to the sonata is better than reading it', and his ability to sustain this torrent of sound for over forty minutes helps to explain why audiences at his live performances found him so arresting.

Mark Harris, on the other hand, adopts a far more sober approach in his recent two-screen video *Marijuana in the UK*. Studious and bespectacled,

a young man reads aloud to marijuana plants from texts by Baudelaire and Walter Benjamin. Both authors deal with the narcotic properties of hashish, and Harris hopes that the plants' potency will be enhanced by these words. The luxuriance of their gleaming leaves certainly contrasts with the prim austerity of the man and his mirror image on the second screen. The plants seem to grow ever more lush as the reading proceeds, but perhaps my response to these tropical images was influenced by the persuasive sound of Baudelaire.

Dan Graham's voice-over commentary on his *Rock My Religion* video is even more matter-of-fact. But his subject is electrifying. Reliant on contemporary footage and texts, he ranges freely over the bizarre connections between the Shakers' trance-like dances when possessed by demons, and the equally ecstatic state of rock bands in full frenzy. Graham himself remains calm and analytical throughout, and the screen prints up Herbert Marcuse's influential prediction in the late 1960s that, after the hoped-for revolution, 'aesthetic play would then replace the suffering of work'. But the most powerful images show far wilder, more disturbing forces at work, galvanizing drugged-up rock musicians and their hysterical audiences with as much intensity as the Shakers' speaking in tongues.

Several of the artists riskily invite us to adopt a more participatory role. Job Koelewijn trusts that we will don one of his grey body-warmers and listen to the 'disembodied voices of poets, living and dead, as a source of psychic energy for artist and viewer'. But the CD Walkman and speakers attached to the body-warmers only emitted indecipherable noises, and no one bothered to take them off their coat-hangers while I was in the gallery. Marina Abramović's exhibits encountered a similar resistance. She invites us to take off our shoes and socks, walk over to a couple of large amethyst blocks and, with eyes closed, place our bare feet inside them. According to Abramović, the wearers will find themselves launched on a voyage into the unconscious. Since all the other visitors showed no sign of undertaking the journey, I decided to oblige. People stared at me oddly as I struggled to push my naked feet into the amethyst. But they were too large for the cavities hollowed out of the blocks, and I had to content myself with contemplating the soft explosion of graphite marks in Shirazeh Houshiary's soothing *Last Gasp* canvas nearby.

Susan Hiller's own contribution, *Magic Lantern*, proved far more engaging. Continually shifting circles of pure colour are projected on to an otherwise dark wall. They are infinitely beguiling, and yet we hear the sound of persistent rhythmic chanting from 'voices of the dead' recorded by the

Latvian scientist Konstantin Raudive. They are as spectral as the after-images left behind by the colours, and Hiller adds to the ghostly mood with her improvised vocal contributions. At once seductive and unsettling, the entire work only lasts twelve minutes. But it is far more hypnotic than Minerva Cuevas's *Drunker*, a seventy-minute video which records, with self-indulgent slowness, the artist's predictable road to inebriation as she boozes from a bottle of tequila.

It is a relief to turn to Lygia Clark's mercifully short *Cannibalistic Slobber*, a 1973 video documenting the macabre performance she developed with her students in Paris. We see them kneeling around a figure stretched out on the floor. They pull thread from their mouths, as if disgorging an unidentifiable substance, and then start wrapping the inert body with saliva-smothered strands. Having started out bearing an odd resemblance to the dead Che Guevara, the figure becomes hidden in a mass of fibres. The whole ritual looks as eerie as an embalming, but the students finally begin pulling at the skeins as though determined to free the body from this ominous web. Brief it may be, but *Cannibalistic Slobber* nagged at my mind after the most long-winded exhibits had begun to fade from memory.

ANISH KAPOOR'S BLOOD

31 May 2000

Unlike so many artists with international reputations, Anish Kapoor refuses to settle for a predictable identity. *Blood*, his new Lisson Gallery show, lives up to its dramatic title. It is flowing with new ideas, springing out of earlier work but pushing into fresh territory. An artist on the move, he is prepared to take risks and ambush us with plenty of sculptural surprises. Kapoor is supremely paradoxical. He has always used three-dimensional work as a means of stressing immateriality. Nowhere more beguilingly than in the first room, where a transparent cube of acrylic rises from a black stand. A white amoebic form is suspended inside, surrounded by tiny bubbles. Viewed from one angle, it looks placid enough. Move towards the nearby window, though, and the form enlarges. It resembles a multi-cratered planet floating in a cosmic void. Kapoor throws us even more off-balance when we gaze at it from above. Here, the form seems to be in a lighter room that does not extend very

far down the cube. But the more you circumambulate this infinitely mystifying sculpture, the more it shifts and confounds expectations. The fact that the rest of the room can be seen through its surface adds to the wonder, while in no sense distracting attention from the thing itself.

So far, the mood of the show has been teasing yet serene. A resin slab on the floor appears more disturbing, however. Inside, half-hidden by deep blue darkness, a bulbous form can be dimly made out. It is reminiscent of a capsule, able to keep a body frozen during a long-haul journey through space. Kapoor generates a sense of pent-up tension, as if the unknown life preserved here might eventually burst out of its confines.

In the Lisson's main space, the feeling of suspense sharpens. At first, the fruit-like form resting on a large wooden base in the corner looks motionless. Then, by degrees, we realise that its white latex surface swells gently before shrinking back to its original size. Attached by an umbilical cord to an invisible and silent electric motor inside the base, it continues breathing in and out. But this enigmatic organism does not yield up its secrets any more than *Turned into the Interior*, a flamboyant fibre-

37. Anish Kapoor, *Turned into the Interior*, 2000

glass and resin sculpture curving in a mighty sweep across a dark table. Suffused with deep purple paint, the gleaming form is alive with energy. And its potency erupts at the centre, where a frankly erect protuberance juts out. The entire work shows Kapoor at his most erotic. For all his fascination with absence and the void, he remains vigorously involved with corporeal sensuality as well. That is why, even at its most spiritual, his work never becomes anaemic.

Kapoor's innate sense of drama also ensures that he arrests our gaze. At the most distant part of the main space, an empty white room is disrupted only by a tall black oblong set in the centre of the far wall. It turns out to be open, and deep inside a lighter form contains the viewer's reflection, upside-down and elongated. It is a tantalizing spectacle, prompting us to peer in. But the darkness quickly envelops our senses. Reaching out as far as an arm will stretch, we realise that our fingers can make no contact with the reflection shimmering at the back. It remains unattainable, taunting us by offering the illusion of an aperture impossible to touch.

This cave-like work is nevertheless far less threatening than a grand, free-standing steel and acrylic piece called *Blood Cinema*. Circular in form, it confronts us once again with our own reflection. From a distance, we see ourselves full-length and veiled by a crimson mist. Walk towards the sculpture, and a pool of darkness opens up at our feet. Like liquid filling the circle, it spreads upwards to the point where, as we stand close-up, our bodies seem submerged in it. Only my head was left above the surface, marooned in a thin haze of redness.

Beneficent rather than aggressive, Kapoor stops short of obliterating the viewer. Upstairs, *Blood Mirror* hangs on the wall like a colossal dish. Approach its concave, lacquered surface, and your inverted reflection quickly starts to evaporate. It disappears in a sequence of abstract, circular bands of colour. You feel momentarily annihilated, but move even closer to the dish and your reflection re-emerges. This time it is the right way up, and its immense size hangs over you like a domineering apparition.

The most captivating of all the exhibits occupies the middle of the upstairs gallery. From afar, its circular steel sides appear to contain a solid red substance sloping down towards a sunken centre. Even when seen near-to, the illusion remains very convincing. The red skin is highly reflective, and a narrow slice of the sky visible beyond the gallery window scythes across the surface. So the surprise is enormous when you touch the supposed skin and feel your finger penetrate water. The entire content of the sculpture is liquid, spun round so fast by a motor beneath that it appears absolutely solid. Gazing down from the opposite

side, I saw concentric circles appear and then, just as quickly, vanish again. I also noticed a cluster of minuscule bubbles revolving at the heart of the whirlpool.

On the whole, though, the transformation of the water is impeccably executed. And Kapoor's readiness to deploy this new medium on a truly monumental scale is now revealed outside the Millennium Dome. Here, in a titanic sculpture called *Parabolic Waters* commissioned for a Thames-side location, coloured liquid revolves at a spectacular rate. Leaning over the side, we feel sucked into the immense vortex and enthralled by Kapoor's ability to conjure sculptural magic from the simplest components imaginable.

TONY BEVAN
23 August 2000

Caught at the moment of maximum anguish, the man's face seems to be disintegrating. Perhaps he has been pulverised by a blow from an unseen assailant. Or maybe he is undergoing a spiritual convulsion, induced by a spasm of despair within his own turbulent mind. Either way, the victim is devastated by the catastrophe's impact. His features collapse, battered and fragmented by the shuddering force of the onslaught. Positioned on the far wall of Tony Bevan's show at Michael Hue-Williams Fine Art, this powerful image is the work of an artist who now commands formidable authority. Approaching fifty, Bevan is painting better than ever. And he handles his immense canvas with absolute assurance. Minute splinters of black charcoal are spattered across the head, projecting outwards like weapons capable of snagging the flesh of anyone rash enough to touch the painting. They accentuate the sense of pain, as well as revealing how Bevan, a highly linear artist, starts work on his wet canvas with charcoal marks that he can easily wash away.

They give the picture a spiky energy, but the eloquence of the work depends finally on brushstrokes loaded with water-based acrylic. Bevan likes to make his own paint, giving it a weight that invests the image with a dense, looming conviction. He never becomes ponderous, though. Pictorial economy is a priority at all times, and this emphasis on concise expression helps to offset the bleakness of a work as troubling as Bevan's colossal *Head*. Although the nose is wrenched to one side, and the

38. Tony Bevan, *Head PC008*, 2000

remaining eye almost closed, the man's face is still animated by a stubborn dynamism. The lines of near-phosphorescent red may lance through his skin like bayonets, but he is not wholly defeated. An underlying resilience can be detected in his pummelled features, signifying the defiance of someone unwilling to surrender.

No other living painter explores human isolation and pain with the bleak power at Bevan's command. He returns, time and again, to an obsession with the agonised individual marooned in emptiness. The consistency of this central, unavoidable theme is pursued as relentlessly as in the work of Bacon or Beckett. But even at the point of total breakdown, Bevan's figures hold firm. The contours defining one side of the man's head and protruding ear are still intact, refusing to yield their tensile strength as the onslaught reaches its bruising climax.

Another *Head* nearby, smaller this time and confined entirely to the greater starkness of black and white, replaces convulsion with stillness. But it is no less disquieting. For this image has stiffened into angularity, looking upwards like a face hardened into a rock. Hints of a vigilant eye or a bony hand can be detected inside this faceted structure, and the head

appears to be stiffened by the beams running across its surface. Their blackness looks charred, as though some conflagration had assailed them. No trace of fire is visible now, however. Instead, the face is surrounded by a darkness so extensive that it fills much of the canvas with its smothering presence. The head is utterly alone, and nocturnal gloom seems to press in from every side. Like a corpse immured inside a coffin, the face appears trapped for ever. And yet it persists in straining upwards, refusing to relinquish all hope of withstanding this oppressive locale.

The head's pose may well be based on Bevan himself. He often uses photographs of his own body as a starting-point, and many of them are reproduced in the substantial accompanying publication. But it would be wrong to assume that the resultant paintings are intended as self-portraits. No striving for a recognizable likeness is visible, and another head on display here rises from the base of the canvas like a disused building whose armature has been exposed. The neck, in particular, is criss-crossed with bars reminiscent of rafters. Looking into this strange apparition is like staring up at the roof of a ruin, open to the sky. In this respect *Head* is intensely frail, and yet it retains a strong overall sense of palpable form. Endurance seems the keynote, however stranded and beleaguered this individual may be as it lingers in the void, like an abandoned planet moving through an otherwise deserted cosmos.

The largest painting, by contrast, has its origins in a boyhood memory. When I was working on an essay for the show's publication, Bevan told me that *Blue Interior* reminded him of 'a Dutch barn I sat in as a child, with slats you could see through'. Although he grew up in Bradford, his father worked for a time as a milkman and took the young Bevan on visits to farms outside the city. Hence, perhaps, the feeling of overwhelming immensity in *Blue Interior*. A boy could easily feel awed as he gazed up at the beams lodged in the roof of this gaunt, uninhabited building. It has a cathedral-like grandeur, and the perspectival recession created by walls, floor and rafters adds up to a feeling of magisterial, controlling force. At the same time, though, *Blue Interior* is far from reassuring. No protection is offered by a structure stripped of everything save the naked struts that keep it upright. They could easily collapse at any instant, and nothing prevents the wind from rushing through them. The predominant colour adds to the feeling of incipient cold, and the gap at the far end looks ominous. This is a stricken building, for all its vastness. Bevan leaves smudges and smears of charcoal at the sides, undermining its solidity and accentuating the air of uncertainty. As for the floorboards, they appear to be oozing dribbles of diluted charcoal like timbers irrevocably affected by damp.

Blue Interior, then, has in no way been softened by Bevan's recollection

of his youthful travels through the Yorkshire countryside. It is a tough work, even if the luminosity of the colour gives this ruin an unexpected, invigorating potency. Nor should it be confined in meaning to a rural location. Without Bevan's memories to guide us, the 'Dutch barn' could easily be seen as a shed left to rot in a blighted urban setting. The artist himself works in south-east London, and travels each day past dilapidated streets where abandoned façades stimulate his imagination. Looking in through the broken windows of one derelict frontage, he found exposed beams unable to provide shelter any longer. In another locale, a gap caused by demolition is riddled with props, assembled in a rudimentary way to support the buildings still standing on either side.

These dark bars have a crude, clustered strength that Bevan finds impossible to ignore. His exhibition contains several *Building Props* paintings, one executed in a smouldering red that makes the forms appear to glow. All documentary links with their starting-point in a London street have been removed. The neighbouring buildings are no longer there, and the props presented in just as much isolation as the heads dominating so many of Bevan's other exhibits. Shorn of function, the red bars stand out starkly on a bare canvas punctuated with charcoal fragments. They seem to hover in the air, whereas the props stamp their taut, fierce authority in a series of horizontal and diagonal lines. Their colour suggests that a fire recently attempted to consume them, but they remain intact. Far stronger than embers, they still look capable of shoring up the invisible walls on either side.

The other *Building Props* picture, painted entirely in black on a pale canvas, is frankly funereal. Silhouetted against the whiteness, the network of bars is no longer kindled by the sensuous warmth of the red version. The fire has long since cooled, leaving behind a skeletal image where everything seems redolent of death. The lowest section of the painting is completely black, and it looks implacable enough to smother the rest of the picture-surface before long. The props pitched so arrestingly against the pallid sky will be snuffed out, one by one, unless they fall prey to decay before then and crumble away.

For the moment, though, they retain their hold. While tiny charcoal particles float among them like summer flies, they withstand the strain and prevent everything else from tumbling. Bevan makes us acutely aware of their vulnerability, just as he exposes the damage already inflicted on his defenceless heads and interiors. But against the odds they remain steadfast, as if stiffened by a stoical determination to survive.

RODNEY GRAHAM: CITY SELF/COUNTRY SELF
3 January 2001

Down the narrow, high-walled, empty street comes the urban dandy, accompanied by the amplified noise of his boots and cane striking the cobbles. The sound is irritable and pugnacious, warning us at once that the impeccably dressed man may be far from harmless. He doffs his tall black hat politely enough at a passing woman. But the dandy's blanched face remains unsmiling, and the rest of Rodney Graham's new film shows just how quickly this elegant *flâneur* can turn to violence.

Projected on a loop as the centrepiece of his exhibition at the Lisson Gallery, *City Self/Country Self* is a showcase for Graham the actor. He plays the dandy as well as the country bumpkin who unwittingly becomes a victim. Since Graham grew up in the Canadian countryside before moving to the city, he identifies with both characters. And he performs the two roles with equal amounts of aplomb, as if they were both integral parts of his own complex, divided personality. The contrast between them is clear immediately the rustic bumpkin appears. He anxiously adjusts his tall black hat in the reflection of a dusty window. Clearly new to the town, he looks up at a civic clock whose loudly ticking hands tell him that noon is only five minutes away. At the same time, the dandy places his elongated, striped trouser-leg on a shoe-shiner's box. A close-up reveals his cruelly shaped, square-toed boot. The shiner rubs it with energy and skill, but the dandy continues to tap his cane with a red-gloved finger. No amount of gleaming shoe-leather can assuage his haughty, glacial impatience.

The bumpkin looks still more vulnerable when the camera returns to him. Wearing a baggy smock, he appears ill-at-ease with the unaccustomed middle-class hat balanced on his head. Beguiling shots of a medieval spire and grand town houses accentuate his sense of awe as he gapes at the architecture around him. The film was made in the historic French town of Senlis, and nothing disturbs the venerable air of a place where, as the bumpkin discovers, an ancient statue can be glimpsed in a wall-niche as you pass. His discomfiture increases when he realises that the carving is decapitated, and that the figure cradles the missing head in his stone arms. But so far, nothing disturbs the placidity of a town where the nearby main street is traffic-free, save for a distant two-horse carriage driven by coachmen wearing sharp green livery.

As the dandy pays the shoe-shiner and decides to walk smartly behind the bumpkin, the once-discreet sound of the horses' hooves becomes a

39. Rodney Graham, *City Self/Country Self*, 2000

deafening clatter. It alerts us to impending danger, and the idea of pursuit quickens when the film intercuts between close-ups of the approaching steeds and the feet of both bumpkin and dandy striding along the pavement. The pace grows frenetic as the carriage passes them with an even greater burst of noise, and the bumpkin starts to cross the street in its wake. The dandy follows and then, in the middle of the road, he suddenly gives his bucolic target a vicious kick in the pants. Seemingly without a motive, let alone a justification, the attack comes as a shock in such decorous surroundings. No warning was given, and no verbal contact of any kind had passed between them in a film where the soundtrack is devoid of human dialogue. It looks like a random assault, but the film makes sure that the dandy's aggression is unmistakable. After the first kick, the town clock strikes twelve with a vehemence that reinforces the jarring impact of the boot. But as the liveried coachmen's heads swing round with bemusement, all normal sounds give way to a dull, repetitive hitting.

Time is arrested as the horses' legs go into slow motion and the dandy kicks his victim again and again. The bumpkin, now seen from the front, flings up his arms in astonishment and pain. He appears powerless to pre-

vent his assailant's square toe from ramming into the seat of his trousers, right at the centre of a strange whirlpool-like pattern embroidering his pants. The bumpkin's hat, whose social pretensions may have done much to excite the dandy's derision, curves backwards through space. Slowed down so much that it looks strangely graceful, the hat appears to be airborne for a long, long time. An incident which probably terminated in a matter of seconds takes on, here, a far more extended and agonizing significance.

We seem to witness an orgy of public humiliation before the hat finally hits the ground and the town clock ticks on to a minute past noon. The dandy, his moment of brutality accomplished with deft precision, saunters off down the street as though nothing had occurred. And the bumpkin picks up his hat, brushes it clean, replaces it on his head and walks away looking shaken and blinking. The gratuitous attack seems to be over, but Graham makes the loop run on so seamlessly that we cannot tell exactly when the film ends.

Without a pause, the story begins once more, drawing us back into its harsh world until we feel enmeshed in a limitlessly repeated cycle of bourgeois cruelty. The bumpkin is condemned to punishment without respite, for no other 'crime' than presuming to hanker after middle-class values. He finds himself reduced to 'peasant' ranks by the ignominy of the kick, and nobody bothers to sympathise with him afterwards. Far from stopping their carriage and coming to his assistance, the aloof coachmen drive on unconcerned: their employer would, after all, side with the dandy rather than the hapless rustic. No friendly faces appear at neighbouring windows or doors, and the bumpkin himself seems to accept the ambush without running after the dandy to demand an apology or hit him back. The meekness with which he picks up his hat is the saddest aspect of the narrative. It suggests an innate deference, and even a belief that the dandy has a right to indulge in an act of callous pettiness.

Graham himself is aware of the story's wider political implications. He discovered it a few years ago in a small Epinal pamphlet in Paris, crudely illustrated with lithographs whose style, along with the prose, was clearly aimed at children. But the mocking of the bumpkin, paying his first visit to the French metropolis and finding himself abused by city-dwellers at every turn, reflected a distinctly adult readiness to ridicule any dreams of betterment by the peasantry. Since the pamphlet was probably written in the late 1860s, memories of the French Revolution and the 1848 uprising would still have been raw. And Courbet, a legendary radical artist of the period, identified himself with the working class by wearing a smock akin to the bumpkin's garment.

Graham subsequently lost the pamphlet, but his memory of the illustration where the kicking episode occurs prompted him to make the film. Despite its brevity, *City Self/Country Self* is an elaborate affair. Shot with exemplary care, and a fastidious attention to period detail, it is accompanied at the Lisson Gallery by a bizarre room filled with the props and costumes used during the shoot. Two mannequins, mounted on a wooden plinth, are posed in opposite directions and wear, respectively, the tight-fitting dandy's outfit and the rustic's loose smock. Their white, headless necks have a macabre air, smacking of the guillotine. And the whorls on the seat of the bumpkin's trousers, waiting to be kicked, look still more surprising than they do in the film itself. Nearby, two green liveried jackets studded with gold buttons hang next to each other like corpses on a rail projecting from the wall. And Graham confirms this eeriness in a nearby showcase, where he displays his white plaster life-mask next to a coloured rubber mask, used by his double when the kicking sequence was filmed.

The whole installation reeks of mortality, and its obsessive emphasis on pairings echoes the theme of duality explored by Graham's enactment of both roles. Although his conspicuously intellectual art is the work of an unpredictable sophisticate, who relishes an ability to move with ease between film, photography, text, sculpture and music, he makes the bumpkin far more appealing in his film than the arrogant dandy. For all its reliance on a 'found' nineteenth-century source, *City Self/Country Self* seems to me a paradoxically personal achievement. Far more melancholy than his earlier *Vexation Island*, a seductive and absurdist tribute to Robinson Crusoe marked by another dramatised moment of injury, it surely reflects some fundamental conflict in Graham's own mind. Perhaps the country-bred part of his character is more alive than we might imagine, and finds itself at war with the educated, world-weary urbanite. For the dandy is viewed with open disgust in this polished yet alarming film, where the wonder and stoicism of the peaceful bumpkin is pitched against the disdainful coldness of a snob who resorts to sadism without any provocation at all.

PROTEST & SURVIVE

11 October 2000

Lodged like an icy splinter at the heart of the Whitechapel Art Gallery, Richard Hamilton's *Treatment Room* could hardly be more bleak. Entering this forlorn, clinical chamber, we find ourselves confronted by a hard bed. The thin blanket laid on the surface seems to be waiting for a patient to lie underneath it. And the bed is positioned directly below a gleaming machine, suspended like a scanner or an observation camera. Over in the corner, the chilling atmosphere is compounded by a stark, stainless-steel sink armed with sharply pointed tap-handles. Nearby stands a bottle of Hibiscrub, used by surgeons to disinfect their hands before an operation begins. But the greatest source of disquiet is provided by the image on the machine above the bed. Pointing down towards a seedy pillow, it silently relays a continuous tape of Mrs Thatcher in her blow-wave prime, delivering a party political broadcast. The flower-adorned warmth of her book-lined study serves only to underline the aridity of the interior where we stand, marooned and disconsolate.

Hamilton first exhibited *Treatment Room* in 1984, driven no doubt by an overwhelming surge of Orwellian pessimism. His initial target must have been the state of the health service, but he wanted this disconcerting interior to act as a gruesome reminder of 'a dentist's waiting room, a prison cell, a Labour Exchange or anywhere in an NHS hospital'. Impelled by anger, and the hope that indignation could lead to change, it is an ideal choice for a show called *Protest & Survive*. For this was the rallying-cry adopted by CND, whose members really did believe that failure to rid ourselves of the nuclear bomb would result in global annihilation.

Matthew Higgs and Paul Noble, jointly responsible for selecting the forty artists on display here, had no desire to make it an occasion for CND nostalgia. But they did aim at foregrounding the political drive behind the survey, and Higgs's own attachment to anarchism is reflected in one of the most dramatic exhibits. Thomas Hirschhorn has been allowed to smash a hole in the Whitechapel's café wall. It enabled him to build a bridge across the dark alley separating the gallery from the Freedom Bookshop next door. With some misgivings, I walked across this narrow, alarmingly sloped structure. Covered from floor to ceiling in slippery brown tape, it is clearly not intended for the nervous or infirm. But the bridge does lead straight into the bookshop, where the first cover to attract my curiosity was a pamphlet called *Anarchism and the Arts*.

Retracing my unsteady way back to the show, I began to have reservations

about its title. On the whole, the works that approximate most closely to the militant spirit of 'Protest & Survive' are least effective in the gallery context. Black-and-white photographs of street events in the 1960s can be found on the walls, documenting actions like Oyvind Fahlstrom's Mao-Hope March, or the Total's Underground group infiltrating an anti-atomic march with plaster-sealed lips. The images seem very remote now, and whatever sting the events may have possessed forty years ago cannot be recreated here. True, Mike Hollist's 1976 photograph of stripper Cher Wood, baring her breasts in front of Eton schoolboys to protest at the college's ban on female pupils, has more impact. The boys' lustful delight is vividly conveyed, and so is the stripper's poised panache. But the photograph is still a poor substitute for the action itself, and the same problem afflicts Valie Export's video of her 1968 *Tap and Touch Cinema*. Standing in the street with a box strapped to her chest, she invites male passers-by to plunge their hands inside the enigmatic contraption. Her coolness is admirable, and the men's laughable mixture of eagerness and embarrassment can still be felt. But time and the inadequacy of documentation has transformed the whole work into a gentle curiosity, far removed from the raw, impassioned indignation behind the urge to 'Protest & Survive'.

So the best way to experience this show is to put the title aside. Then we can appreciate the range of work that Higgs and Noble have embraced in their search for 'works that deal variously with gender, race, class, identity, sexuality, politics, economics, war, idealism, passion, resistance, boredom, frustration and pleasure'. The shameless Tom of Finland is here, with three of his surprisingly small, densely worked pencil drawings of idealised male figures. When he drew these brazenly erotic fantasies in the mid-1960s, homosexuality was still a serious crime in his native country. So there is something brave and funny about Tom's pioneering images, most notably when two muscular loggers break off from their manly tasks and seduce each other at the river's edge. Compared with his orgiastic imagination, Gilbert & George's homoeroticism looks restrained. Their *Cocky Patriot* is an East End youth, standing gravely at the centre of a monumental, twenty-one-panel photographic work flanked by two union jacks sewn on the buttocks of a pair of jeans. The display of patriotism has a disturbing fervency. But the flags threaten to close on the slender figure in the middle, snuffing him out. Although supposedly the standard-bearer of narrow nationalism, he may end up as its victim.

The best works on show here have a similar ambiguity, far removed from crude agit-prop. Allen Ruppersberg's *Letter to a Friend*, made in 1997 from around 1,200 linoleum tiles covering an expanse of floor upstairs, looks at first like an early Bridget Riley monochrome. Then the

40. Wolfgang Tillmans, *Whitechapel Installation*, 2000, and Alan Ruppersberg, *Letter to a Friend*, 1997–2000

black-and-white dazzle of its overall pattern resolves itself into a series of melancholy memorials, naming some of the finest artists, actors, writers and architects who died in the year it was made. Ranging from William Burroughs and Willem de Kooning to Roy Lichtenstein and Allen Ginsberg, it makes for elegiac reading. But Ruppersberg, who casts the whole work in the form of a letter to a friend, ends by declaring: 'What now? I think I will start a new drawing.' So the terminal sadness is countered, finally, by an affirmation.

Jo Spence and Terry Dennett also offer hope. Nothing could be more gruelling than Spence's documentation of her fight against cancer. Diagnosed in 1982, she managed to fight on for another decade and used photography as an important source of therapy in her struggle. Spence spares us nothing, as images and texts reveal how she refused mastectomy in favour of a simple lumpectomy. Opting for intensive Naturopathic treatment and Chinese herbs, she became a heroic embodiment of the will to endure. But her photographs contain no hint of self-glorification: they are matter-of-fact, and helped to demystify the terror that used to bedevil our understanding of cancer. Womanly courage and honesty are likewise celebrated in Grayson Perry's *The Mother of All Battles*. Saddam Hussein's infamous war-cry is subverted here, by a headless mannequin

wearing a full-length folk-style dress. Perry uses computer-controlled embroidery techniques to festoon the cotton fabric with heinous scenes of torture, the underbelly of tyrannical regimes like Saddam's. Helpless figures are pierced, muzzled, butchered and crucified as we walk round the garment, and the decapitated mannequin only adds to the sense of universal suffering.

Millennial events as grandiose as Expo 2000 were supposed to alleviate all our forebodings about the future. But Jeremy Deller's *Has the World Changed, or Have I Changed?* shows just how desperate such ventures can be. Deller went to Expo 2000 with Bonzo the Clown, and the colour snaps he brought back tell a dismal story. Bonzo wanders round a gruelling sequence of zones, escalators and half-empty 'attractions'. They all look wretched, and Bonzo sums up the mood of disenchantment by sitting on a bench next to a grinning, life-sized model of Ronald McDonald. While Ronald blithely waves, Bonzo stares at him with an expression of utter disgust.

The most impressive contribution, though, escapes definition altogether. Wolfgang Tillmans, shortlisted for this year's Turner Prize, spatters an enormous wall upstairs with an unclassifiable array of his photographs and cuttings he has trawled from magazines and newspapers. Some of his images are also reproduced in his guest-edited edition of the *Big Issue*, on sale elsewhere in the gallery. They show how his camera constantly catches life on the wing. He goes to extremes, photographing London from the air and then travelling underground on the rush-hour tube to shoot passengers with an unsettling directness. An anonymous strap-hanger's armpit is revealed in close-up on the Bakerloo Line. So is a shaven-headed man on the Victoria Line who leans wearily against his upturned sleeve. A young woman on the Piccadilly Line eyes Tillmans's lens warily, as she clings to a yellow pillar below the bare forearm of a male passenger. But the photographs do not invade people's privacy: they reflect instead the jarring state of false, unwanted intimacy which commuters endure on so many tight-packed journeys.

Tillmans also includes some camera portraits of individuals campaigning for justice, like Sukhdev Reel whose son Ricky is believed to have been killed by racists three years ago. But this freewheeling, unpredictable artist is just as likely to photograph the oddly molten lines marking a red route on a London street, or an elaborate sandcastle whose turrets and moat are being eroded by an incoming tide on Studland Beach, Dorset. Without straining for symbolic effect, such an image manages to convey a great deal about the human urge to play and build, even in the face of inevitable obliteration.

TONY CRAGG AT LIVERPOOL

23 March 2000

No homecoming could be more spectacular. Liverpool-born Tony Cragg returns to his native city in a show that ambushes the viewer with sculptural surprises all the way through. The top floor of Tate Liverpool is transformed by the fecundity of a fifty-year-old at the exuberant peak of his powers. Wherever you look, Cragg seems to reinvent himself. Scorning smug predictability, he flouts our expectations with a display of sustained, nimble and supremely inventive work guaranteed to rouse even the most torpid onlooker.

The astonishment begins at once. Visitors walking into the first gallery are confronted by a bulging, twisting sculpture in white carbon fibre. Flecked with brown and green, it writhes and swells like some monstrously distorted creature unable to disentangle itself. Memories are stirred of the classical *Laocoön* carving, where the deadly, intricate coils of constrictor snakes trap the limbs of three struggling figures. But Cragg has no intention of indulging in Greco-Roman pastiche. He concentrates solely on the ballooning forms of a being that evades classification altogether. However many times we walk round it, stretching and stooping to discover precisely where all the interlinked elements begin or end, our efforts are frustrated. The organism retains its mystery, for Cragg is an artist who thrives on ambiguity.

He also has an inexhaustible appetite for different materials. Even in the opening room, where most of the exhibits were produced in a prodigious burst of activity over the past couple of months, he moves freely from fibreglass to carbon and kevla, as well as making a resin colossus studded all over with thousands of black plastic dice. They jut out from every curve and dip of this restless sculpture, tempting us to touch them. All Cragg's work is eminently tactile. It demands to be stroked, prodded and grasped, even though the Tate Liverpool staff will not allow you to do so. It continually changes identity as well. From one end, *Connoisseur* gapes with a circular opening. But as we move round it, the cavity disappears and the form begins to ripen in a sequence of sensual undulations. Finally, at the other end, it curves out into an elongated beak. Cragg's playful sense of humour is asserted here, making us realise that he could never be accused of solemnity. The pleasure he takes in constant metamorphosis is evident everywhere, and sometimes his titles seem bent on puncturing pretension. *Big Head* is the name of an exceptionally satisfying presence. Working on such a monumental scale, a lot

of sculptors might easily lapse into ponderousness. But there is nothing oppressive about this deft, mint-green work, enlivened by thin, multi-coloured lines slicing through its bulk in horizontal directions. The opposite of slothful, it seems quickened by the restlessness that runs like a shiver through so many of Cragg's finest pieces.

Walking further into the show, we quickly become aware of his ability to master extremes. *Tripod* is tightly reined-in, dark and compact like a muscular rock formation. In the next room, though, a couple of intoxicating pieces called *Wirblesaule* spiral high in the air. Cragg thinks of them as 'articulated columns', but any building dependent on them for support would be in danger of collapse. They tilt in alarming diagonal directions, like piles of stacked crockery about to fall. As agile as a juggler, Cragg wins our admiration by somehow preventing them from smashing on the ground. They seem buoyed up by a formidable inner energy, like the whirling centre of a typhoon. In this respect, they could hardly be more removed from *Silent Conversation*, two pale figures in ceramic and plaster standing nearby. They appear to be based on oriental art. One, unaccountably turned to the wall, holds a laughing child and a scroll. He seems lost in a meditative trance, while the other is placed at the window so that he gazes out over the grey, wind-rippled expanse of the Mersey far below.

For the most part, however, we have no way of telling whether Cragg's sculpture derives from animal, vegetable or mineral forms. They often resemble a poetic amalgam, embracing possibilities drawn from both natural and artificial sources. He sees no division between those two worlds, just as he sets no limit on the vocabulary of materials that a sculptor can now employ. Based in Wuppertal, he works in an old textile factory filled with ready-made objects as well as organic forms found in the countryside. Cragg started his career in the late 1970s as a resourceful scavenger, cycling round London reclaiming discarded plastic junk from building sites, waste-tips and the edges of polluted rivers. The detritus he discovered there would have been ignored by most artists. But Cragg's open, questioning intelligence detected the potential inherent in this unlikely source. Without disguising its origins, he turned it into work of admirable suppleness and sharp, expressive eloquence.

Since then, he has gone on to explore a whole raft of other possibilities. Bronze is used in all the work occupying a room called 'Envelopes', but Cragg uses this arch-traditional material in an exceptionally fresh, heretical way. *Ferryman*, the largest of the pieces displayed here, looks at first like a sea-creature washed up by the Mersey tides and left to wave its flippers helplessly. But this beached form turns out to be far from

solid. The deceptively bloated bronze is nothing more than a metal skin, enclosing a void within. Its surface is punctured with holes, ensuring that nobody fails to realise just how empty *Ferryman* really is.

Cragg has long been fascinated by the interplay between outside and inside. His preoccupation with flasks and other vessels enables him to

41. Tony Cragg, *Eroded Landscape*, 1998

keep this central tension at the forefront of his concerns. At the age of seventeen, he started on a two-year period of work as a lab technician in the National Rubber-Producers Research Association. The experience left him with an abiding interest in containers of many kinds, and they appear at their most overt here in a room devoted to glass. Cragg's love of building up layers of forms is evident in *Clear Glass Stack*, where a profusion of bottles, vases and flasks are assembled on thick glass sheets. They ascend into a tall structure reminiscent of a shimmering modern building. But no outer walls protect the vessels, and the grandeur of the sculpture as a whole is countered by the fragility of the objects packed so tightly inside.

A more robust feeling is conveyed by *Cistern*, where a variety of containers in coloured glass are slung on three steel spirals. Most of them are bottles, and their often bulbous forms project outwards as if tempting us to pull them off their perches. Cragg marshals them all with an eye for deft variations in hue, ranging from a luminous white to a mysterious, submarine green. At a distance, they resemble strange underwater encrustations, and suggest that Cragg's enquiring mind finds stimulus in the very origins of natural growth. He certainly calls some of his bronze sculpture *Early Forms*, and they are among his most primordial offerings. Starting with the familiar shapes of vessels, he allows their apertures to be pulled sideways and downwards, like drastically distended lips. The original container almost becomes lost as Cragg lets the form develop. It grows convulsive, like a land-mass afflicted by seismic spasms and eruptions. The bronze begins to flow as if in a molten mass, and then, quite suddenly, arrests itself like a startled, open-mouthed bird. Onrush is pitched against stasis, and the conflict between them generates some of Cragg's most intense, dramatic images.

Even so, nothing can quite prepare us for the impact of *Column* in the final room. This tall, whirling sandstone apparition surges upwards like a rocket soaring out of control. But it also looks surprisingly graceful, and the entire sculpture seems animated by the exhilaration of a dancer caught in mid-spin. Whether human or architectural, animal or meteorological, this delirious yet lucid carving shows Cragg at his most irresistible. Other pieces in the same room prove that he can handle travertine marble and Belgian limestone with equal assurance. But *Column* surpasses them all, offering sublime proof that the boy from Liverpool has matured into one of the most outstanding sculptors Britain has ever produced.

CARL ANDRE

12 July 2000

In Britain, at least, Carl Andre will forever be associated with the infamy of 'the bricks'. When the tabloids belatedly discovered that the Tate Gallery had purchased 120 stacked firebricks in the name of art, their reaction was demented. All the pent-up hatred of modernism erupted, and Andre's understated sculpture became reviled as the epitome of charlatanism. Now, on display at Tate Modern, the same brick piece seems incapable of arousing such a bilious reaction. Minimalism has long since ceased to provoke rage, and we are struck instead by the modest, almost self-effacing character of Andre's work. The opposite of provocative, it deserves to be seen on its own terms rather than as the target of Fleet Street's hysterical agenda back in 1976. That is why the Whitechapel Art Gallery's survey of his work is so welcome. We need to make amends for execrating him with such glee, and rid ourselves of this puerile obsession with the bricks. They are, mercifully, absent from a magisterial show guaranteed to silence anyone who encounters its calm, unforced finality.

The first sculpture confronting us inside the entrance is the grandest work on view. Stretching down the main nave of the building, it places eighty-four oblong units of Western red cedar in a dignified ensemble.

42. Carl Andre, *Armadillo*, 1998 (foreground) and *Karlsplatz*, 1992

Either laid flat on the floor or placed upright, their emphatic reliance on horizontal and vertical thrusts gives the whole work a monumental sobriety. It looks pared to the essence, despite the immensity of its parts. Andre calls the sculpture *Karlsplatz*, referring to the address of the Kaiser Wilhelm Museum in Krefeld where it was first shown in 1992. But these mighty timbers, many riven by deep cracks, evoke a locale far removed from an urban centre. I thought of railway sleepers, running along some epic expanse of otherwise wild countryside. The upright forms also reminded me, in their primordial simplicity, of ancient standing stones. And the purged gravitas of the work has an elegiac air, redolent of war cemeteries at their most ordered and awesome.

Although Andre regards his work as abstract, these associations are far from arbitrary. For he was born in Quincy, a small Massachusetts town near Boston where the granite quarry and tombstones impressed themselves permanently on his imagination. Their forceful presence ensured that he proved highly susceptible to the impact of Stonehenge during a teenage visit to England in 1954. It was a formative moment, laying the seeds for his future commitment to sculpture. But an equally fruitful experience came several years later, when he worked on the Pennsylvania Railroad as a freight brakeman. Direct contact with heavy masses of rusty steel widened his feeling for materials in their raw state, and the horizontal vastness of Andre's surroundings made him realise that sculpture need not always aspire to verticality.

By this time, he had already made the early pieces documented in black-and-white photographs taken by his friend, the film-maker Hollis Frampton. Ranged along a side wall at the Whitechapel, they disclose an early desire to rid his work of formal complexity and arrive at distillation. As a visual record of Andre's development between 1958 and 1963, the photographs are invaluable. Many of the works have since been lost or destroyed, but Frampton's camera managed to define their instinctive feeling for monumentality at its most unforced. A few surviving pieces are on display here, and they turn out to be astonishingly modest in size. But their implications are monolithic, and Frampton later recalled that 'what struck me then, as it does now, was CA's utter concern for the root, the fundamental nature of art'.

Minimalism, in which Andre played a defining role, has often been regarded as a quintessentially American movement. He would, however, be the first to admit the size of his debt to Brancusi. The twin loyalties espoused by the Rumanian sculptor, to 'carving direct' and 'truth to materials', were also centrally important in the growth of modern carved sculpture in Britain, from Epstein to Moore. So Andre looks at home

here, even if he discovered his own identity by giving up the whole notion of carving into materials. Instead, he explored the possibilities of using wood, metal or brick units to make cuts in space. He also banished all unnecessary elaboration from his work. This ruthlessness can be seen as early as 1959, when he made a *Convex Ash Pyramid* from eighteen tiers of four interlocking wood units. Remade recently in African walnut, to replace the lost original, its authority is impressive. But it looks over-complex when compared with another sculpture from the same year: the Tate's *Last Ladder*, casually propped against the opposite wall. Although Andre chiselled into this vertical timber, the purged simplicity of the outcome is more prophetic of the work to come. *Last Ladder's* notable refusal to indulge in rhetoric, and its willingness to appear as down-to-earth as an everyday utensil, would become the hallmark of Andre's mature art.

Upstairs at the Whitechapel, wood gives way to other materials as the full extent of his achievement becomes clear. In a highly charged room, three contrasting pieces are placed along the centre of the floor. They reveal that nobody is better than Andre at allowing the intrinsic character of matter to speak for itself. In *Tin Ribbon*, a long strip of thin, pale metal unwinds from a coiled centre. Placed on its side, the tin seems to have been shaken by a slight tremor. Its concentric circles look vulnerable, even as Andre discloses their tensile strength. Next to it, compactness is asserted in *Kristall*, a thick rectangle of 144 lead elements. Their solidity seems satisfying, and they look unshakeably robust after the ruffled attenuation of *Tin Ribbon*. But the surfaces of the lead pieces are surprisingly varied, ranging from dull to shiny. So are their colours, and all kinds of scratchmarks enliven them at every turn. Even so, *Kristall* shows Andre at his most reticent. It refuses to be seductive, whereas the nearby *Glarus Copper Galaxy* presents an irresistible spectacle. Once again, the material is permitted to assert itself unhampered by any changes on the artist's part. His only interest lies in deciding to let it uncoil to a length of 220 centimetres. In this respect, it seems akin to *Tin Ribbon*. But the truth is that the sheen and reflective richness of *Glarus Copper Galaxy* make it far more sensual. An object of delight, this burnished, deep orange vortex draws us into its energy with an almost magnetic insistence.

Andre's handling of the large upstairs room could hardly be more contrasted with the equivalent space below. *Karlsplatz*, after all, dominates the central ground-floor space with its bulky assertion of timber blocks. The gallery above, though, looks emptied out. Nothing is allowed to rise up from floor level. The metal pieces displayed here are all laid

flat, and we gaze out over them like travellers looking down from an eminence on a vast plain. It looks featureless to begin with, and entirely unemphatic. Gradually, however, Andre's work begins to declare its discreet presence.

A copper piece called *36 Cyprigene Sum* moves out in a triangular formation from the nearest corner before suddenly terminating, as if reluctant to appear greedy in its occupation of the space available. Another copper work makes a more dramatic intervention, pushing out at an angle from a nearby skirting-board. By stretching across so much of the floor in front of us, it virtually forces visitors to walk over the copper in their progress through the room. But Andre welcomes the imprint of our shoes on his horizontal work. He has no desire for his pieces to be hallowed or inviolable, and by pacing across we are able to engage with them on a more intimate, tactile level.

Not that the largest sculpture on view here is a particularly inviting object. This great expanse of cold-rolled, weathered steel looks thicker than the other pieces, and many of its square plates have been eaten away by irregular patches of rust. As if to accentuate their roughness, Andre has entitled the work *44 Roaring Forties*. It certainly acts as a disruptive agent, flouting the smoothness of the gallery's bland wood floor like a wind lashing at a placid ocean. Even here, though, Andre stops well short of an exclamatory art. The great steel rectangle remains flat, and we can rest our weight on its surface without fear of instability.

Standing in the middle of *44 Roaring Forties*, we notice a thin line of pale, highly reflective tin elements running along the base of the wall nearby. Beyond, a twenty-seven-unit sculpture made of bismuth, cadmium and indium also invites us to explore it. But there is plenty of time. Andre's supremely contemplative art encourages the viewer to slow down, stop demanding quick-fire sensations, and scrutinise the nature of his materials with a heightened sense of alertness. In an increasingly virtual world, the first-hand experience he offers here is salutary, refreshing and more necessary than ever.

ENCOUNTERS: NEW ART FROM OLD

14 June 2000

In 1909, the belligerent Marinetti published a hectoring, shameless tirade called *The Initial Manifesto of Futurism*. 'Deviate the course of canals to flood the cellars of the museums!' he screamed. 'Oh! May the glorious canvases drift helplessly!' Driven by the desire to launch an avant-garde movement extreme enough for the new century, Marinetti wanted to sweep away all slavish reliance on the influence of the old masters. Now, by contrast, the advent of yet another century is marked by an enormous exhibition celebrating contemporary art's dialogue with the past. Opening today at the National Gallery, it reveals how twenty-four invited artists responded to works of their choice in the collection. Marinetti would have denounced the whole event as a retrograde, sickly affair, heralding modern art's slide into what he derisively called 'passéism'. But the truth is that the show is a triumph. Far from signalling an enfeebled reverence for academic ideals, it contains the work of artists who treat the past as a springboard for exhilarating adventures of their own.

The National Gallery has reciprocated in the same spirit, too. Rather than confining all the exhibits to rooms reserved for temporary exhibitions, it has allowed some of the work to spill out and invade the permanent collection. Coolly provocative, Richard Hamilton's painting is permitted to hang on a wall leading to the Sainsbury Wing. Anyone looking at his exhibit will immediately understand why. For Hamilton has recreated the view stretching ahead of us. Normally, a Venetian altarpiece is displayed at the end of the vista: Cima's *The Incredulity of St Thomas*. But Hamilton has replaced it with his own painting *The Citizen*, where a bearded Republican inmate of Long Kesh prison is juxtaposed with the excrement he has smeared on his cell wall as a 'dirty protest'. In the foreground, a naked woman stands isolated in an otherwise empty gallery, and the precision of the whole image pays homage to another National Gallery possession: Saenredam's *The Interior of the Grote Kerk at Haarlem*.

Howard Hodgkin gets even closer to his chosen painting, Seurat's *Bathers at Asnières*. With breathtaking audacity, he has hung his tribute in the very same room. If it were nothing more than a copy, Hodgkin's painting would have been belittled by such closeness to the awesome, impassive finality of Seurat's precocious canvas. But Hodgkin's headlong image, the largest he has ever painted, transforms the austerity of *Bathers at Asnières* into a far more unbridled, sensuous alternative. Sky, water and

43. Jeff Wall, *A Donkey in Blackpool*, 1999

grass have become turbulent, their presence enlivened by Hodgkin's impulsive, stabbing marks. His radiant colours are more evocative of the Mediterranean than northern France, and Seurat's pallid bodies are now burnished by the sun.

Brave and joyful, Hodgkin's *tour de force* sums up the most exhilarating side of this show. But not all the exhibits are so boisterous. Very surprisingly, Euan Uglow reacts to Monet's *The Water-Lily Pool* by painting a nude woman alone in his cheerless studio. She seems to have collapsed on a long, low stool, and her legs trail off the end on to the floor. With head turned away from us and arms dropping limply, the figure resembles a corpse. Although her body echoes the form of Monet's bridge, the mood of Uglow's painting is far removed from the ecstatic vision of Paradise at Giverny. A similar sadness pervades *A Donkey in Blackpool*, Jeff Wall's large transparency in a lightbox. This time, the starting-point was Stubbs's great *Whistlejacket*, a rearing embodiment of equine energy. But Wall's donkey, seen in a stable resting between beach rides, looks far more weary. Like Stubbs's horse, the donkey is presented in frieze-like profile.

But there the resemblance to *Whistlejacket* ends. For Wall's animal appears stunned, and the besmirched straw around him is a world away from the pristine simplicity of Stubbs's elevating backdrop.

Although the National Gallery's remit is confined to paintings, sculptors often react passionately to its collection. So three-dimensional works rightly play a prominent part in this show. Anthony Caro, whose work is increasingly nourished by its dialogue with the old masters, selects Duccio's *Annunciation*, a small panel from the monumental *Maestà* altarpiece painted for Siena Cathedral as early as 1311. A delicate image, where the tender, nervous interplay between Gabriel and Mary is enhanced by the architecture enclosing them, it has spurred Caro to produce seven substantial and inventive variations. Three of them are on display. They appear at first to concentrate on the setting, along with the delicate still life Duccio placed between Archangel and Virgin. But the figures' presence is implied in all three, and in a highly polished brass version the entire limpid structure emits a visionary glow.

Stephen Cox's sculpture also responds to an Italian painting, Piero della Francesca's late, probably unfinished *The Nativity*. In this case, though, death rather than birth is the overriding theme. Hints of Christ's martyred end can be found in Piero's bitter-sweet image. But Cox confronts us with an immense shrine carved out of *bardiglio* marble. Its tomb-like frontage is impressive, and a surprise awaits anyone prepared to squeeze through the central aperture. The interior, lit only by a few holes puncturing the ceiling, is lined with slabs of porphyry. Its warmth and richness counter depressing thoughts of extinction, and encourage us to think instead about the miracle of Christ's final emergence from his resting-place.

As well as producing works with an independent life of their own, the artists on show here stimulate us into reconsidering the paintings they chose. Vermeer's two interiors are among the most familiar images in the National Gallery. But Claes Oldenburg and Coosje van Bruggen have come up with a novel interpretation of Vermeer's small, exquisite paintings. They see them as a pair and argue that, in the first picture, the woman standing at the virginal anticipates the moment when she will make music and arrive at sexual fulfilment. In the second, the seated woman plays her virginal and thereby achieves consummation – a theme reinforced by the painting of a procuress on the wall behind her. Following on from this interpretation, and inspired as well by Samuel van Hoogstraten's peepshow interior of a Dutch house, Oldenburg and van Bruggen have produced a delightfully ingenious sculptural installation. We peer into a beguiling interior, set back in a shallow space behind

the wall. The viola da gamba propped up in one of Vermeer's paintings has fallen to the floor, and becomes the most forceful object on view. Its former tautness has softened and collapsed, like one of Oldenburg's early disintegrating sculptures. The strings sprawl loosely, projecting into our space. And the Cupid's bow visible in one of Vermeer's paintings now hangs on the wall behind, accompanied by a limp arrow. Everything is in a state of detumescence. Pleasure has clearly been relished here, but melancholy is detectable as well. The emotional resonances of this superb, teasing tableau are complex, and the painted curtain partially pulled to one side conceals as much as it discloses.

Equally ambiguous is Bill Viola's potent video installation *The Quintet of the Astonished*, his response to Bosch's painting *Christ Mocked (The Crowning with Thorns)*. Although he has retained the five people found in Bosch's disturbing, caricatured image, Viola breaks free from any timid reliance on his source. Bosch's vertical format has become horizontal, and none of the people in *The Quintet of the Astonished* is obviously connected with a biblical story. The spiritual intensity of the slowed-down, Caravaggio-like video is beyond debate, though. Each face seems transfigured by a strong emotion. But unlike Bosch's leering tormentors and their victim, Viola's people change their feelings as the work proceeds. They shift continually, caught up in a drama of infinite fluidity.

No single review can hope to encompass the full range of insights in this outstanding show. Guest curator Richard Morphet deserves congratulations, not least for an absorbing catalogue where so many connections between present and past art are elucidated. I discussed and illustrated several of the exhibition's most important participants, including Frank Auerbach, Balthus, Louise Bourgeois, Patrick Caulfield, Lucian Freud, R. B. Kitaj and Paula Rego, in *The Times Magazine* on 3 June. And David Hockney's probing portraits of uniformed National Gallery wardens were reproduced on the front page of *The Times* in March. Influenced by Ingres's portrait of the Baron de Norvins, they address themselves at the same time to the individual reality of twelve men and women who, like Hockney, devote much of their professional life to long, hard looking.

This entire exhibition will, in turn, prompt many visitors to view the National Gallery collection with fresh eyes. Nobody could have predicted that Cy Twombly would choose Turner's *The Fighting 'Temeraire'*, or that he would paint images as fragile and elegiac as the three *Studies* displayed here. His vulnerable vessels, with their streaked and dribbled pigment, look like ships of death carrying unseen passengers from one world to the next. Even more sombre is Jasper Johns's mysterious painting, dedicated not only to the fragments from Manet's dismembered *The Execution of Maximilian*,

but also to Degas who rescued and reassembled them. Their names are inscribed at the bottom of the canvas, but our attention is held mainly by the string describing a slender white curve across the painting's dense, grey surface. Slung from a wooden stick at the right side, it arcs like an isolated suspension bridge through the dark, muted void. The painting's overall melancholy is unmistakable, linking it with the tragedy memorialised in Manet's *Execution*.

In the end, though, Johns's painting also conveys a fundamental sense of wonder. It is a feeling we can share throughout this illuminating show, where the modern is invigorated by its contact with tradition and Marinetti's cry to 'flood the museums' seems grotesquely misjudged.

PANAMARENKO

15 February 2000

Tilting forward as he grips the handles, a sombre life-sized man with long, straggling hair dreams of taking off. The large propellor attached to his backpack power system might soon start spinning, and an enormous parachute curves high above him. Flight appears imminent, yet nothing stirs. The whole gigantic contraption seems held in a state of suspense, longing for aerobatic freedom while remaining motionless and earthbound. Panamarenko, who identifies himself as the would-be pilot, has spent his entire career in just such a state of yearning. It runs like an unsentimental sigh throughout his retrospective at the Hayward Gallery, and gives everything he makes a peculiar poignancy. Now sixty, he is still based in his home city of Antwerp and shares a house with a dog, two fish and twenty birds. He dislikes travel, contenting himself with fantasies of epic voyaging in his own inventions. They are, for him, an alternative reality, like the strange pseudonym he adopted while at art school in the 1960s. He now claims that Panamarenko was a Soviet general. But the apparent reference to 'Pan Am', the former US airline, cannot be ignored. Maybe the name was intended as a demonstration of the artist's global outlook. East meets West, and his willingness sometimes to use the abbreviated name 'Panama' confirms that he likes the idea of making links between different parts of the world.

He is certainly in love with the romance of flight. Downstairs at the Hayward, one long gallery is almost filled with the colossal, swollen form

of *The Aeromodeller*. Even though it is only half inflated, this great Zeppelin-like balloon bulges and presses awkwardly against the ceiling. Its skin of transparent PVC film is spattered with patches, suggesting that it has been peppered by shot during aerial combat. Inside the nearby gondola, surmounted by four motors, a couple of fireproof asbestos suits lie empty on the floor. As inert as corpses, they accentuate the sense of sadness. For *The Aeromodeller* has never been capable of taking to the sky. Panamarenko tried once, inflating it with hydrogen before the police and the local Burgermaster forbade it to fly. They even threatened him with jail, and Panamarenko finally realised that his immense balloon would only ever travel when lent as an exhibit to foreign museums.

He persists, nevertheless, in planning grandiose journeys through the cosmos as well as the sky. *Bing of the Ferro Lusto* is the typically quirky title given to a prototype for a spaceship. To my eyes, it has the period charm of an old-fashioned flying saucer. Panamarenko, who spent much of his time as an art student skipping lectures and going off to the cinema, is particularly fond of science-fiction movies like *The Day The World Stood Still*. I can imagine a Hollywood extra-terrestrial commander stepping out of *Bing of the Ferro Lusto*. But the irrepressible Panamarenko plans to make a far larger version, capable of transporting 4,000 passengers on 'express, short-range space exploration; to the Moon, or even to Mars'.

Everything he produces is shot through with ambiguity. On one level, Panamarenko seems to be an intoxicated inventor who sets no limits on his soaring ambitions. Liberation through flight is a constant source of stimulus: he told me in all seriousness at the Hayward of his resolve to improve an elaborate contraption called *Bernoulli* and make it airborne. On another level, though, the work he produces with such unabated zest is also touched by a strain of melancholy. He appears to be caught half-way between surging exhilaration and a perpetual awareness of futility. That is why his finest art is so haunting, and bears directly on our own aspirations. For humans have always known that they will never be able to fly like birds. But we have constantly dreamed of doing so, and refuse to let the doomed example of Icarus discourage us.

Leonardo was the most celebrated pioneer to explore the possibility of man taking wing, and Panamarenko is often compared with him. The two artists do share a passion for inventing things, even if Panamarenko has never shown any interest in devising the kind of devilish weaponry that Leonardo created for his most warlike patrons. But the links between them can easily be exaggerated. The older Panamarenko has grown, the more his work is tinged with ironic detachment.

Encountering each fresh contraption in this continually beguiling survey, we cannot help smiling at the vein of humour it contains.

Das Flugzeug, one of his most delicate and refined inventions, enlivens the larger gallery upstairs with a linear tracery of slender aluminium tubes. Its six Styroper wings, each covered with white canvas, appear at first to float like fragments freed from a painted paper cut-out by Matisse. They induce a feeling of nostalgia for the early days of heroic aviation, and we cannot help wanting to see *Das Flugzeug* achieve lift-off. At the same time, though, we begin to notice how rickety the whole structure really is. Even when static, the fragile wings have to be supported by taut cords slung from the ceiling. But our concern for the machine's durability turns to disbelief when we notice, at its centre, a leather bicycle saddle, handlebars and pedals attached to a rubber driving belt. Silently waiting for the pilot to sit down and start manic exertions, they look absurdly inadequate. We grin, even as we recognise how magical it would be if someone really did manage to pedal this unwieldy object up into the sky.

Panamarenko himself relishes the idea of playing the role of a dashing airman. He has even made a special *Peaked Cap* to wear for the journey, inspired by an old photograph of an Antwerp shop window around 1900. A mariner's hat was on display there, accompanied by a card claiming that 'all hats are waterproof'. To bear out their boast, the owners had poured water on the hat and let two small fish swim in it. The whole bizarre spectacle bolsters Belgium's reputation as the home of Surrealism. The country that produced Ensor and Magritte has also left its fantastical mark on Panamarenko, who remembers how, during his errant art-school days, he 'discovered all that stuff about art being an unconscious thing'. Accordingly, his *Peaked Cap* not only has the name 'Panamarenko' proudly spelt out in capitals on a label below a tiny metal sculpture of a bird. It also allows two plastic yet highly realistic fish to lie on its gold-painted top. Panamarenko asserts that *Peaked Cap* 'enables you to withstand people. With a hat like this you could enter the best hotel and they would immediately give you the best suite. I know because I have tried it.' Beneath its uniformed assurance, though, *Peaked Cap* possesses a funereal undertow. The dead fish look macabre, and suggest that the cap's owner may have drowned when his fragile aircraft took a nosedive into the sea.

As if to encourage such an interpretation, Panamarenko made a steel submarine in 1996. Big enough to contain several people in appallingly cramped conditions, this boorish hulk squats now on one of the Hayward's outdoor sculpture courts. It was raining when I ventured out

44. Panamarenko with *Ping*, 1996, at the Hayward Gallery, London, 2000

there, and water was dripping off the submarine's crudely soldered plates. It looked even more ungainly when the streamlined and surprisingly elegant Millennium Wheel reared up in the distance. After a time, though, the submarine takes on a perverse fascination of its own. Ludicrous fins jut out from the sides, and a risible propellor protrudes at the far end. Odder still, the other end is covered by a circular sheet of glass. Peering in, we find a claustrophobic green-painted chamber with a diminutive television set resting on a seat. The box of electrical equipment above warns us of 'Danger Period'. But the sinister appeal of the submarine is outweighed by its ridiculousness. Panamarenko gives it the affectionate nickname *Ping*. He imagines that the sight of its conning tower emerging from the waves, emblazoned with a red star and a Russian-looking name, would make startled onlookers think that a 900-foot stealth submarine lurked beneath the sea. In my view, however, *Ping*'s dumpy form and air of obsolescence makes it more weird than threatening. Stranded on a concrete slab far above the level of the Thames, it looks as beached as the glass-fibre *Whale* made by Panamarenko in 1967 and placed so unexpectedly on a plinth made of cellophane and tin. The impotence of the submarine overrode any functional prowess it may command.

I would, for similar reasons, advise anyone to decline the opportunity to try out Panamarenko's *Barada Jet*. Despite its open cockpit, Panamarenko promises that it offers 'the fastest way to get to New York' – before adding with disarming candour that 'you would have to wear goggles, otherwise your eyes would be gouged out by the force of the speed'. It is an unashamedly far-fetched object, powered by a real jet engine that looks more like a rusty stovepipe. And when I challenged Panamarenko about its speediness, he conceded in his best deadpan manner that the trip to New York would really take 'around twelve hours'.

At once visionary and matter-of-fact, high-flown and practical, self-indulgent and disciplined, the contradictory Panamarenko is out on his own in current art. At one extreme, he can alarm us with an electro-magnetic work so high in real voltage that it is surrounded by a barrier, along with a notice warning us that its magnetic field may damage 'hearing aids, mobile phones, bleeps, pacemakers, credit cards, etc.' In a different mood, though, the same unclassifiable artist can arouse pathos with three small robotic chickens. Made of balsa wood, glue, string, electronic chips and servometers, they are supposed to be functional. But they seem on the point of disintegration, especially the hapless creature whose spindly legs and claws already stick up in the air. The very opposite of sky-born, this broken bird will never be able to fly.

FRANCISCO TOLEDO
24 May 2000

In 1960, when he was only twenty years old, Francisco Toledo painted a picture called *Death*. Blue with mould, a skull rests on a chair. The eyes, reduced to target-like circles, look startled. And Toledo adds to the disquiet by scoring thin lines in the skull's dome, nose-cavity and jaw. They look like seismic fissures, running through a highly unstable terrain. Here, at the outset of his career, the young Mexican announced a precocious fascination with mortality. Perhaps it had been triggered by early memories of his mother's family, who were pig-butchers. At dawn, Toledo recalled, 'my grandmother, who was called Ta Gil, killed the pig, then went back to bed, while my mother collected the blood that flowed out in rivers and she and the other women cleaned the animal, and cut it up and went to sell it.'

The likelihood is, though, that Toledo was also influenced by the culture of his own country, where the inevitability of death is exposed and celebrated rather than hidden from view. No artist could be more devoted to his homeland. Around the time he produced the early skull painting, Toledo moved to Paris. He held exhibitions in London, New York, Geneva and Oslo, establishing himself with a burgeoning international reputation. But within five years he had decided to return to his native Juchitan. He was fascinated by the Zapotec way of life, and in particular the extreme cultural diversity of the Isthmus region. Toledo's multi-faceted imagination felt an instinctive kinship with the wild, unpredictable fantasy in popular fables from the pre-Hispanic era. While he found plenty of stimulus in twentieth-century artists, most notably Klee and Miró, the legacy of the remote past nourished his work even more strongly.

Toledo is obsessed by the interplay between humanity and the teeming natural world. At his Whitechapel Art Gallery retrospective we see film of the artist painting outdoors, crouching on the floor beside his paper and clearly at home with the creatures he encounters in the landscape around him. They invade his work at every opportunity. *Snakes in the Waterhole* is the title of a 1972 canvas, where oil-paint and sand are mixed together to create a textured yet strangely dream-like image. D. H. Lawrence, who wrote a mesmeric poem on a similar theme, would have understood why Toledo wanted to define the combination of eagerness and torpor displayed by the snakes, as they extend their tongues towards the sustaining liquid.

But Toledo is more often fired by the spectacle of a strange metamorphosis. Another large 1972 painting, *Woman Attacked by Fish*, is a mysterious, almost apocalyptic image. Undulating brown shoals fill most of the canvas, all converging hungrily on a figure near the centre. Weird protuberances sprout from her head, and she opens her mouth in a cry. Is she under the water, or floating on the surface? Toledo ensures that the image remains ambiguous, but there can be no doubt about the danger posed by the fish as they advance like an army towards her vulnerable flesh. She may, of course, have been guilty of provoking their anger. In a painting called *The Great Cow Robbery*, stealthy silhouetted men in gangster suits carry the animals away from their field. One man seems to possess superhuman strength, as he clambers over a barbed-wire fence with a cow on his back. Early Chagall must be the principal inspiration behind this crazily tilting image, where the moon gleams in a distant fragment of sky and everything appears to be suspended in space.

On other occasions, animals are shown in conflict with each other. A dog with a vicious, outflung tongue barks at a frightened donkey, causing the air around them to splinter like a sheet of glass fracturing in a thousand segments. Toledo's brush delineates each crack in a painstaking, rather pedantic way. But he leaves precision behind in his softer, hazier handling of the animals. He is preoccupied with entrapment, most notably in a convoluted painting of a *Bull in a Labyrinth* where the victim looks dazed by whirling lights assailing his body. More disturbing still are the images where humans undergo a sinister sea-change. In one 1974 canvas, a hunched woman lifts both legs to avoid the crabs encircling her with seemingly sinister intent. Her face has been transformed into a mask, and another sea-creature occupies the space where her nose should be. On her rounded shoulder prances a truly bizarre amalgam, a tiny headless apparition with a shell-like torso and female legs terminating in high-heeled shoes. They appear to be running away, as if terrified by the advancing crabs.

Not all Toledo's work is so ominous. Playfulness erupts in *Crafty Rabbit*, where a long-eared figure with two penises parts his legs, grins and beats off the winged insects dive-bombing him on every side. Toledo's humour is most evident in his sculpture, though. A painted bronze deer with kitschy silver and leaf applied to its body wears four shoes, and a wax woman perched on a precarious base suddenly changes into a bellowing bull whose tail juts out of her skirt, waving aggressively in the air.

This fetishistic fascination with shoes may stem from Toledo's father, a cobbler who once told his son that 'what he liked best was to measure women's feet, because then he could see their legs'. But the most

provocative sculptures centre on the form of a cannon. They are all frankly phallic. In *The Cannon of Juchitan*, a terrified rabbit opens his mouth in a cry as he clings to the upturned weapon. It looks ready for launching, but the inert body of another rabbit gives the sculpture a sense of futility as well. The feeling intensifies in *The Great Cannon*, mounted this time on a large box. Sturdier than its predecessor, it seems ready for action: a flame leaps from its end, as if newly ignited by an unseen combatant. But the cannon's mouth is blocked by a ball, big enough to prevent the weapon from firing. Half-way down, a penis juts from some trousers wrapped round the cannon. But it looks paltry and ridiculous, a symbol of impotence rather than macho power.

Perhaps Toledo's ultimate aim is to subvert the cannon entirely, robbing it of any military effectiveness. In *Cannon of Pro-Oax*, named after a loose circle of artists and activists based in his region, its traditional wheels have been restored and several balls are stacked in readiness nearby. This time, though, the cannon's barrel has been turned into the body of a giant grasshopper. By giving a fragile insect such monumental form, Toledo reveals his true values. Like Joseph Beuys, he insists on widening his role as an artist to become a protector of vulnerable rural cultures. His first scheme centred on an ambitious restoration of an old convent in Juchitan. It became the Casa de la Cultura, a regional centre for the promotion of contemporary art with an emphasis on practical classes in drawing and pottery. More recently, he has initiated the conversion of grand colonial buildings in Oaxaca, transforming them into centres for photography, film, graphics and a library for the blind. A video screened at the Whitechapel shows Toledo interviewed in an immense textile factory. He explains that it will be turned into much-needed artists' studios, and maybe an art school as well.

Despite his success with these projects, Toledo remains an elusive and retiring figure. Almost unknown in Britain, he dislikes exhibiting and shies away from self-promotion. Privacy is of paramount importance, and the increasingly introspective mood of his work in the 1990s discloses a despair that counters the optimism of his great cultural enterprises. Unlike Beuys, he is not sustained by any overriding belief in the shamanlike power of the artist. Far from convincing himself that he can change the world, Toledo recently deplored the 'drive towards total destruction – I don't think anything can stop it. The costs of civilisation are so high. In Mexico people are cutting down all the trees – destroying forests – so then you have the earthquakes, the rains, the mudslides and everything gets washed away . . . I do what I do without any hope of a lasting or significant effect.'

The same mood informs the final room at the Whitechapel, largely

45. Francisco Toledo, *Self-Portrait with Toad*, 1999

given over to fierce and eloquent graphic work. It is by far the best part of the show, displaying an urgency, economy and bite missing from too many of the earlier images. Toledo reveals himself here as a superb draughtsman, capable of unleashing an unsuspected vigour. In one aquatint, the cannon finally bursts into action, lit by a leering, outsized lizard. The balls smash through a fleeing figure of Death, breaking him in half. But Toledo is equally capable of pathos, above all in a drypoint of a crucified wasp whose wings hang down forlornly from the cross. Then the artist himself appears, leaning sadly against a toad while gazing at a grasshopper on his shoulder.

In a 1994 lithograph, another grasshopper jumps on to Death's erect penis, as if determined to vanquish him. But Death will not be ousted so easily. The saddest image in the show is Toledo's small clay *Self-Portrait (The Old Man)*. Reminiscent of pre-Columbian effigy vessels, it shows the artist as a haggard, wrinkled figure peering through grim eyes. His torso is skeletal, his penis limp. The artist now seems ready to acknowledge that his own head will eventually turn into the skull he painted forty years ago, at the outset of his long, restless career.

YAYOI KUSAMA

2 February 2000

When Yayoi Kusama presented her *Driving Image* installation in New York, she unleashed macaroni-covered dogs who careered through the gallery, barking at startled visitors. The year was 1964, and Kusama set out to demolish the barriers separating art from its audience. She wanted viewers to become part of her work, allowing them to tread on the bed of broken pasta where her mannequins and furniture stood. Beatles songs and local television news bulletins were relayed too, flouting the reverential hush normally associated with art galleries.

How can such an uninhibited work be restaged today? This was one of the challenges confronting the Serpentine Gallery when it decided to give Kusama her first, long-overdue British survey. The artist, now a revered seventy year-old, proved very helpful. She even painted a fresh backdrop for the London installation, and made sure that it echoed the original as faithfully as possible. But the whole tableau is cordoned off, so we cannot hear the pasta crackle under our feet. The Beatles have gone, and the noisy dogs are nowhere to be seen.

In other parts of the show, though, the full and bizarre flavour of Kusama's work is preserved intact. It could all be seen as a magnificently brave form of extended therapy, conducted by an artist who is quite open about her lifelong battle with mental illness. Hallucinations have dogged her since childhood. She was terrified, intermittently, by a feeling that her entire body was being crawled over. Obsessed by nets, food, dots and sex, she believed that her own sense of self was under threat of annihilation. Unreality became a spectre to be dreaded, and she still prefers to stay voluntarily at a Tokyo institution when not working in her studio.

She has, however, refused to be stunted by her affliction. 'I, myself, delight in my obsessions,' she insists, and they have become the driving force of her prolific output over the last half-century. They also enabled her to define a distinctive identity from an early age. In 1951, she had already begun deploying the dots that still preoccupy her today. They spread like a rash over an ink drawing called *Accumulation*, one of thousands she recalls making in the post-war period. The dots seem to reflect an intense feeling that she had been reduced, by her hallucinatory fits, to a similar speck. But there is nothing enfeebled about the role they play in her work. They teem and proliferate with zest, especially in a 1955 painting called *God of the Wind* where they appear to swarm all over a turbulent cosmos.

Nor did Kusama allow her mental troubles to weaken her ambition. Defying the disapproval of her conservative family, she emigrated to New York in 1958. It was an audacious step to take. The centre of the Western art world had become a highly competitive arena, where Abstract Expressionism's supremacy was now being challenged by young artists who would soon pioneer Pop, Minimalism and other, more free-wheeling movements. But Kusama proved surprisingly resilient. Despite financial hardship, she was stimulated by the ambition of her new sur-roundings. The repetitive patterns she described as her 'Infinity Net' remained central, and she pursued them on a far more monumental scale. A painting as immense as *No. AB.*, a white monochrome executed in 1959, responds to the titanic proportions so often favoured by Pollock, de Kooning and Rothko. But its quietness is removed from their mus-cular emotionalism. Small circular motifs are repeated all over the can-vas, with a disciplined, pared-down consistency that prompted Don Judd's early admiration. Looking closely at *No. AB.*, we might feel lost inside its vastness and conclude, uneasily, that the painting could extend outwards for ever.

On the whole, though, Kusama is more impressive in three dimensions. The confines of an easel painting, however large, could not satisfy her. And in the early 1960s she burst through them with exuberant inven-tiveness. In *Aggregation Rowboat*, she covered a wooden vessel and oars with stuffed, sewn fabric. Its softness is reminiscent of Dalí's surrealist fas-cination with melting, and of the objects that her neighbour Claes Oldenburg was producing with such gusto. But he splattered and pum-melled his multicoloured Pop sculpture, whereas Kusama's becalmed boat is painted white. From a distance, it appears to be encrusted with bleached barnacles. Move nearer, and the surface erupts in a multitude of phallic forms. Whether sagging or erect, they fill the vessel to bursting-point.

In this sense, the penis-filled boat can be seen as a sardonic comment on an art world still oppressively regarded as a male preserve. Louise Bourgeois, another *émigré* unafraid to incorporate brazen sexual refer-ences in her work, also suffered from the same chauvinistic prejudices. But neither she nor Kusama was disheartened. They both continued to explore their obsessions with undiminished verve, and in 1964 Kusama finally achieved her ambition to create a large-scale environment when *Driving Image* opened. The rowboat was there, up-ended against a wall, and so were clothes covered in stuffed phallus forms. The main focus, though, was provided by the mannequins: three slender, catwalk women and a child, all peppered with the ubiquitous dots and posing beside tables, chairs, tea-cups and flowers in the macaroni-littered room. They

look oddly well-mannered at the Serpentine, and far less provocative than the sultry mannequins exhibited by the Surrealists thirty years before.

But the original installation was probably more lively and unpredictable. Soon afterwards, Kusama made herself the focus of her work by staging itinerant performances in the New York streets. Dressed in a pink kimono and sporting a flower-festooned umbrella, she trips politely past hoardings selling Banquet Meat Pies and Libbys Corned Beef. She stares down at a homeless man sprawling in the shadows, gazes out to sea and pauses warily at the corner of two long, deserted pavements. They unnerve her so much that she lifts a handkerchief to her eye, like an innocent Japanese girl overwhelmed by the crushing, agoraphobic impersonality of urban life.

This *Walking Piece*, probably reflecting memories of her own nervousness when she first arrived in New York, gave way to sensual exuberance in the anarchic summer of 1967. Kusama launched herself into public body-painting events all over the city, inviting passers-by to strip off and be 'made into art'. Recorded by underground film-maker Jud Yalkut in a 16mm film called *Self-Obliteration*, the rituals look unexpectedly solemn and involve cats as well as humans. The following year, though, Kusama became more outrageous in a sequence of Anatomic Explosions, where naked dancers smothered in polka dots flaunted themselves in Wall Street and Central Park. The police intervened eventually, but not before her happening at the Statue of Liberty had exhorted the public to 'take it off for liberty! . . . LET THE PANTS FALL WHERE THEY MAY!'

The film has a strong nostalgic appeal, especially to visitors who, like me, have their own indulgent memories of sixties frolics in Swinging London. The truth is, however, that much of Kusama's subsequent work is darker and more unsettling. Confronted by waning interest in her performance work, she retreated to Japan in 1973. But the stream of paintings, sculpture and installations grew, if anything, more unstoppable than ever. She also wrote eighteen novels, each apparently as violent and sexually explicit as her first, *Manhattan Suicide Addict*. Judging by a book of poems attached to a gallery chair, her literary themes are closely entwined with her visual concerns. In one poem, *Swamp Asylum*, she refers to the 'severed phallus in my pocket'. And in *Dots Obsession*, the aptly named room at the Serpentine where we can wander after discarding our shoes, blown-up yellow protuberances swell suggestively at every turn.

They demonstrate that Kusama is still able to combat her continuing bouts of illness with bursts of high-spirited, comic sensuality. But I found *Dots Obsession* far less powerful than *Infinity Mirrored Room*, a compact,

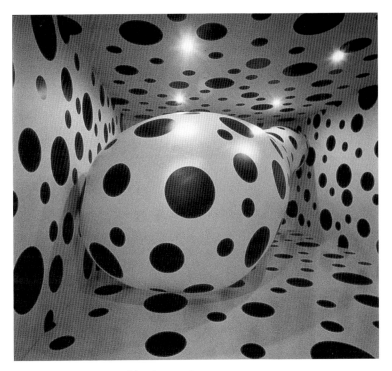

46. Yayoi Kusama, *Dots Obsession*, 1996

freestanding sculpture lined on the outside with reflective glass. Peer in through the letter-box opening, and you find yourself ambushed by manic vistas of flashing light bulbs. They recede in several dizzying directions, like hyperactive airport runways endlessly extending in space. Then, quite suddenly, we are startled to realise that our own reflected eyes are staring back at us, from interior mirrors suspended among the hectic illuminations. It is an authentic nightmare moment, and brings us uncomfortably close to the hallucinatory visions that assail Kusama's own mind. But it also increases our respect for the courage of the woman who confronts her affliction and turns it into defiant, resourceful art.

THE MERIANS COLLECTION
25 November 2000

When Elaine and Melvin Merians bought their first Lucian Freud paint-
ing in 1978, they had no inkling that it would lead them to form an out-
standing collection of contemporary British art. After all, they had
already amassed a formidable array of Post-Impressionist and American
paintings, including work by Bonnard, Léger, Matisse, Modigliani,
Picasso and Soutine. Why should they suddenly sell them and embark on
such a dramatic change in direction, at a time when few American col-
lectors took modern British artists very seriously? Part of the reason lay
in the surging market of the late 1980s, when ridiculously overheated
prices were paid for most of the artists in the original Merians collec-
tion. Realizing that the work was now unaffordable, they took a
momentous and surprising decision. The French masters were dispensed
with, and in their place Elaine and Melvin began to acquire a superlative
range of paintings and graphic work by British artists. Senior painters
like Freud, Frank Auerbach and Leon Kossoff were not, at that stage, as
expensive as they are today. So the Merians have been able to fill their
house, in a small coastal town just outside New York, with a generous
selection of work by each of the painters they admire.

Walking into their home is an overwhelming experience. On every
wall, major canvases by the most powerful figurative artists in Britain today
fill the rooms to bursting-point. They demand the closest attention. Three
major Freuds hang in the living room, along with memorable paintings by
Auerbach, Kossoff and R. B. Kitaj. A luminous David Hockney occupies a
prominent position over the dining-room mantelpiece, while younger
painters, including Tony Bevan and Peter Doig, can be discovered upstairs.
As for the bedroom, it is enlivened by excellent examples of work by
Craigie Aitchison and Euan Uglow, whose recent death deprived English
painting of a tenacious, utterly single-minded talent.

The Merians will miss Uglow a great deal, for they value their friend-
ships with the artists they collect. Early on, they met Kitaj while he was
still closely involved with many of the artists he called, in a celebrated
and much-debated phrase, the 'School of London'. Kitaj fired the
Merians' interest in his old friend Hockney, who still pays frequent vis-
its to England from his Californian home. They also got to know a
remarkable number of other painters, ranging from Peter Blake and
Paula Rego to John Wonnacott and John Lessore. Contact with the men
and women who produce the work means a great deal to the Merians.

It adds another dimension to their collection, enriching their understanding in a way they had never experienced when acquiring paintings by (largely dead) French artists earlier on.

Unlike so many collectors today, who buy for investment or to enhance their social status, Elaine and Melvin are dedicated to aesthetic experience. They value, above all else, the potent emotional charge of the work on their walls. Melvin, whose international business career took him to the Senior Vice-Presidency of the Sara Lee Corporation, has loved paintings from an early age. Both he and Elaine feel passionately about the work they purchase. Although they often have an instantaneous response to the paintings they like, neither of them is willing to buy without careful consideration and repeated viewings. They attach immense importance to drawing, and one room in their house is devoted to graphic work alone. They often acquire preparatory studies for the paintings in their collection, and take great pleasure in the opportunity to watch a work develop in the artist's studio. Kitaj's *Greenwich Village*, saturated with his memories of youthful life and love in New York, is a painting they were able to see from the initial drawn marks on canvas right through to eventual completion. They value such a close involvement with the genesis of art, marvelling at the unpredictable process of growth and change. In the case of a painter as notoriously slow-burning as Uglow, they watched his impressive canvas *The Wave* gradually come into being, inch by carefully calculated inch, over a six-year period. But other artists, Auerbach among them, never allow anyone to see their paintings-in-progress.

Some artists, whom Kitaj enthusiastically included in his 'School of London', have not yet found favour with the Merians. Neither Patrick Caulfield nor Howard Hodgkin can be found in the collection, and even Francis Bacon is excluded. Although Melvin has argued eagerly in favour of Bacon on several occasions, Elaine never felt convinced. Unless they are both unequivocal about an artist, no acquisition will be made. But they never rule out the possibility of changing their minds in future, for the Merians are undogmatic and stake everything on their first-hand reactions to the particular images they encounter. Constantly on the look-out for surprises, they refuse to focus exclusively on senior artists and relish the prospect of discovering new, younger painters whose work they can purchase. Seventeen of the artists in the collection are to be included in a major exhibition at the Yale Center for British Art in New Haven, Connecticut, which houses the most important historical survey of British painting outside the Tate. Its enterprising director, Patrick McCaughey, was astonished when he encountered the Merians collection,

and considers that 'no other private collection of its kind exists on either side of the Atlantic'. The paintings certainly amplify an under-represented era in the Yale collection formed by Paul Mellon, whose greatest enthusiasms centred on earlier British artists, sporting art and, supremely, George Stubbs.

Mellon's own lack of involvement with the 'School of London' was symptomatic of American attitudes as a whole. Apart from Hockney, who has spent so much of his adult life in Los Angeles, few of the painters in the Merians collection have been able to furnish themselves with widespread American reputations. Until recently, even Freud was absurdly undervalued, and only now are Auerbach and Kossoff beginning to attract the level of attention they deserve. Much remains to be done before all the artists in the Yale exhibition receive proper American recognition. Both Elaine and Melvin Merians are conscious of the need to make these painters more visible in the US. They are impelled by what McCaughey describes as 'a missionary zeal', and this impulse proved decisive in overcoming their natural apprehensiveness when he suggested exhibiting the Merians' pictures at Yale. They are instinctively private people, the very opposite of collectors who brandish their possessions with unashamed self-satisfaction. 'The only reason why we are giving our collection to be shown and associated with our name at all', Melvin explains, 'is because we have that "missionary zeal".'

Even so, the excellence of the paintings proves that zeal goes hand in hand with sound judgement. Take the works by Freud, the most senior artist in the collection. His *Naked Girl Perched on a Chair* is particularly heartfelt. The model was Nicola Bateman, whose brief marriage to the uninhibited Australian performance artist Leigh Bowery was tragically cut short by his death from AIDs in 1994. Painted shortly afterwards, this is a stark image of bereavement. Her long neck vulnerably exposed, Bateman sits in a womb-like position and clings to the chair with fearful determination. Absorbed in her own grief, she finds her stability further undermined by the vertiginous floorboards rushing so steeply beneath her seat.

Auerbach's *Head of David Landau* seems to be galvanised by a more convulsive emotion. With eyes almost reduced to black, skull-like sockets, and features pummelled by assertive brushmarks, the sitter appears to be reeling. At the same time, though, he possesses considerable grandeur. The thick, dark strokes enclosing the top of his high head also denote formidable strength, suggesting that Landau is fully capable of withstanding even the most grievous vicissitudes. Kossoff, who studied with Auerbach in David Bomberg's legendary classes at London's

Borough Polytechnic after the Second World War, gives his sitters a comparable amount of surging energy. His turbulent *Head of Chaim*, portraying a brother whom Kossoff has painted for many years, is on one level filled with disquiet. The sitter swings round, his restlessness reinforced by Kossoff's wild, volcanic mark-making. But Chaim is buttressed by a great residual strength as well. The thickness of Kossoff's paint combines with his muscular handling to give this head a craggy, almost sculptural presence.

Bespectacled, grey-haired and supported by a stick, Kitaj looks ill-at-ease in his large, openly despairing painting *Germania (The Tunnel)*. He thinks it 'may be my most difficult painting', and does nothing to hide the claustrophobic impact of a setting inspired by Van Gogh's view of the asylum at Saint-Rémy. Although Kitaj stumbles forward, he is unable to prevent his young son and wife entering a tunnel leading to the gas-chambers of the Holocaust. A nightmarish image of foreboding and frustration, the painting shows how closely Kitaj identifies himself with the tragedy of Jews in the twentieth century.

Hockney's most important work in the Merians collection, *Table with Conversation*, is sublime rather than horrific. As wide as the Chinese scroll-paintings he admires so much, this mysterious image moves between Hockney's California home and the Los Angeles landscape beyond. On the right, a dramatically upturned table inspired by cubist still-life paintings is pressed against the surface of the canvas. A vase of flowers perches on its wood-grained top, but this close-up view of a domestic space gives way to a free evocation of fields, hills, sky and tantalizing suggestions of figures on the other side. What cannot be doubted is the sense of wonder in this ecstatic painting, animated by Hockney's avid response to a landscape he knows so well.

An overtly magical vision of the English countryside provides the setting for some of Peter Blake's small paintings. Stimulated by Shakespeare and Victorian fairy paintings, he transforms Puck into a grinning child whose blitheness and mischief seem threatened by the deeply shadowed gardens beyond. A riot of flowers provides the festive backdrop for *Girl with Wet Hair*, who seems spellbound by her own daydreams. But the mesmerizing face in *Untitled (Fairy Girl)* seeks to train her hypnotic eyes on us, while the bearded *Giant (Study for 'Once Upon a Time')* stares out with a feeling of bafflement from his dark, unidentified locale. Paula Rego has also been enthralled since childhood by fairy-tales, along with the folk stories related by her Portuguese grandmother and aunt. A macabre series of large pastels called *Dog Woman* in 1994 took as its springboard the tale of a lonely woman who went mad and ate all her

pets. *Moth* is the most vulnerable image in the series. Crammed into a bizarre satin ball-gown, the dog woman looks up shyly from her chair. But she raises puppet-like arms as if to fend off an unwelcome advance, while the tilt of her head suggests defiance as well as nervousness.

Vulnerability can likewise be detected in Tony Bevan's powerful, unsettling work. His *Portrait of a Boy* is an ambiguous painting. Hands outstretched, the boy appears to be pleading as he stares out of a space stained with warm red pigment. He might be close to despair, and his prematurely wizened neck and face reinforce the feeling of a child *in extremis*. His gaze, however, is strangely potent. The eyes carry a remarkable amount of concentrated force, and they seem able to exert a surprising amount of authority over the unseen observer. The boy may be anguished, but he retains a formidable capacity to command our attention.

At first glance, the snow-laden scene painted by Peter Doig seems tranquil enough. When we focus on its two diminutive figures, though, the painting's mood becomes more complex. The Edinburgh-born Doig grew up in Canada, and still feeds off memories of its chilled landscape in his work today. One of the figures may even be the artist himself, and they both appear oddly hesitant. Neither acknowledges the other's presence, as they stand on the edge of the forest. The prodigious height of the trees seems to overawe them, triggering an awareness of their own insignificance when pitched against the immensity of the natural world.

Although the Merians are fundamentally committed to figurative art, their collection embraces a broad range of concerns and ways of working. They relish the highly simplified sensuality and spiritual aura in Craigie Aitchison's paintings, as much as the cooler, far more detailed observation informing John Wonnacott's rigorous paintings of himself and his family. Unafraid to contemplate even the harshest aspects of reality, the Merians also delight in lyrical celebrations of life. Above all, their collection testifies to an intense engagement with human experience, and the Yale exhibition should do much to quicken American interest in many of the finest painters at work in Britain today.

47. Peter Doig, *Figures in Trees*, 1997–8

FELIX GONZALES–TORRES

21 June 2000

Dying too soon to have a major show in Britain during his lifetime, Felix Gonzalez-Torres has finally arrived at the Serpentine Gallery with an exhibition substantial enough to reflect his true stature. Posthumous retrospectives can be alienating affairs, consigning artists to history and sealing them off from any discernible contact with the present. But no such blight afflicts Gonzalez-Torres. The Cuban-born American seems peculiarly of the moment, and his physical absence does not prevent him from reaching out, through the work he left behind, to engage us in a direct, open and deeply affecting way.

Right from the outset, his desire to make visitors an integral part of the exhibition is made clear. The ceiling of the first room is garlanded with naked light bulbs. They turn the emptiness beneath into a potentially festive arena, and two headsets hang on a wall plugged in to a Sony Walkman. Lift them to your ears, and the strains of a shamelessly romantic Viennese waltz fill your head. Gonzalez-Torres wants you to dance. English reticence prevented anyone from taking up his invitation while I was there. But the possibility remained potent, challenging us to defy the hushed, reverent atmosphere of the art gallery. Two colour photographs, showing blurred close-ups of elaborate crystal chandeliers, increase the pleasurable mood. They also strike an ironic note, however, indicating Gonzalez-Torres's realization that the gallery's clinical whiteness is far removed from a scintillating ballroom where waltzes are traditionally performed. The longer I lingered in the room, the more conscious I became of the void at its centre. No amount of Straussian music would ever be able to oust the sadness of a place where the light bulbs wait in vain for a party to begin.

This central tension in his work, poised half-way between encouraging a hedonistic mood and acknowledging the likelihood of a melancholy alternative, gives the show its emotional charge. So does his willingness to let viewers dismantle the art he produced. A stack of large printed paper sheets sits in the middle of a neighbouring room. Named with the initials NRA, after the National Rifle Association, they have been produced in a limitless edition. The impact of these blood-red sheets, all bordered by bands of funereal blackness, conveys Gonzalez-Torres's anxiety about the violence endemic in American society. But his stated willingness to let us each take a sheet means that the pile is continually being depleted, as visitors roll them up and depart. The physical

existence of the work becomes threatened by the spectacle of its imminent disappearance.

Gonzalez-Torres spent much of his career resisting the supposed permanence of art. Although profoundly influenced by the Minimalists, he never shared their love of solid, incontrovertible forms stacked or laid out in magisterial progressions on gallery floors. His most arresting and sensuous piece on view here, '*Untitled' (Placebo)*, bears a superficial resemblance to a minimalist sculpture. A colossal oblong carpet of glinting particles is spread out in front of our feet. But he soon makes us realise that its apparent abstraction is deceptive. For the carpet consists entirely of thousands of sweets, each individually wrapped in silver cellophane. The sheer precision of their arrangement is inhibiting: it prevented me, at first, from accepting Gonzales-Torres's invitation to step forward and take one of the sweets. Eventually, though, their enticing sparkle became impossible to resist. I took one, very gingerly, from the edge of the 'carpet', unwrapped it and put in my mouth. The chocolate caramel was so good that I soon flouted the printed instruction and helped myself to another. Temptation is an unavoidable part of his beguiling work, and the Serpentine's staff must spend a lot of time replacing the sweets on a busy day.

At the same time, though, even a work as seductive as this carries a disconcerting undertow. Placebo, after all, means in medical parlance that pills have been given merely to humour patients, not cure them. Moreover, eating a sweet does not take long. It offers an eminently transient pleasure, and the mood in this room changes when we notice the pale blue curtain hanging down from a metal rod over the windows. The park is still visible through the chiffon, but it looks like an unattainable memory when filtered through the blue haze. Occasionally a breeze ruffled it gently, adding to the feeling of languor. Gonzalez-Torres called the work '*Untitled' (Loverboy)*, a tender reference to his life partner Ross Laycock. A summer spent by the sea inspired this understated installation, with its lyrical ability to distil the essence of ocean, sky and tranquil luminosity. Even so, the fragility of the curtains hints at another meaning as well. They hardly seem to be there, and on a nearby wall hangs a mirror that darkens the room's atmosphere decisively. '*Untitled' (Fear)* is its name, and the mirror offers us a blue reflection when we peer at it. This time, though, the colour is far deeper than the curtains, and threatens to snuff out everything reflected in the surface of the glass. It dulls the glistening impact of the sweets and makes viewers feel that their own physical substance is diminished.

Living in New York between 1979 and his death in 1996, at the age of

only thirty-nine, Gonzalez-Torres witnessed at first hand the gruesome onset and spread of AIDS. Like many gay men of his generation, he was profoundly affected by the epidemic. And at the far end of this long room, '*Untitled*' (*31 Days of Bloodworks*) tackles the theme of medical tests. Only with difficulty can we detect, on this cluster of canvases, the slender lines lancing across their pallid surfaces. They resemble the month-long chart of a cell count, monitoring a patient's progress as he copes with the disease. It is a discreet work, and snapshots revealing the identity of the sufferer are confined to the unseen backs of the canvases. Gonzalez-Torres's refusal to expose everything to our gaze may seem inhibited at first. But it ends up implying a great deal about the need for privacy, and the faintness of the linear marks conveys, in itself, an alarming awareness of life gradually ebbing away.

Not that Gonzalez-Torres succumbed to self-pity. He seems never to have lost his appetite for delight, and it lends his work an authentic aching quality as he explores the conflict between presence and absence, pleasure and negation. The centre of the big domed gallery is occupied by a blue platform, almost as pale as the curtains in the previous room. It looks like a plinth, capable of supporting a monumental statue. But the platform is deserted, and the light bulbs ranged around its edges serve only to heighten the sense of departure. The title of the work specifies that, 'when installed publicly', it will be animated by a 'go-go dancer in a silver lamé bathing suit, sneakers and Walkman'. But the dancer only performs for five minutes every day at the Serpentine, at an unannounced time. So most visitors are left with the plinth's emptiness.

The more you wait there, in the hope that the figure might suddenly appear, the more frustrating and thwarted the platform appears. The expectations it arouses remain unfulfilled, unless you are lucky enough to witness the brief burst of energy by the elusive dancer. Even if he had appeared while I was there, his performance would have been curiously silent. The music on his Walkman remains unheard by anyone except himself, unlike the Straussian strains available to every visitor wondering whether to have a waltz in the first room. By reinforcing the go-go dancer's privacy, Gonzalez-Torres surely meant him to seem beyond reach. Although his presence for the allotted time each day cannot be doubted, the body moving so quietly on the plinth must appear more like a mirage than flesh-and-blood reality.

The final room dramatises this life-and-death duality still more movingly. In one corner, a pyramidal heap of green sweets individually wrapped in cellophane allows you, once again, to take one. But the fierce lime flavour is tart, discouraging all thoughts of illicit indulgence. And

the twisted cords of the light bulbs dangling from the ceiling look disconsolate here. They resemble the bedraggled last stage of a party, and the accompanying caption, far from encouraging us to take a bulb away, warns us not to touch 'as they are very hot'. The rest of the room is empty, apart from a colour photograph of Alice B. Toklas and Gertrude Stein's grave in Paris. It appears to be covered in flowers, and a cascade of water is evoked by the blue and white plastic beads streaming down from a nearby doorway. Beyond, like a parting gift, two piles of paper wait for us to take our copies away. They look identical, but each pile is printed with a subtly different sentence isolated in the middle of an immense whiteness. One, referring to 'Somewhere better than this place', seems to offer consolation to anyone faced with the prospect of death. But the other sentence sadly acknowledges the full extent of the regret that premature extinction will provoke: 'Nowhere better than this place'.

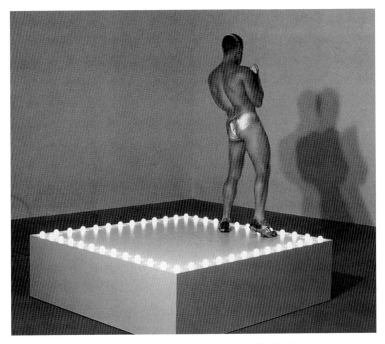

48. Felix Gonzalez-Torres, '*Untitled*' *(Go-Go Dancing Platform)*, 1991

Like his billboard image of an empty, rumpled bed, now displayed in underground stations and on hoardings elsewhere in London, these sentences sum up Gonzalez-Torres's governing obsession. For the two pillows on the bed bear the indentations of the heads that recently lay there. Although they speak of intimacy and love, the disappearance of both occupants also prompts us to lament their loss.

GALLERIES RENEWED,
TRANSFORMED, CREATED

THE NEW POMPIDOU

5 January 2000

After twenty-seven months of frustrating closure, Paris's leading popular attraction has re-emerged at last. Although the Pompidou Centre only opened as recently as 1977, it was threatened by rust and the overwhelming pressures of the eight million visitors who invaded the building each year. The cost of tackling the damage escalated to an exorbitant £54 million. And Richard Rogers, who designed the Pompidou with his Italian partner Renzo Piano, has been mysteriously excluded from the renovation scheme. Piano oversaw the renewal, and a retrospective show celebrating his career will open there later this month. But the all-important task of remodelling the Pompidou's Museum of Modern Art, with an extra 50,000 square feet on levels 4 and 5, was entrusted instead to Jean-François Bodin. Since he has also reshaped the public library below, and the galleries for temporary exhibitions above, it is clear that the Centre wanted a fresh look as well as structural repair.

The Pompidou was right to regard the overhaul of display as an urgent

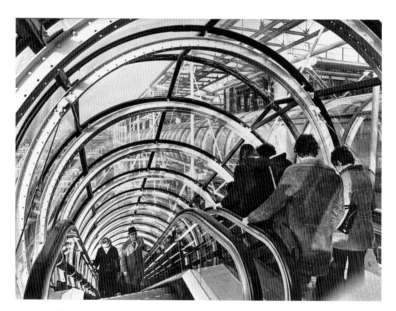

49. Escalator at Pompidou Centre, Paris

priority. In its original open-plan interior, the collection never seemed to be displayed with the aplomb it deserved. I often felt lost within the labyrinth of partitioned spaces. They looked temporary, failing to provide a confident sense of place. The exhibits suffered, and the Pompidou's President, Jean-Jacques Aillagon, now admits that the visitors' ratio for the permanent collection 'has always been a disappointment'. Too many people, apparently, took the free ride up the external escalators, savoured the spectacular views from the top, and then left without paying to see the art. From now on, that option will no longer be available. And visitors encounter a collection presented far more enticingly than before. A new command of drama enlivens the display devised by its Director, Werner Spies. He confronts us, at the level 4 entrance, with the provocative orange presence of Claes Oldenburg's *Giant Ice Bag*. Slowly, even mournfully, it rises to an overwhelming height and then, absurdly, collapses. At once celebratory and satirical, this *tour de force* of New York Pop Art announces a new spirit of showmanship at the Pompidou. Armed with an annual acquisitions grant of £3 million, the museum has been buying objects as flamboyant as *Giant Ice Bag* to give the collection an extra *élan*.

50. Claes Oldenburg, *Giant Ice Bag*, 1969–70

Other recent purchases are equally arresting. Nothing could be more theatrical than Francis Picabia's enormous painting *Le Dresseur d'Animaux*, where an owl perches incongruously on a stand while dogs prowl, scratch and leap up at their sinister, masked trainer. But even the most exuberant acquisition could have been snuffed out by dismal display. I am relieved to report that Bodin has achieved remarkable improvements in the presentation of modern art. It begins upstairs on level 5, where big early paintings by Matisse and Picasso flank the entrance to the first room. Here the first avant-garde group on show, the Fauvists, are displayed in all their flaring, sensual incandescence. Each eye-burning canvas is given plenty of white space on the wall.

Spies has adopted 'less is more', a classic modernist dictum, as the principle guiding his approach to hanging. And it pays awesome dividends in the second room, where four grand, vertical Cubist paintings by Braque and Picasso dominate the far wall. Their impact is magisterial, announcing the emergence of the most far-reaching movement in twentieth-century art. Opposite them, Spies has placed a showcase of African and Oceanic carvings collected by those artists most indebted to 'primitive' sculpture. Its profound influence on Cubism is beyond dispute, but the carvings also inaugurate a refreshing emphasis on sculpture throughout the collection. Revolutionary carvings by Derain and Laurens enjoy prominent positions early on, and major works by Calder, Ernst and Miró enliven the terraces overlooking the roof-tops of Paris.

The views commanded by the Pompidou benefit paintings as well. Turning from Robert Delaunay's exhilarating canvas of the Eiffel Tower, we find ourselves, directly opposite, confronting the tower itself through a nearby window. Inside, Bodin has adopted a subtle, sensitive approach to his improvements. The grand concourses running the full length of each level are retained, even lengthened. But the rooms leading off these spaces now seem more settled, substantial and serene. They allow us to focus more sharply on the images shown there, and discreet lighting confined to the edges of each room illuminates everything with great clarity.

It enables us, for the first time, to assess the strength of the Pompidou's modernist holdings. According to the bullish and patriotic Aillagon, the collection 'has no other equivalent in the world than New York's MOMA'. In other words, the reborn Pompidou already considers itself superior to the forthcoming Tate Modern at Bankside. But how does this claim square with the work on show? During the earliest decades of the twentieth century, the Pompidou is undoubtedly richer than the Tate. Matisse is shown at his most sublime in a wonderful room, where three outstanding canvases painted during the Great War hang opposite his

superbly severe, icon-like portrait of the great collector Pellerin. Kandinsky, represented at the Pompidou by over 250 works, is impressively displayed with several dynamic, pioneering abstractions. Léger, Mondrian and Malevich are likewise shown at full strength. The Expressionists and Futurists are far less amply represented, but the Tate is also weak in those areas. British artists are wholly invisible at the Pompidou until the emergence, at a much later stage, of Francis Bacon. On the whole, though, the pre-1945 avant-garde is displayed with impressive breadth, and the Surrealist collection has been transformed by the recent gift of Ernst's marvellously witty, nightmarish collage series *La Femme 100 Têtes*. The Pompidou finds room, too, for architecture, design and film. Le Corbusier's magical maquette for his sublime chapel at Ronchamp is among many exhibits that stress the fruitful interplay between artists and architects. In the same interdisciplinary spirit, Buñuel's scandalous cinematic masterpiece *L'Age d'Or* is screened in a dark space near a room devoted to de Chirico's images of eerily deserted piazzas.

After the Second World War, however, the Pompidou collection is less outstanding. My own prediction is that Tate Modern will surpass its Parisian rival in terms of art's development from 1945 until now. On level 4, where the later decades of the twentieth century are surveyed, the Pompidou's grasp loses its former authority. American art is patchily represented, and I did not feel that the Centre is engaging vigorously with the art of today. Spies told me that a different notion of time is at work on level 4, where the rooms' contents will be changed with far greater fluidity and younger artists dropped in at strategic points. Such a freewheeling approach is healthy enough, and should ensure that the collection never stagnates. But there is surprisingly little room left for the art of the future, which will surely need large spaces in order to be shown with the flair it deserves.

The challenge of catching contemporary art's pulse will be met, above all, on the dramatically remodelled level 6. Expansion there enables the three modules to show an ambitious, constantly shifting range of temporary exhibitions. Their commitment to present-day initiatives is heralded by *Jour de Fête*, a lively survey of young French artists filling two galleries with uninhibited, often zany inventiveness. Next week, another large gallery on level 6 opens with an ambitious exploration called *Le Temps, Vite*. Ranging from Holbein to Bruce Nauman, it will give more space to visual art than the current 'Story of Time' blockbuster at Greenwich. But the Pompidou's longstanding commitment to experimental music is also reflected in its decision to let the composer Heiner Goebbels create a 'scenic direction in sound', running through the show like a wave.

Until the entire building's profusion of activities gets fully under way, its true vitality cannot be measured. Concerts in abundance will be performed on level −1, a vast underground area now transformed into a home for four superbly equipped theatres dedicated to dance, theatre, music, film, debates and symposia. They should all ensure that the Pompidou becomes a crucible for cross-fertilizing developments in the century ahead. Visual art will never be seen as an isolated activity in this re-energized institution. Nor will it adopt a haughty attitude to public understanding. On level 0, an immense new education area includes a gallery specially for children, as well as workshops where enjoyment of art can be expressed in a more practical, uninhibited way. The old stereotype of the museum as a stern institution dedicated to moral improvement has been banished for ever, allowing far more supple and invigorating alternatives to flourish instead.

THE NEW ART GALLERY, WALSALL

16 February 2000

Kathleen Garman, the girl from Wednesbury who became Lady Epstein, would be astounded. When she and her friend Sally Ryan gave their collection to nearby Walsall in 1974, it was housed in the local library. Screens were installed to display the 350 works by 153 artists, and an air of well-meaning clutter prevailed. Now, however, the Garman Ryan Collection has been transformed. Its paintings, watercolours, prints and sculpture, including forty-three works by Jacob Epstein himself, are unveiled today in a new, purpose-built gallery of outstanding and awesome stature. Designed by the young architects Caruso St John, this £21 million Lottery-funded building is a triumph and a delight. It is also a towering achievement for Peter Jenkinson, the gallery's tireless and engaging Director. His enthusiasm overcame everyone who refused to believe that a blighted industrial town in the Midlands either wanted or deserved such a monumental showpiece. Siding with Garman, who wrote in 1973 that 'I feel we are dealing in dreams', he is a visionary who entertains the boldest possible hopes for the gallery's social role.

Far from deploring or sneering at the building, local people seem proud of their new arrival. When I left the station and asked for directions, the man by the flower-stall said cheerfully: 'You can't miss it – it's

the biggest building in Walsall!' He was right. But the gallery gains from the tactics of surprise. Rather than revealing itself at once, the building stayed hidden while I walked up the pedestrianized street towards Woolworths. Then suddenly, round a narrow corner, my eyes were ambushed by Caruso St John's soaring cubic monolith. Although uncompromisingly modern in its refusal to employ superfluous decoration, the purged and pale structure rears like an ancient fortress from a once-derelict part of the town centre. The building's rectilinear severity and subdued terracotta tiling are utterly removed from the swaggering, baroque theatricality of Frank Gehry's Guggenheim Bilbao. But its appeal is still potent. Four-square and robustly assertive, this doughty *tour de force* has a sense of absolute finality. Its 100-foot tower looks wholly at home in surroundings where industrial chimneys still thrust upwards from Victorian foundries. And the expanse of water alongside reinforces its kinship with a moated castle.

There is nothing grim or oppressive about its sturdiness, though. The vehicle-free Gallery Square designed by Richard Wentworth offers a welcome to anyone passing through, and his black, six-metre-wide asphalt stripes fling themselves across the ground like shadows cast by a giant sun. High above, another artist's commission is installed on top of a neighbouring block: a blue neon sign by Fiona Banner, illuminating the words 'Be There Saturday, Sweetheart' written in a love letter from Epstein to Kathleen. And down below, in a large gallery window, Catherine Yass is screening a sequence of video works shot around Walsall, ranging from lyrical children's faces in a chip shop to a claustrophobic freshwater sewer running under the High Street.

Once inside the gallery, in a foyer as immense and muscular as a medieval keep, its austerity softens. True, the ceiling is raftered with redoubtable concrete beams, and the same material reappears, subtly textured, on the upper walls. But it gives way to Douglas fir timbers further down, and their colour lends immediate warmth. The urge to touch is irresistible, for Caruso St John know precisely how to make their surfaces seductive. And in the very first room, at the foot of the wide staircase leading to the galleries above, children are invited to feel, explore and make their own versions of the original works, including a Damien Hirst spin painting, on view there. Called the Discovery Gallery, its prime position in the building announces Jenkinson's commitment to young visitors who may never have visited a museum before. In this respect, he is again honouring the beliefs of Kathleen Garman, who hoped in 1972 that the collection would strike 'a note of intimacy and spontaneity that will appeal to all ages'.

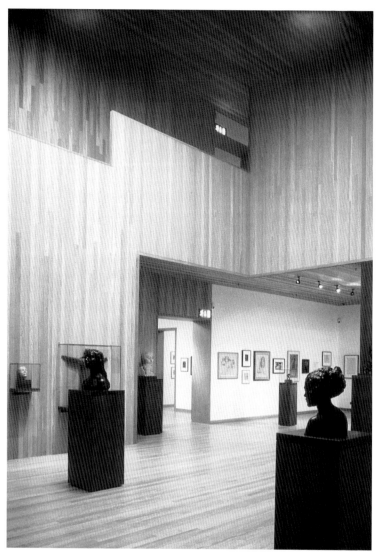

51. Interior of Caruso St John's New Art Gallery, Walsall

Setting off to investigate the rest of the building, I soon realized that it achieves a brilliant balance between dignity and approachability. The broad stairs, deep-set windows and tall passageways are all noble in form, mercifully unadorned and a pleasure to encounter. But the gallery spaces are also capable of accommodating with ease the smallest, slightest drawings from the Garman Ryan gift. Several Epstein bronzes confront us first, perched on plinths in a large, panelled space. It is as impressive as the hall in a great country mansion. I was reminded in particular of the great Tudor house erected by Bess of Hardwick in Derbyshire. Without indulging in pastiche, Caruso St John have created a similar sense of unforced grandeur here.

At the same time, the lower-ceilinged rooms behind show off objects small enough to hold in your hand: a greenstone Maori carving of a grinning figure, a Chinese incense burner shaped into a tortoise, and a sternly incised comb from New Guinea. Roaming freely across continents, the sculpture reflects Epstein's own pioneering fascination with cultures far removed from the classical tradition. But there are outstanding European images here as well. Van Gogh's spiky drawing of a hunched, dejected prostitute is the epitome of desolation, and inscribed in the artist's hand with the question 'how can there be on earth a woman alone, abandoned?' As for Modigliani, who befriended the young Epstein when *The Tomb of Oscar Wilde* was installed at Père Lachaise Cemetery in Paris, he is represented by a poised and sensual crayon study of an undulating female *Caryatid*.

The pleasures of the display are heightened, time and again, by unexpected juxtapositions. The rooms are hung thematically, and we find Géricault's virile oil *Study of a Nude Man* placed next to Epstein's frankly phallic charcoal drawing for his mechanistic *Rock Drill* sculpture. Not all the displays are as provocative: an untypically dark Monet of *The Sunken Road in the Cliff at Varengeville* is hung, aptly enough, near Bonnard's view of *The River Seine at Vernon*. But I relished the more surprising and revelatory pairings. Degas's solemn portrait of his young sister Marguerite is positioned next to Lucian Freud's portrait of his first wife, Kitty. These two paintings, executed when both artists were young, are exactly the same size. The Degas is warm, full-face and intimate. The Freud, painted nearly a century later in 1948–9, is cool, profile and oddly remote. Kitty, whom Freud married in 1947, was the eldest daughter of Kathleen and Epstein. Her nervous, wide-eyed features appear in several of Freud's finest early portraits, but here she turns away. Her tense mood is accentuated by the peeling paintwork on the shutters behind, and the light filtering through them picks out each tendril of Kitty's hair with forensic

precision. Degas's portrait is softer in handling, but Marguerite still seems reserved and a little melancholy.

Closely hung on the walls and clustered in showcases, the Garman Ryan exhibits deserve studying near-to. The feeling of a family affair, embracing work by relatives as well as by Dürer and Matisse, gives the collection its idiosyncratic informality. Upstairs, however, a more monumental series of spaces has been constructed for temporary exhibitions. With lofty raftered ceilings and dark concrete floors, these magnificent rooms make spectacular use of natural light. They will surely enhance everything installed there in future, and certainly provide a superb, luminous setting for the inaugural show called *BLUE: borrowed and new*. It is a celebratory survey, exploring the sensuous and haunting presence of the colour blue in twentieth-century art. The theme is wide enough to let Jenkinson bring together new work and modern classics as icon-like as Picasso's 1905 *Girl in a Chemise*. He is not afraid to hang unlikely paintings next to each other. The Picasso, a wan yet tender image from the end of his Blue Period, looks better here than it has ever done at the Tate Gallery. It is treated as the centrepiece, and proves a commanding presence even when seen through a distant doorway. At the same time, Picasso's stained and dribbled paint is handled so freely that it could be the work of a young painter today.

Its vitality is stressed by the nearby presence of Jason Martin's exceptionally vigorous new painting, alive with linear rhythms coursing across the surface like waves breaking in a Japanese print. At the other extreme, Callum Innes's new painting thrives on stillness and a few pared-down blocks of reined-in colour. Some powerful sculptures are included, among them Anthony Caro's 1965 painted steel *Slow Movement*, Tony Cragg's fragmented *Policeman* relief in found plastic, and a meditative plaster and pigment piece by Anish Kapoor. On the whole, though, the emphasis rests on paintings. They range from Franz Marc's lyrical expressionist *Blue Foals* to Andy Warhol's *Last Supper*, seen through a blue so deep and intense that Christ and his disciples appear to float underwater.

Although James Turrell has not been selected, his luminous vision of nature is evoked in views of clouds and sky through the windows. Caruso St John continually make us aware of the world beyond the gallery. And their prodigious structure comes to a stunning climax on the top floor, where windows of panoramic proportions combine with a wide, open-air terrace to provide vistas of epic immensity. Gazing out over Walsall to the countryside far beyond, I realized just how boundless the gallery's appeal could be. For this exemplary building is, above all else, an act of faith. It deserves to attract not simply local visitors but anyone,

across the world, who cares about placing architecture and art at the very heart of daily life. Kathleen Garman's dream has become a handsome reality, sending out its message of regenerative optimism as a new century begins.

TATE BRITAIN'S INAUGURAL SHOW
27 March 2000

Now that Tate Britain has lost all its modern foreign masters, will the depleted old gallery lapse into a timid nationalistic backwater? To judge by its opening displays, the answer is a defiant 'No'. Even before we enter the spruced-up Millbank building, a giant neon work by provocative young artist Martin Creed proclaims his defiant belief that contemporary British art should have the widest global resonance. 'The whole world + the work = the whole world' announce his white letters, adding an elegant glow to the sturdy Victorian portals. Creed's clarion-call turns out to reflect the mood inside the building as well. Far from mourning the loss of all its Picassos to Tate Modern at Bankside, Tate Britain is determined to stress that it still retains a feisty contemporary edge. And it is also eager to scotch the idea that the Millbank collection will henceforth look narrowly insular. On both these counts, the woman whose new work now fills the lofty Duveen Galleries could hardly be better chosen. For Mona Hatoum is among the most mesmeric of the individuals who have transformed British art over the last decade.

Equally significant, for a collection anxious to look beyond these shores, is the fact that she grew up far outside our territorial boundaries. Although a British citizen, Hatoum was born in Beirut. Her parents are both Palestinian, and she only settled in London at the age of twenty-three. The year was 1975. Civil war had broken out in Lebanon while she was visiting Britain, and Hatoum decided to stay. She has been based in London ever since, but her attitude is the very opposite of parochial. Preoccupied with the fragility of the human body, and the violence constantly inflicted on it, she knows just how to trigger a powerful sense of unease. Nowhere more overwhelmingly than in the first sculpture to confront us. Towering so high in the air that it makes the Duveen space shrink, this dark colossus in mild steel looks at first like a gigantic predator from another planet. But then we begin to identify its component parts, and realize that the entire structure

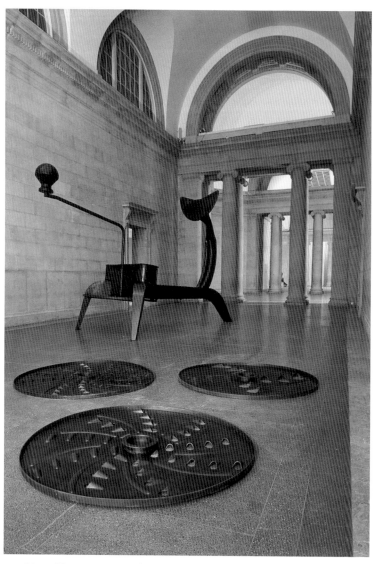

52. Mona Hatoum, *La Grande Broyeuse (Mouli-Julienne ×21)*, 2000

is a vastly enlarged version of a mouli-julienne. The classic French vegetable shredder has been transformed, here, into a sinister apparition. With its immense handle thrusting balefully into space, the machine seems capable of seizing us and, after throwing our bodies into its great drum, slicing us up beyond recognition. Three circular plates lie on the floor nearby, waiting to be used as cutter replacements once the process of destruction has begun. But for the moment, *La Grande Broyeuse: (Mouli-Julienne ×21)* stays grimly poised and expectant, its brutal potential as yet unleashed.

Hatoum sets no geographical limits around the applicability of her work. Just as Martin Creed would hope, she takes a global view. Resting on the floor of the Duveen's central space, a round platform supports a cut-out glass map of the world in low relief. A black layer of iron filings beneath responds to the movement of a motor-driven magnetized arm, circling clockwise and then anti-clockwise. It looks like a radar tracking device, and the filings perpetually threaten to invade the land masses. Their fragility creates a menacing mood, and the title of the work reinforces the sense of ever-shifting malaise: *Continental Drift.*

Rows of taut horizontal wires prevent us from going too near *Homebound*, Hatoum's final exhibit. We are forced to peer through them, like observers who have stumbled across a prison fence. Initially, our eyes travel across a bedroom and kitchen interior dominated by a yellow table. But instead of finding a real mouli-julienne there, we notice a colander, a saucepan, some scissors and a lethal-looking knife. The entire scene seems normal enough, until we realize that all the objects in this large installation are wired to each other. Nothing, not even the birdcage, cot, toy train and bed, escapes these electric coils. Hatoum ensures that they are galvanized by a regular discharge of voltage, too. It fizzes, crackles and flashes, making the entire work resemble a house whose defenceless inhabitants are nowhere to be seen. Perhaps they have fled or fallen foul of ethnic cleansing. Either way, their recent presence can be felt wherever you look in this chamber of death.

Hatoum's icily controlled yet alarming show delivers a rebuff to anyone who thinks that British art is a mild-mannered affair. Elsewhere in Tate Britain, a selection of acquisitions over the last decade also includes some disturbing images. Even in the earliest period, traditionally dominated by portraits of Tudor grandees and monarchs, surprises abound. Nobody knows who painted the strange, haunting panel called *An Allegory of Man*. Probably commissioned for a private chapel around 1596, it shows at the centre a praying man. On every side, the skeletal figure of Death and the Seven Deadly Sins assault him with spears and crossbows. An angel with a shield protects him from the arrows, while Christ makes

a gesture of salvation from the clouds. But the man still looks beleaguered, and the painting gains most of its force from dramatizing his plight with as much gruesome power as the painter can command.

The re-emergence of such a fascinating image makes us revise our lazy preconceptions about British art. So does another recent Tate purchase, Johan Zoffany's crowded and disconcerting painting of *Colonel Mordaunt's Cock Match*. The central figures are galvanized by the spectacle of a vicious fight. Colonel Mordaunt, an English mercenary in charge of the body-guards looking after the Nawab Wazir of Oudh, gestures in trim, elegant clothes. He owns one cock and the plump Nawab, who rushes towards him in high excitement, owns the other. Zoffany spares us nothing in his graphic depiction of the birds' mortal struggle. But he also shows an even more disturbing turbulence breaking out in the crowd behind, where Indian figures jostle and a Muslim boy is attacked by a Hindu man.

The truth is that plenty of British artists, from Hogarth to Damien Hirst, have been prepared to tackle the most disturbing aspects of life. The tradition is upheld by the new generation as well, and Tate Britain does not hesitate to acquire their work. Sarah Lucas is here, brazenly resting her naked bottom on a toilet with trademark cigarette in hand. So is the admirable Chris Ofili, who aroused so much of Mayor Giuliani's absurd anger when the *Sensation* exhibition was shown in New York a few months ago. His enormous painting of a weeping woman is an excellent purchase for Tate Britain. Although Ofili's familiar elephant dung appears here, slung like a pendant from her necklace, there is no desire to court controversy for its own sake. Taking his title from Bob Marley's song *No Woman, No Cry*, Ofili intends the entire painting as a tribute to the murdered London teenager Stephen Lawrence. A close look reveals his face, collaged on to each of the pale blue tear-drops falling profusely from the woman's eyes.

Ofili's painting defies the widely held view that the British shy away from open displays of emotion. Although it was once true, the temper of the nation today is changing. And Ofili is a spirited example of how British art has undergone a metamorphosis. By bringing to his work a whole range of influences, from African culture to hip-hop music, he is helping to combat national stereotypes and transform all received notions about our national identity. Everything is ripe for redefinition in the new century, and Tate Britain should be commended for appreciating the importance of renewal.

But the gallery should never forget its responsibilities to the past. The finest collection of historic British art does, after all, stretch back several centuries, and the great period of landscape painting is here made a focus

for rediscovery. A remarkable school of artists flourished in Norwich during the early nineteenth century, and their finest works have never left the city's Castle Museum before. But now, a Lottery-funded renewal of the Norwich building has enabled it to lend Tate Britain a prime selection of paintings and watercolours by John Sell Cotman, John Crome and the other artists who devoted themselves to depicting the local towns, harbours, beaches and medieval buildings. Their debt to seventeenth-century Dutch landscape painting was considerable, and they were also aware of Turner's revolutionary achievements. But the Norwich School attained a quietly distinctive poetry of its own, showing a becalmed world where boats, trees and people all appear spellbound in their luminous surroundings.

At their best, the Norwich artists are delectable. And the decision to show their work in the Clore Gallery also proves welcome. Turner has presided there for so long that visitors were in danger of imagining that he was the only British artist to pioneer Romantic landscape painting. The Norwich School needed wider recognition, and Constable also deserves a broader representation than he has hitherto been given at the Tate. To find his work filling the first Clore room is a tonic. A choice group of fourteen Constables have been loaned by the Victoria and Albert Museum, ranging from the most spontaneous oil sketches of clouds on Hampstead Heath to a full-scale, wildly handled study for *The Haywain*. Coupled with his electrifying late painting of *The Glebe Farm*, lent by Sir Edwin Manton, they amount to an invigorating spectacle. They also prove, along with Hatoum's show and the other new displays, that Tate Britain has no intention of feeling traumatised by losing half its collection. Looking forward to the opening of its major new extension next year, the Millbank building has already renewed itself in fine, fighting style.

WHITE CUBE² AND ANT NOISES
19 April 2000

Jay Jopling, the prodigious dealer behind Damien Hirst, Tracey Emin and other Young British Artists, has always operated in surprisingly small premises. As its name suggests, White Cube is a plain, simple gallery of modest size, discreetly tucked away up a narrow staircase in Duke Street,

St James's. However memorable the shows held there over the past eight years may have been, they were all constrained by the room's physical limitations. But now, Jopling has moved to the East End and gone monumental. White Cube[2], his new gallery at up-and-coming Hoxton Square in Shoreditch, has its name proudly emblazoned high on the brick façade. Tall glass doors seduce the passer-by with inviting glimpses of the spectacular space inside. And the opening exhibition turns out to be a typically uninhibited celebration of the artists who won such widespread notoriety in the 1990s.

Stretching seventeen metres in length, and generously illuminated by grand rectangles of filtered daylight from the ceiling, the gallery is a handsome arena. Mike Rundell, the architect responsible for Damien Hirst's Pharmacy restaurant in Notting Hill, has here designed a white-walled, concrete-floored space where nothing distracts attention from the work on display. On the far wall, a surprise awaits anyone who imagined Jopling dealt exclusively with young artists. Gilbert & George, who recently made a well-publicised exit from the Anthony d'Offay Gallery, have joined the Jopling stable. And their wide, twenty-one-panel photo piece proves how well they fit in with the YBAs around them. George yells from the centre, red-faced and lodged between the thighs of a naked man. Boughs of trees spread their intricate undulations behind, and threaten to entwine the limbs of the other male bodies reclining at either side. Desire and death fuse in this image, just as they do in so much work by artists who are decades younger than Gilbert & George.

The most erotic exhibit is Sam Taylor-Wood's *Soliloquy VIII*, dominated by a large photograph of a young man's blindfolded head. He seems to be entering a room, and the predella below opens out into a sequence of interiors where distorted perspective lends mystery to the naked men and women lounging there. All this pent-up lust is deflated by Marc Quinn, who reduces his male nude to a grotesquely misshapen piece of cast lead flattened on the floor. The hapless figure seems to have been run over by a pantechnicon. With pummelled head and limp genitals, he is as woebegone as Michelangelo's horribly emptied-out body in *The Last Judgement* at the Sistine Chapel. But at least Quinn's figure still retains the vestiges of his skin. Damien Hirst goes further, robbing his figure of everything except a skeleton. Suspended on a crucifix of glass panels with arms outstretched, he is a macabre spectacle. Hirst rams home the warning behind the sculpture by calling it *Rehab is for Quitters*. But graveyard humour alleviates some of the grimness: the skeleton's eyes, represented by ping-pong balls, float above its empty sockets with the help of a hissing compressor.

Gavin Turk also tackles mortality in his life-size waxwork figure of the dead Che Guevara. But in this case, even with blood-clogged trousers and stains running down from the body towards an adjoining drainhole, the result smacks too much of Madame Tussaud's. Theatrical in the wrong sense, it compares poorly with the restraint of Antony Gormley's *Edge II*, a life-sized naked man projecting his iron body from the wall high above our heads. The loftiness of White Cube[2] is used here with understated power: not immediately noticeable, the Gormley figure suddenly makes its presence felt with a sense of vertiginous shock.

Just how flexible will this new space be? Only after it has adapted to the different needs of solo shows will the answer become clear. But it can be divided up with ease, and the sheer size of the room – far larger than most dealers' galleries – augurs well for its ability to cope with even the most demanding installations. Although Jopling still retains his Duke Street premises, the Hoxton Square building will undoubtedly become his main showcase. And by choosing to settle in Shoreditch, where so many young artists already have their studios, he is helping to shift the axis of the London art scene from west to east.

For sheer immensity, however, no dealer's premises can yet compare with the Saatchi Gallery. It remains, quite simply, the most breathtaking space for contemporary art anywhere in Britain. Charles Saatchi's commitment to his converted factory is vigorously reasserted in the latest show staged there. Called *Ant Noises*, an anagram of *Sensation*, it shows recent work by several of the most prominent artists in that notorious Royal Academy exhibition. The most arresting image, Damien Hirst's six-ton *Hymn*, is so tall that trusses were cut out of the roof to accommodate it. Rearing to a height of nearly twenty feet, it looks as awesome as a colossus from ancient Rome. By a paradox, though, Hirst has based his titan on a Humbrol Young Scientist toy, a ten-inch anatomical figure retailed for £14.99. The fact that Saatchi paid £1 million for *Hymn* has provoked incredulity in the tabloid press, as well as widely publicised indignation from the toy's original designer Norman Emms. But the truth is that Hirst has not been as provocative as Marcel Duchamp, who purchased ready-made objects from department stores and, without altering them in any way, nominated them as his own works of art. Quite apart from transforming the toy by vastly expanding its size, Hirst has changed it from plastic to garishly painted bronze.

No photograph can convey the visceral impact of the giant who now bares his internal organs in the biggest Saatchi space. Surging upwards from a black, polished plinth where Hirst has incised his signature in flamboyant style, it exposes the man's stomach, lungs and intestines with

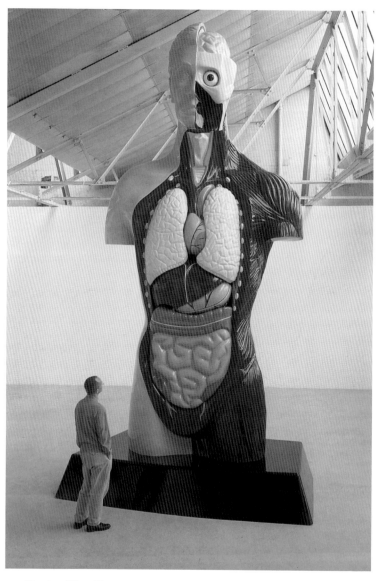

53. Damien Hirst, *Hymn*, 1999

the most brazen clarity. But it is a schizophrenic sculpture. Viewed from his right side, the figure looks surprisingly normal: cream-coloured, placid and physically intact. Then he is turned, on the other side, into a flayed, blood-red apparition fresh from the abattoir. The head is particularly gruesome, with an enormous eye-ball projecting from a white skull-like profile capped by a segment of exposed brain. Worse still, the face has been cut away below the eye. The purpose was originally scientific, to disclose the structure of the mouth, jaw and teeth. But in Hirst's nightmarish version, the sliced cavity resembles a horrific injury sustained in the killing fields of the First World War. So although his starting-point was an instructional toy, revealing the insides of the human body with anatomical fidelity, it ends up as a monstrous and unsettling image. Instead of presenting an impregnable façade to the world, like a classical statue on a heroic scale, the figure seems above all intensely vulnerable.

In this respect, he is akin to Hirst's bisected animals floating in their formaldehyde tanks. The adoption of painted bronze as a medium may appear to remove *Hymn* from his shark, cows and pigs of previous years, but the obsession with mortality is as relentless as ever. Far from being a gimmick, Hirst's formidable new work deserves to be ranked among the most forceful British sculptures of the twentieth century. It has a mesmeric presence, and Norman Emms should feel flattered that his toy has inspired such a powerful meditation on the frailty of the human condition.

Inevitably, *Hymn* dominates everything else on view at the Saatchi exhibition. But the entire show is exceptionally well displayed, and Jenny Saville holds her own next to Hirst with a group of large, enormously assured paintings of naked women. The most haunting is *Fulcrum*, where three bloated bodies sprawl on top of each other in an ignominious heap. Bruised and exhausted, their limbs are trussed with cord. They look like victims, helplessly waiting to be dumped in a charnel house. Saville is developing into a painter of remarkable authority, and her supple manipulation of pigment ranges from passages applied with great delicacy to more impersonal, flat areas and glimpses of spattering like droplets of blood on the bare canvas.

By giving every artist a generous amount of room, the show displays everything with aplomb. Rachel Whiteread's superb *Untitled (One Hundred Spaces)* is a 1995 work, originally unveiled at the *Sensation* exhibition. But it looks far better here without any distracting paintings on the walls around. Ron Mueck's giant suspended *Mask*, a stubbly self-portrait head in polyester resin, also has the maximum amount of scowling impact as it projects into space. The other two participants, Sarah Lucas and Chris Ofili, likewise benefit from their limpid, purged presentation.

The exuberance of Ofili's feisty paintings is undimmed, while Lucas is at her most pungent in a sad, dreamlike self-portrait constructed entirely from filter cigarettes. No two artists could be more contrasted, in mood or materials, and their inclusion here stresses the ever-increasing diversity of the YBA generation as they move towards a greater maturity.

A NEW WING FOR THE NATIONAL
PORTRAIT GALLERY
5 May 2000

Tucked away in cramped, inadequate premises behind Trafalgar Square, the National Portrait Gallery suffered from an identity problem. Although it attracts one million visitors a year, the NPG has often been confused with the far grander National Gallery next door. And once inside, people became even more perplexed by the NPG's eccentric lay-out. Amazingly, a mere 20 per cent of them found their way to the upper floors, where the highly important, pre-Victorian part of the collection was displayed. But now, just over a century after the original building first opened its doors, a major new extension transforms the gallery. With the aid of £11.9 million from the Heritage Lottery Fund, and another £4 million from private donations, a soaring and ingeniously devised wing has been inserted at the very centre of the building. It is a triumph for the architects, Jeremy Dixon and Edward Jones. They realised that a drab service yard between the NPG and the National Gallery could become the unlikely launch-pad for an ambitious, continually surprising intervention. So in 1995 an advantageous deal was struck with the National Gallery, enabling the NPG to gain control of this fallow space. Construction started three years later, and the outcome turns out to be exhilarating.

No new frontage is visible when you approach the gallery entrance. Dixon and Jones's work is all found inside Ewan Christian's doughty 1896 façade. But we do not have long to wait. After walking through the recently renovated foyer and up the first flight of stairs, visitors are now welcomed by a luminous new central hall. The purged simplicity of this cool, white chamber is uninterrupted by portraits of any kind. A solitary column seems to support the floors slicing through the tall space. But the full, dramatic height of the hall only becomes apparent when we walk

towards the steeply inclined escalator on the left. Suddenly, the unexpected loftiness of the structure is revealed. The colossal side wall surges upwards, until it terminates in a wide band of windows ablaze, like a clerestory in a cathedral, with natural light. It is an arresting spectacle. And the dizziness of the hall's triple height is reinforced by the escalator, stretching twenty-three metres up to the level where any proper exploration of the NPG now ought to start: the Tudor Gallery.

Until today, all the portraits from this vitally significant era were scrappily hung on different staircase landings in the old building. Here, by contrast, the exhibits have the coherent setting they deserve. The display commences with Rowland Lockey's imposing, full-size copy of Holbein's great painting of Thomas More and his family. The original, surely one of the finest group portraits ever produced in England, was tragically destroyed. But the Lockey version, for all its manifest shortcomings, at least provides a hint of the spellbinding verisimilitude that Holbein invested in his painting. Mercifully, we do still have Holbein's own cartoon drawing of Henry VIII, standing in a typically assertive pose in front of his father. Made in preparation for a dynastic mural painted at Whitehall Palace, subsequently burned in a disastrous fire, this grave and definitive image looks far better than it ever did before. So do all the other paintings nearby, hung on dark grey walls and spotlit by fibre optic lights that subtly evoke a Tudor atmosphere without resorting to a bogus attempt at pastiche décor.

There is no sign, here or elsewhere, that Dixon and Jones were tempted to indulge in heritage-style, theme-park historicism. They are unapologetically modernist, but that does not prevent them from suggesting the ambience of a Long Gallery in a grand Elizabethan country house. The so-called Ditchley Portrait of Elizabeth I, painted by Marcus Gheeraerts the Younger, looks thoroughly at home in these surroundings. Standing on the globe of the world with her feet over Oxfordshire, this blanched and rigid apparition exudes a formidable charisma. She looks down the room to the end wall, where an equally theatrical group portrait commemorates the 1604 Somerset House Conference, when tense diplomats from Spain and England negotiated a peace treaty from opposite sides of a lavishly draped table.

By no means all Elizabethan images strive for such a monumental impact. Beyond the Tudor Gallery is a small, low-ceilinged space mainly devoted to portrait miniatures. Dimly lit in showcases to protect them from fading, these intricate heads of the monarch herself, along with Sir Francis Drake and other hirsute grandees of the period, exert a potency that far outstrips their modest size. Only two larger paintings hang in this

room, and they both portray playwrights: the robust, earthy Ben Jonson and the more feline Shakespeare, depicted here in the first portrait ever to be acquired by the infant NPG. Beside them, a mood of architectural impishness inspired Dixon and Jones to construct a narrow passage leading off the room. Walk down it, and you will quickly find yourself gaping through a slit-like window at a vertiginous view of the escalator hall far below.

On the level underneath, where the Balcony Gallery is suspended on cables from the Tudor Gallery, the hall becomes far more visible. Four white partitions, all set at an angle to the opposite wall, allow us to move between them and gaze down into the void. They also protect the exhibits from the threat of sunlight beyond. On fine days the brightness of the escalator area will be dazzling, and photographs in particular need shielding from the glare. That is why they are hung on the dark side of the partitions, offering a range of contemporary faces beginning with the young George Best and terminating, at the other end of this immensely long space, with the elderly Isaiah Berlin. He looks apoplectic with indignation, possibly because Lady Thatcher at her most haughty has been displayed next to him.

But the mood lightens on the other wall, largely devoted to paintings that include the shamelessly cosmetic glamour of Andy Warhol's pouting Joan Collins. By their very nature, the portraits owned by the NPG vary alarmingly in quality. Banal and insipid likenesses often find a place here, merely because they are the only available portraits of outstanding people. The aesthetic level of the exhibits rises considerably when we reach a group of artists' self-portraits. A densely furrowed, anguished painting by Leon Kossoff stands out, and so does Lucian Freud's strangely spectral face brooding in the shadows of his own studio. The excellence of such images is all too rare, however. Judged solely as works of art, most late twentieth-century portraits are pedestrian. Some can only be described as excruciating, and their inadequacy raises tough questions about the advisability of commissioning so many routine paintings of celebrity sitters today.

The full richness of the NPG's historical holdings only becomes clear below the Balcony Gallery, where an open-plan IT Gallery occupies the mezzanine level. I am instinctively suspicious of computer rooms in art museums: they could easily seduce visitors into spending their time staring at screens rather than contemplating the original paintings. Here, however, the excellence of the information on offer helped to quell my misgivings. At the touch of a finger, we can gain speedy access to the astounding abundance of the collection stored here. Although the new

54. View from the restaurant in the new wing by Jeremy Dixon Edward Jones, at the National Portrait Gallery, London

wing provides 50 per cent more public and exhibition space for the NPG, it is still unable to display more than a fraction of the images in its care. Over 250,000 portraits are preserved in the Photographic and Archive Collections alone, and another 10,000 can be found in the Primary Collection. The IT Gallery provides by far the speediest means of summoning them up. A remarkable array of Charles Dickens portraits, ranging from Maclise's idealised painting of the young prodigy to scratchy caricatures of the ageing, cantankerous novelist, all appear on the screen at once. But details from individual images can easily be obtained, and you may even turn the pages of photographic albums as fascinating as Lewis Carroll's studies of his Oxford contemporaries. The trickery in the NPG's celebrated anamorphic portrait of the short-lived Edward VI is analysed with great clarity, showing precisely how its illusionism teases the eye. And we can watch video interviews with artists, who describe how they set about painting portraits for the collection.

So long as the IT Gallery does not tempt visitors to ignore the paintings on the walls, its advent should be applauded. For these ten large touchscreens add up to an invaluable resource, and should help anyone eager to explore the individuals who helped to shape the nation's history.

But even the most indefatigable researcher grows tired eventually. And the new extension reserves its most spectacular *coup* for everybody who mounts the uppermost flight of stairs to roof-top level. For here, running all the way along one side of the new Portrait Restaurant, is a revelatory view. It extends over the National Gallery, across Trafalgar Square and down Whitehall to Big Ben and beyond. The heart of London is seen, through this astonishing panorama, in a wholly unfamiliar way. Swinging our gaze round from the steeple of Gibbs's St Martin in the Fields to the summit of Nelson's Column and a close-up of Wilkins's dome crowning the National Gallery, we can relish this aerial prospect as keenly as the historical discoveries waiting to be made below. Both the architects and Charles Saumarez Smith, the NPG's enterprising Director, deserve an accolade for turning the awkward old gallery into such an irresistible delight.

TATE MODERN OPENS
10 May 2000

In two days' time, Britain's attitude to visual art undergoes a momentous transformation. Entering the newly opened Tate powerhouse on Bankside, the public will be able to explore the nation's first fully fledged modern art museum. The interest it excites is impossible to calculate, but I predict that the response will outstrip all expectations. For Tate Modern is an irresistible showcase, enabling us at last to celebrate the sweep of a seismic period dominated by artists at their most inventive, bold and turbulent.

Soon after I began visiting galleries, the British unwillingness to grant modern art due prominence struck me as deplorable. Writing as a hot-headed undergraduate for *Cambridge Review* back in 1969, I called for the building of a new gallery devoted to twentieth-century art and funded by a nationwide lottery. Even then, the absurdity of the Tate's dual role seemed indefensible. Crammed inside a Victorian building at Millbank, modern artists were forced into an uneasy coexistence with the historic British collection. In this hopelessly schizophrenic institution, the full significance of modernism's eruptive vitality was always underplayed. It seemed to have been admitted to Millbank only with profound misgivings, and treated like a dysfunctional child whose behaviour is endured but never relished.

Now, thanks above all to the steely resolve of the Tate's Director, Nick Serota, this shameful nonsense has been terminated. The converted power station at Bankside amounts to a long-overdue, monumental vote of confidence in the art of our era. And it reflects a dramatic change of outlook in a country whose anti-modernist prejudices once seemed so ingrained. They belong increasingly to a dismal past, overtaken now by a new generation with different, far more refreshing priorities. The automatic impulse to condemn experimental initiatives out of hand has been shaken off. Members of the young, ever-expanding audience for art no longer confine their sympathies to work that satisfies rigid, preconceived notions about what art 'ought' to be. They enjoy being taken by surprise and shaken out of narrow, censorious habits. They are, in a word, open. And they realise that the momentum of change will not slacken in the century ahead. It may well accelerate, for art always runs the risk of ossifying if it does not seize the chance of renewal. Our old stagnation and blinkered defensiveness must never be allowed to blight Britain's visual culture again. Hence the overwhelming importance of the Tate's Bankside colossus, where the full, restless dynamic of the modern period in art is revealed without hesitation or apology.

The sheer size of this gaunt industrial building might raise the fear that its contents will be dwarfed by the architecture. But anyone walking down the epic entrance-ramp into the vastness of the Turbine Hall is confronted, at its centre, by Louise Bourgeois's gigantic steel spider. Called *Maman (Mama)*, this egg-carrying apparition rises to an awesome height of thirty feet from the bridge spanning the Hall. Although the spider embodies girlhood traumas that continue to nourish the eighty-nine-year-old artist's work, Bourgeois has given her sculpture a spellbinding presence. It charges the emptiness around it with sinewy power.

Her three tall towers installed beyond are even more provocative. Rather than appraising them from a distance, we are invited to climb their spiralling staircases and confront the circular mirrors sprouting at the top. The installation is entitled *I Do, I Undo, I Redo*, reinforcing the idea of a psychological journey where self-definition is in conflict with despair, confusion and loss. In the middle tower, where a heavy steel door clangs shut alarmingly behind us, we find ourselves gazing up a cylindrical shaft studded with fierce lights. But the overall feeling, enhanced by recurrent images of a mother and child, is positive rather than depressing. And the way we are encouraged to discover the secrets lodged within the towers prepares us, in turn, for the freewheeling spirit that informs the brave arrangement of the Tate's permanent collection in its new home.

55. Interior at Tate Modern, London, with the Louise Bourgeois towers
I Do, I Undo, I Redo, in May 2000

The old chronological approach to the story of modern art has been jettisoned. And along with it, the reliance on a sequence of 'isms' charting the rise and fall of avant-garde movements in separate countries. Instead, the collection has been divided into four main sections, reflecting the principle subjects of art: still life, landscape, the figure and history painting. All these traditional categories have undergone deep-seated changes during the twentieth century, and incessant shifts in emphasis are charted as we move through the rooms. Unfussy, handsomely proportioned and built to last, the galleries designed by Herzog & de Meuron provide an admirable backdrop. The architects were clearly determined to serve the art, not indulge in an ego-trip. At the front of the building, windows offer beguiling views over the Thames to St Paul's beyond. It is a seductive and inspirational prospect, offering tough competition for the exhibits on the walls. But the majority of rooms have no windows, thereby ensuring that we can concentrate on looking hard at the work shown there.

In the Still Life section, the outstanding quality of Tate Modern's display spaces becomes clear almost at once. After passing through a small room, where seminal works by Braque, Duchamp, Morandi and Kosuth introduce key transformations through the century, I was transfixed by a Patrick Caulfield in the gallery beyond. It hangs in a large, luminous space near a grand Lichtenstein bedroom interior, a radiant Craig-Martin painting and lean furniture sculpture by Artschwager. They add up to a superbly coherent ensemble, but Tate Modern can be equally effective when focusing on a single artist. The unchronological plan enables curators to bring together works from different periods by an individual as outstanding as Tony Cragg. His big room, encompassing early stacked work from the 1970s as well as a recent glass sculpture, is a triumph. It demonstrates Tate Modern's welcome willingness to give contemporary artists as much space as the hallowed masters of modernism. Nearby, a limpid room is devoted to Duchamp and Picabia, enhanced by several much-needed new purchases like Duchamp's notorious ready-made urinal, called *Fountain* and signed 'R. Mutt.' Cragg is inconceivable without Duchamp, but Tate Modern allows us to make the connection for ourselves.

At every turn, it highlights the continuing stimulus of the past by viewing it from today's perspective. And in some places venerated historical work is shown alongside recent art. A gallery devoted to 'Subversive Objects' includes Surrealist sculpture as flamboyant as Dalí's *Lobster Telephone*. But it also shows how Surrealism affected the original cover design of Germaine Greer's *The Female Eunuch*, and finds space for

Sarah Lucas's disturbing fusion of a chair with a headless female body. Film finds a merited place at Tate Modern as well. On a tiny screen in the 'Subversive Objects' room, we can watch Buñuel's eye-slitting scene from a surrealist movie that still has an unsettling power seventy years after it was shot. But an entire gallery is given over to the screening of Léger's mesmeric 1924 film *The Mechanical Ballet*, and an extensive loan from the Victoria and Albert Museum means that photography, in the shape of the revolutionary New Objectivity movement, also plays a potent role in the Tate's expanded view of modern art.

Not all the displays are so successful. Matisse's sublime *L'Escargot*, one of the collection's greatest images, needs the maximum amount of space available. But it looks cramped here, in an over-busy room called 'Structure and Form' in the Landscape section. Brancusi, in this cluttered gallery, is overshadowed by the looping rhythms of a Richard Deacon sculpture nearby. Too much is going on here – a surprising failure in view of the lucid presentation that prevails elsewhere.

The gallery given over to Joseph Beuys is particularly stunning. Far higher than most, and lit by immense vertical windows like a secular cathedral, it contains two spectacular works: the heaped basalt boulders called *The End of the 20th Century*, and an exclamatory masterpiece lent by the Davros Collection entitled *Lightning with Stag in its Glare*. Dramatically suspended from a steel beam high above our heads, the triangular bronze seems to pierce the entire space with its high-voltage force. Throughout this incessantly exciting, roller-coaster ride of a museum, individuals thrive with more vigour than movements. Even when a large room is filled with major surrealist canvases by Ernst, Magritte and Miró, it ends up with the title 'Inner Worlds'. Wherever we look, the Tate invites us to think about intention and meaning rather than the clash of art-historical style wars. It offers a bracing corrective, and enables the curators to break the automatic habit of dividing artists so neatly and predictably into national schools.

In the section devoted to the Figure, a room called 'The Myth of the Primitive' unites Epstein with Modigliani, Kirchner with Derain, and Gaudier-Brzeska with Picasso. Far more startling, though, is the next gallery where Matisse's four great bronzes of a nude female are displayed opposite Marlene Dumas's full-frontal ink studies called *Magdalena 1–6*. And then, through heavy wood doors, we are confronted by one of Bacon's finest triptychs: an elegiac work meditating on the suicide of his lover. The vertiginous view from here, plunging down towards the Bourgeois towers far below, is almost as compelling as the emotions untapped by Bacon. But the sheer intensity of his triptych, combined

with his far earlier *Three Studies for Figures at the Base of a Crucifixion*, draws our attention remorselessly back to the art. Further on in the Figure section, I was particularly impressed by an unexpected pairing of Giacometti and Barnett Newman. A row of etiolated bronze bodies gaze across at Newman's two paintings of *Adam* and *Eve*. Flat, purged abstraction is contrasted with pummelled, vulnerable images of humanity *in extremis*. And yet both artists gain from this unlikely confrontation, and emerge united by their commitment to direct, uncompromising emotional conviction.

The grandest room here is devoted to American Minimalists, but Tate Modern again avoids the 'ism' and calls it 'The Perceiving Body'. Those three words challenge us to see Andre's metal floorpiece, Judd's ascending steel units and Morris's hanging fibreglass sculpture in relation to corporeal experience. However remote and austere they may at first appear, these works are shaped by fundamental bodily concerns. On the whole, the second half of the twentieth century is shown to better advantage than the first. It is a regrettable yet sadly understandable imbalance. For Tate Modern's collection is weak in cardinal works from the early, heroic years when the modern revolution was at its most volcanic. True, the opening room of the History section introduces us to militant manifestoes from that heady period. Pages from the Futurist broadsides, the Vorticists' belligerent magazine *Blast*, the Bauhaus manifesto and surrealist publications shout from the walls, along with radical paintings by Kandinsky, Malevich, Wyndham Lewis and Moholy-Nagy. But it is a small arena, especially compared with the vast gallery next door where 'Structures for Survival' includes sculpture as immense as Mario Merz's igloo.

Today's work often requires extravagant amounts of space, and the gigantic scale of Giles Gilbert Scott's old power station seems ideally suited to house the enormous installations made by so many artists now. They are seen at their most ambitious in a special survey of twenty-five leading contemporaries called *Between Cinema and a Hard Place*. The title derives from a work by Gary Hill, one of the most outstanding and poetic practitioners of video art. But the show ranges broadly, from Antony Gormley's crouching cast-metal figures to a nightmarish labyrinth where Ilya and Emilia Kabakov lead us through narrow, shabby corridors towards an inner room where the air of desolation is at its most poignant. Video work, which has reached a formidable maturity over the last decade, is shown at its most bizarre and erotic in Matthew Barney's theatrical exhibit. But Bill Viola goes far deeper, contemplating the essential mysteries of birth and death in his hugely moving *Nantes Triptych* where

a baby's emergence is juxtaposed with the last moments of the artist's elderly mother.

Although wildly different materials and strategies are deployed in this survey, many of the exhibits share a preoccupation with mortality. Christian Boltanski uses photographs to create a dimly lit, shrine-like memorial to blurred faces, whereas Douglas Gordon deploys archive film to chart the near-unbearable dilemma of a young man traumatised by the Great War. Cornelia Parker organised her own explosion to blow up the contents of a shed, and she suspends the remains in a melancholy yet strangely resilient cluster of preserved fragments. As for Rachel Whiteread, her *Ghost* presents a glacial cast of the emptiness inside a living room. Its sealed-up surfaces are mournful, but they also testify to the endurance of intimacy, domestic quietness and love.

However radically these works may depart from conventional ideas of art, they repay prolonged scrutiny. For the artists who made them offer enormously stimulating, alternative ways of understanding the world and our place within it. Now, at the beginning of a new century, the advent of the magnificent Tate Modern means that Britain no longer has an excuse for ignoring or dismissing such work. Anyone who visits Bankside will be invigorated, not only by an awesome building, but by encounters with artists who are alive to the multiple, unpredictable energies of their own time.

THE HOLOCAUST EXHIBITION

7 June 2000

Time and again in this overwhelming exhibition, survivors break off their recollections of the Holocaust, falter and then admit in voices disintegrating with emotion that it was 'beyond describing'. So how can the Imperial War Museum hope to convey the truth about such an abomination? After four years of planning, with a £17 million budget, its ambitious Holocaust Exhibition opens today in a new extension. But visitors entering the show must wonder if any amount of expertise will ever get near enough to the central darkness of the Nazis' genocidal atrocity. At first, I feared that the survey would tumble into sentimentality. In a curved, wood-panelled room, *Life Before The Nazis* offers film footage of Jewish families dancing, skating, swimming, sunbathing and laughing at

Chaplin movies. A German male-voice choir sings 'Happy Days Are Here Again', while schoolchildren wave at the camera with no trace of fear on their faces. On a nearby screen, an elderly woman recalls how 'I was the apple of my father's eye', and framed photographs testify to the close-knit affection of family life. No reference to the unrest and despair afflicting Germany after the defeat of 1918 can be found here, and I wondered if the rest of the exhibition would present an over-sanitised vision.

My doubts were blasted away before I reached the end of the opening room. A large screen set at a slanting angle introduces film of Hitler's war. Below, a terse statement informs us that six million Jews were murdered by industrial methods, while the new racism also led to the extermination of blacks, 'gypsies', homosexuals, people with disabilities and the mentally ill.

Turning a corner, I found myself in a low-ceilinged gallery shaken by the sound of crowds chanting their hysterical adoration of Hitler. It was the start of a journey into hell, made all the more harrowing by the show's refusal to indulge in over-emotive tactics. If anything, too many words punctuate this section, explaining how the Jews, a traditional scapegoat, were blamed by many Germans for their country's defeat. But the filmed evidence, showing book-burning, slogan-daubing on shopfronts and Goebbels promising to 'shut their lying Jewish mouths', already possesses a raw, visceral power. In a small room, a modest screen transmits an excellent, concise history of anti-Semitism. Called *The Longest Hatred*, it traces back to distant times the poisonous belief that the Jews were a dangerous yet inferior race. But the programme ends by returning to the 1930s, with Hitler uttering his damning prophecy about 'the annihilation of Jews in Europe'.

The exhibition organisers, led by Project Director Suzanne Bardgett, know exactly how authentic objects can be used to tell their own ghoulish stories. The metal measuring instrument, employed by Nazi 'race scientists' to discover if skull dimensions matched the 'Aryan' ideal, has a menacing, pincer-like presence. Pernicious propaganda films fan racist aggression, while branding the sick and mentally unstable as pollutants who should be wiped out by the Nazi sterilization programme. The slick professionalism of this footage only adds to its horror, while copies of the anti-Semitic newspaper *Der Stürmer* show how their rabid front-page headlines were reinforced by vicious cartoons and caricatures.

Then the thuggery commences in earnest. Beata Green remembers how her father staggered home one day, bleeding and dishevelled after 'a beating by brownshirts' at the local police station. I watched her testimony while resting on a weatherbeaten wooden seat, a reminder of

the yellow-painted benches where '*Juden*' were forced to sit and endure verbal and physical attacks. As Kristallnacht erupts and 7,500 Jewish shops are wrecked, we view the burning Bielefeld synagogue with its majestic dome collapsing into the flames. Refugees flee, and Herbert Hölzinger describes how his 'first day in Birmingham was hell'. A thirteen-year-old exile without any relatives or friends, he spent 'most of that day in and out of the toilet so that no one could see the tears rolling down my cheeks'. But the show does not make the mistake of lingering on the British aspect of the story. It swiftly returns to the epicentre, confronting us with a white marble dissecting table from a psychiatric hospital at Kaufbeuren-Irsee. Displayed as carefully as a sculpture, it arouses a sense of instinctive dread: the narrow channels cut into its surface run down to a sink where the blood was all washed away. But the table is still here, offering its own chilling proof of Hitler's 'Programme T4' focused on 'mercy killing' of the disabled people he despised.

Nothing, however, can prepare us for the rest of this gruelling show. Beside the dissecting table, a steep wooden staircase leads down past dark, metal-plated walls to the floor below. Here, the horror intensifies at once. With the invasion of Poland, Hitler's true ruthlessness was exposed. We see film of wary, demoralised Polish Jews wearing armbands and yellow stars in the street, and hear survivors describe their treatment as 'very, very degrading'. The air of relentlessness increases, along with the feeling that escape is impossible. Films reveal the brutality inflicted in Lithuania, soon after the unexpected invasion of the Soviet Union in 1941. Dragged through the streets by their hair, and beaten to death in front of leering crowds, the Jews were treated like vermin.

A blown-up photograph of naked women and children strewn across a Ukraine hillside is almost too appalling to look at. But the exhibition rightly insists that we are exposed to these sickening images. In the next room, a young Nazi soldier aims his pistol at the brain of a stunned Soviet Jew, kneeling at the edge of a deep pit where corpses have already been dumped. Nearby, a melancholy showcase displays personal belongings – spectacles, combs, buttons – of people slaughtered at Ponary, near Vilna. Interspersed with bullets and cartridges excavated from mass graves, their poignancy is heartbreaking.

Beyond this preliminary charnel house, a narrow, low doorway leads through to the 'Ghetto' section. Concentrating on Warsaw and Lodz, where 500,000 died of disease and starvation, it deals starkly with the accelerating trauma of a community bullied, marginalised and finally riven by enforced separations. An old woman tries without success to stem the tears in her eyes as she remembers being forced to leave her

mother: 'I never saw or heard from her again.' Spirited attempts were made to maintain a semblance of normal life, with concerts, theatrical performances and religious services, often held illegally. But the bravery counted for nothing. The Nazis' hatred was implacable, and hardened still further with the introduction of gas vans to replace mass shootings. It heralded the final step into engulfing darkness, but one Nazi colonel remembered the vans' arrival only as a source of immense relief for the executioners. 'The shootings', he explained with unbelievable callousness, 'were a great strain on the men involved.'

At this point, guessing what lay ahead, I felt an urge to leave. On my right, a 'short route to exit' provided a dimly lit passage lined with benches for anyone wanting to sit and meditate before escaping. But my concomitant need to see and know proved stronger, and most visitors will surely share that urge to keep on going. Ahead lie the Death Factories, the assembly-line of mass obliteration. They were the Nazis' most original and sinister invention, and the first one opened at Chelmno, near Lodz, in 1941. By the following summer, the British government knew about large-scale massacres in the East, but kept the information secret for fear that the Germans would realise their codes had been broken. The Nazis, in turn, did their best to ensure that extermination was veiled in the language of euphemism.

In a room called 'The Final Solution', where a polished, white-tiled floor creates an appropriately clinical mood, black walls carry elaborate diagrams showing how responsibility for the Holocaust was administered by a complex network of agencies and private firms. It reveals the bureaucracy of genocide, backed up by a solitary typewriter from the office of the Nazi governor of the Netherlands. Deportation orders would have been tapped out on this gleaming machine, but the exhibition has no intention of shielding us from the human suffering involved. Soon enough, we find ourselves walking through a gloomy room barrel-vaulted like a cattle waggon. The side of a similar vehicle rears up on our left, looming and implacable. Cunningly, the wagons were booked like chartered holiday trains through the German State Travel Bureau. But the reality on board was obscene. Survivors describe the stench, the fainting and the fear experienced by everyone crammed into these claustrophobic, airless containers. Even today, over half and century later, their faces are etched with despair as they struggle to find the most accurate words.

Then, quite suddenly, we move out of darkness and into a panoramic arena suffused with light. But the brightness is glacial, and it illuminates a colossal model of a snow-covered camp where trains, fences and sheds

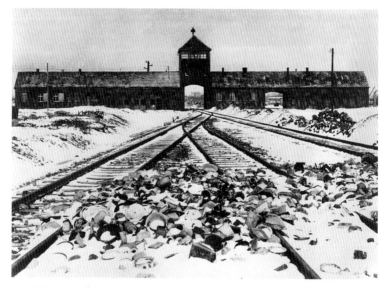

56. Main Guardhouse, named by prisoners the 'Gate of Death', Auschwitz II – Birkenau

act as a grim backdrop for the tiny figures of 2,000 Hungarian Jews, shuffling along the railway tracks and platforms to their doom. This frozen waste land represents Auschwitz, the largest of all the death camps. Here the Nazis perfected their killing technology, and below the model we find accounts and photographs of the walk to the gas chambers. The witnesses' descriptions are at their most unbearable here. We are able to sit on grey-painted chairs and listen to their voices issuing from speakers alongside us. It becomes as intimate as a confessional in a Catholic church, but no relief is on offer for the participants. Instead, the subdued and halting voices refer to the humiliations, the beatings, the screaming mothers wrenched from their husbands and sons. Sometimes, the witnesses talked so quietly and reluctantly that I had to lean against the speaker to hear them. But they manage to continue, relating how long it took for inmates to die, how the gas-chamber walls were covered in scratches made by the fingernails of victims desperate to escape the lethal fumes. Even the people who evaded execution found themselves assailed by chimney-smoke from the incessant body burnings. 'We were actually choking in that smoke,' says one woman, 'day after day and night after night.'

Wandering on, past metal shelves heaped with shoes and other possessions of the dead, we find a canister of Zyklon B gas pellets. Soaked with hydrogen cyanide, which evaporates to form a deadly gas, this was the principal weapon deployed by the Nazis. Each chamber was capable of killing 2,000 people at a time, and afterwards the hair and gold-filled teeth of the corpses were wrenched out and exploited for economic gain. Meanwhile, other officials were sadistic enough to practise excruciating medical experiments on adults and children alike. No wonder so many prisoners found the torment impossible to withstand for long, running on to electrified barbed wire or hanging themselves in barrack huts.

After a while, we wonder how anyone could have survived such protracted anguish. Near the war's end, the Nazis did their best to erase their crimes. But they could not destroy all the evidence. By far the most shocking of all Holocaust images are the films and photographs of piled-up corpses discovered by the Allied forces at the camps. One witness recalled how 'tough soldiers, who had been all the way through on the invasion, were ill and vomiting, throwing up, just at the sight of this'. We can watch bulldozers pushing pitifully emaciated bodies towards a grave. Captured Nazis sling corpses grudgingly on their backs and carry them, with no sign of remorse, to makeshift burial. As they are dropped into the pits, the victims' limbs swing and jerk in a sickening semblance of life.

We will never know the full extent of the barbarity unleashed in the camps. But attempts must be made to grasp something, at least, of its unprecedented degradation. That is why the Holocaust Exhibition is so important and so necessary. We need to learn as much as possible about this wholly repugnant tragedy, and listen to the memories of those who miraculously succeeded in emerging from the inferno.

In the last room of this unforgettable show, a series of witnesses speak in quiet, intensely moving ways while bleak images of a snow-laden camp are shown on a neighbouring screen. None of the faces provides comfort. One woman believes that we have learned no lessons from the past, and hopes only that she can deliver 'a warning to future generations'. Another concentrates, without self-pity, on the enduring nature of her spiritual pain: 'once you've been tortured, you remain tortured for the rest of your life'. The extent of her torment cannot be imagined, let alone gauged from her stoical face. 'I appear like an ordinary human being,' admits a third woman, 'but the storm of my experiences is still lying in my heart'. The impossibility of coming to terms with such an ordeal is emphasised, with utter finality, by another survivor: 'I forgive

nothing. You cannot forgive the unforgiveable.' But the last word surely belongs to the man who says, with infinite sadness, 'I remember the cold. From beginning to end, you were cold, cold, cold.'

TRANSFORMING THE WALLACE COLLECTION
19 June 2000

Of all the galleries I have visited across the world, the Wallace Collection holds a very special place in my memory. Here, on a visit to London at the age of thirteen, I walked in one morning. It was gloomy and deserted, and all the glass-covered paintings threw my own reflection back at me. But I eventually found myself in the Great Gallery upstairs. The sight of Rembrandt's *Titus*, Rubens's *Rainbow Landscape*, Velázquez's *Lady with a Fan* and much else besides overwhelmed me. Emerging from Hertford House, I knew that the excitement generated by these superb European paintings had somehow transformed my life. I bought the illustrated catalogue for five shillings – a great deal of money to me then, but a gesture that seemed an appropriate salute to my revelatory experience. Even today, looking through the monochrome plates in this well-used book reawakens the profound wonder and delight they gave me on that decisive summer's day in 1960.

Rosalind Savill, the ebullient Director of the Wallace Collection, understands why its contents could trigger such a momentous response. 'I have a passion for this place,' she says, leading me through the ornate rooms of a house bequeathed to the nation by Lady Wallace in 1897. Savill has worked here for twenty-six years, and published her prize-winning catalogue of its Sèvres porcelain collection in 1988. But time has not tempted her to take the Wallace for granted. Walking through one especially sumptuous interior, now being enhanced by new lighting, she describes it with infectious relish as 'my favourite room – it's got a rococo clout which I adore. It's about as hunky as you can get: opulent, rich, embracing.'

The Wallace Collection was largely acquired by the Fourth Marquess of Hertford, indulging in bouts of extravagant spending while based at the Château of Bagatelle in the Bois de Boulogne. Neurotic and reclusive, this unabashed Francophile amassed a staggering array of paintings, porcelain, furniture, miniatures, gold boxes, tapestries, sculpture and, not least, Oriental arms and armour. The rooms at Hertford House still retain the

air of a private collection, and Savill is determined to protect its essential, unique character. At the same time, though, she realised years ago that the Wallace needed rejuvenating. 'When I put in for the Director's job in 1992,' she recalls, 'I said that the central courtyard should be glazed over. The suggestion was met with cries of horror.' But Savill was duly appointed, and now finds herself nearing the end of an ambitious, brave, and at times alarming six-year building programme costing £10.6 million. Funded by the Heritage Lottery Fund, the Wolfson Foundation, the Monument Trust and private donations, the Centenary Project will be launched on Thursday – in celebration of the moment when the Wallace opened to the public as a national museum on 22 June 1900.

Savill is feeling exhilarated as the day draws near. 'Any changes we've made only underpin the existing character of the Wallace,' she says. 'The idea is to get away from dark, municipal dreariness, and take the building into the light.' Backing up her words with action, she pushes open the doors and leads me over a glass-sided bridge to the courtyard beyond. I found myself confronted by a spectacular sight. Rick Mather, recently responsible for the beguiling and eminently tactful extension at Dulwich Picture Gallery, has designed the lofty, 120-pane glass roof floating over this monumental space. Made in Czechoslovakia, it balances courteously on top of the existing architecture. As well as providing a cover for the new courtyard restaurant, the first in the Wallace's history, it enables Savill to create a Sculpture Garden.

'Rick Mather's presentation in 1995 was simply extraordinary,' she recalls. 'He won over all the judges, above all because his proposal was the least invasive. Another architect wanted to put in an Edwardian conservatory on the first floor. But it took us nine months to get planning permission for Mather's roof. It was a nightmare: Westminster and English Heritage were both very difficult.' The battle proved eminently worth waging. Luminous and welcoming, the courtyard has been transformed from dingy, bomb-damaged neglect into an arena of delight. The Café Bagatelle, opening on Friday, promises to live up to the pleasure provided by Mather's architectural drama. It will be run by the French restaurant company Eliance, whose portfolio includes The Louvre and the Jules Verne restaurant on the Eiffel Tower's second floor. The Paris-loving Fourth Marquess of Hertford would surely have approved, and feel even more gratified to discover that an elaborate nineteenth-century bronze fountain, from his Château of Bagatelle, has been reinstalled in the centre of the courtyard. Festooned with snails and an undulating serpent, its presence here ensures that innovation runs hand in hand with continuity at the heart of the Wallace's renewal.

57. Café Bagatelle in The Sculpture Garden, Wallace Collection, London

Even so, the Centenary Project amounts to a great deal more than an ace caff. It also creates 30 per cent of new space within the building for exhibitions, conservation, research and an immensely improved educational programme. Savill realised that there was no hope of building outwards: the Wallace is bounded by roads, and the existing historic house could not be altered. So the only place where expansion might happen was below ground. 'We've excavated between sixteen and twenty feet down,' she explains, 'creating space where none existed before. The crane brought out 10,000 tons of debris and earth, but we've managed to get rid of the miserable, cold basement area and open up an entire subterranean level.'

At an early stage in the digging, an alarming discovery was made. 'They encountered rotting eighteenth-century piles at the front,' Savill remembers with a shudder. 'The building would have collapsed within five years, so it's just as well we found out in time.' She leads me down Mather's steep new stairs from the courtyard and into a large, handsome room with a curving front wall. 'It used to be a picture store,' she says, 'but now it'll serve as a Meeting Room and anyone can hire it.' Walking in an easterly direction, we arrive at an even more impressive Library Wing. Here, beneath the leaping vaults of an arched ceiling, the walls are lined with elegant wood shelves. Looking at this airy interior, where anyone will be able to drop in and consult the book collection, I found it hard to believe that the Wing was once 'a dingy air-raid shelter'. Now, claims Savill with a smile, 'anyone wanting to find out why Fragonard's girl on a swing has no underwear can come in here and consult the library'. Walking further, through the new Archive Room, she points out that 'from here on, this is all out of the soil'. Now it has become an Education Studio, custom-built for expanding the Wallace's ability to elucidate the importance of the collection as a whole. Together with the Seminar Room and a 150-seat Lecture Theatre, it will give Savill much-needed facilities for her plans to make the museum more open, informative and accessible. 'We had very few educational initiatives here until the Lottery application,' she admits, 'and a church hall had to be hired for lectures.'

But she has not forgotten the prime importance of contact with the works of art themselves. 'I'm so object-orientated,' she says, adding with a laugh that 'it's the only reason why I get out of bed in the morning'. On the west side, a new Conservation Gallery offers everyone a chance to see the works currently in restoration. 'I want everything to be on a level with the visitors,' she insists, 'and the display here should tell you how things were made.' In the bad old days, conservators wanted to

make the Wallace's exceptional French furniture 'look as it did when Marie-Antoinette ordered it. But now we'll never take an object's appearance back further than the accession date of 1897.' Then Savill leads me in to a long room where the Reserve Collection can at last be viewed. Virtually everything is now on display, including some minor Murillos, several attractive Dutch paintings and a number of works whose attribution is still debated. When the Wallace opened, it boasted twelve original Rembrandts. Now only one, the outstanding portrait of his son Titus, is universally accepted. But one or two others may be better than the Rembrandt experts think, and the advent of the Reserve Collection space will enable us to make up our own minds.

Beyond, I find myself in a new Watercolours Gallery, where the Wallace will stage a new exhibition every three months. The inaugural show concentrates on Richard Parkes Bonington, the short-lived and precociously gifted landscape artist. The museum's ten oil paintings by Bonington are already well known to its devotees, but now twenty-five of his finest watercolours can be relished downstairs as well. Temporary exhibitions will also be held in the red-walled, modest room beyond, where the five generations who created this family collection are celebrated in the opening survey. From the First Marquess of Hertford to Lady Wallace, they would surely applaud Savill's enterprising efforts. While revealing that 'my dream is to increase visitors from the current annual tally of 187,000 to 250,000', she is also at pains to stress the importance of retaining the Wallace's idiosyncratic identity. 'We mustn't destroy the very thing we want to preserve', she emphasises, 'but you just have to stick your neck out and hope for the best.' Her boldness and sensitivity have paid off. The transformation of this venerable institution is magnificent, and certain to win the museum many new friends. Savouring the Wallace's enhancement, a lot of visitors will agree with her that 'achieving all this extra space is total magic'.

THE RENEWAL OF SOMERSET HOUSE

22 November 2000

The stern words 'Inland Revenue' may still linger like a warning over doors on the side-elevations of Somerset House. But the courtyard they enclose has been transformed by superbly orchestrated ranks of fountains. They spring up, dance and confound our expectations with insolent, teasing vivacity, announcing the spirit of renewal now transforming the great building designed by George III's architect Sir William Chambers.

The metamorphosis is long overdue. When I spent three years on a Henry Moore Fellowship at the Courtauld Institute, whose staff and students inhabit the Strand side of Somerset House, most of the building was still occupied by tax offices. Approaching the Courtauld through the graceful, multi-columned north entrance, I used to stare aghast at the tax inspectors' car park defiling Chambers' noble paved court. One of the finest public spaces in London, it urgently needed liberating. So Lord Rothschild and his resolute team deserve our congratulations for ousting the bureaucrats, restoring dignity to Somerset House and turning this assured example of eighteenth-century civic architecture into a monument available to everyone. Now, at last, we can walk past the ceaselessly fluctuating fountains and enter the Seamen's Waiting Hall beyond, lined with portraits of Nelson and other weatherbeaten embodiments of our maritime prowess. To the right, a corridor leads past the new café and restaurant to Chambers's *tour de force* at the far end, a muscular vaulting staircase whose ironwork banisters spiral upwards to a luminous oval ceiling above. Straight ahead, doors give access to a wide and sweeping Riverside Terrace, where visitors capable of withstanding the November chill drink their coffee and gaze over an epic Thames panorama initially defined by Canaletto in his celebrated views of London from the same location.

But if visitors turn left inside the Seamen's Waiting Hall, they will find themselves entering The Hermitage Rooms, a freshly converted suite of five spaces devoted to a loan show from the palatial museum in St Petersburg. Because it was founded in 1764 by Catherine the Great, she becomes the subject of the inaugural exhibition. But the film projected on a twelve-foot screen in the first room quickly establishes that the Hermitage today is far larger and more resplendent than anything dreamed up by the indefatigable empress. She built two pavilions on to the Winter Palace, largely in order to house the swiftly accumulating results of her voracious forays as an art collector. The extensions became

58. Somerset House at night, with Edmond J. Safra Fountain Court

known as hermitages, the name traditionally given to the spiritual retreats erected by Renaissance princes on their country estates. Peter the Great built one in the grounds of his country palace at Peterhof, and Catherine regarded her pavilions as private places where she could entertain an ever-burgeoning circle of friends and lovers.

However ostentatious Catherine's retreats may have been, no unruliness was allowed to sully their splendour. She drew up a list of 'Rules' for behaviour in the Hermitage, insisting that 'all ranks shall be left outside the doors, similarly hats, and particularly swords'. Stripped of their finery, guests were commanded to 'be merry, but neither spoil nor break anything, nor indeed gnaw at anything'. Guests were further ordered not to 'sigh or yawn, neither bore nor fatigue others', and drink 'with moderation so that each should be able always to find his legs on leaving these doors'. If they ignored Catherine's wishes, the penalties were bizarre. 'For any crime,' she insisted, 'each guilty party shall drink a glass of cold water, ladies not excepted, and read a page from the Telemachida [an excruciatingly long and dull Russian poem] out loud.'

Laughable though her rules may sound, Catherine had plenty of possessions to worry about protecting from drunken guests. Her florid state portrait, the first painting we encounter in the show, has been lent from Houghton Hall in Norfolk, where Sir Robert Walpole assembled an outstanding collection of paintings. After his death, clamorous of British connoisseurs and artists wanted them to form the nucleus of a putative National Gallery in London. Catherine, however, was determined to have them. In 1779, Walpole's grandson sold her the entire collection, and she conveyed her gratitude by presenting him with this ornate effigy of the plump, beaming empress advancing from her throne in full ceremonial robes. But the painting, a mediocre copy of an original by Alexander Roslin, is no substitute for the canvases that Catherine exported to St Petersburg. Only one of them has been returned to England for this exhibition: Poussin's formidable and statuesque *Moses Striking the Rock*, where the prophet's upraised staff causes water to flow towards thirsty followers who fill their vessels and drink with near-hysterical eagerness. The painting is only on display here until March, when it will be replaced for a further three months by Jordaens's equally grand *Allegorical Family Portrait*. Then, for the final stages of the show, Hals's engaging *Portrait of a Young Man with a Glove* will be sent over from Russia instead. But these are the only top-flight paintings so far released from a museum rich in superb old masters.

The computer screens lodged so neatly in the first room's long table permit us to explore the Hermitage's website, where 2,000 of its treasures

are reproduced. At the touch of a finger, paintings by Leonardo, Rembrandt, Rubens, Ingres and many others spring on to the screen, and they are only a fraction of the staggering three million objects owned by the museum. A mere five per cent of this hoard can at present be displayed at the Hermitage, even though its ten kilometres of galleries were built with unparalleled extravagance. Some of the most sumptuous interiors, to be found in the New Hermitage built by Catherine's grandson Nicholas I in 1852, are explored on film in the exhibition. Swooping through pavilions festooned with colossal chandeliers, up the encrusted magnificence of the Ambassadors Staircase and into the Great Throne Room, the cameras succeed in conveying the pomp and lustre of the Hermitage's shameless, glistening splendour. It was the work of the German architect Leo von Klenze, a favourite of the even more outrageous Ludwig I of Bavaria. And Klenze was also responsible for the revolving hexagonal gilt-bronze and glass pyramids supported by gilt-wood gryphons, which act as arresting showcases for so many of the exhibits lent to Somerset House.

Catherine, accompanied by all her proliferating lovers, presides over the second room. Although the modest dimensions of the spaces available here are no match for the Hermitage's glamorous immensity, they do at least offer a hint in miniature of the attractions awaiting us at St Petersburg. Despite her boundless desire for amorous entanglements, Catherine was no beauty. But she always got her way. She looks particularly menacing in Vigilius Eriksen's equestrian portrait, dressed in martial uniform and brandishing an unsheathed sword as she trots her horse Brilliant past a tree inscribed with her monogram and the fateful date 28 June. It was the moment in 1762 when Catherine exposed the most ruthless side of her complex personality, setting out for Peterhof at the head of an army to confront her recently crowned, incompetent husband, Peter III. The following day, he signed his abdication and Catherine became sovereign in his place. She cleverly evaded responsibility for Peter's brutal assassination eight days later. But the gusto with which the future empress wears the uniform of a Life Guards officer in Eriksen's painting suggests that she was quite capable of consenting to her husband's murder.

Catherine's macabre wig, made entirely of silver thread, is on public display here for the very first time. It looks surprisingly small, suggesting that the dimensions of her skull did not reflect the size of her ego. She knew precisely how to aggrandise herself, and the fellow rulers who gave her diplomatic presents ensured that the gifts boosted her lust for absolute dominance. No one more blatantly than Frederick II of Prussia, to whom

Catherine had given some valuable furs. Hearing that she had a weakness for porcelain, he sent her a gilded dessert service with a figure of the empress at its centre, enthroned beneath a baldacchino imposing enough for the Pope himself. The most alarming aspects of the service, though, are the Russian peasants in national costume, bowing and kneeling in abject feudal obeisance on either side of their monarch. The pronounced theatricality of their gestures serves only to increase their servility.

But it also reflects Catherine's own fondness for drama. She built a Hermitage Theatre in St Petersburg, and among the satirical plays performed there was her own comedy *The Siberian Shaman*. Replete with learned allusions, the text conveys the extent of the empress's education. During the eighteen tedious years before her husband's accession, when she had to endure both his neglect and an infantile obsession with toy soldiers, Catherine applied herself to learning philosophy, history and Russian tradition. No wonder she delighted in presenting herself as Minerva, the Roman goddess of learning and intellectual activity. Double-chinned and wearing a winged helmet, the empress's profile appears in this guise on an eighteenth-century engraved gem. The work of the Grand Duchess Maria Fyodorovna, it was inspired by Catherine's infatuation with the engraving of gems. She encouraged her entourage to make them, and in 1788 exclaimed triumphantly to Prince Yusopov that 'the learned and the ignorant – all have turned into antiquarians'.

She also loved chinoiserie, receiving gifts from the Emperor of China and creating elaborate Oriental interiors in several of her endlessly expanding palaces. The most intriguing Chinese artefacts on view here are intricate gold hairpins, bearing minuscule images of crabs, phoenixes and even the god of longevity. In the last analysis, though, the Roman world held Catherine more securely in its thrall. The corridor leading out of this paradoxically small exhibition is lined with skilful gouaches by Charles-Louis Clérisseau, an architect and archeologist who executed diverting fantasies where naked figures swim in the oddly limpid waters of ruined baths. He had a particular fondness for the Arch of Titus in Rome, but Clérisseau also ventured into the sulphurous smoke of the smouldering crater at Mount Vesuvius. Gazing at this ominous image, Catherine doubtless pondered the fate of Pompeii and yearned to buy the mosaics, frescoes and other treasures newly unearthed there.

This time, they eluded her. But she did manage to purchase the entire collection of classical sculpture formed by John Lyde Brown, a director of the Bank of England. The carvings were transported *en bloc* to a special 'Grotto' pavilion at her summer palace, and some of the busts are displayed in this final corridor. They testify to the imperial longings of

an irrepressible woman whose intellect was as redoubtable as her erotic appetite, and whose gargantuan acquisitive urges led, at St Petersburg, to the creation of an overwhelming treasure-house on the banks of the River Neva. The proceeds from this exhibition are partially intended to preserve the Hermitage and its contents from advancing decay, but they will also help to ensure that the rejuvenated Somerset House remains accessible to us all.

THE BRITISH MUSEUM'S GREAT COURT
6 December 2000

Entering the British Museum used to be a chaotic and dispiriting event. The austere dignity of Sir Robert Smirke's Ionic portico gave way, in the space beyond, to dinginess and turmoil. More often than not, gaggles of disoriented tourists, day-trippers and schoolchildren thronged the entrance hall, gazing in understandable disappointment at the dull grey emulsion and wondering how to negotiate a path through the collections beyond. It offered a shameful reflection of the nation's miserly attitude to displaying the artefacts in our care.

Now, at last, all this bewilderment and alienation has come to an end. When Lord Foster's triumphantly soaring transformation is revealed on Thursday, visitors making their way into the £100 million development will experience a heady surge of wonder, exhilaration and astonishment. Looking up at the entrance hall's coffered ceiling, they will find a multicoloured scheme of decoration inspired by Athenian temples in the fifth century BC. Leonard Collman designed it in 1847, as an appropriately festive greeting for Victorians about to explore their newly completed treasure-house. But his high-spirited hues were replaced by drabness in the 1920s, summing up the puritanism of civil-service officials bent on reducing museum-going to a dismal, dutiful affair. The re-emergence of Collman's joyful colours signals the banishment of old, repressive attitudes. But it is only a preliminary fanfare. Nothing can prepare us for the elation beyond. Instead of wondering whether to turn left or right, and trudging in bewilderment through congested passage-ways, we realise with accelerating delight that the way ahead is open for the very first time. It used to be confined to a dingy corridor, where only card-bearing members could make their way through to the Reading

Room. Now that the British Library has moved to Euston, however, the hitherto inaccessible Great Court is open to us all.

When Sir Robert Smirke's building was completed in 1850, everyone could explore this immense inner courtyard, lined with Portland-stone frontages and open to the sky. But not for long. Only a few years later, the round Reading Room designed by Smirke's brother Sydney touched down like a gleaming, globular spacecraft near the middle of the Great Court. And then, far too soon, the remaining space was filled up with bookstack structures, hastily erected to accommodate the ever-burgeoning supply of new publications. Nobody except librarians was allowed into this musty, mysterious region, and the very existence of the Great Court was forgotten by the public for almost 150 years.

Eventually, in the 1990s, the transferral of the nation's books prompted the British Museum to reconsider its dark, dormant centrepiece. Chronic space constrictions elsewhere in the swelling institution, often throttled by the press of 5.5 million visitors each year, meant that a radical initiative was needed. And Lord Foster, who had previously performed a similar balancing-act by inserting his Sackler Gallery into the Royal Academy's lightwell, arrived at a visionary solution. With his partner Spencer de Grey, he decided to fling a roof over the entire Great Court and free the Reading Room from all its disfiguring additions. An immense amount of space could thereby be restored to public use, providing the British Museum with an irresistible central arena for us to enjoy. It would also, like I. M. Pei's pyramid at the Louvre, act as a multi-level point of access to the rest of the collection. After decades of bafflement, visitors will now be able to find their way with ease into even the most remote sections of the building, and discover far more of its inexhaustible riches.

But the Great Court itself is spellbinding enough to detain all who wander there. Walking in from the entrance hall is like entering a magical realm, where everything seduces us with a radiant apprehension of light's transfiguring power. Intoxicated by this spectacle, I could not decide where to look first. Far above my head, an arching steel and glass roof studded with 3,312 separate triangular panels stretches across the emptiness like a glistening benediction. Even on a dreary December afternoon it succeeds, with the help of a blue-green tint, in enhancing the sky beyond. And the geometric intricacy of its computer-calculated tracery is exhilarating to study. I marvelled at the roof's supple ability to soar through the air, and come to rest on top of Smirke's façades, without any visible means of support. Foster's mastery of minimal, elegant structures has never been more adroitly deployed than it is here. Heart-

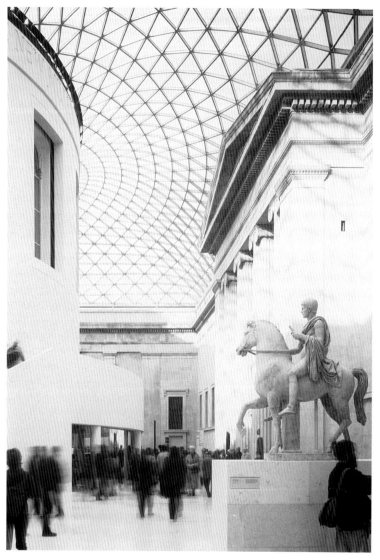

59. The Great Court at the British Museum, London

stoppingly theatrical, and yet never marred by vulgar ostentation, this undulating roof coated with enamel dot-matrix solar shading is a marvel of lean, streamlined vivacity.

It also provides a soaring canopy for the Reading Room beneath, now transformed into an impeccably bleached drum. When Foster and de Grey took the external bookstacks down, they discovered that the Victorian building had no proper cladding at all. Only its upper sections were covered in rudimentary brickwork, so the architects felt free to cover the whole exterior with white Spanish stone. It has a commanding, potent presence. As coolly classical as Smirke's porticoes on every side, this stripped cylindrical sculpture could only have been designed today. But it also stirs memories of Renaissance precedents as exquisite as Bramante's Tempietto in Rome, or the 'ideal city' laid out with such beguiling lucidity in a painting at Urbino attributed to Piero della Francesca. They, in turn, found nourishment in the Greco-Roman architecture that inspired Smirke. For all its purged simplicity, Foster's drum looks thoroughly at home in this context.

So does the south portico, demolished in the 1870s to enlarge the entrance hall and now reconstructed with admirable fidelity. The recent *brouhaha* about the wrong kind of stone, supplied from France rather than the approved Portland source, is little more than hysteria. The restored portico certainly looks pale beside Smirke's stonework on either side, but it should not pretend to seem old. Any attempt to pass it off as the Victorian original would have looked bogus. And its pallor does, after all, chime with the drum nearby. The rebuilt portico should be allowed to stay, and the ludicrous clamour surrounding it must not detract from Foster's overall achievement.

The renewed Great Court is surely his masterpiece. We can roam around its vast yet inviting spaces in a mood of sustained, avid admiration. In two corners, refectory-sized tables are laid out for visitors to rest, drink coffee and gaze at the colossal carvings positioned so magisterially on nearby plinths. Outstanding among them is a basalt titan from Easter Island called *Hoa Hakananai'a*, an ancestral figure carved around 1000 AD and presiding over us now with benevolent power. Its drastically simplified and compressed masses appeal to us more directly than the Roman equestrian statue in another corner, an imperial effigy heavily restored during the sixteenth century. Indeed, the Easter Island carving played an important role in the evolution of an impressive twentieth-century sculpture: Henri Gaudier-Brzeska's forceful *Bust of Ezra Pound*, executed in 1914. Like the other young London-based artists who revolutionised modern British sculpture, Gaudier haunted the British

Museum. The immense geographic range of the collection liberated him, along with his older friend Jacob Epstein, from an inhibiting reliance on the classical tradition. They learned a great deal from African and Oceanic cultures, and the next generation of sculptors, Henry Moore foremost among them, likewise found the museum a perpetual source of stimulus.

For too long, the Ethnography collections were removed from its main building and displayed instead at the Museum of Mankind in Burlington Gardens. But now they have returned to Bloomsbury, and the Wellcome Gallery of Ethnography is being constructed in the old North Library. Although it will not be finished until 2003, a temporary scheme is visible there today. And the Sainsbury African Galleries, revealing the full range of the museum's holdings, is scheduled to open next February. The significance of reuniting these superb collections with the other possessions at Bloomsbury cannot be exaggerated. At the Museum of Mankind, the exhibits in the Ethnography collections looked isolated and marginalised. Now they are being lodged here, on equal terms, with the other great civilizations of the world. And wherever we look in Foster's Court, enticing views of the galleries behind Smirke's façades beckon us to explore their contents. Mounting the white staircase curving round the west side of the central drum, we can see the grave, mesmerizing grandeur of Egyptian statuary through distant windows, leading in turn to the Assyrian and Greek rooms beyond. Then, at the top of the stairs, Foster's sweeping white concourse shrinks dramatically to the narrowness of a short, glass-bottomed bridge. It leads us under the pediment of Smirke's north portico to further Egyptian galleries where, past an ominous showcase called The Great Death Pit, we discover the mummies in all their hypnotic, unnerving stillness.

Walk back over the vertiginous bridge, with its dizzying drop down to the pale paved floor far below, and we find the New Court Restaurant welcoming us. Behind the tables, though, a truly astounding sight awaits. For the tall windows set into the Reading Room's walls offer captivating views of its newly restored interior. In collaboration with Antonio Panizzi, the formidably ambitious Keeper of Printed Books, Sydney Smirke excelled himself by designing one of London's most electrifying interiors. On a revolutionary cast-iron structure, he conjured up a delectable decorative scheme in cream, gold and azure-blue with a papier-mâché material invented only a few years before.

After successive generations of readers had used the room, ranging from the dandefied Oscar Wilde to the ever-diligent Karl Marx, its initial burst of splendour became dulled. So, to former Reading Room *habitués* like myself, the impact of this replenished interior is at once star-

tling and magnetic. The leaping lines of its dome, bigger than St Paul's and second only in size to the world's largest dome at the Pantheon in Rome, give the viewer an adrenalin surge as they flow upwards to the luminous, circular apex of glass. Looking in through the upper windows, we can savour the dynamism of Smirke's vaulting with unprecedented clarity. But our eyes are also drawn down, to an arresting aerial view of the floor below. Here, the central librarians' desks spread outwards in concentric circles and then, with an intensely dramatic flourish, give way to long readers' desks radiating like shafts of light from an immense, overwhelming sun.

At the bottom of Foster's staircase, the steps at either side converge on a remarkably small entrance. Its doors are open, providing permanent access for the first time to everyone wanting to explore the Reading Room on ground-floor level. Standing inside, we can appreciate even more vividly the aspiring energy of this resplendent chamber. Gilded ribs spring up from bases where Alfred Stevens wanted to place statues celebrating human creative achievement. The museum's Victorian trustees, already alarmed at the £150,000 lavished on the Reading Room's 'reckless extravagance', rejected the proposal. But it does not matter. Smirke's scheme remains glorious enough without sculptural elaboration, and visitors are now able to consult a new library of 25,000 books and catalogues relating to the civilizations and societies represented in the museum's collections. The laudable emphasis on knowledge continues below the Great Court, where a capacious Centre for Young Visitors has been constructed in Smirke's original, wonderfully restrained vaults. As many as 1,500 children will come here each day, and the nourishment they gain from the experience is immeasurable. Having been hamstrung for years by disgracefully inadequate facilities, the museum should find that its new Education Centre and Lecture Theatre offer limitless opportunities for introducing fresh generations to its multifarious holdings.

In the last analysis, though, no amount of elucidation and learning can match direct, first-hand encounters with the original works themselves. That is why I particularly welcome the advent of the Joseph Hotung Great Court Gallery, located in the elliptical extension half-way up the stairs wrapped round the Reading Room. Here, in a custom-built space for temporary exhibitions, the inaugural show looks at the Human Image. Although the gallery should have been larger, its curator brings together a host of sculpture, paintings and drawings from the earliest era to the present day. Juxtaposing an ancient Cycladic figure with a modern Russian medal, a Syrian carving with an Egyptian Mummy portrait, and a scowling Japanese executioner with a stern warrior by Leonardo,

it travels across every conceivable boundary dividing the cultures of the world. A grimacing temple figure from Hawaii is as commanding as a Benin horn player, while a New Zealand ancestor figure holds its own with an Iraqi relief carving of the King of Babylon. They all enjoy equal status here. And the inclusion of Picasso's bold drawing for *Les Demoiselles d'Avignon* reminds us that studying the past could, in this magnificently reborn museum, become a springboard for the most audacious art of the future.

TALKING TO TATE

TATE BRITAIN: INTERVIEW WITH
STEPHEN DEUCHAR
20 March 2000

For the old Tate Gallery at Millbank, the final countdown has now begun. Next week, the doughty Victorian building casts off its familiar identity and re-emerges with a new name: Tate Britain. It marks the moment when all the great international masters of modernism, Picasso and Matisse outstanding among them, leave and travel along the Thames. They are being installed in Tate Modern, the freshly converted Bankside power station scheduled to open its mighty doors to the public on 12 May. The advent of this innovative colossus, London's first-ever fully fledged museum of modern art, is bound to generate huge excitement. But what is the mood back at Millbank, stripped of so many treasures and expected, now, to concentrate on the history of British art from Hans Holbein to Damien Hirst? From the outside, the building erected to house Henry Tate's collection in 1897 looks more pristine than anyone can remember. The façade has emerged crisp and glinting from a careful hosing-down, and the once-scrappy gardens in front are being sharply redesigned with a welcome awareness of the need for greater public use and enjoyment. True, the west frontage is still largely screened off by builders, at work on the major new side entrance and extra galleries due for completion at a cost of £32 million next year. But inside Tate Britain, the entire institution is already pushing ahead with a raft of new initiatives to define the reality behind its new title.

The staff's awareness of historic, irreversible change is palpable. And the gallery's Director, Stephen Deuchar, wants to celebrate. On 23 March, a late-evening champagne party will be held in the building, when Tate Britain is officially launched. For the first time in the institution's history, dancing to a live band will be allowed until midnight. Around 2,000 guests have been invited. And at some point in the evening, they will be asked to participate in *Make Your Mark*, scrawling graffiti all over a large gallery wall. Next day, the drawings and comments will all be whitewashed over, but they will continue to lurk beneath the paint as a time-capsule recording the tipsy British art world at a moment of startling change. Behind all the cork-popping, though, a real challenge has to be confronted. How will Tate Britain overcome the notion that all the most provocative and exciting art has been taken away? Picasso and the other stellar names of twentieth-century art were always the prime attraction at Millbank, even among modernism's enemies who never

60. Stephen Deuchar, Director of Tate Britain, London

tired of insulting the artists they loved to hate. What can be done to ensure that Tate Britain does not lapse into relative obscurity, regarded as an elderly relative and frequented only by devotees eager to trace the historical development of our national school?

Deuchar, who cheerfully admits that his life is 'very high-pressure at the moment', is well-qualified to run the historical side of the collection. Educated at Dulwich College before attending universities at Southampton, London and Yale, he says that 'British art was always my thing. I can't imagine anywhere that I would rather have ended up – this job is perfect for me.' A specialist in eighteenth-century English painting, he has written a scholarly book on sporting art of the period. He lives in a Kent village near Ashford, and his love of the countryside makes him prepared to endure long, tiring train journeys to and from Millbank each day. 'I do enjoy the schizophrenia of being torn between country and city,' he says with a grin.

But if anyone imagines that he is essentially a quiet, retiring art historian, they would be mistaken. Before coming to the Tate in March 1998, Deuchar masterminded the £20 million redevelopment of the National Maritime Museum's Neptune Court Project at Greenwich. It was an apt preparation for coping with the even more ambitious Millbank expansion. And I suspect that his involvement with contemporary artists at

Greenwich holds one key to his policy now. 'People might assume that Tate Modern is everything new and Tate Britain everything old,' he admits. But next week the venerable façade at Millbank will be emblazoned with a neon work by Martin Creed, among the liveliest of a new generation of British artists. 'It'll signal our continuing commitment to contemporary art,' says Deuchar, adding that an alcove in the Rotunda will now house 'Tate On-Line with Tate website – it gets visitors into the illustrated Tate database'.

Walking into the main part of the gallery, we will become quickly aware of new signage. 'Its designers are presenting the word Tate as a neon sign,' Deuchar explains, 'so it's not remotely corporate in terms of feel. Behind the redesign is the idea of welcome. That'll change the mood of Millbank, and just for a year we've painted all the walls the same colour: goosewing grey. It helps to give the interior a cleaner, fresher feel, allowing us to have a neutral canvas for all the displays. And the warders will now be called "gallery assistants". Why? Well, the new name announces that they're here to help the public as much as to protect the works of art.' Deuchar feels that the word 'warder' carries oppressive associations, reflecting the bizarre fact that the Tate was built on the site of the old Pimlico Penitentiary. Plenty of cynical jokes used to be cracked about the Tate's prisonlike character, but Deuchar is determined to blow away any lingering traces of old-style museum gloom. He even announces that 'a new uniform is coming for the gallery assistants, as part of the corporate identity change. They're designed by Paul Smith.'

Beyond the image-building manœuvres, though, will the exhibitions held at Tate Britain turn out to be as up-to-date as its trendy clothing policy? Contemporary artists have complained for years that scant room was devoted at Millbank to displaying new work. Deuchar is aware of the problem. 'We're putting a lot of effort into new art,' he stresses. 'It'll be released from the box reserved for Art Now at the back of the gallery, and this summer we're staging a huge exhibition called *New British Art 2000*.' Curated by Charles Esche, Research Fellow at Edinburgh College of Art, and Virginia Button of the Tate, the show includes around twenty artists spanning different generations. The largest exhibition of contemporary work ever held at Millbank, it will, according to Deuchar, 'demolish the idea that all the new art has moved down to Bankside'.

Another manifestation of this important commitment is the show of recent work by Mona Hatoum, opening next week in the Tate's nobly proportioned Duveen Galleries. One of our finest middle-generation artists, Hatoum is precisely the kind of individual who deserves greater

exposure at Millbank. Her *Corps étranger*, a disturbing video exploration conducted by a camera roaming inside her own body, was an outstanding exhibit at the Turner Prize exhibition a few years ago. A key element in the campaign to keep Millbank modern is the retention of the Turner Prize itself, along with the accompanying show of shortlisted artists. The annual *brouhaha* generated by this notorious event may be outrageous, but Tate Britain would have suffered a grievous blow if the Turner shenanigans had been transferred to Bankside. Keeping the prize at Millbank will help a great deal to ensure that the institution does not shy away from even the most controversial and vilified developments in the strange new art of the twenty-first century.

But what about British art of the past, and the Tate's responsibility to show its large historical holdings in the fullest way possible? After all, it owns the greatest collection of British art in the world. Until the new extension opens in 2001, the Millbank gallery will be unable to present the 'grand parade with a chronological thread' that Deuchar promises. Already, though, the opening displays at Tate Britain give a foretaste of the open-ended approach he favours. In the Clore Gallery, hitherto reserved for the prodigious genius of Turner alone, a group of fourteen Constables lent from the Victoria and Albert Museum will now be displayed. They include his wildly handled, full-scale oil study for *The Haywain*. Constable, so often overshadowed at Millbank by the vastness of the Turner collection, is at last being given more of the prominence he deserves.

Both artists will be seen in the larger context of Romantic painting as a whole. The Norwich Castle Museum has lent a selection of its finest works, among them major paintings and watercolours by John Sell Cotman, John Crome and other important artists from the Norwich School. 'You'll get a rich idea, walking through, of romantic landscape in its largest sense,' says Deuchar, who is keen to expand the parameters of the collection in other ways as well. 'The whole idea is to celebrate the Tate and British art in a slightly unusual way. This is the year to do something special with the collection, to disrupt the sense of familiarity and show its hidden potential. So the new displays are thematic, stressing continuity across the centuries. After all, a long timespan is one of the main factors that distinguishes us from Tate Modern.'

Accordingly, a fizzy and continually surprising cocktail of disparate artists greets the visitor. Bacon and Sickert are now hung in the same room as Hogarth and Reynolds, united by the theme of 'Portraits'. Stubbs is displayed near Paul Nash in the 'Home and Abroad' gallery. Lord Leighton and Lucian Freud cohabit in an 'Artists and Models'

space, while an 'Images of War' display unites Jagger's gruesome 1919 bronze *No Man's Land* with de Loutherbourg's 1799 painting *The Battle of Camperdown*. Such couplings undoubtedly jolt us out of complacent ways of looking. They may sometimes seem jarring to a fault, but Deuchar insists that it is a healthy innovation. 'We are saying that there are many stories to tell about art, and many ways of presenting the collection,' he explains. 'It's all part of the Tate's commitment to speak more openly and directly to its public.' Tate Britain also aims at widening its historical brief, staging a 'small show of medieval sculpture' as well as including James Gillray's lacerating prints in a display devoted to 'Roast Beef and Liberty'. 'We don't collect caricatures,' admits Deuchar, 'but we can't be the National Gallery of British Art without addressing the issue of satire.'

Nor will he feel satisfied until Tate Britain has acquired for its collection paintings by those major artists who produced so much important work in this country. 'There are obvious gaps, ranging from Holbein and Van Dyck to Canaletto,' he says, before telling me that Millbank will be staging, in 2002, Britain's first survey of nineteenth-century American Landscape painting – 'a good example of Tate Britain's willingness to do exhibitions about art beyond these shores'. Such an admirably open approach may help to silence anyone who complains that Millbank has now been confined to a narrowly nationalist identity. Already, Deuchar anticipates the criticism to come. 'Some might say: "what are you doing? You're just reviving Henry Tate's original jingoistic enterprise, telling the world how great British art is." Just at the point when we're going deeper into Europe, that might seem anachronistic. But on another level, it's a perfect time to re-examine Britishness. To question our national identity now seems relevant, urgent and rather exciting. I enjoy our ability to become a forum for debate. But I don't want to fall into the trap of forever wrestling with identity issues. We do need, ultimately, to look at British art in a much bigger sense.'

TATE MODERN: INTERVIEW WITH LARS NITTVE

1 May 2000

At the end of next week, London's first fully fledged museum of modern art finally opens its doors. Liberated from their cramped former home at Millbank, Picasso and all the other masters of international modernism have now been transported to a converted power station at Bankside. Here, on a prime riverside site opposite St Paul's Cathedral, Tate Modern is about to be born. Lars Nittve, who was appointed Director of this immense new institution in April 1998, has every reason to feel nervous. When I go to see him, the entire building is still swarming with hundreds of workers in hard hats, all urgently engaged in last-minute adjustments. But the genial forty-six-year-old Swede exudes optimism rather than panic. Nittve was, after all, Director of the much-loved Louisiana Museum of Modern Art near Copenhagen before landing the Tate job. And he oversaw the building of a large extension at the Louisiana, thereby equipping himself with crucial experience for the Bankside project. Even so, Tate Modern remains a truly awesome undertaking. At a cost of £134 million, Sir Giles Gilbert Scott's imposing brick colossus has been transformed into a setting capable of displaying four times as much modern art as the old Tate Gallery at Millbank. The Swiss architects, Herzog & de Meuron, did not want to disguise the building's tough industrial origins. So the outcome will be very different from the rural gentleness of the Louisiana, custom-designed as an art museum in 1958.

Nittve was very happy at the Louisiana: on taking up the post, he famously declared that 'I'm going to stay until I'm 70.' But directing Tate Modern is for him 'the perfect job', and he delights in the building's strong, uncompromising character. 'Most of the good places I know for art are converted industrial spaces, like the Warhol Museum in Pittsburgh,' he says. 'They're not always successful, but artists really feel at home in these kinds of spaces, so the art work also feels at home there. After all, they're like the converted warehouses where so many artists have their studios. They're very straightforward, simple spaces, and all the architectural energy goes into dealing with the needs of the art.' But what about the needs of visitors, who might feel daunted by the sheer vastness of Tate Modern? 'That's the real challenge,' says Nittve, leaning forward in his elegant Charles Eames-style chair, 'because these buildings were not made for the public. So you can compensate for that, making sure the entrance is felt as a public space and that circulation, inside, is

61. Lars Nittve, first Director of Tate Modern, London

easy and effortless. The 'wow' factor of the great turbine hall is exciting, not oppressive. But we must make people feel welcome.'

This priority is especially important in Britain – a country where, as Nittve soon came to realise, 'visual art is not at the top of the cultural agenda. And the media here are often ready to direct the word "scandal" at modern art, particularly when works relate to the ready-made tradition. It's almost a century since Marcel Duchamp started appropriating things already existing in the world, and yet people are still offended by the lack of craft in modern art.' But Nittve learned at the Louisiana that if a museum offers a welcome, 'visitors have much less of a problem with difficult art. I don't want to make them feel they're in Disneyland, but the warders we have recruited will be more active. They'll know more about the art and why it's here. They'll be breaking down the thresholds and making things accessible, without interfering with the art. We want people to feel that they're not just visiting the gallery, but finding meaning in their lives.'

Nittve also hopes to involve the public by devising a radically different way of hanging the collection. 'Before I came here, the Tate Modern staff had already started thinking from scratch about ways of showing modern art. In dialogue with artists, historians and curators these ideas were tested, to see if it was possible to move away from chronological narrative. After all, the story of modern art is based on a paradigm developed by the Museum of Modern Art in New York over half a century ago. Now the story is so much longer, and a single narrative does not seem adequate. There are many different stories now, and we need to answer the public's question: why is this art?' The solution adopted at Tate Modern is to tell four stories instead, one in each suite of galleries. 'We take the four basic genres, of Landscape, Still Life, the Nude and History Painting. Then we see how they develop, expand and mutate. They become Landscape, Matter, Environment; Still Life, Object, Real Life; Nude, Action, Body; and History, Memory, Society. But we're not leaving historical perspective behind. At certain points, there will be a juxtaposition between the historic and the contemporary. Monet's late water-lilies painting, for example, is shown near a stone circle by Richard Long on the floor.'

Apart from setting up these stimulating, unexpected encounters, the break-up of a chronological hang also enables Tate Modern to bring together different aspects and periods of one artist's work. Mark Rothko, Tony Cragg, Francis Bacon, Bridget Riley, Anthony Caro and Frank Auerbach are among the outstanding individuals granted such an accolade at Bankside. British art will be generously represented, for

Nittve believes that Tate Modern should not end up as 'an impersonal modern museum without national character. I don't want to think about British art too much, but Stanley Spencer's *Resurrection* will be here.' Is there a danger of siphoning off so many important British works that the old Tate at Millbank becomes severely depleted? Nittve seems unconcerned, maintaining that most of the singled-out artists are very substantially represented in the Tate's collection and can be shown in both buildings. But he does acknowledge 'the risk that some British artists will be upset because they are not displayed at Tate Modern. We can't show everything here, but some of the monographic rooms will change every six months so that other individuals can be included.'

Far more daunting is the problem of trying to acquire key examples of twentieth-century art, especially from the early decades where the Tate's collection is at its weakest. 'I'm avoiding the word "gap", because that implies there's a "true story" to tell,' says Nittve. 'But there are works we'd like to have more of. Many are very difficult to buy with cash, and the Tate only has £2 million a year to spend on purchases for both museums. It's not a lot of money, and I hope in future we'll be attractive to donors. But help has come from the Tate Friends, English Heritage, the National Art Collections Fund and the USA to acquire major recent acquisitions like David Smith's *Waggon*, the Mondrian painting, Miró's *Paysan Catalan* and some really good Duchamp purchases.'

Tate Modern hopes to attract up to 2.5 million visitors in its opening year, and I am sure that it will be spectacular enough to meet that target easily. But sustaining this initial burst of interest is more difficult, depending in large part on the excitement generated by temporary exhibitions. Some of them, like a big Matisse and Picasso survey also travelling to Paris and New York, will explore classic aspects of the modernist canon. But others are more experimental, and break new ground in terms of Tate exhibition programming. 'We'll launch the loan shows next January with a survey called *Century City, Art and Culture in the Twentieth-Century Metropolis*,' reveals Nittve. 'It looks at a series of moments in the life of nine capital cities, when art combines with literature, film, music, poetry, dance and architecture to make a creative hot-spot.' Some of the choices, like Vienna in 1910 or Moscow in the early 1920s, are familiar enough. But others, including Rio, Lagos and Bombay, take the Tate far outside its existing geographical limits. And the decision to embrace so many different art forms means that, from now on, a multi-disciplinary awareness is firmly on the agenda at Bankside.

Nor does Nittve want Tate Modern's activities to be confined solely within its new premises. 'We've already staged projects outside,' he points

out, 'and we're not going to stop now that we have our building. Plenty of today's artists have another context in mind, and we're prepared to provide the right place, whatever the art requires. We want above all to create a meeting-place between the artist, the art and the public.' It is an admirable aim, and should do much to counter any suspicion that Tate Modern might imprison contemporary art within its high, monolithic walls. Nittve seems far too open and engaging to countenance such a policy. 'On one side,' he admits, 'I hope Tate Modern is seen as one of the absolutely substantial, major museums of the world. But at the same time, it intends to rethink what modern art is, and maybe change the agenda, becoming fast, flexible, informal and with a streak of counter-culture. There's a tension, here, between being solid-as-a-rock and being alive, having the energy to work with artists and do shows in six months if necessary. So alongside the sense of confirmation, marking the arrival of Britain's national museum of modern art, we'll have accessible, friendly and fresh thinking. If we can manage to achieve all that, and people really do feel welcome, I would be very happy.'

'WHO'S AFRAID OF MODERN ART?':
INTERVIEW WITH NICHOLAS SEROTA
20 November 2000

Now that Tate Modern has attracted over three million visitors in its first six months, Nicholas Serota has every excuse for feeling gratified. After all, the spectacular Bankside behemoth has outstripped expectations, attracting crowds eager to goggle at the vastness of the converted power station. It is an immense success, and should do much to ensure that the notorious British dislike of modern art is overcome. But Serota, preparing himself to deliver the Twenty-fifth Richard Dimbleby lecture on BBC1 this week, is feeling far from triumphalist. The only two paintings in his white room at Tate Britain, where he has decided to retain his office, are by the powerful American artist Philip Guston. And they convey a mysterious, even ominous mood. One is dominated by a black, featureless head emerging from a sombre grey cloud. The other shows two members of the Ku-Klux-Klan, eyeing each other balefully through the slits in their hoods.

In a typical burst of chutzpah, Serota has elected to call his lecture 'Who's Afraid of Modern Art?'. But after taking off his jacket and joining

me for tea at a window overlooking the swollen, darkened waters of the Thames, he admits in his quiet voice that 'I don't feel very optimistic, actually'. What does he mean? 'Well, there are a lot of young people interested in the visual arts, but I'm nevertheless conscious that a huge part of the public remains sceptical about modern art. Whether it's people in positions of power, or the many letters I receive that complain about "lack of standards" in the art displayed at Bankside, a lot of people clearly find it difficult to live in the present. And the press play up the sensational aspects all the time, reiterating clichés like the old accusation that "a child of six could do it".'

Serota remembers how, as an adolescent in the 1960s, he became aware of the excitement then surrounding contemporary work. The Pop movement in particular ensured that art became fashionable for a while, and Serota himself experienced a Pauline conversion while still at school in 1964. Until then, he had been planning to study economics and sociology. But curiosity took him on a Damascan road to the Tate Gallery, where a mammoth international survey of modern painting and sculpture had just opened. 'I was bowled over,' Serota recalls. 'Suddenly, art was not just Turner and Constable, or Leonardo and Michelangelo, but objects of considerable size and brilliant colour, dealing with the sensations, subjects and issues of the sixties.' Soon afterwards, when he went to Cambridge and studied art history, Serota decided that the visual arts should be his field. 'I was hooked,' he says, before adding wrily that his earlier study of economics has proved useful at the Tate 'as I have ploughed my way through those challenges which face all arts organizations in the late twentieth century: cashflow, retail, marketing initiatives and performance indicators'.

But the popular boom that contemporary art basked in during the 1960s did not last. Succeeding decades witnessed the resurfacing of ingrained British prejudices, with their dismissive attitude to the whole notion of innovative developments. 'Until pretty recently,' Serota says, 'the visual arts had very little social importance in this country. It was OK not to know about visual art, as opposed to theatre, music or literature. Even as a student I was conscious of the fact that people who took Eliot or Yeats seriously would regard Picasso as a charlatan. I think that's different from continental Europe. In post-war Germany, if you made money as a doctor or lawyer, you'd form a contemporary collection, or commission a modern architect to design your house. But in England, people who became wealthy would buy a Georgian country mansion.' Even now, when we might seem to be enjoying what Serota describes as 'a sea change in public appreciation of the visual arts', he emphasises that

62. Sir Nicholas Serota, Director, Tate, London

'a huge amount remains to be done here. People may be attracted by the spectacle of new buildings, they may enjoy the social experience of visiting a museum, taking in the view, an espresso or glass of wine, purchasing a book or an artist-designed T-shirt. But I have no delusions. Many are delighted to praise the museum, but remain deeply suspicious of the contents.'

In his remarkably frank Dimbleby Lecture, Serota tackles this central problem afflicting our culture head-on. 'What lies at the root of a fear that we are being deceived or tricked?' he asks. 'Is this art which can have meaning for the many or is it simply for the few, those critics, curators and collectors who form an inner circle?' Serota acknowledges that, for a lot of us, the most rewarding art belongs firmly in the past, and confesses

that 'it remains hard to see how similar qualities can be found in the art of our own time'. But he makes no apologies for the fact that much contemporary work can, at first glance, appear unnerving. 'Personally, I rather welcome this', he says, before pointing out that 'new art, like old, repays prolonged attention as layers of meaning slowly disclose themselves'.

The examples Serota selects to back up his case prove how determined he is to avoid blandness. He plumps first for Damien Hirst's *Mother and Child Divided*, even though its 'two brutally severed carcasses' are still derided by those who hate adventurous modern work. 'For me,' Serota explains, 'the undoubted shock, even disgust provoked by the work is part of its appeal. Art should be transgressive. Life is not all sweet.' But he does stress that, 'walking between the two halves, and seeing the isolation of the calf from the cow, encourages deeper readings of the work. Perhaps this is an essay on birth and death and on the psychological and physical separation between a mother and her child, especially given that the work was first made for an exhibition in Venice, a city filled with images of the Madonna and Christ child.'

Not that Serota maintains a stance of infallibility in his encounters with the new. Often accused of arrogance and inflexibility, he disarmingly admits now that, when looking at work in an artist's studio, 'I am very familiar with the experience of being completely at a loss when confronting a new idea or image'. But he welcomes this 'state of "not knowing", of "not understanding", of being disorientated or challenged by the unfamiliar. One of my responsibilities as a curator is to remember that a visitor encountering an unfamiliar work of art in the museum is likely to be as unprepared as I was in the studio.' Indeed, Serota goes so far as to confess that, 'over a period of time I have come to realise that it is precisely when I am most challenged in my own reactions that the deepest insights emerge. Frequently, the greatest rewards come from the most unyielding.' He realises, however, that there are two fundamental questions 'which go to the heart of a fear of modern art. But is it art? and How do we decide which art is "good"?'

The first question is usually bound up with the notion of skill, and Serota does agree that skill is an essential part of art. But in his view, skill can be manifested in many different ways, even by ordering art on the telephone, and he insists that 'there is no intrinsic reason why art cannot be made from new materials, including "low" materials such as brick, plastic rubbish or even elephant dung'. As for the second question, about whether art is any good, he says that 'an honest curator will admit that judgement is fallible, especially for art made yesterday'. In the present, 'we can only ask that contemporary art offers compelling insights into our

own condition or raises compelling questions'. He singles out, as examples of work that 'can inspire engagement and identification', Michael Craig-Martin's *An Oak Tree*, Rachel Whiteread's much-lamented *House*, Gillian Wearing's video *10 to 16*, Mark Wallinger's *Ecce Homo* on the Trafalgar Square plinth and Anish Kapoor's *Untitled*, a deep blue bowl that induces 'an exploration of self and of the world of feeling and intuition'.

This lies at the heart of the experience offered by art, but how available has it become? Serota devotes the rest of his Dimbleby Lecture to hitting out at the inadequacy of the support that art is offered by the present government. He deplores the fact that 'visual arts and design have been increasingly excluded from the secondary national curriculum', emphasizing that 'the visual is no less important than the three Rs'. He attacks Tony Blair, reminding the prime minister of his promise two years ago that 'the arts are to be written into the core script of government'. In a key passage Serota comments, with understandable bitterness: 'I have to say that in the visual arts we are still waiting for many of the words of that script. Chris Smith has taken the courageous decision to use all of his available resources to defend and extend the principle of free admission to our national museums, but otherwise there is little to cheer, especially for those who live outside London. As a recent study has shown, central government in France spends on the arts twice as much as in Britain, even allowing for the Lottery, which is not really government money, while regional expenditure is four times that of British local authorities. Across the country, great museums like the city art galleries in Leeds and Glasgow are withering, not for want of imagination, but for want of resources which can unlock new opportunities.'

This is the most urgent part of Serota's message. He believes that 'failure to act now' in collecting and presenting the art of our own time 'will result in permanent loss'. Unlike the Netherlands, where a population of only fourteen million is served by modern art collections of international standing in six cities and towns, Britain only has two: the Tate and the Scottish National Gallery of Modern Art in Edinburgh. 'Elsewhere, as in Manchester and Newcastle, collections of modern art are almost dormant,' he says, complaining that 'there are very few opportunities for a British public to experience contemporary art on a regular basis. The tabloid, even broadsheet, view will prevail until it is challenged by a wider experience of exhibitions, acquisitions and commissions of contemporary art.' In the end, Serota's most passionate belief is that the chance 'to confront directly the ideas, values and insights of the gifted individuals of our own time should be easily available. While modern art may not be for everyone, it should be for anyone.' And he attacks the illusion, still so

prevalent in Britain, that art will somehow, some day 'come to its senses. To argue that art can "get back on track" is a delusion. The most radical art has always been disturbing and for this reason has been attacked by conservatives. Art should overturn as well as confirm values. We need to be able to live with uncertainties in our lives. There will not always be an answer to every question. Art obliges us to answer questions for ourselves.'

BEYOND THE GALLERY

ALEX HARTLEY'S PAVILION
29 December 1999

What shape is adventurous art likely to take in the new millennium? An early answer will be provided by Alex Hartley when ART2000, the twelfth London Contemporary Art Fair, opens in Islington on 19 January. Outside the newly expanded Business Design Centre, where last year's fair generated sales worth over £10 million, the first-ever winner of an ambitious new £30,000 sculpture prize will be unveiled. And Hartley's impressive work, *Pavilion*, is set fair to bewilder, fascinate and mesmerise many of the thousands who encounter it.

They may not, to begin with, realise that it is a sculpture at all. Seen from afar, *Pavilion* will live up to its name and resemble architecture rather than art. Set on a raised platform, with a forecourt at one end protected by an overhanging roof, its four glass walls will initially seem to offer unimpeded, well-lit views of the interior. But closer inspection leads to a rebuff. For the 'building' has no doors, and the rooms visible behind the walls are calculated above all to perplex anyone peering in at them. Walking around *Pavilion*, in the hope of clarifying the mystery, will only generate further bafflement. The view through one wall is contradicted once you turn the corner and gaze through the next sheet of etched glass. Nothing adds up. The rooms look serene enough, with their minimal sequence of doorways leading from one cool, uninhabited chamber to another. But they do not constitute a coherent interior, and the deep perspectival recession evokes distances that the narrow building could not possibly accommodate.

Although Hartley has created a series of wilfully disorientating experiences, the perplexity they offer is seductive. During the day, *Pavilion* will emit a soft glow, compelling you to move nearer and become absorbed in scrutinizing the world behind the glass. At night, though, the luminosity will grow far more dramatic. 'It'll flare and almost burn your retina,' predicts Hartley. 'I'd like viewers to feel themselves pulled towards it, and find that the views inside *Pavilion* look more real than the actual urban space surrounding it.'

How does he plan to bring about such a perceptual conjuring trick? I first marvelled over a model of Hartley's project earlier this year, when serving on the judging panel for the new prize along with Wilfred Cass of Sculpture at Goodwood, Curator of the Arts Council Collection Isobel Johnstone, Tate Curator Sean Rainbird and architect Michael Wilford. But a visit to the M. J. Smith Workshop off the Old Kent Road, where

Pavilion is now being fabricated, helped to clarify Hartley's thinking by confronting me with the sculpture itself. The enormous, low-lying warehouse inhabits a desolate area dominated by brooding gas holders. And here, in a building where Damien Hirst's formaldehyde tanks are often built, *Pavilion* is now rising from its sturdy base of metal-edged I-beams.

Hartley, a tall and engaging man who graduated from the Royal College of Art in 1990, is supervising its construction. At the beginning, he admits, the experience was 'a bit odd – I normally like to make my own work'. He also points out that 'the budget is really tight', and adds with a sardonic grin that the £30,000 prize is wholly devoted to the cost of the sculpture 'with no fee for the artist, which pisses me off. But it's been great collaborating with Mike Smith, and there's no way I could have funded such a large piece myself. Working on it has already opened up other possibilities for the future, doing more sculpture on this scale in the public realm.'

Escaping from the din of the construction process, Hartley takes me through to a quieter room where we can look at a revised model of *Pavilion*. Originally, the sculpture was based on a Mies van der Rohe building, and lacked the forecourt with its projecting roof. 'But it was

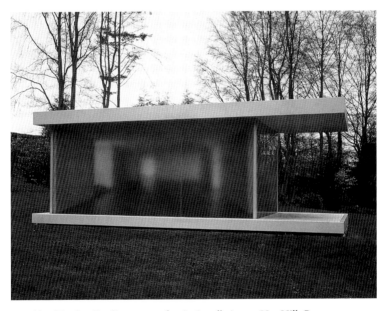

63. Alex Hartley, *Pavilion*, 2000, after its installation at Hat Hill Copse, Goodwood

too much of a box', he explains, 'and it felt too close to one of those World Fair pavilions sixty years ago. Now, it's more like a sculpture that still has those architectural references. The horizontality and materials remain close to Mies, but I hope that the form is strong enough to be a frame for the images inside.' Lifting off the roof, to be made of powder-coated metal, he shows me how the illusion of interior rooms will be created. Curving sheets of PVC, 'the kind they use for billboards on really big buildings', will stretch from corner to corner across all four walls. Lit from the back, photo-sheets will provide the powerful illusion of spaces extending into depth. 'The tuning of the lighting is crucial,' Hartley emphasises. 'For the Islington location, the lights must be turned up to take your eyes away from all the city clutter around it. I want the images to draw people in and then deny them access. I want to mystify and frustrate, making an impossible space that seems to have been teleported in like a piece of virtual reality.' The interiors will be at their clearest when viewed from a distance of about twenty feet. 'They'll look most exciting from there', he says, 'and close-to they will become, paradoxically, more diffuse and blurred. The nearer viewers get to *Pavilion*, the less they'll find out.'

Hartley made his early reputation with equally unfocused images, based on black-and-white photographs of subjects as unpromising as the infamous Ronan Point tower-block. Enclosed in tomblike, steel-cased boxes, they already proclaimed Hartley's involvement with twentieth-century architecture at its most forbidding. But their powerful sculptural presence was countered by the elusiveness of the images inside. Hartley enjoys tantalizing viewers, nowhere more spectacularly than in his recent installations where the gallery seems to extend into wall-sized, backlit images in etched glass of other rooms beyond.

Pavilion, with its even more inviting yet inaccessible views of an impossible, dreamlike space, is the spell-binding outcome of these concerns. Wilfred Cass, who initiated the new prize with ART2000, intends it to help sculptors fulfil a vision to make a large-scale work. And Hartley acknowledges that the commission 'gives me the opportunity to bring together separate strands of my work, and to unify them in a sculpture of greater ambition than any I have made before'. Even so, he is the first to concede that *Pavilion*'s impact on site is impossible to predict. 'I'll only find out what I've done when I've done it,' he says with commendable honesty, admitting that 'I can't even imagine what I want people to do with it.' At the moment, he is trying hard to ensure that potential problems are dealt with before the installation in January. 'Early-morning dew would ruin the side views with condensation, so we're putting in a heat-

rope which runs round the interior like a cable.' He is also determined to make the glass tough enough to withstand vandalism. 'Guys drink and sleep in that part of Islington at night, and they might decide to attack the art. *Pavilion* is not a provocative object, but part of the site is landscaped with giant pebbles lying loose on the ground. There ought to be security guards patrolling the area.'

Hartley has persuaded himself not to become over-anxious. But he is understandably worried about the crucial moment when the glass walls are craned in. 'The fitting is calculated down to the last millimetre, so the crane driver will have to be really good.' Any artist brave enough to place a work of this scale in an exposed setting must be prepared to confront such difficulties. Hartley seems both resilient and resourceful, even though he admits that 'I hate the idea of public sculpture. I find it all very patronizing, and the only decent contemporary piece I've seen in London is Richard Serra's work at Broadgate.' All the same, he is excited about the most unusual challenge presented by this commission. After its inaugural display in Islington, Cass will transfer *Pavilion* to West Sussex and reinstall it in Hat Hill Copse on the Goodwood Estate. Here, in a location punctuated by the work of other contemporary sculptors, it will inevitably take on a very different identity. Although some artists might feel confused by the prospect of making a work for such contrasted settings, the urban and the rural, Hartley relishes the move to Goodwood. 'I really like that manicured landscape, pretending to be wild but not really,' he says. 'I can't wait to see *Pavilion* in the country at night, glowing and floating in the dark.'

NORIAKI MAEDA AT YORKSHIRE

26 January 2000

Sometimes, our experience of an artist's work can be transformed by a congenial outdoor setting. The epic landscape at Yorkshire Sculpture Park offers just such a location, and provides an ideal range of spaces for the young Japanese artist Noriaki Maeda. His work is liberated by its positioning here, especially in the open air where even the most monumental pieces seem able to breathe more easily. The show could not have come at a better time. For Maeda, who has been based in London since 1998, felt increasingly restricted by the confines of galleries. His earlier work, often

made of corten steel, could easily look oppressive when placed indoors. Here, by contrast, the bulkiest sculpture frees itself from ponderousness and develops a nourishing, unforced relationship with its surroundings.

The parkland locale also helps to clarify Maeda's fundamental fascination with organic form. He has been committed to it ever since studying at the Tokyo National University of Fine Arts in the early 1980s. At that time, a lot of Japanese sculptors were exploring geometrical abstraction. But Maeda was independent enough to strike out on an unfashionable path of his own. He started making naked human figures, then bodies disturbingly sliced and incomplete. His interest in vulnerability was already being asserted, but the sculpture remained ambiguous. Were the bodies mutilated, or simply anatomical details taken from larger, intact figures? Maeda provided no answer. He always preferred to let viewers speculate for themselves. That is why, throughout his career, he has left his works untitled. Determined not to limit their possible range of meanings, he already began suggesting an interplay between human limbs and branches lopped from a tree.

Maeda was equally unafraid of allying his work with ancient sculptural traditions. On one level, his figures had links with medieval statuary in the great European cathedrals. But in a more meditative sense, they recalled the bronze gods made for temple shrines during the Kamakura period, when Japan enjoyed an astonishing sculptural renaissance while Gothic art flourished in the West. Many of Maeda's early figures seemed to have suffered, like victims of some terrible, harrowing conflict. Just as Georg Baselitz's battered sculpture reflected on the aftermath of the Second World War in Germany, so Maeda's melancholy warriors seemed to brood on Japan's tragic role in the same struggle.

By the end of the 1980s, though, he had moved away from the human figure. References to felled, close-grained tree trunks, colossal bones, ruined buildings and monumental vessels supplanted the earlier concentration on bodies. But Maeda's involvement with breakage remained constant. His work veered, during the early 1990s, between impressive assertions of wholeness and sudden, dramatic signs of damage. The interest in fragmentation also reflected his increasing urge to counter the previous emphasis on heaviness and solidity. A striking tension developed between these broken forms and their finely crafted textures. Look at *Untitled 95-1*, now installed so majestically among the tall trees in Yorkshire. Its two principal cylindrical shapes look like great steel bells, but damage has been inflicted on them. The feet jutting from its base look stunted. And the elongated bar supporting one of the bell-like forms has buckled under the strain. All the same, the surface of *Untitled 95-1* has been manipulated with

conspicuous care. Maeda shows great accomplishment in his intricate handling of their striations, which suggest that the bells were once intended to play their part in a major building. The disaster they have undergone cannot hide the finesse devoted to their making. Although the bells have lapsed into silence, they still possess a formidable, latent vitality.

Further along the same stretch of grass on Driveside, an even more battered form in *Untitled 96-A* is lifted up on legs. It looks, now, more like an animal's hollowed-out carcass. Despite the supports, it also appears unsteady. Only the shell survives, and its attempt to remain upright seems futile. At the same time, though, there is a surprising sense of grandeur about this ramshackle presence. It even looks slightly comic, like a doughty old creature trying in vain to defy the inevitability of decay and extinction.

Elsewhere on the grass, a later sculpture in corten steel no longer struggles to fend off disintegration. *Untitled 97-11* has been reduced to a hulk, the darkened remnant of a catastrophe that has long since passed. One side is rent by a jagged tear, and the work as a whole lacks the sprawling impact of the sculpture Maeda made the previous year. It is more compact, and the pummelled surfaces are buttressed by an upright form standing at a slight remove. Moreover, it offers an implicit invitation. The holes could easily be seen as entrances, through which someone might crawl and find shelter within. Its protectiveness is reassuring, and its resemblance to a primitive kiln reinforces the possibility of regeneration ahead. Maeda's old studio in the Japanese countryside looks like a blacksmith's forge, equipped with a coke-fuelled furnace, hammers and anvil. So he may well have seen *Untitled 97-11* as a sculpture hinting at future renewal, a ruined chamber where fresh work could one day be produced.

For the time being, though, Maeda has pursued other directions since he settled in London. He needed to shake off his identity as an artist concerned above all with weighty, monumental work. He also wanted to explore alternatives to the idea of a central, dominating image, developing instead a freewheeling approach that paid more attention to a supple interplay between sculpture and the space surrounding it. That is why, in the work displayed inside the Pavilion Gallery, nothing rears up like a monolith any more. The largest exhibit, *Untitled 99-A*, is more akin to an installation than a sculpture. Made of perspex, stainless steel mesh and bronze, as well as his favourite steel, it is for the most part a low-lying work. Transparency is the keynote here, along with a greater degree of simplicity. The references to nature are more overt as well. Bronze branches, two of them covered in silver paint, lie in open-ended containers as a reminder of the landscape visible through nearby windows.

64. Noriaki Maeda, *Untitled 99-B*, 1999, at Yorkshire Sculpture Park

As for the ample perspex box resting on the floor beside the branches, its base is lined with green powder pigment even more redolent of the turf outside. The old weightiness has disappeared, and a new spirit of play infects the smaller bronze maquettes on view elsewhere in the gallery. Two prongs rise in the air from *Untitled 97-004* like a dancer's outstretched arms, or plants surging upwards in search of the light. And in *Untitled 97-003*, Maeda delights in making a sculpture whose four upright elements are in the process of collapse, like books about to tumble from the edge of a shelf.

The most recent sculpture, however, is positioned outside the Pavilion Gallery. Far larger than the maquettes, and returning to a vertical format, it incorporates a substantial amount of corten steel once again. In every other respect, though, *Untitled 99-B* makes a decisive move away from Maeda's earlier work. For it also incorporates an expanse of stainless steel mesh, which billows around the corten steel with the airiness of a curtain stirring in the wind. It seems alive to the natural elements, reacting to the sunlight and divesting itself of the bodily substance that pervaded so much of Maeda's sculpture in the past. It feels like an invigorating departure, and augurs well for the future of this inventive artist as he explores his new-found relationship with the world beyond the gallery.

JAMES TURRELL
March 2000

No contemporary artist has entered the new millennium with a more enticing and ambitious raft of new projects than the tireless James Turrell. In London, his vast oval room at the Millennium Dome is saturated with shimmering blue-violet light and offers a view, far above your head, of the sun seen through a tantalizing veil of cloud. 'The wow is here' wrote one awed reviewer, describing how 'the installation really does work on you, and it leaves a memory of colour – like a stain – in your head'. Similar astonishment will no doubt be expressed in April, when Turrell transforms the great Pont du Gard near Nîmes into a permanent lightwork. The 2,000 year-old acqueduct is France's most spectacular Roman landmark, but Turrell is expected to make the hallowed structure even more spellbinding than before.

In the very same month, another dramatic Turrell work will go on display in the Palais des Papes at Avignon. As simple and dramatic as all his installations, it bisects a room with a diagonal curtain of light. A similar piece recently impressed visitors to the Hirshhorn Museum in Washington DC, and in September Turrell's thoroughly international year continues with his grand illumination of the Baths of Trajan in Rome. He is fast becoming an inescapable presence, in Europe as well as his native America. And plans have now been announced for Turrell's transformation of the River Thames, at the sensitive point where it flows through the very heart of London. The South Bank Centre has invited him to devise a large-scale light sculpture. It would illuminate the Thames between the Centre and Somerset House on the opposite bank. Turrell intends to unite both sides of the river with a radiant work, suffusing both the water and the bankside buildings with seductive colour.

But that is not all. If everything goes according to plan, he will be able next year to complete his visionary transformation of an extinct volcano in Arizona's Painted Desert. The Roden Crater project has been at the centre of his ambitions for the last two decades, and it drove him to raise over fifteen million dollars in order to execute it. The complex task of shaping the volcano's cone was completed by the early 1990s, after bulldozing some 200,000 cubic yards of earth from the rim. Since then he has built an intricate sequence of pathways, chambers, stairs and corridors within the 400,000-year-old crater. It sounds a formidable task, but Turrell himself talks about the venture with an assurance bordering on serenity. 'I want to make spaces there which will perform the music of the spheres in light,' he explains. 'I'm interested in creating a place where you become involved with geologic time, making you feel as if you really are on the surface of the planet. The series of spaces will be a combination of bunker and observatory, with the different orientations adding up to a full work covering all aspects of the sky.' In order to ensure that the positioning of the spaces accords with the stars and planets visible through the volcano, he has used his expertise as a pilot and aerial surveyor to map the crater's celestial location with impressive precision.

How did he ever come to dedicate himself to such a daunting, almost superhuman enterprise? The fundamental answer lies in a formative experience he relished in his boyhood. An articulate, white-bearded man now in his late fifties, Turrell has been fascinated by the mysteries of light and the cosmos since boyhood. Growing up in Pasadena, he inhabited a bedroom which his father, an aeronautical engineer and amateur ornithologist, had earlier peppered with little windows to let birds fly in and out. The imposition of wartime blackouts meant that

65. James Turrell, *Roden Crater*, in 2000

each window was supplied with a dark blind, and the young Turrell would use them to shut out all the sunlight. Then, in the darkness, he got to work. 'I made pinholes in the blinds to represent a constellation of stars,' he recalls, 'making visible the things that were in the sky but normally invisible during the day.' Although his fascination with light grew from that point onwards, he had for a while no idea what to do with it. After graduating from Pasadena High School in 1961, he studied Psychology and Mathematics for a BA at Pomona College in Claremont. Only then, at the age of twenty-two, did he begin Graduate Art Studies at the University of California. His ambitions at that stage centred on becoming a painter. 'I looked at the artists who had painted light, especially Monet, Rothko, Reinhardt and Newman,' he says. 'But with my American directness and *naïveté*, I decided in the end to dispense with painting and take light itself as my working material.'

The outcome, so far as his early work is concerned, can be seen in a work called *Decker*. Entering a darkened and empty room, the viewer is confronted by a dazzling rectangle of light projected on to the end wall. Turrell made this taut, economical piece in 1967, when the minimal movement was at its austere height. All his work of this period was very spare, a quality he relates in part to his Quaker upbringing. 'They thoroughly disapprove of art and don't even believe in decoration', he says with a smile, 'but the whole Quaker thing is to do with going inside yourself to meet

the light. Consciously or not, the Quakers do in fact relish a kind of lush severity: their meeting-houses of plaster and wood are very beautiful.'

So is one of his most spectacular gallery installations, a monumental work from 1982 called *Rayzor*. The room it occupies is transformed into a wide, white box, and at the far end a colossal oblong hovers in space with intense blue-green light pulsating around its edges. Using a blend of natural and fluorescent light, Turrell manages to flood the entire space with a soft, hazy radiance. Within this highly charged chamber, the oblong seems to float with ease, changing colour from near-silhouetted blackness to a deep, rich purple. It is a magisterial work, at once severe and sensuous. The light presses itself forcibly upon us, helping to explain why Turrell wants to 'move consciousness out through the eyes to feel the space. The eyes are the most exposed part of the brain, and we have this great capacity to feel through them.'

He regards his gallery work as 'chamber music, which helps me learn how to handle the symphony'. And my most exciting encounter with his magical installations occurred in 1993 at the Hayward Gallery in London. Turrell, the master-manipulator of light, initially forced visitors to grope their way towards *Wedgework IV* through corridors as dark as midnight. Then blackness gave way to a vast and airy chamber, filled with misty red light. In the background, beyond public access, a large rectangular opening led to a distant room. Partially visible and veiled with a softer radiance than before, its loveliness was intensified by an aura of unattainability. Spare yet overwhelmingly sensuous, *Wedgework IV* seduced at once. But the neighbouring exhibit worked far more stealthily. A dark corridor led, this time, into a far cooler chamber. The main illumination was provided by pools of light on the left and right walls, flanking an opening as wide as a cinema screen. As I approached, the opening gave out on to an infinitely mysterious emptiness beyond. It seemed to be swimming with fog, but the whole expanse was so hard to fathom that I instinctively wanted to reach out and touch it. Nothing was there, of course, but Turrell handles light with such deftness and subtlety that it almost becomes palpable.

His wizardry was at its most captivating in the open air. Seen from outside, the bunker-like structure built on the gallery forecourt looked as unprepossessing as the Hayward's own brutalist concrete architecture. Inside, though, it was awesome. A tunnel-dark entrance guided me through to a startlingly bright space, lined on all four walls with plain wooden benches. Their high backs sloped away, inviting me to lean against them and look upwards without neck-strain. They terminated in a hidden strip of light, running round the room and brilliantly illuminating the

walls extending about twenty feet in the air to a plain ceiling. Here, a square aperture had been cut out, giving directly on to the sky. I sat in the room watching night descend. Heavy clouds, combined with the encroaching dusk, should have ensured a dull spectacle beyond the roof. But by contrasting it with the brightness of the room below, Turrell intensified the sky's colours with extraordinary potency. By the time darkness settled in, the square opening had been turned into an irresistible expanse of deep, rich blue. It was as if a swathe of velvet had been attached to the ceiling, and the effect was mesmeric.

For Turrell, though, the volcano in the vastness of the Arizona desert remains 'the thing I most want to do'. He flew all over the western states in his own aeroplane looking for the site, before he found it near Flagstaff. It allows him to use the sky 'as my arena, my canvas if you like'. Here, with luck and the requisite amount of sponsorship, Turrell will be able to generate 'the sense of awe I find in Egyptian art, Mayan culture and the great cathedrals. If you're taken away from the city lights, you'd be surprised how much you can really see.'

Turrell uses the word 'odyssey' to describe how he has travelled towards this enormously ambitious goal. At a crucial stage he found the writings of Antoine de Saint-Exupéry and Sir Francis Chichester inspiring in their dedication to epic journeying. A similar commitment sustains his own belief in the feasibility of the volcano scheme. Ultimately, Turrell regards art as 'a long-distance race, and only when you've gone way down the road do you see art as it really is'. He quotes with approval a remark that Fats Waller once made: 'People never change, they just stand more revealed.' The unveiling of the great Roden Crater project could be the moment when Turrell's life work is finally defined, in all its single-minded tenacity, dedication and sense of wonder.

BILL WOODROW ON THE PLINTH
15 March 2000

Ever since Trafalgar Square was laid out 160 years ago, one of its large granite plinths has remained empty. Positioned near the corner bounded by Canada House and the National Gallery, it could hardly be a more prominent site for sculpture. But the plinth remained obstinately vacant, until a brave and lively scheme was inaugurated last year to occupy it

with temporary commissions. Mark Wallinger's *Ecce Homo*, the first of the three new sculptures to be placed there, aroused intense and widespread debate when it was unveiled. His decision to place a defiantly small figure of the bound and humiliated Christ near one precarious edge of the plinth took everyone by surprise. With great daring, Wallinger left most of the plinth empty and made no attempt to turn this solitary man into a grandiose monument. Pale and resigned, he was the essence of vulnerability. And his straightforward, life-size humanity spoke to many who might have found a more conventional, elevated statue of Christ unbearably pious.

Many viewers were so moved by *Ecce Homo* that they wanted him to stay. Among its admirers is Neil MacGregor, the Director of the National Gallery, who has included a photograph of the figure in the final room of his immensely popular *Seeing Salvation* exhibition. But Wallinger's admirable sculpture has now been replaced by a rumbustious alternative. At noon today, Bill Woodrow's towering bronze will be unveiled by Lars Nittve, Director of Tate Modern. Weighing eleven tons, rearing twenty-seven feet into the sky and funded to the tune of nearly £300,000 by the Sculpture at Goodwood charitable trust, it is a colossus. Made from 130 pieces cast separately in the foundry, its theatrical flamboyance is at the furthest possible remove from Wallinger's undemonstrative martyr. The Christ looked so blanched and modest that he offered an implicit reproach to the hackneyed rhetoric of so much public sculpture. We could easily imagine him climbing off the plinth and shunning his exposed, lofty location. Woodrow's sculpture, by contrast, occupies the space with such robust conviction that it even holds the plinth itself in an unexpected grip.

Entitled *Regardless of History*, it shows an immense, probably male head lying on its side. Directly above, a heavily bound book threatens to crush him with its oppressive weight. Only his neck escapes from the burdensome volume, projecting upwards like the tail of a monstrous, flailing fish. But both book and man are imprisoned by a tree that has taken seed on top of them and stretches its bare branches high in the air. At the same time its roots writhe their way downwards, holding head and book in a sinister embrace and spreading past them to wriggle over the granite support as well.

When Woodrow received this commission from the enterprising Prue Leith, in her role as Deputy Chair of the Royal Society of Arts, he was determined to produce a work that would arrest the public's attention. Although he has lived in London ever since his student days in the late 1960s, Woodrow confesses that 'I wasn't really aware that the plinth was empty'. But he did realise that 'people have got so used to seeing statues

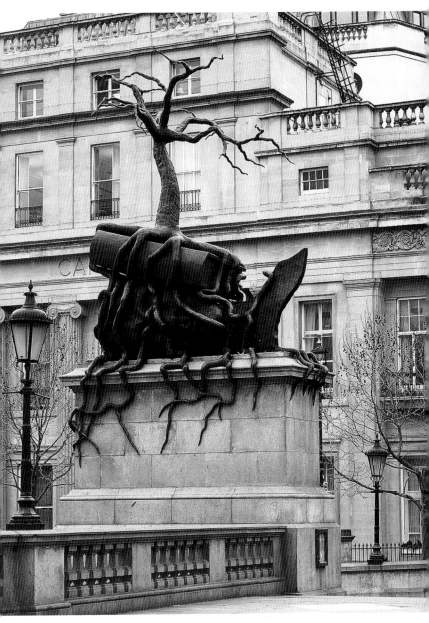

66. Bill Woodrow, *Regardless of History*, 2000, Trafalgar Square, London

of kings, queens or generals on horses that they're not noticed except by specialists. I wanted to put on this classical plinth something different enough to make people stop.' Not that his sculpture, with its rugged figurative language and frank reliance on symbolism, is very radical in its formal qualities. In many ways, *Regardless of History* looks stubbornly old-fashioned, especially when compared with the inverted cast of the plinth in water-clear resin that Rachel Whiteread will install there this autumn. But Woodrow feels that 'at the moment there's such a plethora of forms and ways of making art that the notion of "radical" is quite difficult'. There is, of course, a huge irony attached to the spectacle of a modern sculptor producing anything for a plinth at all. So much of the finest and most questioning twentieth-century sculpture was at war with the convention of a traditional plinth, and many artists jettisoned it completely. Wallinger indicated the ambivalence of his attitude by leaving most of the plinth provocatively bare. But Woodrow, confronted by the same challenge, decided that it was 'crucial for me to involve the plinth, and make it become part of the sculpture. The simplest way to do that was to extend the root system, so that the tree grows over the architecture as well as the sculpture. It's almost an illusion, if you like. But that was more interesting than leaving the plinth as a pure place, to put something on.'

So did Woodrow want to imply that some kind of victory has been achieved by the tree, as it rears over book and head with such undulating aplomb? He shies away from the word 'victory', possibly because of its military associations with Nelson triumphant on his column nearby. 'What interests me about this sculpture is the cyclical notion of time,' he says, 'and the idea of the tree, which can signify nature, having the last word. Civilizations come and go. Our civilization in the scheme of things is a mere drop, a mere second.' But he does not see *Regardless of History* as an apocalyptic work. 'I hope it's quite a calm sculpture. It's not supposed to be, as some have thought, a depressing image. I just see it as an account of how things are – I'm being realistic about things.'

Part of this realism involves acknowledging the prodigious antiquity of trees. 'They generally live a lot longer than people do,' Woodrow points out. 'They're fascinating things in themselves, apart from how they look visually. I've seen photographs of ancient ruins covered by the jungle, and growth just sticking out through them. I enjoy those images a lot.' It sounds as if Woodrow might be attracted to the melancholy of ruins, and the elegiac emotion explored in Shelley's *Ozymandias* where the 'traveller from an antique land' comes across a 'shattered visage' lying 'half-sunk' in the desert sand with a chilling inscription still visible on the pedestal:

'My name is Ozymandias, king of kings:
Look on my works, ye Mighty, and despair!'

Woodrow agrees that he sees his reclining man as 'a fallen head, but it's really fuelled by images I've seen on television. For example, when the USSR broke up and all the statues were toppled. That made me think about how dictatorships are always bolstered by lots of images, so this fallen head for me is very contemporary.' He is even prepared to admit that there may be an unconscious element of self-portraiture here, in the sense that 'my face is the one I see most of all in the mirror, and it just comes out'. But he sees the head in the sculpture essentially as 'humankind, a generalization', and the book lying on top 'represents the accumulated knowledge of the world'.

Woodrow's views about literature and its relationship with the contemporary reader are complex. On one level, he says that 'books are things that fascinate me. I don't read as much as I would like to, because I'm doing other things. I'm always in awe of books and the knowledge they hold. And I still think, even in today's computer age, that books are the most sophisticated form of keeping knowledge. They don't need electricity: all you need is light and yourself to access them.' He sees the enormous tome in his sculpture as the history of the world, but the ominous title indicates another, darker level of thinking altogether. By placing the book over the man's ear, and allowing tree roots to dangle over his eyes, Woodrow implies that the head 'could listen to history but couldn't see. It's just my feelings about how we learn, or not, from history.'

Woodrow refuses to describe himself as either an optimist or a pessimist. He is also at pains to stress that his provocative Trafalgar Square sculpture is 'not political. First and foremost, it deals with form in an exciting and interesting way, for myself. It also contains something of my response to the world. But if I made political sculptures they would turn out to be posters, like agit-prop. I want to do things that maybe last a little longer.' Ultimately, he sees *Regardless of History* as a work that can 'exist in any climate or situation: that's what I'd hope'.

JAN FABRE: A CONSILIENCE

19 January 2000

Encrusted with Victorian carvings of dragons, monkeys and a riotous menagerie of other creatures, the Natural History Museum is an enticing place for artists to explore. The entire building teems with bizarre exhibits capable of kick-starting even the most jaded imagination. Its collections of insects alone are the richest in the world, amounting to a mind-reeling total of around twenty-eight million specimens. So Jan Fabre, an uninhibited Belgian artist obsessed in particular with beetles, must have felt instantly at home when he visited the museum last year.

Now the outcome of his unpredictable encounter with the institution has been put on view, and it amounts to the strangest show in town. Fabre begins on a menacing note. At the exhibition's entrance, a transparent box jutting from the wall encloses a sculpture of a human skull, studded with real beetle shells. Whether shiny, striped or mottled, they cover the surface of the head and its sunken eye-sockets, glinting like limpets attached to a sea-drenched rock. Move through the nearby doorway, though, and a more unsettling spectacle confronts you. In a wide, darkened gallery, where Alfred Waterhouse's lofty rafters almost vanish in the gloom, two large video screens are installed at opposite ends of the chamber. They tug our eyes incessantly from one side over to the other, as we struggle in vain to catch the different images projected there. In this respect, Fabre makes almost as many conflicting demands on our attention as Jane and Louise Wilson, who assail us with an even greater choice of simultaneously projected video material.

There, however, the resemblance ends. For Fabre is completely out on his own in contemporary art. On one level, he has inherited a great deal from his great-grandfather, the distinguished entomologist Jean-Henri Fabre. Renowned for his pioneering nineteenth-century research on beetles, this single-minded ancestor clearly provides Jan with a major source of inspiration. But Fabre is an artist rather than a scientist, and he can also be linked to fellow-countrymen as fantastical as Magritte and Ensor. The latter, with his similar love of bugs and ever-present awareness of the grave, is especially close to Fabre's concerns. But he belongs as well to a far older tradition in Flemish art, stretching back at least as far as Bosch and the late medieval painters who depicted colossal insects with meticulous, admiring precision.

Fabre's great-grandfather, though, is surely the decisive influence on his Natural History Museum commission. Instead of looking at its collections

in isolation, he decided to meet the entomologists who work there and learn from their experience. The installation is called *A Consilience*, which he defines as 'a "jumping together" of knowledge and facts across disciplines to create a common groundwork of explanation'. Fabre certainly engaged with the experts there, and his video relies in particular on the white-bearded charisma of Dick Vane-Wright, the Head of Entomology. But *A Consilience* proves that their encounters were a two-way process. The museum staff turned out to be just as willing to learn from Fabre, and ended up donning flamboyant, intricately constructed insect costumes. Vane-Wright became a butterfly, while Martin Brendell, the Collections Manager, was transformed into a beetle. As for Ian Gauld, from the Flora & Fauna Division, he took on the macabre role of a parasitic wasp.

Fabre has long been involved with the scarab beetle, aware that it symbolises the passage of new life in traditional Flemish art. Perhaps he aimed at a similar sense of a fresh beginning in *A Consilience*, where many images are pervaded by the spectacular prospect of metamorphosis. Seeking the darkness for his manœuvrings, he filmed mostly in the bowels of the museum. There, in narrow, claustrophobic spaces lined with shelves of jars containing carefully preserved body-parts, Fabre and the staff enacted their mysterious rituals. A seasoned playwright, director and performance artist in his native Antwerp, Fabre clearly knew how the entomologists could be persuaded to cast their scholarly inhibitions aside. One curator appears wearing a man-sized black beetle costume. He makes wild gestures with its spindly limbs, and mutters indecipherable comments. The only coherent word is 'wasps', repeated like a magical incantation. We could almost be witnessing the activities of some eccentric cult, and Fabre compounds the manic mood by suddenly appearing in close-up, waggling his tongue at the lens. Then we see even more intimate shots of stuffed creatures, concentrating on details of their eyes and teeth. But the camera is never allowed to rest on anything for long. The cutting is quick and restless, perpetually on the move to keep pace with the figures who parade through the shadowy store-rooms.

Sometimes the video is fastened up to a jerky, crazy rhythm, as if to stress the urgency of the performance it records. The pace becomes frenetic when one figure, clad in elaborate flaring wings, starts jumping high in the air. He resembles a Renaissance bird-man engrossed in a Leonardo-like attempt to fly. But the experiment ends in an abject earthbound shuffle, reinforcing the impossibility of vying with an insect's effortless command of aeronautics. Only by resorting to camera trickery does Fabre ever achieve the transformation he desires. At one point, wearing goggles and swathed in the carapace of his chosen creature, he

67. Jan Fabre, *A Consilience*, 2000 (Fabre with Dick Vane-Wright, Head of Entomology, Natural History Museum, London)

starts to revolve. The spinning soon becomes hectic and, dissolving in a blur of speed, he changes from human to insect and back again.

Fabre knows, as well as his academic collaborators, that it is only a fantasy. His imagination is haunted by death, and the mood grows morbid soon afterwards. The camera peers at skulls ranged on shelving. Amid copious muttering on the soundtrack, one pessimistic phrase leaps out with bitter clarity: 'dead flies are blood-suckers on the body'. We find ourselves roaming through the public spaces of the museum, moving slowly round skeletons whose bones blur and bifurcate as the camera travels over them. But the mood does not last. Subversive humour keeps breaking through, and reaches a weird climax when Fabre starts wandering outside the building at night. Staring over the cast-iron railings, he brandishes a gigantic butterfly net in the blackness. Although an absurd spectacle, he is not afraid to court hilarity. Entomologists and artist join in a dance at one stage, and the bearded chief curator starts playing a trumpet. It could well be a dance of death, but the feeling is unexpectedly festive. Perhaps they are celebrating the coming-together of different disciplines, united in their desire to arrive at a closer understanding of the insects that fascinate them. If Fabre sees himself as a self-appointed ambassador of the beetle world, the dance suggests that he has succeeded in his task. For the curators are exploring, here, a new level of engagement with their specialist subject. Far from studying insects with pure scientific dispassion, they have momentarily jettisoned professional codes of behaviour and entered into the spirit of the creatures themselves.

Quite how far they went in the direction of empathy cannot be gauged. Fabre's installation is fragmentary, even teasing, and raises questions rather than answering them. It can, on occasion, be irritatingly opaque, above all in impenetrable snatches of dialogue exchanged by the participants. I often felt excluded from the secretive interaction between Fabre and his fellow-performers. Their enjoyment is evident enough, but they seem too absorbed in their own antics to ensure that anyone watching them could share the excitement.

At other times, though, *A Consilience* yielded moments of dreamlike potency. They centred especially on a shrouded white figure, half outsized chrysalis and half Lazarus emerged from the tomb. Tilting motionless in the shadows, this unexplained phantom suddenly reached out a blanched hand. It clasped an equally white pod surmounted by a cross, a form that recurs in Fabre's work. Then the pod was secreted in the phantom's pouch, where it will presumably be left to germinate one day. This emphasis on the future seemed, in the end, very apt. For Fabre's exploration of the uncharted relationship between humanity and insects

will probably continue to bear fruit long after his departure from the museum. Vane-Wright and his colleagues could not easily forget their adventures in the fabulous costumes, and nor will anyone who views this installation in a sympathetic way. With luck, it may even help to change our attitude to all the vulnerable fauna placed in our care.

MODERN SCULPTURE AT GLOUCESTER CATHEDRAL
5 June 2000

However magnificent our medieval cathedrals may be, the loss of their finest paintings and sculpture is often painfully apparent. Gloucester, an outstanding abbey before it surrendered to Henry VIII's commissioners in 1540, is no exception. The presence of King Edward II's tomb saved the building from destruction. But most of its other carvings were swept away, and Cromwell's philistine Parliamentarians finished the job by smashing up the Lady Chapel's reredos a century later. English sculpture took a long time to recover from this annihilation. Only in the twentieth century did a sustained spirit of innovation and vitality return. The young Jacob Epstein, Eric Gill and Henri Gaudier-Brzeska opened up the expressive possibilities, and their revolutionary drive was inherited by Barbara Hepworth, Henry Moore and their allies. Since the Second World War, the adventurous momentum has, if anything, quickened even more. The meaning of the word 'sculpture' now encompasses an unprecedentedly wide range of materials and working methods. The results would have startled the masons and artisans who once enriched our great cathedrals. But even the most audacious contemporary sculptors can still find a rewarding place in these hallowed buildings. Until now, Gloucester has never housed an exhibition of modern sculpture. Thanks to the enterprising artist James Castle, though, this superb example of Romanesque and Gothic architecture has become a temporary home for the work of twenty-one sculptors.

Some devotees may regard the whole notion of this show as tantamount to desecration. After all, the noble Norman nave and spectacular fan-vaulted cloisters are full of sculptural power in their own right. So why run the risk of blunting their impact? Placing contemporary work in such settings could easily look like an invasion, disrupting sacred spaces that deserve to be left alone.

68. Alison Wilding, *Graft II*, 1994

To his credit, Castle realises the dangers involved. He knows the virtue of restraint, and refuses to bombard any sector of the cathedral with a sculptural overload. Immediately we enter the nave from the south-west, his wisdom is apparent. For here, advancing down the centre of an aisle, are three carvings in Brazilian granite by John Maine. Their prominent position might have made them obtrusive. But Maine's *Escarpment* is modest in size, and its companions are smaller still. In no danger of vying with the awesome immensity of the cylindrical Norman columns, they complement their Romanesque surroundings without any sense of strain. Indeed, their presence here intensifies our response to the nave, making us realise how sculptural these columns and their surmounting arches really are. A dialogue is established between the Middle Ages and the new millennium, and their interplay proves mutually enhancing.

Just beyond Maine's carvings, Alison Wilding shows that modern sculpture is capable of potency even when minuscule. Her *Graft II*, an

impeccably smooth alabaster vessel which seems to be spilling its dark, unruly resin contents, is attached to one of the great stone columns. It looks thoroughly at home, like a votive offering left behind centuries ago. I found myself imagining it as a light holder, glowing in the shadows of the cathedral at night. Glynn Williams, whose painted carvings in Hopton Wood stone are displayed in the south transept, makes the idea of a vessel more explicit. Alongside his tall bottles, though, rudimentary forms with gouged cavities suggest that an act of partial destruction has occurred. They cast shadows on rougher fragments lying alongside, giving them the appearance of standing stones on some remote, prehistoric site. But the shadows are made from hatched lines, dense enough to be reminiscent of Morandi's still-life etchings. Carving and graphic art come together here, united by a sculptor who understands the melancholy allure of damaged forms. In this respect, Williams's exhibits chime with the poignancy of the so-called *Prentice Bracket* projecting from a nearby wall. One of the few Gothic carvings still to be found at Gloucester, it commemorates a young mason spreadeagled as he falls to his death in the abbey.

An even more dramatic juxtaposition can be found on the north side of the nave. Here, marooned on a tall plinth just before the transept, Ana Maria Pacheco's polychromed wood *Study of Head (John the Baptist II)* sounds an anguished note. It probably shows the saint after his execution. He seems to be displayed like a trophy, and his expression looks frozen in the most excruciating moment of pain as the severing occurred. Staring up at his parted lips and tormented eyes, we might initially recoil from such a grim image. But Gloucester would once have housed equally gruesome carvings and paintings of Christ's suffering. Besides, Pacheco's outspoken head is strangely akin to the stark face of Thomas Machen's wife, kneeling in a sombre family monument on the neighbouring wall. Dressed in black, she clasps her hands in prayer along with eleven children ranged below as they mourn their dead father. The Machen memorial was carved as long ago as 1614, but its uncompromising harshness appears uncannily in tune with Pacheco's mesmeric sculpture.

Not all the exhibits carry such an ominous charge. Positioned at the centre of the north transept, Paul Aston's painted limewood carving *Fifty-One Year-Long Echo* flourishes in its spacious location. The undulating forms sprout and burgeon, as if reacting to the loftiness of the ceiling far above them. They are the epitome of natural vigour, and a similar vitality informs Annie Cattrell's *Access* flanking the entrance to the cathedral's Treasury. Made entirely of glass, it is a *tour de force*. The human heart and lungs are shown, life-size, in all their astonishing intricacy. However anatomically faithful the sculpture may be, Cattrell transforms

her subject through a virtuoso command of her chosen medium. The delicacy of her work could hardly be further removed from Steve Dilworth's *Sacred Heart*, a spiked lump of limestone lying on the floor. Rather than translating bodily organs into glass, he opts for the real thing. Inside his sculpture is a medieval nail, stolen by a souvenir hunter many years ago from the door of Chartres Cathedral. Dilworth has now wrapped the nail in an ox heart, itself sealed in lead. And the outer casing of limestone comes from a quarry near the Marquis de Sade's chateau. It is a thoroughly sinister object, made by a sculptor who points out that churches once provided the only doors sturdy enough to be used for flaying people. John Gibbons's steel piece, nestling in a niche nearby, develops the theme of violence and suffering still further. His sculpture, ostensibly echoing the structure of a cathedral, ends up resembling a macabre instrument of torture.

James Castle's selection does not, therefore, err on the side of blandness. The range of feelings explored here swings from the brutal to the lyrical, and his own exhibit is among the most arresting. Boldly positioned against a Norman column in the nave, it presents at its apex an empty limewood vase. The vessel has a funereal air, accentuated by Castle's decision to paint his sculpture black. Further down, though, the plinth supporting the vase swoops outwards, branching into the forms of giant seeds on the north aisle flagstones. These flamboyant forms seem bountiful enough to play their part in a Harvest Festival, and they have a splendidly theatrical impact. But Jane Gledhill's large abstract sculpture looks ill-at-ease further down the aisle. Placed too near Castle's work, it appears at odds with this setting.

In the sublime cloister walk, where exuberant fan-vaults surge like trees in a tropical forest bursting with growth, Neville Gabie's exhibit seems even more out of place. But the rest of the sculpture sited here suits the cloisters magnificently. Both the pieces by Lynn Chadwick, the oldest participant, thrive in this setting. A spiky work from the 1950s at one end confronts a 1995 bronze of a young woman at the other. Her hair and skirt are blown with apocalyptic force, seemingly by a wind tearing through the passageway. But Peter Randall-Page's bulky carvings in Kilkenny limestone look safely ensconced within their twin shelters, while Keir Smith's bronze *A Lily Among Thorns* appears utterly at home as it gleams and twists among the tracery of gothic stone arching on every side.

When these felicitous moments of correspondence are achieved, they justify the whole risky attempt to locate contemporary art in such a revered context. Present and past invigorate each other, with unexpected consequences. Outside the cloisters, in a secluded garden, Barry Mason's

Thales rises to a point that echoes the cathedral steeples above it. Leaf-like in form, his stainless steel sculpture lets water drop slowly through its ribs. The sound is wonderfully therapeutic, and goes a long way towards explaining why Mason deplores 'the death of magic, our loss of ritual'. Maybe today's artists can emerge replenished from their contact with places as inspirational as Gloucester. Down in the crypt, where part of the apse built by Abbot Serlo in 1087 still survives, Andrew Stonyer has installed an audio-kinetic sculpture whose electric components are triggered by exposure to the sun. When the solar energy is sufficiently strong, it transforms his work into a musical instrument whose notes reverberate through the dark, subterranean chamber. They seem respect-ful of antiquity and, at the same time, celebrate a reawakening.

A MYSTERIOUS RUSH OF VOICES:
TWO ARTANGEL COMMISSIONS
3 May and 10 November 2000

I Witness

A feat of subdued yet eerie concentration is achieved by Susan Hiller's compelling *Witness*, an Artangel project installed on the upper floor of a derelict Baptist chapel in Notting Hill. At the top of a narrow circular staircase, visitors are confronted by an extraordinary combination of sight and sound. Hundreds of long wires dangle from the lofty ceiling. Dimly lit, they seem about to disappear in the encircling shadows. But the noise they emit is intriguing: a mysterious rush of voices, subdued in volume yet urgent in delivery.

Fascinated by the whispers and murmurs, we move forward. The wires surround us now, like strange vines slanting down through an overgrown forest. The voices come from small speakers attached to the filaments. They seem to be conversing with one another, in a multilingual babble. But when we lift the speakers and press them to our ears, we find that each relays a monologue about a first-hand encounter with a UFO or an extra-terrestrial being. Although Hiller has recorded them specially for *Witness*, the voices all read authentic accounts of sightings across the world. The testaments are precise and factual, made by people deter-mined to convey their astounding experiences with as much fidelity as

69. Susan Hiller, *Witness*, Notting Hill, London, 2000

possible. We move through the muted chorus, grabbing the wires and watching other visitors also absorbed in listening. Their concentration becomes part of the work, an intimate experience shared with strangers. And gradually, as we sample the voices, a global pattern emerges of individuals united by their absolute belief in the visitations they describe.

One of them, seventeen-year-old Alex Carrara, is convinced that he saw a UFO in the sky, 'soundless, with a yellow-orange glow or aura emanating from it'. After performing 'strange turning manœuvres', it disappeared, but Carrara remains just as haunted by the memory as Roberto Cardoso of Portugal. Driving home with a friend late at night, he saw 'a white-blue round object appear from behind a cloud and make a perfect vertical descent of 500 metres from the rainy overcast sky'.

Closer to home, and more dramatic still, is the testimony of a security guard on Blackpool's Central Pier. 'I want to keep my job,' he says, 'so I will not give out my name.' Around 2 a.m. one night, he suddenly 'felt the main pier rattle and vibrate as if struck by a very heavy swell – yet the tide was out'. He rushed into the open air and saw 'a ball of orange light over the sea to the south. It shot into the distance incredibly fast, making a roaring noise, and then it vanished north-westwards. There was a lingering smell, a bit like ozone.'

Whatever we make of such bizarre accounts, their proliferation is as incontestable as their sincerity. The contributors to Hiller's quietly persuasive audio-work really do believe they saw these spectacular events, and their voices add up to an unforced yet highly charged demonstration of faith in the potency of the paranormal.

II The Influence Machine

Soho Square on Hallowe'en night was a spooky enough place before I reached Tony Oursler's powerful installation *The Influence Machine*. Dodging my way past small witches in tall black hats, not to mention belligerent boys sporting grotesque masks, I felt ready for anything. And the magnified voices bouncing round the square prepared me for the images to come. 'Universe is teeming with them, there are no dead!' cried one, before chanting 'Noise Noise Living Noise Dead!' The whole area seemed alive with spectres, a 'psycho-landscape' where spirits from the past haunt us with their unfettered, often hysterical ramblings.

Once I entered the garden in the centre of the square, phantasms ambushed me at every turn. A colossal man's head reared up, video-projected from a state-of-the-art machine with an old-fashioned umbrella perched incongruously on top. He started off spread across an entire bush, then floated upwards before coming to rest in a lofty tree. There he muttered, pleaded, ranted and protested, with an obsessive theatricality familiar to anyone who has seen Oursler's compelling work in exhibitions. When encountered inside galleries, his dummies perform their deranged monologues so intimately that they draw you into their crazy confidence. But here, the giant faces seemed to be hurling their words at the universe. I felt dwarfed by the disembodied man's head, and then intimidated by his female counterpart hovering on a nearby clump of foliage. She moved around even more restlessly, gazing at us through mesmeric eyes. At one moment wheedling like a neurotic child, and then transforming herself into a more monstrous persona, she kept threatening to lose her physical substance and revert to the realm of spirits.

Oursler, who has recently been researching the history of the media, relishes the fact that John Logie Baird made his initial public experiments during the 1920s in neighbouring Frith Street. He used ventriloquist dummies for his pioneering experiments with mechanical television, closeted in the first-floor room of a building now occupied by Bar Italia. The ghostliness of Baird's explorations is evoked at the very centre of Soho Square, where the darkened windows of the tilting, half-timbered

70. Tony Oursler, *The Influence Machine*, Soho Square, London, 2000

summer house are illuminated only by a solitary source of light within. The doors are closed. But if you stand beside the building, voices seem to float out of the walls and compete for your attention.

They need to be compelling. Oursler has created some formidable competition for them nearby, projecting a mysterious profile on to the trunk of a slender tree. We are tempted to approach and listen, like voyeurs spellbound by an essentially private, even illicit spectacle. To the south, though, far larger and more daunting images of fists are flung on to the frontages of buildings. They introduce a sense of extreme physicality, suggesting that Oursler's adventures may be more violent than we imagined.

On the whole, however, *The Influence Machine* is concerned with essence rather than solidity. Over on the west side of the garden, illuminated chemical smoke pours out of machines accompanied by the voice of a medium. 'Oh the noise the noise the noise is killing me' he cries, before pleading 'mommy mommy I'm here don't leave me'. But he should not worry. Oursler has created an arresting psychodrama in the heart of Soho, and we find ourselves lingering among the phantasms for as long as they last.

FILLING THE EMPTY PLINTH
3 July 2000

When I joined Sir John Mortimer's Vacant Plinth Advisory Group last year, the strength of public feeling about this granite slab in Trafalgar Square took me by surprise. After all, it had been unoccupied for 160 years, and nobody complained passionately enough to mount an effective protest. So why should anyone care now, let alone start noisily proposing suitable subjects for a commemorative statue? The answer lay in the arrival of Mark Wallinger's quiet yet potent *Ecce Homo*. When this modest white figure appeared at the precarious front edge of the plinth, the response was extraordinary. Presented without rhetoric as the embodiment of Everyman, the suffering Christ had a vulnerability that impressed many who came to view the statue after its unveiling. Suddenly, the entire nation knew about the plinth, and we found ourselves inundated by suggestions for a permanent solution to the problem of its occupancy.

Culture Secretary Chris Smith set up our Advisory Group to make recommendations on the future of the plinth. Anticipating the strength of

71. Mark Wallinger, *Ecce Homo*, on the plinth in Trafalgar Square, London

national feeling, he and Sir John Mortimer made sure that the Group's members were drawn from widely differing sectors: Cambridge Modern History Professor Peter Clarke, Chair of the Association of Local Government's Arts and Leisure Committee Bob Harris, National Gallery Director Neil MacGregor, architect Elsie Owusu and novelist Ruth Rendell. But none of us could have predicted the overwhelming amount of proposals submitted for our consideration. In the end, a dizzying total of 328 subjects were put forward by over 8,000 individuals, many of whom backed up their ideas with elaborate, cogently expressed arguments.

Some took a monarchical cue from George IV, astride his horse on the matching plinth at the north-east corner of Trafalgar Square. Modelled by the reliable Sir Francis Chantrey, this suave bronze was originally intended to stand on Marble Arch in front of Buckingham Palace. The statue was moved to the plinth as a temporary measure in 1844, but it has stayed there ever since. Records indicate that the other plinth was also meant to carry an equestrian statue, so plenty of people responded by calling for a sculpture of the present Queen on a horse. Some even suggested, in all seriousness, a statue of Princess Diana riding in a jeep.

Several proposals were seasoned with satire. They included a giant pigeon, an equally colossal handbag (in memory of Lady Thatcher), Winnie the Pooh, Dolly the cloned sheep and, inevitably, David

Beckham, Posh Spice and little Brooklyn, singly or together. In general, though, the suggestions were notable for their gravity. Plenty of them ranged back into history, focusing on Charles Dickens, Captain Cook, Thomas Paine, Sir Francis Drake and (God bless him) the Venerable Bede. The twentieth century, however, proved the most popular period of all. Both the world wars found eloquent champions. The suffering of animals, particularly in the Great War, won widespread support. But they will now have their own memorial at Hyde Park Corner, and other advocates favoured a monument to the evacuated children of the Second World War. The best-organised pressure groups chose to back a memorial to the Women of World War II, embracing the Land Girls, the Wrens and all the other women who contributed to the struggle against Hitler. They have never received proper acknowledgement in the masculine world of commemorative statues, and the case in their favour was a persuasive one.

So, too, was the call for a sculpture that took proper critical account of the existing monuments in Trafalgar Square as a whole. After all, the entire space is overshadowed by Nelson's Column surging a mighty forty-four metres into the sky. Nobody now remembers the name of the man who carved the figure of Nelson himself, a surprisingly obscure sculptor called E. H. Bailey. As for the identities of the two Victorian statues on nearby plinths, few passers-by ever notice that they commemorate Major-General Sir Henry Havelock and General Sir Charles Napier. Along with the later busts of Admirals Beatty, Cunningham and Jellicoe set against the north terrace wall, they set the tone of a square dedicated to white, male heroes and the British Empire's military prowess. Several popular proposals offered a salutary corrective to the imperial emphasis, nominating Mahatma Gandhi, Mother Theresa and Nelson Mandela.

But as Professor Linda Colley pointed out when she gave evidence to our Group, Trafalgar Square has also been used as a location by mass rallies for a variety of dissident causes, including the Suffragettes and CND. So the empty plinth could legitimately be used to reflect the desire for a vigorous alternative to conformism and the *status quo*. Although Sir Charles Barry cannot have viewed the plinth in this light when he designed it, his redoubtable granite base now offers an opportunity to convey imaginative visions far removed from the martial values lauded elsewhere in the square. The more evidence we considered in the Group's meetings, the more convinced we became that the plinth should provide a clear alternative to the statuary nearby. Some proposals exhorted us to commission a sculpture that would blend with the traditional language employed in the square's nineteenth-century bronzes. But we felt that a conventional exercise in Victorian portraiture would amount

to nothing more than feeble pastiche. Besides, a statue executed in such a bogus style is unlikely to excite any interest. It would simply go unnoticed, and soon become as forgotten as the tepid, dutiful effigies of Havelock and Napier.

Moreover, no contemporary artist worthy of the name would be prepared to produce a pseudo-Victorian image. Rather than gazing back to the past, driven by a misconceived desire for historical aptness, we should be looking forward. At the beginning of a new century, the vacant plinth ought above all to be a place where the emergent spirit of our own time can find a voice. London, taken as a whole, failed to provide public spaces for outstanding modern sculpture during the twentieth century. Even Henry Moore, who would undoubtedly have been eager to accept a commission for a prominent metropolitan setting, had to content himself with a carving for the Time-Life headquarters in Bond Street high above the pavement. Unless pedestrians look up, they will miss it, and Jacob Epstein's ecstatic *Rima* carving in Hyde Park occupies an even more tucked-away location. The most accessible outdoor spaces in London are inhabited almost exclusively by somnolent nineteenth-century bronzes of bewhiskered aristocrats, politicians, soldiers and grandees.

During the 1960s, at the high point of Pop Art's irreverence, Claes Oldenburg fantasised about invading these hallowed arenas. He proposed replacing *Eros* in Piccadilly Circus with a giant drill bit, or even a lipstick. Then, moving on to Trafalgar Square, the irrepressible sculptor suggested that Nelson's Column give way to an even more phallic gear-lever, acknowledging the thousands of drivers busily steering a path in cars, buses and lorries all around the monument. Oldenburg's feisty projects came to nothing, and in subsequent decades few notable sculptures have been allowed to penetrate London's public spaces. Timidity prevails, except in the Broadgate development bordering Liverpool Street Station. There, in 1987, Richard Serra installed his monolithic *Fulcrum*. Its robust cluster of rusted cor-ten steel plates is at once defiant, menacing, vertiginous and unexpectedly welcoming. Serra showed how the capital can be enlivened by sculpture at its most audacious, providing a lean, uncompromising distillation of the energy that makes London such an invigorating city today.

A similar inventiveness marks all three of the temporary sculptures commissioned by Prue Leith and her colleagues at the Royal Society of Arts. Mark Wallinger, Bill Woodrow and, at a date later this year, Rachel Whiteread have responded to the challenge of the plinth with admirable aplomb. This enterprising scheme terminates next summer, but our Advisory Group unanimously concluded that the plinth should continue to be used as a springboard for specially commissioned sculpture. Indeed,

the current project deserves expansion, ensuring that it is no longer restricted to British artists alone. Sponsors could easily be found for such a high-profile venture, enabling the plinth to play host to a new sculpture every year. Situated at the heart of the metropolis, with an enormous potential audience, it could provide a superb showcase for adventurous artists across the world. The advent of each fresh work is bound to generate debate, helping to prompt a widening awareness of contemporary developments in art. The unprecedented wealth of materials and strategies now deployed by artists should be reflected in the proposals chosen by a small, open-minded and regularly changing group of selectors. Although radical sculptors spent much of the twentieth century taking their work off the plinth, Barry's dignified slab still provides a stimulating foil for artists bold enough to take it on.

They must be given freedom of expression in their approach to the project. Any bureaucratic attempt to direct artists towards rigidly defined methods of working would be a disastrous deterrent, driving them away from the scheme. Perhaps, in 2007, the second centenary of the Bill abolishing the slave trade in Britain could be celebrated by the sculptor chosen that year. But modern artists should never be constrained in their ideas. They must remain at liberty to react to the plinth and its context in their necessarily individual, unpredictable ways.

The Advisory Group ends its report by urging that the commissioning of new work begins as soon as possible. Our recommendations will now be passed by Chris Smith to Ken Livingstone, who as London's Mayor is assuming responsibility for the future of Trafalgar Square. To his credit, Livingstone has already declared his wholehearted support for pedestrianizing the north side of the square, thereby hugely enhancing the public space in front of the National Gallery. Turning the plinth into a spectacular, ever-changing site for sculpture would dovetail perfectly with such an initiative, and I hope that the Mayor will seize this chance to place adventurous art at the very centre of modern urban life.

MICHAEL LANDY: PLANNING BREAK DOWN
16 October 2000

As the first winner of *The Times*/Artangel Open, Michael Landy has every reason to feel relieved. After all, over 700 artists submitted proposals. And before his project was selected, he began to wonder if it would ever be realised. Now, after several years' planning, Landy knows that *Break Down* – by far the most ambitious and disturbing enterprise he has yet undertaken – will soon be installed in a large, disused commercial space on a busy London high street. *The Times*/Artangel Open aims at encouraging and enabling artists to work in the boldest way imaginable, and Landy's highly provocative project is conceived on an epic scale.

It is also unavoidably personal. For Landy intends to offer nothing less than 'an audit on my life so far, stretching back over the past 37 years'. Everything he owns will be gathered together, weighed and catalogued with care and then, quite deliberately, destroyed. The sustained and relentless process of dismantling, sawing, torching and shredding will take a fortnight to complete. Nothing will be spared in this act of comprehensive obliteration. Belongings of great sentimental value, like 'a sheepskin coat that my Dad bought years ago', will be consigned to oblivion. But so will the most expensive object Landy has ever bought: his Saab car, purchased after the Tate Gallery acquired a major work. He will even sacrifice examples of his own art, along with work by fellow-artists in his collection including a print by Chris Ofili and a painting by Gary Hume.

It may all sound as if Landy is about to indulge in an orgy of self-annihilation. But the artist himself is adopting a highly disciplined, analytical approach to his unsettling task. Sitting in the kitchen of the small South London council flat he shares with Turner prizewinner Gillian Wearing, Landy told me that 'I see *Break Down* as an examination of consumerism, not as self-revelation'. Above the wooden table, he has covered the wall with no less than 243 parts stripped from a stereo CD player. Each one is numbered, identified and placed neatly in a plastic envelope. Taken together, row after row, they testify to the astonishing profusion of components lurking inside an ordinary domestic object.

Landy has decided that the hundreds of belongings he is amassing for *Break Down* will suffer a similar fate. Every item, whether a heated blanket bought last year by his mother, a 'no bite mosquito killer device', or a miniature golf set with artificial grass cover, will be weighed, catalogued and then taken apart. Some possessions, like the electric shaver he

bought in Bristol and only used once, will yield far more parts than his Saville Row jacket or the black-and-white photograph of his ex-girlfriend Jackie. But they will all be treated with an equal amount of remorselessness, in an installation where metal conveyor belts will wind round an electrical dismantling table, a shredder, a car dismantling space and an area where large household objects can be cut apart with saws and power tools. Landy admits that there will be 'noise and violence', especially when the full force of oxy-acetylene equipment is unleashed on his hapless Saab. But years of preparation and research will ensure that everything is conducted with meticulous precision.

Although Landy studied at Goldsmiths College in London with Damien Hirst and other *enfants terrible* of the 1990s British art scene, he is the first to admit that 'I've had a very sporadic career'. He was included in *Sensation*, the Royal Academy's notorious show of the Saatchi Collection. But he explains, with self-deprecating humour, that 'no sooner have I raised my ugly head than I'm gone again for two or three years planning a big project. Which is a strange business, because artists are supposed to be visible. I'm very much a tunnel-vision person: I have to be really determined, because each of my works is such a big production and I keep getting turned down by the people I approach for help. I invest so much time and energy in the projects that I ask myself: "can I continue like this?" It's all a bit dysfunctional, and fellow-artists often have career chats with me, telling me to pull myself together.'

Landy persists, nevertheless, in obstinately pursuing his grandest dreams. 'The larger projects ask more questions', he explains, 'and I ask more of myself. They're always on my mind.' After leaving Goldsmiths in 1988 and exhibiting with Hirst, Hume, Sarah Lucas and others in the legendary *Freeze* show, he spent two years working on a monumental installation called *Market*. Multi-tiered street merchants' display stalls and plastic crates were set up in an East London warehouse. They looked ready to sell but, devoid of any wares, remained as austere as minimal sculpture. For his first solo show in a dealer's gallery, held at the precocious age of twenty-four, Landy went to the opposite extreme. This time, he called the exhibition *Closing Down Sale* and filled Karsten Schubert's white space with shopping trolleys loaded with appliances and toys. Dayglo signs on the walls promoted a mood of hysteria, insisting that 'Everything Must Go' in a 'Meltdown Madness'. With its emphasis on bankrupt businesses, the show mirrored the economic recession of the early 1990s. But Landy left the gallery soon afterwards. 'I wasn't selling, and I had a lot of animosity towards me,' he recalls, adding that 'I haven't really had a commercial dealer since then.'

72. Michael Landy

It was a low point. He signed on, and started planning a major work called *Scrapheap Services* 'born out of my own feelings of worthlessness. My confidence was all shot by this time.' But he persisted, taking three years to make thousands of miniature figures by hand. His material was junk, culled from midnight raids on McDonald's garbage and Sainsbury's tin banks: 'the smell was terrible'. In the final *Scrapheap Services* installation, the figures were strewn across the floor while life-sized, uniformed mannequins seemed to be sweeping them away and feeding them to a voracious waste-disposal machine called *Vulture*. It was a cold, nightmarish vision of a world where the redundant work-force becomes disposable trash, a mere embarrassment. *Scrapheap Services* was the most powerful work Landy had yet produced, and it eventually entered the Tate's permanent collection as a landmark of 1990s art.

Apart from reflecting his concern with a society where humans are so often treated like rubbish, the work may also have stemmed from a tragedy in Landy's own family. For his father, an Irish tunneller, suffered a severe accident in the North of England when Landy was only a child. 'It crushed his spine and he hasn't worked since,' says Landy, describing how 'he got compensation but not half enough'. The father's plight must, at the very least, have given his son an abiding awareness of human vulnerability, and made him realise how the needs of the helpless can easily

be overlooked. So far as Landy is concerned, though, *Break Down* will not primarily be an autobiographical work. 'It'll examine consumerism as a way of life,' he explains, 'and ask why people increasingly invest all their dreams in it.' The installation will be based on a Material Reclamation Facility which processes solid waste. It separates, through different kinds of automation, materials that still have a value in the market-place. But *Break Down*, promises Landy, will be 'much more labour-intensive. I've been up several times to an Oxfam centre in Huddersfield, where all the clothes not wanted in the shops end up on this huge sorting system. People do the separating, so a lot depends on hand and eye co-ordination. Then the clothes get baled and sent out to Africa.'

Several people will be employed in *Break Down*, lining a section of the conveyor-belt and working very hard, sorting things into plastic, steel, glass and rubber components. In this respect, the prevailing atmosphere will be more like a laboratory than a breaker's yard. But a clinical setting can be just as disturbing as a place where everything is being smashed and obliterated. Landy may want to investigate consumerism rather than attack it, but his decision to get rid of everything he owns is inherently threatening. He would like everyone visiting *Break Down* to think about the 'black hole of credit, and how we are pressured by an infinitely adaptable consumer society. People see it as a stabilizing force, something you can depend on to cheer you up. I'm sure that I can be as whimsical as anyone else about the purchases I make. But here I'll be destroying things that have some kind of worth.'

On the kitchen wall, below the CD player's dismantled parts, Landy has pinned up an article by Tara Palmer-Tomkinson headlined 'Spend, Spend, Spend'. Its subtitle strikes an ominous note: 'Retail isn't always good therapy. Sometimes it's like a drug and almost as dangerous.' So does he hope, in some way, to be purged of his own consumerist urges by staging *Break Down*? 'Well, you could say it's a self-portrait, and that I'm attacking myself,' he concedes. 'But it's not cathartic: I don't imagine that by destroying all my property I'll come through cleansed. Maybe I'm exerting freedom of choice according to the consumer society.' In the end, though, Landy stresses that 'I'm trying to put on a show. It'll be a lot of hard work, blood and sweat. And it's my first live event – normally I just make objects. So I'm apprehensive: it has to be seen to work.' And when it is all over? 'Well, I won't think: "Thank God all my belongings have gone, now I can live a spartan life." I'll feel sad about it. A huge loss is involved.'

REASSESSING THE PAST

GOLDEN DEER IN NEW YORK, VAN GOGH
IN PHILADELPHIA
27 November 2000

Just over a decade ago, an astounding discovery was made in the steppes of southern Russia. Working on an ancient burial site near the village of Filippovka, archaeologists unearthed a hoard of golden deer. Preserved in their hundreds, these gleaming funerary objects had been carefully deposited there between the fifth and fourth centuries BC. And now, the Metropolitan Museum of Art in New York has scored a great *coup* by displaying these treasures for the first time anywhere in the world. Mystery surrounds these extravagantly crafted animals, not least because robbers plundered the central burial chamber at Filippovka long ago. Although an enormous amount was taken away, they overlooked two substantial deposits preserved in a wooden structure above the chieftain's tomb. Here the carved and decorated stags were discovered, along with further animals adorning the tomb's entrance. Their ornamented bodies showed how important they must have been to the dead ruler. But his identity remained unknown, and scholars are still debating whether he led a nomadic tribe associated with the Sarmatian people. Although such a tribe did inhabit the area at that time, the funerary hoard also has persuasive links with the Scythians who lived to the west, on the shores of the Black Sea.

Unless another, equally magnificent treasure is uncovered in the same region, we will probably never settle the question. What cannot be disputed, though, is the outstanding quality of the animal images found in the burial mounds. The exhibition at the Met is superbly staged, informed not only by scholarly expertise but an eye for the dramatic presence of these lustrous deer. The great centrepiece of the show, isolated in a space large enough to evoke the grandeur of the southern Ural Mountains area, presents a cluster of the finest stags. Nothing like them has been discovered in any other early Eurasian nomadic mound. Some rise almost two feet in height, given stature above all by the elaborate, imposing treatment of the antlers. Their legs are relatively short, and their slender bodies stretch a surprisingly long way back before terminating in compact hind-quarters. Vigorous curving patterns are incised in their hides, lending them a tense energy that they might not otherwise possess.

They look expectant, as if sniffing the air for danger or the arrival of another herd. Their snouts are elongated, and so are their startlingly

73. Golden Stag, 4th century BC, Archaeological Museum, Ufa

erect, jutting ears. These animals must be on the alert, and their parted mouths look predatory. For all the stillness of their poses, they are hunters – just like the humans who created these hypnotic images. Clearly prized by the chieftain, the deer were regarded as precious enough to be overlaid with sheets of gold and silver. It was the ultimate

accolade, and their remarkable state of preservation means that they still shimmer and glow with their original allure intact.

Not that deer were the only animals discovered at Filippovka. Leopards, boars, wolves, rams and camels were also found there, as well as bizarre mythological griffins sporting lions' bodies surmounted by eagles' heads and wings. The entire natural world was seen as a fit subject for the anonymous craftsmen who fashioned these artefacts. And the Met places them in a wider context, not only in essays commissioned for the excellent Yale University Press catalogue but also by borrowing sumptuous objects from the State Hermitage Museum in St Petersburg. They show how the Golden Deer of Eurasia are connected with luxury objects unearthed in the graves of other steppe tribes.

The most irresistible of these stunning Hermitage loans is a golden comb. Excavated in the Solokha burial mound, this superb Scythian utensil is a marvel. Made between 530 and 490 BC, and discovered next to the skull of an entombed ruler, it boasts nineteen teeth and, on top, a group of fighting warriors. The inspiration of Greek art lies behind the vitality of this battle scene, resting on a frieze of five reclining lions. It may represent a real-life dynastic conflict between three brothers: Octamasades, Oricus and Scyles, the warring sons of the Scythian king Ariapithes. Although a moment of extreme violence is depicted here, with one wounded horse already dying on the ground, the warriors also possess an almost balletic poise. No comb could be more exquisite, or offer more eloquent proof of the extraordinary sophistication attained by some, at least, of these remote, frustratingly unknowable nomadic societies.

Van Gogh, by contrast, has left behind a body of images and writings that bring the whole man vividly to life. His illuminating letters, which reveal so much about his hopes and intentions as an artist, are used to eloquent effect in *Van Gogh Face to Face*, the first exhibition ever to concentrate on his portraits alone. Lucidly displayed at Philadelphia Museum of Art, the drawings, watercolours and paintings vindicate his headlong claim, in June 1890, that 'what excites me the most – much, much more than all the rest of my *métier* – is the portrait, the modern portrait . . . I should like to paint portraits which will appear as revelations to people in a hundred years' time.'

They certainly do. Admirers of Van Gogh's flower paintings and landscapes may be surprised to learn how much passionate importance he attached to portraiture. But it makes sense immediately you enter the show. The opening section is largely black and white, focused on the work he made with pen, crayon, chalk, ink, pencil or wash during the early part of his career. Dark and intense, they were produced by an

ardent young man relying solely on a monthly stipend from his devoted brother Theo. The money enabled him to hire old pensioners as models. Whether posing in top hat and coat-tails or sporting an eyepatch as a souvenir of the Belgian war of independence, these doughty veterans look battered yet resilient.

Van Gogh was already capable of probing far beneath external appearances, and a large drawing of his mistress Sien is particularly haunting. A seamstress and former prostitute with an illegitimate child, Sien had every reason to look melancholy. But sitting with a cigar on the floor of their grim lodgings in The Hague, she seems stoical as well as beleaguered. Their affair did not last long. Van Gogh had just as much difficulty with relationships as he did with building up his professional career. Nobody wanted to commission a portrait from him, any more than they showed a desire to collect his other work. So the lonely, unregarded yet stubborn Dutchman had to rely on painting peasants' heads, largely in preparation for the most ambitious canvas he produced during his Netherlands period: *The Potato Eaters*. The gnarled and weary faces loom out of the shadows, impressing us with the strength of Van Gogh's commitment to depicting their hardship with dignity and compassion.

He could, of course, paint his own features. During his two-year sojourn in Paris, commencing in 1886, he portrayed himself nearly twenty-four times. One painting shows him wearing a felt hat and stiff white collar, arrayed in the formal attire he would put on before making forays into the city. He looks gaunt, almost emaciated. But the potency of his gaze is unmistakable, and in one 1887 self-portrait he assumes a very different guise. Flaunting a brilliant yellow straw hat, and an open-necked smock as blue as the summer sky, he seems to be mentally preparing himself for his momentous move to Provence the following year. The colour of the hat infects the surrounding space with small, nervously applied flecks of heightened colour, heralding the far brighter palette he would develop down in Arles.

The most prophetic Paris self-portrait reverts to the felt hat. This time, though, restless brushmarks break up the image with darting strokes of light colour. He was ready, now, to revolutionise his art in the forceful sun of Provence. And this firework of a painting sends particles of brightness showering across the canvas, bearing out Van Gogh's claim that 'I am not trying to achieve this by a photographic likeness, but by rendering our impassioned expressions, by using our modern knowledge and appreciation of colour as a means of rendering and exalting character.'

He realised this ambition during his short yet astonishingly productive time at Arles. Here, Van Gogh managed to befriend Joseph Roulin, the

extravagantly bearded official who ran the postal service at Arles railway station. A fervent republican and socialist, Roulin pulled off the rare feat of getting on well with the notoriously nervous artist. He posed proudly in full uniform, its yellow buttons singing out against the darkness of a deep blue jacket. Van Gogh thought that Roulin had 'a head somewhat like Socrates', and he caught in his first portrait the pride of a man whose wife Augustine had just given birth to a baby girl. Encouraged by its success, Van Gogh went on to paint the rest of the Roulin family. He portrayed Augustine holding up baby Marcelle like a trophy for inspection. And he painted the elder son Armand, a cocky apprentice blacksmith with an incipient moustache and stylishly tilted hat. Armand's face is one of Van Gogh's finest achievements: ostensibly filled with teenage swagger, his features also betray insecurity and sadness. The portrait of his younger brother Camille is equally searching, outlined boldly with red contours and capturing the stare of an eleven-year-old absorbed in his own private world of childhood.

But Augustine fascinated Van Gogh more than anyone. He painted no less than five versions of a portrait where the auburn-haired mother sits beside a cradle we cannot see. Only the rope is included, clutched in her hands like an umbilical cord linking her with the baby. Boisterous white flowers dance across the wallpaper behind her, bursting like flares in a storm at sea. And Van Gogh confirmed the maritime analogy by telling Theo that he wanted to paint Madame Roulin 'in such a way that sailors, who are at once children and martyrs, seeing it in the cabin of their Icelandic fishing boat, would feel the old sense of being rocked come over them and remember their own lullabies'. Art, in Van Gogh's heartfelt view, should above all offer consolation, and his portraits are among the most profoundly redemptive images he produced.

SEEING SALVATION

1 March 2000

Like so many parents today, I did not bring up my children in the Christian faith. So whenever we visited the National Gallery or any comparable collection, they felt excluded from the wealth of references in religious art. I soon realised that no biblical knowledge could be taken for granted, and many of the finest achievements in European painting

needed careful, patient explanation. That is why *Seeing Salvation* is such a welcome and indispensable event. By looking at the development of Christ's image in Western art, the National Gallery's new show helps non-believing visitors to arrive at a fuller understanding of the momentous narrative depicted here. Christian viewers will also find themselves exploring, all over again, the richness of meaning in pictures they might previously have regarded as over-familiar.

Neil MacGregor is right to stress, in his lucid catalogue introduction, that contemporary records of Jesus's appearance do not exist. Nowhere in the New Testament can we discover a description of his face, and this astonishing omission presented artists with a formidable challenge. Around AD 200, when the first Christian art appeared on funerary slabs in Roman catacombs, the problem was avoided. Anonymous carvers represented Christ with symbols, cutting the outlines of a cross-anchor and fish in the marble. Some are on loan here from the Vatican Museum, and the most arresting fish design helps to explain St Augustine's belief that Christ 'descended alive into the depths of this mortal life, as into the abyss of waters'. The dramatic words already convey an overriding preoccupation with the idea of danger and sacrifice.

Even so, early Christian images remain largely placid. The most elaborate example on view here, a Roman marble carving of the *Good Shepherd* from the fourth century AD, takes as its springboard St John's claim that Christ likened himself to the shepherd who 'giveth his life for the sheep'. But no hint of the suffering to come can be detected in this blithe, curly-haired youth, who carries a bleating sheep so effortlessly on his shoulders. Hence the shock when Zurbarán, around 1635–40, decides to paint Christ as *The Bound Lamb*. He took his cue from John the Baptist, who greeted Jesus at the River Jordan by calling him 'the Lamb of God which taketh away the sin of the world'. There is, however, no trace of radiance or triumph in Zurbarán's uncompromising canvas. His feet trussed with rope, the helpless animal lies isolated on a stone slab. He looks weary and defeated, capable only of waiting for death. The skill invested in Zurbarán's handling of his soft fleece only adds to the sense of vulnerability, and the darkness surrounding his slumped body is funereal.

By the time this stark image was painted, many Church leaders had long since distanced themselves from the symbol of a sacrificial lamb. As early as AD 692, a Christian council in Constantinople insisted that Christ should henceforth be shown as human, since 'the painter must, as it were, lead us by the hand to the remembrance of Jesus, living in the flesh, suffering and dying for our salvation and thus obtaining the redemption of the world'. This eloquent passage leads us to the very

heart of the drama enacted throughout the exhibition. However reassuring the final stage in Christ's story may be, his progress towards the cross is as relentless and bloody as anything in Greek tragedy. And the most powerfully affecting of the paintings gathered here involve us in the terrible inescapability of the journey undertaken by Jesus.

The duality of his nature posed an awesome problem for even the most accomplished artists. As they began to appreciate the importance of showing his humanity, painters knew that he must somehow be seen in all his divinity as well. Murillo solved the problem by showing the Christ child holding hands with Mary and Joseph while gazing up at the dove of the Holy Spirit hovering below God the Father in the sky. But the sweetness and piety of this altarpiece remove it from an earthly dimension. The boy already seems safely sanctified, and beyond any threat of mortal suffering. Murillo is too sentimental an artist to arrive at the lacerating centre of the Christian mystery, and yet he does provide a tough corrective in one very remarkable painting from the 1670s. Here, the sleeping Christ child is shown reclining on the cross where he will eventually be killed. Two angels are suspended on clouds above him, and one makes a gesture of apparent distress. Murillo, however, rams home Christ's mortality by making his right arm rest on a skull. Although he looks plump and serene, the death's head is placed unavoidably near his defenceless flesh.

To our eyes, the brutality of this juxtaposition appears heavy-handed. We suspect that the artist, and by extension the patron who commissioned the work, were too programmatic in their determination to use painting as a means of delivering a religious lecture. The Perugian master Benedetto Bonfigli, who may have painted a small panel of the *Adoration and Crucifixion* around 1465–75, saw nothing wrong with combining these two subjects in a single scene. But the result looks naïve and over-eager to sermonise. The child encircled by gift-bearing monarchs on one side of the painting inhabits the same pictorial space as the dying Christ on the other.

Better by far to adopt a more subliminal approach, exemplified here in Bellini's sublime *The Madonna of the Meadow*. It appears, at first, to be a lyrical and celebratory image. The Virgin joins her fingertips in prayer as she stares raptly down at the child asleep on her lap. A luminous Venetian landscape behind them enhances the mood of serenity, and the distant crane fighting a snake is intended as a harbinger of spring. Renewal seems palpable in the air, and yet the very stillness of the baby gradually begins to haunt our minds. His limbs look ominously rigid, and his expression is devoid of conventional happiness. The downturned

mouth seems particularly grim, as if forced to confront the moment when, as a martyred adult, he will once again lie across his mother's lap in the grip of rigor mortis.

Such a painting is far more likely to move modern onlookers than any spurious attempts to strive for an 'authentic' likeness of Christ. Saint Veronica is supposed to have taken pity on him as he stumbled under the burdensome cross *en route* to Calvary. Having wiped his face with a cloth, she was rewarded for her compassion with an image permanently imprinted on the fabric. Ridolfo Ghirlandaio shows the miraculous event in his large, plodding altarpiece, where Veronica is overcome by wonder as she realises what has happened. But an unknown master from Cologne transforms her into a more complacent woman, holding up the cloth like a housewife proudly showing off the whiteness of her wash-ing. The outsize, gold-haloed face staring out from her fabric is a Christ purged of emotion: long-haired, neatly bearded and unmarked by the agony he has endured.

Dürer delineates a more troubled holy face in his engraving of Veronica's souvenir, and Zurbarán presents a frankly tormented Christ when he paints his version of her cloth. Their emotional exposure is far removed from the more resigned expression of Christ's face preserved on the *Turin Shroud*, an image venerated for centuries and still the focus of intense speculation now. The most recent Carbon-14 tests suggest that the shroud originated in medieval times, but plenty of worshippers per-sist in believing that the imprinted body was transferred to the cloth by a thermo-nuclear flash at the moment of resurrection. Whatever the truth of its origins may be, the face emerging from the *Turin Shroud* is incapable of arousing the charged feelings generated by the greatest paintings in this survey. Look at the *Man of Sorrows*, occupying one half of a diptych painted by an Umbrian master around 1260. Although still resting against the cross, he clasps his wounded hands on a chest drained of the blood sustaining the Virgin and Child in the companion panel. They both seem gravely preoccupied with the prospect of the agony ahead, and the *Man of Sorrows* is no longer able to lift a head contorted with appalling, terminal pain. The two diminutive angels above him can-not endure his suffering: they claw hysterically at their own faces, as if determined to inflict on themselves the excruciating injuries he is still obliged to withstand.

Only in the final stages of the show does acute bodily distress give way to a consoling alternative. In Titian's superb *Noli Me Tangere*, an ecstatic Mary Magdalene falls to her knees and reaches out impetuously to touch the newly risen Christ. Her lunging eagerness goes unrewarded. With

74. The Umbrian Master, *Man of Sorrows*, 1260

the deftness of a matador, Jesus frustrates her outflung hand by blocking its advance in a flourish of white drapery. But he does so with infinite tenderness, and leans over her with a warmth that holds out the promise of infinite spiritual love. In this complex manœuvre, at once elusive and reassuring, the full redemptive significance of the Resurrection is conveyed with incomparable grace.

TILMAN RIEMENSCHNEIDER AND
NAM JUNE PAIK IN NEW YORK
March 2000

Tilman Riemenschneider deserves to be ranked among the most out-
standing sculptors in European art. But beyond Germany, his name
remains obstinately unfamiliar. Some of his most ambitious carvings
cannot be moved from their settings in out-of-the-way churches. And
only now, well over 500 years after he was born in Heiligenstadt, has the
first full-scale international survey of his work been organised. Superbly
displayed at the Metropolitan Museum of Art in New York, it amounts
to a revelation. Like many of the German sculptors who began their
careers in the late fifteenth century, Riemenschneider favoured lime-
wood. With revolutionary boldness, he was often prepared to jettison
the venerable tradition of coloured sculpture and reveal the true nature
of his material. The crisp and sensuous appeal of limewood, freed from
any polychrome overlay, gives this show an immediate impact. By the
time he obtained the title of 'master' in 1485 and opened his own work-
shop, Riemenschneider had become a supreme manipulator of his cho-
sen medium.

He is first seen at full stretch in six major carvings from a complex,
highly charged altarpiece made for the Church of Mary Magdalen at
Münnerstadt. Four separate limewood saints demonstrate his ability to
invest Matthew, Mark, Luke and John with an intense, engaging human-
ity. The opposite of remote or impersonal, these straining figures are indi-
viduals wholly and vigorously involved with their scriptural tasks.
Religion really matters to them, and the urgent emotions animating
their faces seem to pulse like an electrical discharge through their con-
voluted draperies as well. Riemenschneider's insistence on keeping the
wood exposed soon proved too hard for the local burgomaster and his
council to stomach. Within a decade, they had ordered the entire altar-
piece to be polychromed by another sculptor, Veit Stoss. The carvings
were only freed from their superfluous, clogging colour 150 years later.
Judging by the polychromatic pieces included later in this show, they
must have looked appallingly garish. But recent restoration has given
back the Münnerstadt figures much of their original freshness and
incisive energy.

Not that Riemenschneider was solely committed to wood. He also
excelled in other materials, and the sandstone group of the enthroned
Saint Anne with the Virgin and Christ Child proves just how masterly his

75. Tilman Riemenschneider, *Mary Salome and Zebedee, c.* 1505–10

technical prowess really was. The dutiful, quiescent piety of the seated Virgin is superbly contrasted with the child's impulsive desire to adopt a standing position. At once robust and dependent on Saint Anne's protective hand, his chubby body grows out of the stone to assert itself as a miracle of carving in the round.

Alongside his capacity for startling innovation, Riemenschneider can be seen as an inheritor of the Gothic tradition. Like his great contemporary Dürer, he combined elements of medieval art and thought with a thirst for renewal, and his emotional range was impressive. Nothing could be more intimate and tender than his graceful limewood statue of the *Virgin and Child on the Crescent Moon*. The boisterous infant wriggles as he tugs at his mother's veil, prompting Riemenschneider to indulge in one of his most tortuous passages of tangled drapery. The Virgin retains her composure, and yet undulating tendrils of hair ripple down her back with a frankly erotic exuberance.

His handling of furrowed old men, stooped with frailty and exposing prominently veined flesh, is equally persuasive. And he knows how to convey the intolerable anguish of mourning. The church of Saints Peter and Paul at Grossostheim has lent an outstanding *Lamentation* in limewood, where seven agitated figures give vent to their distress as they cluster round the near-horizontal rigidity of the dead Christ. An extravagantly bearded Nicodemus looks hunched as he struggles to carry the weight of the corpse's legs, while the inconsolable Virgin strives to support her son's head with one hand and clutch a crushed veil with the other.

The *Lamentation* was carved around 1510, when Riemenschneider's career flourished with commissions throughout Franconia. His standing in the Würzburg community was so high that he was elected mayor in 1520. But this involvement with politics eventually proved his undoing. After the Peasants' Revolt in 1525, the prince-bishop of Würzburg wanted his troops to occupy the town and turn it into a defensive centre against the rebels. But Riemenschneider and the rest of the municipal council resisted the idea, and he was imprisoned and tortured. Worse still, the demand for his work came to a halt. The humiliated sculptor was reduced to repairing his own carvings, and nothing new was produced by his once-prolific workshop after the revolt terminated.

If the elderly Riemenschneider was denied the acclaim and patronage he deserved, Nam June Paik is now enjoying a late burst of acclaim. Although he suffered a stroke four years ago at the age of sixty-four, the Korean-born artist has managed to continue working with undiminished flair. And he has now been granted the ultimate accolade of a grand retrospective at the Guggenheim Museum. It is a spectacular affair. The moment we enter Frank Lloyd Wright's great spiralling Rotunda, Paik assails our eyes with a battery of light and motion. On the floor, an enormous bed of 100 video monitors transmit conflicting images from their upward-pointing screens. Behind them, a seven-storey waterfall courses down from the distant ceiling, its splashing progress enlivened by the

angular beams of a laser projection penetrating the liquid's flow. Paik calls it *Jacob's Ladder*, and as we follow it up to the roof, our already dazed retinas are further invaded by big-screen video projections, ranged in ascending ranks on the other side of the Rotunda. They reflect Paik's long-standing interest in television at its most flamboyant, combining music, dance and much else besides in a cascade of hugely theatrical images. But high on the ceiling, a specially installed canvas is stretched across the empty space to act as a gigantic screen. Here, a constantly shifting and whirling array of multicoloured lines is projected from lasers lodged among the monitors on the gallery floor far below.

So we are encircled by the flickering, darting and flashing outcome of Paik's infatuation with multimedia in motion. Unable to settle for long on any single aspect of this extravaganza, we can only find respite by taking the lift to the top of the Guggenheim building. Here, in a large gallery off the Rotunda, the exhibition begins with a concise introduction to Paik's early work. He came to New York and settled there in 1964, having spent a while in Germany and met John Cage. The seasoned experimental composer proved enormously stimulating to Paik, who had studied music along with art history at Tokyo University. In New York, he experimented with performance, television, sculpture and a host of collaborative projects alongside other freewheeling members of the avant-garde.

His most notorious work involved Charlotte Moorman, who played a cello with remarkable dignity while wearing an incessantly transmitting TV bra designed by the puckish Paik. She was arrested by the police for brazenly performing in public, but both artists remained unabashed. Paik enjoyed inviting viewers to participate in his interactive monitor pieces, playing with signal amplifiers and even hand-held magnets applied to the sets. He can now be seen as the immensely influential founding father of video art; and when we walk down the Rotunda's curving pathway, the electronic moving image turns out to dominate all his grander, more recent works placed on the ever-sloping floor.

Real fish swim unconcerned in tanks backed by screens relaying typically energetic, restless images. A darkened garden appears, bristling with plant-life as luxuriant as Monet's horticultural paradise at Giverny. Instead of water-lilies, though, television sets are embedded in the proliferating leaves. Their ceaseless torrent of pictures disrupts the surrounding shadows, never letting us forget that we live in a video-saturated era. There is no escape, even when Paik wrily reflects on his cultural roots in Seoul by including a seated Buddha. For the deity also turns out to be staring at a television screen. Everyone is in thrall to its

ubiquitous power, and Paik's humour becomes mischievous when he presents a *Family of Robots* whose stiff, unwieldy limbs and bodies incorporate laughably obsolescent television equipment.

He understands the potency of simple interventions, too. In one haunting work, a hollowed-out television set acts as the melancholy location for a lit candle. Its flame returns us to the world inhabited by Riemenschneider and the churches where his carvings must have captivated the worshippers who saw them. Here, however, the candle looks solitary and vulnerable. Its victory can only be momentary, and Paik ensures that the electronic media swiftly reassert their dominance elsewhere in his dynamic, irrepressible show.

ROME RENEWED
13 September 2000

For too many years, Rome was a hugely frustrating city to explore. Boarded up, festooned with scaffolding or simply decayed, it took a smug and perverse satisfaction in disappointing visitors by refusing them access to many of its greatest treasures. Burdened by an overwhelming legacy from the past, Rome seemed incapable of showing off its tarnished treasures with the care they deserved. The so-called Eternal City looked alarmingly vulnerable.

Now, at last, the long period of neglect has come to an end. Go to Rome this autumn, and you will reel from revelation to revelation. The advent of Jubilee Year has finally galvanised the owners of churches, galleries and temples into cleaning their finest possessions and placing them on view. The results are spectacular, and become obvious the moment you start looking at this inexhaustible city. At St Peter's, the exterior fabric has emerged resplendent from an interminable restoration. Astonishingly pristine, Carlo Maderna's façade glows in the Roman sunlight with a radiant intensity. The pale stonework looks almost as fresh as it must have done when an elated Pope Urban VIII dedicated the basilica in November 1626. Now, once again, it provides a dazzling centrepiece for the sweep of the semicircular colonnade that Bernini designed for the piazza a few decades later.

Bernini benefits even more from the long-awaited reopening of the Villa Borghese. Shamefully closed for decades, it houses a magnificent

array of paintings, sculpture and classical treasures amassed in the seventeenth century by the tirelessly acquisitive Cardinal Scipio Borghese. Astounded by the collection on my first trip to Rome in the late 1960s, I have been impatient to return ever since. And I was not disappointed, at least by the work on display. The villa itself has been superbly restored. But the strict, two-hour time-limit imposed on my visit is wholly inexcusable, and a notice in the picture gallery bossily insists that half an hour will be quite sufficient to view the paintings. Since they include masterpieces by Bellini, Raphael, Correggio, Titian, Lotto, Caravaggio and much else besides, I could happily have lingered there all day. One canvas in particular, Titian's sublime *Sacred and Profane Love*, had impressed me unforgettably on my previous visit. A recent cleaning has removed the golden varnish, and so my memory of the painting did not tally with the far brighter, less mysterious image now on the wall. Gradually, though, the harmonious interplay between the two women – one clothed, the other near-naked – reasserted its hold over me. The contrast between the two landscapes behind them is equally arresting: the dark, secretive hillside on the left, crowned by a vigilant tower, gives way on the right to a distant panorama enlivened by riders, lovers, blue mountains and a luminous Venetian sky.

But the most enthralling exhibits in the Borghese collection are on the ground floor, where four of Bernini's most eloquent carvings are displayed with irresistible panache. The earliest, *The Flight from Troy*, was jointly executed by the young Bernini and his father. Their collaboration echoes the subject, for Aeneas struggles here to carry his own elderly and frightened father away from the city. For all its sensitive accomplishment, the statue looks subdued and cautious compared with the eruptive violence and sensuality of the carving in the next room, *Pluto Abducting Proserpina*. Her flailing attempts to resist are vigorously conveyed, and so are the imprints of Pluto's lustful fingers pressing deep in her flesh. Below, the yelping, triple-headed Cerberus adds to the sense of vicious alarm. This urgency reaches a dynamic climax in the later carving of David. With great audacity, Bernini shows the lean, frowning figure at the instant before he hurls the stone from its sling. Swivelling his body in order to summon the maximum force, this resolute young warrior could hardly be more removed from Michelangelo's posed, self-admiring *David* in Florence.

Even so, none of these carvings can match *Apollo and Daphne*. In my view, it is far and away the most consummate of all Bernini's sculpture. He concentrates on the moment when Apollo – plumper, younger and more naive than David – catches up with Daphne after chasing her hun-

grily through the forest. His right hand clasps her stomach. But at the very second when he secures his prize, Apollo discovers that Daphne is growing into a tree. The surprise on his face cannot, however, compare with the amazement and fear transforming Daphne's features. Mouth agape and arms flung wildly upwards, she reacts with panic both to Apollo's hand and the metamorphosis of her own body. Although her transformation means that she will elude Apollo, Daphne is being pitched into another form of oppression. For the bark of the tree is already imprisoning her legs, and leaves sprout in terrifying profusion from her fingertips. Soon she will be robbed of her human identity altogether, and Bernini defines the shock with painful immediacy. Ultimately, though, the complex emotional reverberations animating this poignant carving are shared equally by Daphne and her pursuer. Apollo, his right leg still raised in the act of running, is caught half-way between exhilaration and despair. He realises, at one and the same time, that the attainment of his infinitely desirable prize is being undermined by loss. He succeeds in grasping his idol, only to realise that her departure is both imminent and irreversible.

My delight in revisiting this supreme example of Bernini's work was marred only by the guards, who ordered me to leave the gallery long before *Apollo and Daphne* had exhausted my attention. When I first went to Rome, nothing prevented me from gazing at the sculpture for hours. Nobody should put an odious time-restriction on our ability to commune with great art, and I hope that the Villa Borghese will soon realise its folly and revert to a more enlightened way of displaying its collection. Mercifully, no such rules interfered with the other discoveries awaiting me in Rome. At the church of S. Agostino in Campo Marzio, the priest could not have been more hospitable as he guided me towards Raphael's dynamic fresco of the prophet Isaiah. Cleaning has transformed this monumental figure, heavily indebted to Michelangelo's prophets on the Sistine ceiling. He unfurls a scroll bearing a Hebrew inscription declaring: 'Open the doors, where the people who believe may enter'. It was an appropriate text in view of the priest's friendliness, and a similar spirit prevailed at the superb Villa Farnesina, where Raphael can be seen at his boldest.

His headlong fresco of *Galatea*, riding the sea in a shell-like chariot pulled by powerfully arched dolphins, leaps out of the wall. I remember drawing her poised yet spiralling body on my first visit to the villa, and Galatea retains all her athletic brio intact. The great surprise today can be found in the entrance loggia, where Raphael's pupils painted an elaborate scheme of frescoes after their master's designs. They were intended

76. Raphael, *Galatea*, c. 1513, fresco, Villa Farnesina, Rome

to celebrate the marriage of the villa's owner, the Sienese banker
Agostino Chigi, to the young and beguiling Francesca Ordeasca. Both
the centrepiece, *The Banquet of the Gods*, and the other frescoes have long
been badly affected by damage and clumsy, discoloured repainting. Now,
fully cleaned and accompanied by an exhibition charting the restoration,

they are vastly improved. Giulio Romano and other members of Raphael's workshop may have been responsible for the painting, but the master's drawings testify to his overall conception of the ambitious scheme. The airborne cupids soaring through the spandrels are particularly inventive and exuberant, but the entire loggia decoration is a spellbinding display of the High Renaissance at its most confident.

Bramante, the architect who had the strongest influence on Raphael's designs for buildings, has also benefited from the Jubilee Year springcleaning. His small and exquisite Tempietto, tucked into a narrow courtyard beside the bulky church of S. Pietro in Montorio, has only just emerged from extensive renovation. The shining outcome is a triumph. Built in 1502 on the site where St Peter was supposedly crucified, it looks as palpable as the most monumental sculpture. Despite the austerity of its Tuscan Doric colonnade, this justly renowned building has a vibrant presence. Everything is precisely calculated and resolved, making its disposition of volumes among the most satisfying I have ever encountered.

By no means all the finest monuments in Rome are now fully available to the public. The sumptuous Palazzo Farnese, partially designed by Michelangelo, contains on its first floor an immense gallery of frescoes by Annibale Carracci. Among the most overwhelming achievements of Roman Baroque, they are supposed to be viewable. But the building, bizarrely, is occupied by the French Embassy, and when I called at the palazzo a dismissive official curtly informed me that the frescoes could on no account be seen. Both the building and its painted decorations are far too important in the history of Western art and architecture to be hidden away by arrogant bureaucrats.

They should be made as available as the splendid Capitoline Museums, newly reopened after an extended period of restoration. The three outstanding buildings facing the hilltop Piazza del Campidoglio, designed with such distinction by Michelangelo in 1536, can now be explored on an intriguing new route. Starting in the Palazzo dei Conservatori, where the majestic equestrian bronze of Marcus Aurelius is now prudently preserved, we can once again relish the colossal fragments of Roman statues in the courtyard. Upstairs, in renovated galleries, a special exhibition focuses on the ancient Capitoline bronze sculpture of the She-Wolf. But now a subterranean passage enables us to walk under the piazza and enter the Palazzo Nuovo, where its celebrated collection of classical sculpture is still displayed in the original eighteenth-century manner. Among the busts of philosophers and Roman emperors, as well as the melancholy carving of the *Dying Gaul*, the Renaissance veneration of its antique heritage is vividly recaptured. But the most

exhilarating passageway leads to the Palazzo Senatorio, where we can walk through the lofty spaces of the Tabularium. Here, where vaulted Roman architecture is at its most awesome, immense open arches provide staggering views of the Forum and the Palatine. Seen at sunset from this ideal vantage, the imperial ruins silenced me with their haunting grandeur. Decayed they may be, but Rome has now ensured that its matchless legacy will survive for a long time to come.

THE ARTIST AND THE GARDEN
23 August 2000

Although the English have long been infatuated with the garden, they were surprisingly slow to commission paintings that testified to their horticultural passions. Roy Strong, who has created with his wife a large private formal garden at their Herefordshire home, had no hesitation in asking a young artist, Jonathan Myles-Lea, to paint it in 1995. The result reinforced Strong's urge to embark on an ambitious survey of painted, drawn and engraved images of English gardens, ranging from Tudor times to the early nineteenth century. Deeply researched and based on a profound knowledge of the subject, this superbly illustrated book amounts to a major achievement. It is also a triumph of sharp-eyed detection. Strong had to look very hard at the earliest pictures, catching glimpses of extensive gardens relegated, very frustratingly, to the background in portraits of flamboyant monarchs and grandees.

Around 1545, an unknown artist indebted to Holbein painted a dynastic celebration of Henry VIII, Jane Seymour and his three children. Grouped like a secular version of a Holy Family, they exude regal authority in the gilded, multi-columned splendour of Whitehall Palace. But if we peer through distant archways, past a serving maid and a court fool with a monkey on his back, fragments of the Great Garden become visible. Far too little is revealed, and yet some of the garden's most spectacular features can be detected: the carved heraldic beasts perched high on stanchions, lauding the Tudors' legitimacy through references to Edward III's griffin, the Richmond greyhound and much else besides.

At this stage, then, gardens were only admitted to portraits as a means of enhancing the sitters' status. Discussing Marcus Gheeraerts the Elder's painting of *Elizabeth I with a view to a Walled Garden*, Strong stresses that

the increasing grandeur of gardens in the sixteenth century mirrored 'the rise of absolutism and the reassertion of aristocratic hierarchy'. But enchantment creeps in, especially when Nicholas Hilliard paints Henry Percy, Ninth Earl of Northumberland reclining with dishevelled doublet in a hedged garden on a summit. Pale and elongated, his book flung aside, the young 'Wizard Earl' looks in thrall to the spirit of his lonely, mountainous locale. Even more melancholic is the unknown man in Isaac Oliver's miniature, fashionably attired as he leans against a tree with a symmetrical patterned flower garden beyond.

Royalist pomp was renewed after the Restoration, reaching bizarre heights in the 1670s when the aptly named John Rose, the King's Gardener, is seen kneeling before Charles II and presenting his master with a pineapple. Charles stares out haughtily at us rather than bothering with the exotic gift. But the garden behind now occupies a far greater expanse of the picture. And, with the advent of Leonard Knyff and his Netherlandish colleague Jan Siberechts, English patrons suddenly developed an appetite for country-house and garden-view painting in its own right. Knyff is the most startling exponent, producing aerial views of aristocratic estates with dizzying perspectives. His dynamic painting of Clandon Park in 1708 is a *tour de force*. It shows Baron Onslow's ostentatious gardens as if from the cockpit of a plane, preparing to land on the runway-like avenue of trees far below. The house itself seems subservient to the regimented ranks of greenery massed on every side. Siberechts is more seductive, most notably in a lyrical painting of Cheveley near Newmarket, the opulent seat of the debauched Restoration rake Lord Jermyn. His Catholic loyalty to James II led to the storming of the house by a Protestant mob in 1689, but nothing disrupts the tranquillity of Siberechts's beguiling scene.

Before long, artists found themselves invited to paint a garden on its own. And the first series ever produced in England was devoted to the grounds of Chiswick House in Middlesex. Created by the fastidious Third Earl of Burlington, they are celebrated in Peter Andreas Rysbrack's delicate vistas of the Orange Tree Garden with its domed temple, or the formal avenues terminating in a Cain and Abel statue and other quirky delights. The paintings' dreamy stillness generates an almost surreal mood, akin to de Chirico's images of empty, expectant piazzas 300 years later. But Strong speculates that Rysbrack failed to satisfy his patron, for Jacques Rigaud was soon commissioned to produce eight polished drawings of the same Chiswick gardens. Despite his greater sophistication, enhancing his subjects with glamour and panache, Rigaud fell out with Lord Burlington over the fee for the drawings. The haggling artist

77. John Constable, *The Flower Garden at East Bergholt House, Essex*, 1815

was 'sent away like a lying rascal', and his humiliated return to France meant that he left unfinished some even more remarkable engraved views of Stowe. Developed over a twenty-year period by Lord Cobham, this great Buckinghamshire garden is surely the most outstanding of the entire eighteenth century. Rigaud's images do sprightly justice to the parterre, the lake, the Gibbs building and Vanbrugh's looming pyramid. It all adds up, as Strong points out, to 'a Whig garden celebrating the principles of the Constitution'. He also describes the gardens at Hartwell House, Sir Thomas Lee's estate near Aylesbury, as 'a minor Whig paradise'. It may have been the work of Stowe's designer Charles Bridgeman, and Balthasar Nebot's series of Hartwell paintings are outstanding. More rustic in feeling than Rigaud, they show men scything among the topiary arcades and columns, while dogs, sheep and cattle are allowed to enliven Nebot's view of the bowling green and octagon pond.

But just at the moment when garden paintings seemed poised to enjoy a flourishing future, they became subsumed in the new demand for parks. Richard Wilson, recently returned from Italy, depicted Wilton House in a Utopian setting deeply influenced by 'Capability' Brown's enthusiasm for picturesque landscape. Captivating garden pictures continued to be made, though. Johann Zoffany's painting of a relaxed Mr and Mrs Garrick taking tea in the grounds of Hampton House, on the

edge of the Thames at its most seductive, is a good-humoured master-piece. As for Constable's two 1815 views of the flower and kitchen gardens at his parents' Essex house, they rank among his finest early achievements. His mother, who had created the flower garden a year before, died just as Constable was about to paint it. So the spread of evening light, combined with an air of desertion and the distant storm, testify to his sense of grief. Having begun as a pompous symbol of aggrandisement, the painted garden here becomes a modest site of mourning – not only for the artist's parent but also, by extension, for the childhood he has lost.

CHARDIN
10 March 2000

Modest in size, subdued in tone and focused on ordinary household objects, most of Chardin's paintings might appear unambitious. But their apparent quietism is profoundly deceptive. In eighteenth-century France, when artists vied with each other to concoct elegant and fanciful rococo showpieces, Chardin was a rebel. Before he began working in the 1720s, still life was scorned by all the most prominent painters. By the end of his long career, though, Chardin had transformed this lowly genre so radically that his canvases were admired by discerning critics, collectors and fellow-artists across Europe.

The son of a cabinet-maker, Chardin studied under two painters who specialised in complex scenes drawn from the Bible and mythology. They would have exhorted him to aspire to the elevated realm of history painting. But Chardin, right from the outset, was his own man. Stubbornly refusing to tackle the human figure, he concentrated on simple groups of dead animals or equally motionless objects posed on a bare stone ledge. His earliest painting in the Royal Academy's irresistible retrospective, *Two Rabbits with Game Bag and Powder Flask*, belongs to the tradition of sporting trophy images. By placing the animals next to the equipment used by their killer, Chardin may seem to ally himself with the prowess of the hunter. The longer his rabbits are examined, though, the more they engage our sympathies. Half lost in the shadows, their limp forms look forlorn. And Chardin's broken, blurred handling of their fur reinforces the pathos, implying that the very texture of their bodies is on the point of dissolution.

Still in his twenties, Chardin had already defined his own singular identity. He did so by attempting, as far as possible, to cast precedent aside and gaze with fresh eyes on the mute interior world that fascinated him. Chardin later recalled how he told himself that 'in order to concentrate my mind on reproducing it faithfully, I must forget everything I have seen, even including the manner in which such objects have been handled by others'. It sounds like an impossible task for any artist to fulfil. But Chardin was determined to try, and soon realised that he wanted to pare his paintings down to their absolute essentials. Only thus could he escape from the clutter that still mars his image of the dead rabbits, where he persists in thinking of heaped precedents from sporting images of the past.

By the time he painted a remarkable small still life around 1726–8, the urge to fill the canvas with incidental baggage had disappeared. Shadows spread over half the picture-surface, obscuring anything that might lurk there. Through the gloom an apple is discernible and, more prominently, a bunch of red and white grapes next to it. But they are little more than a foil for the real drama: an encounter between a peach and a silver goblet. Miraculously responsive to the soft, glowing texture of the fruit, Chardin further enhances its sensuous appeal by allowing the peach a generous reflection in the polished surface of the goblet. Illumination from an invisible window flares on the vessel's side, tantalizing us with glimpses of the room inhabited by the artist. He also enjoys painting the pinheads of brilliant light on two stray white grapes, which have detached themselves from the main bunch and rolled almost to the edge of the stepped stone support. There they stop, arrested and trembling in the luminosity as they prepare us for the far greater blaze generated by peach and goblet alike.

Confronted by such an image, we feel a sense of revelation. Chardin proves that an artist can penetrate the very heart of existence by ignoring flamboyance and training attention on the fundamental essence of things, out there in front of him. It all depends on the quality of his scrutiny, and an ability to convey the tactile intensity of his response through the subtle marks he makes on canvas.

Even when he began admitting more elements to his pictures, Chardin was able to orchestrate them with a masterly command of pictorial interval. Five cherries, a carafe of wine and an apricot join two peaches and a silver goblet in an even more outstanding work executed around 1728. But they do not crowd the composition. On the contrary: a sizeable gap separates a trio of cherries on the left from the other two nestling by the goblet. Chardin does nothing to disguise the emptiness

in between, or the even greater distance separating the peaches from the apricot and a large green apple. These voids become almost as potent as the full, substantial immediacy of the objects themselves. Our senses grow more and more heightened, making us alert to the slightest incident. We notice how the thin, shimmering rim of the silver goblet slices into the dark and swollen bulk of the carafe behind it. We realise, with a start, that the apricot has been cut open and its stone placed in front of the peach. Chardin loves enhancing the singularity of objects by contrasting them with remarkably different neighbours. In another painting from this exceptional early period, he allows a squat, black bottle at the centre of the canvas to be partially interrupted by a glass of water. The solidity of the one could hardly be more opposed to the transparency of the other. Their relationship is made even more dramatic by the unexpected arrival of a cucumber, rearing above the glass like a mysterious creature emerging into the light after a long sleep.

Cézanne, who likewise preferred the most everyday things in his still-life paintings, would have cherished these images. With his passion for setting up tensions between tilting objects, he would also have appreciated why Chardin liked his ledges to be sloping or curved rather than straight. They help to ensure that the pictures never lapse into ponderousness or excessive stability. And as he grew older, Chardin started to experiment with a greater amount of movement. In two larger pictures, cats are introduced. They disrupt the larder-like calm, reaching forward to poke a slice of salmon with a paw or claw some oysters from their shells. In a superficial sense, they must be intended to amuse the onlooker. But on another level they look predatory, reflecting Chardin's interest in violence and its aftermath. A brace of mackerel are slung from their mouths on a hook in one of the cat paintings. And a dead ray dangles from a similar hook in the other picture, its spectral whiteness spilling pink organs in all their rawness from the ray's slashed body. Beneath it, Chardin accentuates the air of menace by including a knife. Its handle projects out towards us, as if proferring an invitation to seize the weapon and disembowel the fish even more thoroughly.

As Chardin became bolder, so he explored the theme of destruction with brazen starkness. A dead hare appears around 1730, its splayed legs sickeningly up-ended against a wall. Nothing distracts our attention from the pathos of those V-shaped limbs. They have the impact of a protesting exclamation, and arouse our compassion far more strongly than the early painting of rabbits had managed to do.

Not all Chardin's experiments were as successful. His surprisingly large painting of *Musical Instruments and a Basket of Fruit*, executed as an

78. Jean Siméon Chardin, *Basket of Wild Strawberries, c.* 1761

overdoor decoration for the Comte de Rothenbourg, is a dull and duti-
ful exercise. Its earnest elaboration compares very poorly with the little
panel hanging next to it, where Chardin confines himself to a pestle and
mortar, a bowl, two onions and a copper pot. The result is mesmerizing,
but Chardin was now determined to investigate the possibilities of the
human figure. Around 1734 he produced one of his earliest and most
haunting images of people. A young man leans over an unusually solid
stone ledge and blows a soap bubble through a slender pipe. It seems a
light-hearted work at first, and a small child strains to peer over and see
the bubble expanding for himself. After a time, though, we notice the
fragility of the bubble as it sags down into the blackness below the ledge.
At any instant it will burst, and Chardin soon had good reason to be pre-
occupied with the transience of life. His first wife died in 1735, only four
years after he married her. Neither of their two children survived into
adulthood, and so his captivating paintings of a girl with a shuttlecock or
a boy with a spinning top must have possessed, for him, a special

poignancy. They are far more engaging than the portrait of the older Charles-Théodose Godefroy, posing self-consciously with violin and bow in hand. Children excited Chardin's keenest and most tender interest, but after moving into an adult world he could not resist painting domestic homilies with images as prim as *Saying Grace* or *The Diligent Mother*.

Mercifully, Chardin left sermonizing behind in his final years. The old obsession with still life at its most purged and quotidian returned. He painted, for the first and only time, a delectable bouquet of carnations, sweet peas and other flowers erupting with overwhelming freshness from a slim porcelain vase. Elsewhere he made something truly momentous simply by placing a glass of water near a coffee pot, and punctuated the gap between them with three bulbs of garlic. Above all, though, he positioned at the centre of his most sublime late painting a pyramid of wild strawberries. Resting in a basket and accompanied by two white carnations, the fruit has a melting sensuousness. Spellbound, we want to reach out and taste it, even as we realise that the strawberries will soon be overtaken by the shadows spreading across the wall beyond. Chardin urges us to savour them while they last, and so indeed we do.

WILLIAM BLAKE
8 November 2000

Stretching his muscular arms as wide as an aeroplane's wings, the Evil Angel hurtles through the sky with a diabolical scowl. Although his enlarged eyes are sightless, the Good Angel beside him reels back in terror. She attempts to protect a naked infant in her arms, but he seems on course to snap the chain enclosing his left foot and grab the child. Titanic struggles always drew out the best in William Blake. Convinced that 'Energy is Eternal Delight', he rejoiced in the ability of even the most murderous figures to galvanise his prints and watercolours with lithe, darting dynamism. Blake's thunderous imagination was ignited by violence. One of his most potent images allows the sinewy body of the Great Red Dragon to fill the paper with baleful strength. Wings blocking out the light, he bestrides the space in front of a helpless 'Woman Clothed with the Sun'. We only see him from behind, but nothing seems capable of preventing him from devouring both the woman and the baby in her womb.

Blake's refusal to curb or censor his most urgent, alarming visions ensures that his fieriest work retains its forcefulness today. Regarded by many in his own time as a madman, he persisted in remaining open to whatever stimulus his feverish mind could seize. Often penniless and usually disregarded, he had every reason to grow despondent. Instead, he never stopped writing charged, fervent poems, illustrating them with equally ecstatic images and striving to print them in books as awesome as the grandest illuminated manuscripts of the medieval period.

Blake was infatuated with Gothic art. His teeming, exuberant and exhausting Tate retrospective opens with some of the reverential drawings he made as an aspirant young artist in Westminster Abbey. They give little hint of the visionary to come, but Blake found these tomb effigies enormously inspirational. They liberated him from what he regarded as the crushing dominance of the classical tradition. Many of his figures seem to have leaped down from their original places in carved or painted images in Gothic depictions of heaven and hell.

The idea of damnation fired Blake as vigorously as it did his forerunners in the Middle Ages. One of his most densely wrought watercolours is *A Vision of the Last Judgement*, where the entire surface appears to be convulsed with writhing bodies. Many float upwards, as they aspire to lodge themselves beside Christ seated on the Throne of Judgement. But the serenity of the heavens is completely upstaged by the turbulence below, where angels blowing their trumpets to the Four Winds evoke the chaos of the deep. There, in caverns where flames surge and undulate, a grotesque dragon with seven heads and ten horns becomes the nightmarish centre of attention. Michelangelo, whom Blake revered, clearly supplied the precedent for this watercolour when he covered the east wall of the Sistine Chapel with his *Last Judgement*. But Blake crams an astonishing amount of flailing activity into a far smaller space. He must have lavished a prodigious amount of care and forethought on this immensely complex design. Far from simply obeying the imperative of his visions, and producing his art in a frenzied rush, he laboured long over *A Vision of the Last Judgement*. It was, after all, commissioned by the Countess of Egremont. He must have hoped that it would lead to further work, either for her or the aristocratic collectors she knew.

Blake, however, was never able to procure the patronage of the mega-wealthy. Formidably hard-working and prolific, he strove throughout his career to obtain the munificent support that his increasingly ambitious ventures required. But it never materialised. No wonder his work is permeated with such a powerful sense of doomed conflict. Blake was obliged to see life in terms of arduous, day-by-day struggle. Even *A*

Vision of the Last Judgement, one of the few pictures he ever succeeded in showing at the Royal Academy, was not mentioned in a single critical review of the 1808 exhibition. As for his largest surviving picture, *An Allegory of the Spiritual Condition of Man*, it does not seem to have attracted a buyer at all. Indeed, the precise meaning of this ink and tempera image, with its devout ranks of ascending deities, still eludes Blake scholars. While recognizing that it 'represents the summation of the artist's theological thinking', they have failed to identify the theological text on which it is surely based.

Similar mysteries encircle much of his work, ensuring that the academic literature generated by Blake's enormous output is already voluminous. He was not always so complex: when Thomas Butts commissioned him to paint four 'frescoes' around 1810, presumably for a decorative scheme, he made sure that Blake confined himself to biblical sources. All the same, *Adam Naming the Beasts* looks as strange as its companion piece, *Eve Naming the Birds*. Both man and woman stare out at us through oddly expanded pupils. They look glazed, as if under the control of a higher being who manipulates their gesticulating hands and reduces them to the level of puppets.

Even when he tackled a subject as familiar as the creation of man, Blake insisted on transforming it into a typically idiosyncratic, heretical statement. His hero, Michelangelo, had painted a joyful image of Adam on the ceiling of the Sistine Chapel, galvanised into life by God's advancing and beneficent finger. But Blake, in one of his grandest colour prints finished with a flourish of ink and watercolour, turns God the Creator into a more sinister figure called Elohim. The Hebrew word for God, it also means 'judge'. And Elohim, in Blake's picture, is an anguished patriarch who descends on Adam's outstretched body like a burdensome weight. Laying one hand on Adam's head, he certainly enables the young man to grow out of the earth. But he also seems likely to smother him with oppressive authority. And Blake makes sure that a worm symbolizing mortality is already coiled tightly around Adam's leg. His woebegone face could hardly be more removed from the alert optimism conveyed by Michelangelo's Adam. Blake saw God as a tyrant, and in another magnificent colour print the sinning Adam is accused by a ferocious Creator surrounded by the leaping, hungry forms of a vengeful fire.

Blake's abhorrence of organised religion knew no bounds. He loathed it as vigorously as he hated the Royal Academy and its first President, Joshua Reynolds, whom he denounced as a man 'hired by Satan to depress Art'. Uncompromising, vehement and obsessed by the dictates of the angels who appeared before him in the streets of Lambeth and

Covent Garden, Blake must have been a difficult man to deal with. He also presents problems to exhibition organisers. Most of the images he produced in such quantities are small, and when ranged in long rows round a gallery's walls they can look daunting. So the Tate is right to off-set them in the largest room with the redoubtable presence of an old wooden printing press. It occupies a central position with the sturdy aplomb of a carved sculpture. The spokes of its wheel jut into space, rein-forcing the stark impact of Blake's own protesting words inscribed in monumental letters on the wall beyond: 'I was in a Printing House in Hell & saw the method in which knowledge is transmitted from gener-ation to generation.' He wanted to combat this relentless system with his own publications, and we are able to see some of the plates he engraved in nearby showcases. The exhibition also tries to set Blake in the politi-cal context of his revolutionary period: his most frequent employer, the publisher Joseph Johnson, welcomed freethinkers to his printing house, and Blake drew strength from aligning himself with the popular tradi-tion of Dissent.

In the end, though, this robust, obstinate and indefatigable man belongs to no one save himself. He can disappoint, most notably in a tedious frieze portraying all twenty-nine of Chaucer's pilgrims *en route* to Canterbury. He even fails to produce a suitably blazing illustration for his own poem *The Tyger*, supplying instead an oddly subdued image of a tame-looking animal who could never be accused of 'burning bright'. But for all his unevenness, Blake's triumphs easily outnumber the disas-ters. Nowhere more astoundingly than in his last series of watercolours inspired by Dante's *Divine Comedy*. They are an old man's distillation, executed with a freedom and exhilarated daring he had never attained before. Nothing could be more delirious than the whiplash whirlwind enclosing the lustful bodies of lovers, condemned by their own carnality to be tossed and battered in the blasts of Hell. Only Paolo and Francesca are rescued and redeemed, kissing in the sun because Blake could not bear to let them become the victims of God's legalistic vengeance. Even when, in another superb watercolour, Dante and Virgil arrive at the gates of Hell and read the inscription 'all hope abandon ye who enter here', Blake shows the travellers consoling each other before venturing into the bleak, smouldering regions beyond.

Still more consoling is the brilliant, audacious watercolour where a naked Pope is hurled, upside-down, into a cylinder of fire for buying and selling ecclesiastical preferment. While the pontiff burns, Virgil grabs Dante with enfolding arms and pulls him away to safety. For his part, Dante responds by hugging his rescuer like a boy. The two companions

79. William Blake, *The Simoniac Pope*, 1824–7

are locked in a heartfelt embrace, depicted with such passionate, loving conviction that Blake must have seen it as the surest way to counter the dangers of a world where 'mind-forg'd manacles' condemned so many to infinite wretchedness.

TURNER'S WATERCOLOURS
18 November 2000

When Turner is at his most fresh, swift and direct, he appeals to us with the greatest immediacy. The simplest of his watercolours are wholly in tune with our taste for images purged of distracting detail, and we often claim him as the first of the 'modern' artists. But the truth is that Turner's vast and protean achievements still cannot be fully grasped. Like the immense, engulfing panoramas of water, land and sky that he so often painted, Turner's formidable output evades any attempt to pin it down. The Royal Academy's survey of his 'great watercolours', organised to mark the 150th anniversary of his death, concentrates on the finished images he produced for public exhibitions, private patrons and extensive sequences of prints. So the most limpid and economical examples, brushed in with an eye for essentials alone, are excluded. But their absence does not mean that Turner emerges, here, as a less radical or surprising artist. On the contrary: to explore the 110 watercolours on display is to be continually amazed at how restless and inventive he was, how deftly he defies categorization in his long, prolific search for different ways of encompassing the infinite richness and dynamism of the observed world.

The first exhibit may not be the most sophisticated or accomplished image in the show: Turner was, after all, only fifteen when he exhibited it at the Royal Academy in 1790. But this view of the Archbishop's Palace at Lambeth is far more than a straightforward topographical study. The ancient buildings are depicted with precocious assurance, and they announce Turner's lifelong love of medieval architecture with strong ecclesiastical associations. The great surprise of this modest watercolour lies, however, in the dandified couple mincing their way along the cobbled thoroughfare. By mocking their fashionable affectation, Turner discloses a gift for metropolitan satire rarely detectable in his mature work.

He was also capable, in this early period, of acting like a reporter hungry

for a scoop. When the celebrated Pantheon Opera House burned down in February 1792, Turner must have realised that such a tragedy would make an arresting subject for a topical watercolour. Just as he hastened along to the Houses of Parliament in flames decades later, so now he hurried to Oxford Street and studied the melancholy scene. On this occasion, he missed the fire and found only a gutted frontage surviving in the morning. But Turner made full expressive use of the icicles left behind by the Pantheon's dousing in the wintry night. They hang down like jagged white teeth from pediments, capitals and window-ledges alike, providing a mournful backdrop for the bucket-filling firemen still animating the foreground with their urgency. Turner's involvement with humanity should never be underestimated. He did not regard the figures in his watercolours merely as props, and an elaborate view of Wolverhampton's annual fair is filled with feisty performers. They prance and gesticulate as boisterously as anyone in a Rowlandson watercolour, while Turner's gleeful engagement with the subject even led him to lavish particular care on a banner advertising Wombwell's Menagerie, with an elephant depicted below the words 'TO BE SEEN ALIVE'.

Confronted by such an image, anyone might have predicted that the twenty-one-year-old Turner would develop into an adroit and irreverent observer of the urban scene. His burgeoning ambitions were, however, boundless. And within a year of completing the Wolverhampton picture, he demonstrated a far more memorable feeling for the potency of emptiness. In *The Transept of Ewenny Priory, Gloucestershire*, Turner allows only two or three incidental figures to punctuate the silent, deserted gloom of a suppressed Benedictine monastery. A man is just visible, half-hidden by the tracery of a carved medieval screen. And an equally distant woman can be glimpsed, feeding the chickens who have made the Priory into their illicit, makeshift home. But nothing else disrupts the Rembrandtesque drama of radiance and shadow in this dusty interior, where light is filtered through crumbling windows and some of Turner's brushmarks already achieve the broken subtlety of his later work. The sun falls in particular on a solitary tomb, where the armoured effigy of Sir Paganus de Turbeville of Coity is stretched out for eternity with only a few errant hens to alleviate his isolation.

Determined to seek out other monastic ruins, on his indefatigable journeys elsewhere in the country, Turner increasingly indulged an elegiac obsession with transience and decay. But he was also capable of standing elated in front of a rainbow on his 1801 Scottish tour, and turned its arching luminosity into the focus of an epic watercolour. Curving high over Kilchern Castle and the aptly named Loch Awe, the

rainbow has been defined by the most unorthodox of means. Turner boldly rubbed it out from the colour he had already washed in beneath. He would employ any methods available in order to arrive at a more direct, sensuous engagement with nature, and his audacious use of fingers in the rainbow scene gives it an astonishing, almost phosphorescent presence on the paper.

This revolutionary resourcefulness sits uneasily with Turner's urge, in other pictures, to vie with Claude. It led him to place Caernarvon Castle in a highly self-conscious classicizing framework. The quotations from Claude's paintings may have clarified the extent of Turner's ambitions, as an artist who wanted to elevate the art of landscape and attain the dignity of history painting. But it made Turner censor too much of his own vaulting originality. His Claudian idylls often look strained and embarrassingly artificial, awed in the wrong sense by reverence for a seventeenth-century master whose example threatened, at times, to alienate Turner from his independent vision. In a watercolour as painstaking as *Lake of Geneva, with Mont Blanc from the Lake*, both Claude and Cuyp are in danger of ousting Turner's own authentic response to the scene. Even here, though, he manages to sound an individual note: the robust forms of the naked women splashing in the water are free from any Claudian quotations. They look forward instead to the sturdy bodies in Cézanne's paintings of female bathers almost a century later.

Whenever he liberated himself from the Claudian ideal, Turner was more able to give unfettered expression to deeper preoccupations. His art was often galvanised by the spectacle of energy coursing through nature. In a dramatic vertical study of the Reichenbach Fall, where Holmes and Moriarty later met their end, the water plummets towards a foaming river straddled by a fallen tree. There, in the broken branches, stray goats struggle to prevent themselves from tumbling downwards while a herdsman scrambles after them. The smallness of both animals and keeper, pitched against the immensity of the cascading water, further intensifies their plight.

Turner's imagination was inflamed by peril. When he returned from Italy in 1820, his frozen carriage tumbled over as it crossed the Mont Cenis Pass. After failing to open the doors he escaped through a window and, while his driver started fighting some officials, he staggered down to Lanslebourg through a deep snowdrift. Soon afterwards he produced a watercolour of the scene, viewing his carriage from afar so that it could be marooned in a desolate expanse of rock, turbulent clouds and giddy, unnerving voids. It was the Alpine equivalent of the storms Turner often depicted at sea, assaulting vessels and overwhelming the passengers who

80. J. M. W. Turner, *Passage of Mont Cenis*, 1820

cling so desperately to masts and rigging. Diminutive, their struggle to survive appears doomed when contrasted with the size and ferocity of the elements ranged against them. But at least they are determined to try, and Turner allows us to hold out some hope for these frantic, hysterical figures.

That is why a later image called *Longships Lighthouse, Land's End* is so alarming. For he fills the paper this time with a chaos of hurling waves, spray and foam thrown off by the gale-maddened sea. In the far distance, the lighthouse sends out a faint glow. It looks minuscule, vulnerable and sadly ineffective. Seagulls scatter on a clifftop, as if frightened by the approach of a ship. But nothing seems visible through the spume until, quite suddenly, we realise that a vessel is foundering in the darkness. It is only an empty hulk, whose occupants have long since been tossed into the maelstrom.

Humanity is helpless in the face of such a relentless attack, and this fundamental fact appears to overshadow even the most festive of Turner's late watercolours. Young men arrayed in Renaissance costume parade on the shore in a resplendent view of *Heidelberg with a Rainbow*. They could be a reference to the city's distinguished history, or alternatively a group of present-day students dressed up for a party. Either way, they do nothing to

quell the underlying suspicion, fuelled by the rainbow, that the sunlight may soon give way to a tempestuous alternative.

In an 1843 view of Goldau, the finest and most stirring image on show, this threat becomes an annihilating reality. The forlorn figures angling in the foreground seem unaware of the apocalypse behind. They do not even turn their faces to acknowledge its eruptive advent. Instead, they seem overcast by the glacial landscape around them, where boulders still testify to the calamitous partial collapse of the Rossberg mountain in 1806. The village and 457 of its occupants were buried outright, turning the entire locale into a mass graveyard. And Turner transforms the sun descending on the distant Lake of Zug into a vehement, flaring echo of that catastrophe. Rubbing with a sponge, scratching with his thumbnail and cutting with a scalpel, he used violent ways of working to match the force of an event as devastating as the detonation of an atomic bomb. Blood-red clouds surge upwards as they appear to consume everything within their range. It is an end-of-the-world scene, terrifying and absolute.

But Turner finds beauty in it as well, just as he derives consolation around five years later in the melting, fragmented dissolution of a water-colour called *The Lauerzersee, with the Mythens*. All the fancy dress, the Claudian quotations and virtuoso showmanship have dropped away now, leaving behind an old man's Prospero-like vision, a flickering and fugitive distillation of a dream.

RUSKIN, TURNER AND THE PRE-RAPHAELITES
8 March 2000

Mounting an exhibition about an art critic is a hazardous enterprise. Words lie at the centre of any critic's activity, and they cannot be allowed to smother a gallery's walls. Better to rely instead on the achievements of the writer's favourite artists. But their work might easily dominate the entire show, ensuring that the critic who supported them ends up ignored.

With John Ruskin, far and away the most influential of Britain's art critics, the difficulties evaporate. For this most prolific of writers also found time, throughout his career, to make drawings and watercolours of remarkable quality. There was a potentially powerful artist lurking in Ruskin's complex, troubled temperament, and he could not resist his

instinctive urge to draw the places he loved. But criticism kept pulling him away, and it led to immense frustration. 'I could have done something,' he complained of his own picture-making in 1878, 'if I had not had books to write.'

Most of his prodigious energy was poured into a torrent of around 250 publications, starting with art and then widening out to encompass architecture, the environment, politics and much else besides. Yet he still managed to produce an astonishing amount of drawings, mainly focused on the remote landscapes that fired his urge to sit down and put a line around what he saw. These studies, often freighted with an obsessive amount of careful scrutiny, form the heart of the Tate Gallery's superb centenary exhibition organised by Robert Hewison and his colleagues. At the same time, though, this large central room opens up on every side to other galleries, where the artists most admired by Ruskin are displayed with appropriate richness.

Pride of place is given to Turner, by far the greatest British artist he supported. Ruskin was only a young man when, stung by dismissive criticism of Turner's innovative late work, he published an impassioned defence of his hero. Cautioned by his father, a wealthy and respectable sherry importer, Ruskin signed the article only as 'A Graduate of Oxford'. In every other respect, though, he spurned moderation and thrust himself headlong into his crusading task. The fervent disciple proclaimed that Turner had been 'sent as a prophet of God to reveal to men the mysteries of His universe'. Revealing a religious zeal inculcated since boyhood by his devout and over-attentive mother, he even declared that Turner stood 'like the great angel of the Apocalypse, clothed with a cloud, and with a rainbow upon his head, and with the sun and stars given into his hand'.

Such an overblown claim courted absurdity, and probably embarrassed Turner himself. But Ruskin was a man with a messianic mission. And behind the intoxicated prose lay a keen, fiercely intelligent and wholly accurate awareness of Turner's revolutionary stature. Paintings as visionary as the 1842 *Snow Storm*, displayed in the first room of the show, were reviled by critics with a myopic attachment to the academic rule-book. Their derision incensed Ruskin, who published the first volume of *Modern Painters* only a year after *Snow Storm* was executed. He lauded Turner's swirling, vaporous *tour de force* as 'one of the very grandest statements of sea-motion, mist, and light, that has ever been put on canvas, even by Turner. Of course it was not understood; his finest works never are'. Initially, then, Ruskin's critical impulse was triggered by an urgent desire to make people understand Turner. The rhetorical potency of his

word-play soon earned him a wide readership, avid for a closer under-standing of God's creation as a whole. Ruskin believed that 'all great art is praise', and he tried to provide his own form of worship through the elevated prose of criticism. His books commanded a near-biblical authority among Victorians already enraptured by the vaulting achieve-ments of Romanticism in art and poetry alike.

Within a few years, however, Ruskin also emerged as the prime apol-ogist of the Pre-Raphaelites. Their precocious approach to the natural world flouted academic propriety as brazenly as Turner had done. So, on one level, Ruskin could only be expected to announce his support for Millais, Holman Hunt and their brethren in two influential letters to *The Times* in 1851. On another level, though, the gulf between the ageing Turner and the young Pre-Raphaelites pointed to a contradiction in Ruskin's thinking. How could he laud the radically simplified, near-abstract boldness of *Snow Storm* and, at the same time, praise the newly formed Brotherhood for their diligent, microscopically detailed exami-nation of nature? Turner would never have wanted to involve himself in the laborious minutiae pursued by Millais when he embarked on his portrait of Ruskin in 1853. The rinsed rocks and equally pristine water at Glenfinlas in the Trossachs made a Turneresque setting for the frock-coated critic, standing so sternly with his walking stick near the bed of a rushing stream. But the sober recording of every bubble and crevice took Millais over a year to perfect. The painting's tightness ended up very far removed from Turner's wild and summarizing approach. Ruskin asserted that the Pre-Raphaelites were obeying his celebrated clarion call in *Modern Painters*, imploring artists to 'go to nature in all singleness of heart . . . rejecting nothing, selecting nothing, and scorning nothing'. Such dogged scrutiny had nothing to do with Turner's masterly capacity to define the essence of a scene.

Millais's handling of Glenfinlas is diligent to a fault, even if his stran-gely funereal likeness of Ruskin says a great deal about the critic's dis-abling puritanism. The ardency of Ruskin's response to landscape is at odds with his cold, frightened avoidance of the human body. While Millais was labouring over the portrait, Ruskin's disastrous six-year mar-riage to Euphemia Gray was annulled. His 'incurable impotency' made him 'incapable of consummating' their relationship. Millais, by a supreme irony, married her a year later. In public, at least, Ruskin did not allow this bizarre reversal to affect his writing on Millais. The two men had, after all, worked together with like-minded intensity on open-air stud-ies of Glenfinlas while Ruskin's portrait was being prepared. But they eventually grew apart. Never again would Millais paint the countryside

81. John Everett Millais, *John Ruskin*, 1853–4

with the same fanatical diligence. Ruskin, on the other hand, returned to Scotland in 1857 and executed there his most painstaking study. Concentrating this time on the Pass of Killiecrankie, he worked six hours a day for an entire week on an exceptionally meticulous watercolour of rocks crowding towards the water's edge. The outcome undoubtedly testifies to Ruskin's growing technical prowess. But it also betrays a frankly neurotic need to set down even the most niggling detail, and the result promotes a feeling of pictorial suffocation.

Ruskin's work as an artist is far more impressive when he follows Turner's example, stopping short of over-elaboration and allowing subjects as sublime as the mountainous Bay of Uri in Lucerne to breathe on the paper. They are charged with a sense of the landscape as a living, altering force, not a specimen to be pinned down with daunting precision. Almost without exception, his finest art is his most unforced. In 1863 he executed some relatively swift studies of craggy ranges, first at Mornex and then at Lake Annecy. They have a freshness that escapes entirely from the stilted claustrophobia of his Scottish watercolours, reflecting the exultant mood that high peaks regularly engendered in his mind.

Away from Switzerland, though, Ruskin increasingly succumbed to depressive attacks. At their darkest, they could prevent him from working altogether. They also contributed to his intemperate condemnation of Whistler's *Nocturnes*. The critic who had defended Turner's boldness reached his nadir when he accused Whistler of 'flinging a pot of paint in the public's face'. It was a ridiculous slur. After all, Ruskin had argued in *The Stones of Venice* that 'the arrangement of colours and lines is an art analogous to the composition of music, and entirely independent of the representation of facts'. Whistler would have agreed, but Ruskin could not forgive him for refusing to accept that 'full comprehension and contemplation of the Beautiful' should be regarded as 'a gift of God'.

Ruskin's mounting depression had led him to voice an anger that blinded judgement, and the Whistler débâcle coincided with his first mental collapse. He did not appear in court when Whistler rashly sued him for libel. Ruskin was still struggling to recover from the death of Rose La Touche, to whom the middle-aged critic had made a futile marriage proposal when she was only eighteen. He lost the libel case, retreated to a remote home in the Lake District and became preoccupied with an apocalyptic fear of 'the storm-cloud of the nineteenth century'. Ruskin's horror of industrial pollution was well-founded, and links up with his prophetic concern for the environmental future of the planet. But throughout the final decade of his long life he was defeated by severe mental illness. It silenced his eloquence as a critic for ever, depriving British culture of an impassioned, tireless and resourceful champion. The most poignant image in the Tate survey is his watercolour of sunset at Seascale, a fishing village on the Cumbrian coast. Executed in 1889, it shows Ruskin at his most deft and limpid. Soon afterwards, his turbulent mind was assailed by a protracted attack of insanity that brought his working life to a terrible, premature close.

IMPRESSION

1 November 2000

When bilious critics denounced Monet for producing mere 'impressions', they coined the name of the most popular movement in art history. The gallery-going public never seems to tire of the Impressionists, and the National Gallery's new survey will probably attract enormous queues. But is it anything more than a crowd-puller? Does it add anything to our already comprehensive knowledge of the Impressionists' achievements? According to the show's curator, Richard R. Brettell, Impressionism needs rescuing. 'The bourgeois drawing-room and the general art museum', he declares, have 'gradually robbed it of its sheer inventiveness and daring'. So he set about choosing an exhibition focused on regaining the spirit of risk, energy and even danger that galvanised these young painters. Far from playing safe, they pushed themselves into working faster than any artists had dared to before. Their first reviewers felt short-changed by the sheer sketchiness of the canvases they displayed. But Brettell places this appetite for speed at the centre of their audacity, and concentrates on paintings that look as if they were produced at white heat.

They may not, of course, have been dashed off as quickly as we imagine. Manet's mercurial painting of *The Races at Longchamps* catches the riders in full, headlong gallop, while his swift brushstrokes make onlookers and landscape rush past in a blur as well. But closer scrutiny discloses the remarkable amount of care Manet has lavished on this electrifying image. Each upright plank in the wooden fence is carefully defined, and the crowd behind contains some substantial figures among the frenzy of darting, improvised stabs of paint.

Although this zesty canvas captures the exhilaration of a quicksilver event, it was not simply produced on the spot in a flurry of inspiration. Nor were the earliest Monets on view here. One of the best walls in the show is devoted to his seascapes of the 1860s. The magnificent *Towing a Boat, Honfleur* looks as if it might have been executed in a hurry, while the sun went down behind the distant lighthouse. But the foreground figures, pulling their vessel in for the night, must have been added later. Monet worked up his composition in the studio, realizing that it would otherwise have been too raw for public consumption. Both he and Manet were ambitious enough to care about acquiring reputations in Paris exhibitions, and they also measured themselves against some of the finest masters of the past.

82. Claude Monet, *Beach Scene at Trouville*, 1870

Even so, they did not allow the pursuit of professional success to compromise their boldness. When Monet went on honeymoon in summer 1870, he painted his wife Camille sitting on the beach at Trouville. In one canvas, the wind is so fierce that she reels back from its impact, struggling at the same time to prevent her parasol from blowing away. Half-obscured behind a veil, Camille's face looks beleaguered: she must have longed for her husband to finish, so that they could escape from the blasts. But in another beach scene, she savours the force of a sun that makes bars of brilliant white light break up her pale blue dress. Grains of sand can be detected in the paint, testifying to Monet's defiance of seaside obstacles. He was determined to work in the open air, despite the discomfort and practical problems it generated. And the outcome captures the freshness of a breezy day at Trouville with unprecedented immediacy. The modest size of this canvas belies its revolutionary significance, in an exhibition that encourages us to marvel at the Impressionists' daring all over again.

Looking at even the most spontaneous-seeming pictures of the 1870s, we cannot tell for certain how swiftly they came into being. But Monet's unfamiliar and fascinating *Harbour at Le Havre at Night* must have been largely executed on the spot. Rapidity is of the essence here. Every jab and wriggle of the brush exudes a darting sense of certainty, as he allows the fiery lights of ships and the more tempered illumination of the port to punctuate the deep nocturnal hues of sky and water alike. It is an audacious painting, where Monet pushes his subject to the very limits of visibility and comes up with a potent evocation of the dark, silent allure of the sleeping harbour.

By bringing such little-known works to our attention, the show does succeed in recapturing the spirit of daring behind the Impressionist adventure. It also manages to make me admire painters whose work I find wearisome. Renoir, so often saccharine, produced a masterpiece when he painted *A Gust of Wind*. Everything in this invigorating scene is animated: the clouds surging wildly across the distant hillside, the tree shivering with motion and the foreground bushes shaking and almost foaming as they react to the weather's onslaught. Judging by his equally impetuous *Road at Wargemont*, painted a year later in 1879, Renoir should have placed landscape at the heart of his work. Then we would have been spared some, at least, of all those repetitive, cloying nudes.

Although Impressionism was largely a male affair, Berthe Morisot is revealed as sprightly, assured and deftly individual. Her *West Cowes, Isle of Wight* is a little triumph of crisp, witty and buoyant observation. As for *The Jetty*, she manages there to anticipate the economy of certain Matisse sea views by over half a century. Morisot clearly deserves extended scrutiny, and I hope one day to see a proper retrospective of her whole career.

Pissarro and Sisley, who have both been granted far greater attention than her in major exhibitions, can often disappoint. But Pissarro's early painting of Dulwich College, executed when he escaped from the war in France to live in south London, is a wonderfully direct, vigorous response to architecture, trees, water reflections and autumnal leaves. Sisley also excels, not only in a limpid view of a lock-keeper's house but also in a later, more complex painting of the Roches-Courtaut Woods where writhing, excitable foliage looks forward to Monet's ecstatic late paintings of his overgrown bridge at Giverny. Such surprises guarantee that the show does not deteriorate into a tedious parade of the over-reproduced images we already know too well.

PARIS EXHIBITIONS: THE RIVIERA, MANET AND GUSTON

15 November 2000

Standing alone on a rock before a limitless sea, the ecstatic Gustave Courbet raises his hat in theatrical salute. The year is 1854, and Courbet had just discovered the Mediterranean. Invited to Montpellier by a friend, he found himself gaping at the view from the shore near Palavas Les Flots. Until then, the Riviera had been largely ignored by artists and writers alike. But Courbet's elation proved prophetic, inaugurating a love affair with the Côte d'Azur that nourished French painting for decades to come.

Now, at the Grand Palais in Paris, a spectacular exhibition pays tribute to the Mediterranean's inspiration. It amounts to a continually seductive experience. Even the earliest canvases on view, by minor artists like Paul Guigou, beguile us with their images of an Arcadian region. In his 1866 *Surroundings of Marseilles*, nothing disturbs the solitary calm of a woman walking along the coast with mountains beyond. The beginnings of industrialization can be glimpsed in Emile Loubon's panorama of the same area. But even he celebrates a pastoral idyll, where animals are herded to market across a bare, primordial landscape.

It would not last. By the time Cézanne painted L'Estaque in the late 1870s, a lone factory chimney had thrust its way into the Gulf of Marseilles. But Cézanne savoured its columnar form, and clearly found the town, sailing boats and iridescent sea a place of enchantment. Provençal by birth, he encouraged Monet and Renoir to visit the Riviera a few years later. Renoir's painting of *Rocks at L'Estaque* is mercifully free from his usual sweetness. As for Monet, he became reckless in a large, almost slapdash view of a *Path at Cap Martin*. Then, painting a sea panorama at Antibes in 1888, he lets an isolated pine tree fling itself in a writhing near-silhouette across the sky. The leaping vitality of its trunk and branches conveys the ardency of the painter himself, intoxicated by the sensuous delight of what he described as 'a pure riot of colour'.

These orgiastic words are even more applicable to the work of the young Fauves. Derain and Matisse discovered boundless stimulus at the tiny port of Collioure near the Spanish border. Here, between 1905 and 1907, they allowed the onslaught of the sun to inflame everything they painted. Derain heightened his palette and broke up his impulsive brushmarks, conveying the impact of Mediterranean light as it shattered the sea, sky and sailing boats visible from the harbour. Matisse allowed the

83. Claude Monet, *Antibes*, 1888

heat to penetrate his palette indoors, surrounding a sleeping woman with colours hot enough to roast her on the bed. And Braque, over in the bay of La Ciotat, went still further, breaking up the radiant view with a boldness that prepared him for the even greater extremes of Cubism soon afterwards.

Picasso, his cubist ally, makes a surprising contribution to the show. He first tried to paint Mediterranean views as a teenager, and the outcome was a modest brace of hesitant little images. But his encounter with the coastline was potent enough to stay with him, igniting his imagination far more powerfully when he returned in the 1920s. At Antibes, in particular, he confessed with bewilderment that 'I am in the clutches of this Antiquity'. It impelled him to paint the monumental young men in *The Pipes of Pan*, spellbound by music and sun in their stilled, elemental surroundings.

But the final images in the exhibition belong to Picasso's great rival, Matisse. In 1914, just after the outbreak of the First World War, he painted the view from his Collioure window at night. Shutters, wall and sky beyond are reduced to a series of bold vertical bands, the most abstract image Matisse had yet executed. It looks like a farewell, the work of a man

oppressed by his awareness of the tragedy ahead. By 1917, though, he had returned to the Mediterranean. Painting now in a Nice hotel room, he alleviates the darkness of the interior with its blue violin by raising one shutter towards the sea. Its lure was irresistible, and Matisse went on to rejoice in the Riviera light for the rest of his long, exuberant career.

Over at the Musée d'Orsay, a choice survey of Manet's still-life paintings proves equally irresistible. At a time when fruit, flowers and vessels on table-tops were deemed a minor genre, he insisted on making them the subject of around eighty canvases. They include many of his most delectable achievements. Manet believed that 'the still life is the touchstone of the painter', and the images gathered for this show bear out his claim with triumphant, sensuous conviction.

The earliest disclose the extent of his reverence for masters from the past. An elaborate, little-known 1862 painting called *Guitar and Hat* is riddled with affectionate references to Spain, and in particular to his infatuation with Velázquez. But the home-grown inspiration provided by Chardin was surely just as important. He must lie behind the reverence with which Manet approached a plate of oysters, juxtaposed with a sliced-open lemon and a fork whose handle juts temptingly towards us over the shelf's edge.

Manet paints his salmon, melon and peaches with the zeal of a gourmet, and the results arouse our appetites as well. Nothing could be more delicious than his little painting of strawberries piled in their basket, pitched against a shadowy backdrop that serves as an ideal foil for their soft, blushing ripeness. But Manet was not afraid of exploring the darker side of what the French so starkly call '*nature mortes*'. In 1866 he painted a dead rabbit slung by its legs from a gloomy larder wall, and the newly caught fish gaping in the centre of a great canvas lent from Chicago is handled with a violence worthy of Goya. Elsewhere, pruning shears lie open beside the peonies they have just sliced off at the stalk. And in a magical painting of 1880, a solitary asparagus seems about to dissolve into the pale marble table where it rests.

By this time, however, Manet had good reason to become preoccupied with transience. His health deteriorated, leading to illness so severe that he died three years later at the age of only fifty-one. His suffering in these final years often became intense. But Manet, who was increasingly forced to limit himself to painting small studies of flowers in vases, never allowed his art to grow dejected. Once, in a painting of two cut roses abandoned on a table, a melancholy mood predominates. On the whole, though, these images are astonishingly buoyant. Blackness often provides a funereal backdrop, yet the bouquets of peonies and

white lilacs are handled with a lively, effervescent touch. The final room devoted to these lyrical studies is almost unbearably poignant. They constitute Manet's spirited farewell, and their consummate subtlety makes his untimely loss seem even more deplorable.

Philip Guston's retrospective at the Pompidou Centre reminded me of his great Whitechapel Art Gallery exhibition twenty years ago. Staged just after he died in 1980, it focused exclusively on the astonishing late work. Now, in Paris, the eruption that Guston's art underwent during his last decade is placed in the context of the very different paintings he produced before then. Having started his career as a committed left-wing muralist in the 1930s, Guston became a distinguished member of New York's Abstract Expressionist movement after the Second World War. Jackson Pollock had been a fellow pupil in his schooldays, and Guston grew even more abstract than his old friend during the 1950s. The heroic, monumental figures in his youthful murals vanished completely, to be replaced by boldly handled paintings where clusters of fragmented forms struggle to emerge from an overall mistiness. They seem burdened by Guston's determination to avoid figurative references. He appeared to be struggling with himself, and by the late 1960s his urge to abandon abstraction became an overwhelming imperative.

Returning to his earlier obsession with the Ku-Klux-Klan, Guston introduced hooded figures into paintings where comic-book stylization fused, unforgettably, with pictorial lessons he had learned during his abstract period. Often working at night, he turned his own studio into a dreamlike arena for looming images of distress, yearning, anxiety, nausea and love. The audacity commanded by Guston during these final years still seems astounding. It ensured that his late paintings are by far the finest works he ever produced.

Casting all inhibitions aside, he painted bug-eyed heads drowning in a deluge, and chopped-up bodies careering pell-mell into a ravine. Nothing was too macabre for Guston at his most reckless. The upturned soles of hob-nailed shoes are an inescapable theme, and they sometimes threaten to thrust out of the canvas and stamp on us with their boorish weight. But Guston's own formidable energy is unmistakable, too. He shows himself, bulbous-cheeked and paunchy, boozing and smoking in his nocturnal studio. As if conscious of the fact that he had only a few years left, the ageing painter produced a prodigious body of work. It contains an impressive array of masterpieces, and Guston died at the height of this final, imperious burst of unfettered inventiveness.

ART NOUVEAU

5 April 2000

Flaunting her bare, green-tinted breasts, René Lalique's *Dragonfly Woman* could hardly be more bizarre. Instead of arms, jewel-encrusted wings sprout from her shoulders. The head of a masked creature scowls in her loins, dangling a long tail and raising two gold talons with mock-menace in the air. Diamonds and moonstones spatter the surface of this glinting apparition, adding to its sinister allure. Produced only two years away from the close of the nineteenth century, Lalique's corsage ornament is a masterpiece of Art Nouveau extravagance. Even the most resolute society hostess would have difficulty in attaching this large, elaborate concoction to her bodice. But practicality was never an overriding concern with Art Nouveau's devotees. By this time, the movement was at its zenith. Capital cities across Europe had succumbed to the sinuous vitality of an intoxicating 'new art'. It had a molten force: Henry van de Velde's electroplated bronze candelabra flows like freshly erupted lava. And its impact was volcanic, ensuring that Art Nouveau asserted an infectious dominance as the new century approached.

England, admittedly, resisted its undulating advance. Alfred Gilbert, the sculptor of *Eros* in Piccadilly Circus, spoke for many of his disgruntled fellow-countrymen when he declared: 'L'Art Nouveau, forsooth! Absolute nonsense! It belongs to the lady's seminary and the duffer's paradise'. But as the Victoria and Albert Museum's scintillating survey demonstrates, Gilbert and other English artists provided the movement's seed-bed. Writhing plant forms transform the back of Arthur Mackmurdo's mahogany chair into an astonishing prophecy of Art Nouveau at its most exuberant. And a year later, in 1883, the same designer turned the title page of a book on *Wren's City Churches* into a leaping linear inferno that anticipates the buildings' fate during the Blitz. At the other stylistic extreme, though, English designers made an equally potent contribution. E. W. Godwin's remarkably severe sideboard, produced as early as 1867, has a purged geometry that influenced Charles Rennie Mackintosh in Glasgow and Josef Hoffmann in Vienna. The silver fruit basket made by Hoffmann in 1904 owes a clear debt, in its structural clarity, to Godwin's example. Art Nouveau reached its most refined and austere point in Vienna, where Hoffmann's bracing lucidity looks forward so strikingly to the even more pared-down minimalism of today.

Elsewhere in Europe, though, the serpentine tendrils of Art Nouveau at its most flamboyant won the day. French designers as outrageous as

Emil Gallé, based at Nancy, drew on the spirited excess of their own rococo tradition. But Persian art was an effervescent source in Spain. The brilliant Antonio Gaudí, conscious of his country's links with the Islamic world, found inspiration in the interlaced geometric carvings of sixteenth century Persian doors. The invigorating energy of Japanese prints also proved decisive. Art Nouveau learned invaluable lessons from the waterfalls, whirlpool seas and intertwined erotic coupling in the work of Hiroshige, Hokusai and Utamaro. Their dynamism, at once disciplined and delirious, gave the tortuous lines of Art Nouveau an essential tenacity. Without it, the movement might well have lapsed into flaccid self-indulgence. After all, its weakest designers can look alarmingly kitsch. Japanese wiriness, coupled with the vigour of the folk art that excited Gauguin in Brittany, helped to prevent Art Nouveau from losing itself in extravagant absurdity.

So did nature herself. The burgeoning forms of plants, flowers and other, less identifiable organisms provided the movement with its trademark language. Darwin's radical theories had overturned evolutionary ideas for everyone apart from diehard religious fundamentalists. *The Origin of the Species* gave nature-study a built-in modernity. Hence the sense of uncheckable growth spreading its tendrils over the floor, walls and ceiling of Victor Horta's heady Tassel House in Brussels. Tangled and yet liberated, his inventive lines are thrown like spiralling lassos across space. They even end up transforming the staircase's ironwork balustrade into a *tour de force* of feverish flourishes. Sunflowers sprouted in equally rank profusion from either side of the portals at Siegfried Bing's gallery in Paris, where the name *L'Art Nouveau* was proudly proclaimed over the door. But the exuberance of nature reached its most public manifestation in Hector Guimard's irrepressible entranceways to Parisian Metro stations. One of them has been transplanted, full-size, to the V & A exhibition, providing it with a spectacular vegetal showpiece. The towering stalks and bulbous flowers deployed by Guimard defy identification, and yet their mysterious red glow gives them the air of science-fiction sentinels.

The fanciful strain in Art Nouveau could whirl off into shamelessness. Rupert Carabin, a virtuoso wood sculptor who made superbly crafted furniture, could not resist injecting gratuitous violence into one of his chairs. The back becomes a serpent, whose body curves down to be bitten in the head by an owl. Elsewhere, Carabin inflicts indignities on women. Two of them crouch naked under his massive table, struggling like inadequate caryatids to support the immense book that serves as its top. But female subservience reaches a scandalous peak in a walnut chair, where two cats serve as the arms. It seems harmless enough from the

front, but around the back we discover another naked female with trussed fingers and pinioned legs. Reduced to a humiliated plaything, she embodies the erotic fantasies of Art Nouveau at its most misogynist.

Time and again in this show, woman turns out to be subjugated. She finds herself trapped in the writhing stems of a petal-bearing candelabra, or transformed into a mermaid who clings haplessly to a lamp holding a nautilus shell in its bronze leaves. One of the few female figures to escape from this passive role is Loie Fuller, who captivated Paris with her head-long dances at the Folies-Bergère. Using the newly invented electric light and billowing drapery, she personified a more liberated female ideal. And her dancing figure spawned a host of excitable statuettes, including Raoul-François Larché's bronze-gilt lamp where Fuller's drapery rushes up above her head like a burst of smoke from an apocalyptic fire.

More often than not, though, powerful women are regarded as a threat in this exhibition. Nothing could be more glacial than Theodore Riviere's ivory and bronze statuette of *Salammbô*, an unfathomable beauty made famous in Europe by Flaubert's notorious novel. She stares down impassively at the collapsing Libyan captain Matho, who clutches her waist in a frantic attempt to gain her love. Soon afterwards, he died a gruesome death for Salammbô's sake, but she remained unmoved in all her gold-painted exotic trappings. Salammbô is as disastrous for men as Salome, who makes an erotic appearance in Gustave Moreau's painting. Holding a white flower enticingly in one hand, she points venomously with the other at St John the Baptist's severed head floating in space. Here, in a painting influenced by Indian and Persian miniatures, the lethal power of the *femme fatale* is fully unleashed.

The prospect of death is often accompanied by a frisson of unabashed luxury. Charles van der Stappen's *Sphinx Mysterieux* is a haunting, almost bloodless image, where a woman raises fingers to white lips like a priest administering the last rites. But the sculpture's purchaser would have relished the Congo ivory employed in the carving. It was regarded as a prize feature of Art Nouveau in Brussels, a city flourishing from the fortunes amassed in Belgium's recently acquired African empire.

If the show consisted solely of sumptuous artefacts, conspicuously parading their owners' *fin-de-siècle* fortunes, it might become intolerable. But Charles Rennie Mackintosh provides a superb corrective, trans-forming the tearooms and public institutions of Glasgow with his remarkably austere, stripped vision. If his rectilinear oak chair seems puritanical compared with continental furniture by Guimard or Horta, its restraint is bracing. Mackintosh could be quietly seductive, whether in his glass-panelled doors for the Willow Tearooms' Salon de Luxe or in an

84. Charles Rennie Mackintosh, *High Backed Chair*,
c. 1900

elongated poster of a robed muse promoting *The Scottish Musical Review*.
But we revere him above all for his heroic rigour. Both he and Josef
Hoffmann, exercising a similar severity with his geometric tea-service
and cutlery in Vienna, are the most forward-looking artists on view here.
They offer an implicit rebuke to all the rampant excess, in a show where
the volcanic flow of Art Nouveau finally surges through the iridescent
vases designed by Louis Comfort Tiffany in New York. Some of his
blown favrile glass vessels are actually called 'lava', and they look far more
convincing than Tiffany's florid, overwrought stained-glass windows that
bring the show to a close.

Art Nouveau is always most impressive when at its most daring and eruptive, but the movement could not survive the far greater cataclysm of the First World War. Rampant machine power blew apart the organic world celebrated here, crushing its elegant plant-life in the mud-filled trenches of the Western Front.

1900: ART AT THE CROSSROADS
14 January 2000

With a showmanship as brash as Barnum and Bailey, the Royal Academy's invitation promotes its latest blockbuster as a 'Battle of the Heavyweights'. The year is 1900. In one corner, bushily bearded Auguste 'The Chisel' Rodin glowers through middle-aged spectacles. In the other, Pablo 'The Palette' Picasso stares out impishly with young, mesmeric eyes. Although the invitation also promises 'supporting bouts', the main event is supposedly between these two doughty contenders. But the exhibition itself presents a far more complex, unpredictable picture of the period than a straightforward contest between top-of-the-bill bruisers. Picasso is only represented by a few early canvases, in an amazingly panoramic survey containing 250 paintings and sculpture by 180 artists. The initial focus is the Exposition Universelle, a Parisian extravaganza mounted as the world's grandest celebration of the dawning century. Only the most officially approved art was shown there, although the surprising range of countries embraced Australia and Japan as well as the US. Works included in the Exposition are scattered through the entire RA show, testifying to the impressive amount of fresh research carried out by the organisers. But the biggest concentration of them can be found in the opening gallery, dominated by a colossal bronze version of Rodin's lithe lovers intertwined in *The Kiss*.

It provides the only real innovative power in the entire room. Otherwise, establishment art prevails, and it ranges from the hair-raising to the hilarious. The most shameless is Paul Joseph Lamin's *Brennus and His Loot*. The shaggy, victorious plunderer stands on a bloodsmeared doorstep, gazing lasciviously at the severed heads, bejewelled booty and manacled, naked women heaped within. Titillation disguised as history painting here reaches its nadir, and young artists were right to rebel against such risible banality. The only revolutionary artist on display in

85. Auguste Rodin, *The Kiss*, 1898

the room is František Kupka. Within a decade, this pioneering Czech painter would be among the first to develop an uncompromising abstract language. But his painting here, *The Book Lover I*, is a simpering exercise in watered-down Impressionism. Three artfully posed women stare through dappled leaves at an oblivious man reading at a table. Executed with bland professionalism, the image gives no hint of Kupka's future appetite for revolt.

It is a relief to move on, and discover in the first thematic room a far more diverse array of styles. Nudes and bathers is the subject, its possibilities explored by everyone from diehard academics to outright insurgents. The most spectacular showpiece is Paul Chabas's *Joyous Frolics*, where laughing women in damp, body-revealing draperies splash, tug each other and flash their tumbling breasts at the viewer. It is a frothy affair, a world apart from the earnest nearby painting of wrestling men by Thomas Eakins. Locked into a muscular embrace on the gym floor, their photo-based figures are depicted with clinical precision. But behind the coolness lies homoerotic feeling, made more evident by the painting's proximity to Henry Scott Tuke's *Noonday Heat*.

Here, two sunbathing youths stare affectionately at each other on a quiet Cornish beach. Although Tuke's repressed coyness is easy to mock, his inclusion here reminds us that the centuries-old bathing idyll was undergoing significant changes. There are plenty of traditional nymphs in this room, disporting themselves by the water or emerging from crepuscular glades. But Sickert's robust bathers striding out to sea at Dieppe, their purposeful bodies emblazoned by striped costumes, have the snapshot feel of contemporary life. They make Cézanne's superbly limpid painting of male nude bathers look Arcadian, the work of an arch-experimenter still, paradoxically, in love with the classical past.

By placing innovators like Cézanne and Gauguin within such a broad context, the exhibition clarifies their links with more conventional artists. Take Edvard Munch, seen in the next room exposing emotions that remained pent-up in the work of his Scandinavian contemporaries. The man and woman in Richard Bergh's diligently painted *Nordic Summer Evening* stand and gaze at the placid lake beyond their terrace. The woman's back arches, as if in response to the sun falling on her dress. But the man's arms are tightly folded, and any feeling they have for each other is implied rather than stated. Munch's *Man and Woman*, by contrast, is a headlong image. Both naked, the lovers confront one another with a rawness matched by Munch's hectic brushmarks. Their passion is unmistakable, and yet the man buries head in hands as if overcome by anguish.

There are plenty of discoveries to be made in this stimulating, at times

torrential exhibition. Ignacio Zuloaga's *Portrait of a Dwarf*, sulkily clutching a large glass orb, looks back to Velázquez. But it also bears a fascinating resemblance to Lucian Freud's work, and the silhouetted painter reflected in the orb surely deserves re-examination. So does Mikhail Vrubel, whose painting of *Nadezhda Sabela-Vrubel at the Piano* fizzes with impulsive vitality. Its delirious looseness makes Picasso's nearby *Portrait of Josep Cardona* look disappointingly suave and well-mannered to a fault. Painted in 1899, when the artist was only eighteen, this lamplit image is a slick performance, and devoid of any restless urge to kick against prevailing *fin-de-siècle* taste.

Picasso's urge for renewal began to burgeon in 1900, when he travelled to Paris especially for the Exposition Universelle. His *Moulin de la Galette*, a wide and boisterous celebration of garish night-life, shows how much brash confidence the city injected into him. The top-hatted men dancing with their feathered, blatantly rouged companions are handled with precocious zest. Picasso grows wilder still the following year, in his painting of an emaciated absinthe drinker approaching her glass with bent, talon-like fingers. His debt to Toulouse-Lautrec is clear, and the show's organisers hang *The Absinthe Drinker* next to a flaring late Lautrec painting of *The Opera 'Messaline' at Bordeaux*. Its flamboyant audacity makes Lautrec's early death, just after he finished this canvas, all the more deplorable. He was only thirty-seven, and might well have developed with immense daring if a long life had been granted him.

Giacomo Balla, soon to become an outstanding member of the rumbustious Futurist movement, looks positively subdued in comparison with Lautrec. His 1900 painting of the Exposition Universelle at night is tightly handled, with none of Picasso's boldness. But Balla is already captivated by Luna Park, where merry-go-rounds bask in an illuminated blaze. Looking down the Champ-de-Mars to the Palais de l'Electricité, Balla marvels at the rapidly spreading potency of electric light. Within a few years, he would learn how to convey this excitement in paintings that helped to shape the emergent character of modernism.

This overwhelming exhibition is replete with similar auguries of the art-quake to come. In the largest room, serenity predominates as painters throughout Europe and the US explore the subtlest modulations of dawn, noon and twilight. Among these delicately brushed panoramas, though, several small paintings hint at the eruption ahead. Emil Nolde, who would flourish with uninhibited energy when Expressionism arrived a few years later, is represented here by a pale, reticent seascape. Its sparing reliance on a few horizontal sweeps of the brush already seems strikingly abstract, and August Strindberg's turbulent application

of thick, loose pigment in *White Mark IV* prophesies the freedom of Jackson Pollock half a century on. As for Kandinsky, his little *Study for a Sluice* belies its modest size with colours and mark-making vehement enough to anticipate the upheaval he would soon help to ignite.

With its rich array of images on the end wall by Cézanne, Degas, Gauguin and Monet, the landscape room offers far more hints of future vivacity than the religious section. Dominated by a nauseating *Regina Angelorum* by the anaemic William-Adolphe Bouguereau, the pious images assembled here prove just how insipid most church art had become. Among the mawkish devotional pictures, though, one canvas strikes a chilling note. In Ludwig Herterich's painting of the armoured knight Ulrich von Hutten, the crucified Christ appears in the shadows behind him. It is a gloomy canvas, and Herterich has been long forgotten. But the myth of von Hutten flourished along with German patriotic militarism. They both came to a climax when Hitler seized control, using propagandist image-making to portray himself as a neo-medieval warrior. By then, he had denounced modernism as a 'degenerate' sickness, extinguishing the hopes of everyone in Germany who had contributed to the avant-garde dynamic of early twentieth-century art.

Ultimately, though, the spirit of adventure outlasted Hitler's brutal censorship. It continues to enliven art in the new century, and this well-timed, epic and inexhaustible show widens our understanding of its origins at every turn.

PAINTING THE CENTURY
1 November 2000

What is the point of the painted portrait? Before photography was invented, plenty of answers could be given to that question. Sitters wanted to be flattered, exalted, memorialised or shown in a seductive light to a prospective suitor. But during the twentieth century, the whole notion of painting a likeness seemed more and more anachronistic. And the excruciating dullness of boardroom portraits threatened to reduce the entire genre to extinction. All honour, then, to Robin Gibson, whose illuminating millennial exhibition at the National Portrait Gallery redresses the balance. The 101 images he has selected for *Painting The Century* may not all live up to the catalogue's rash claim that they are 'portrait masterpieces'. But there

are enough incisive, adventurous, moving and even profound works on display to prove that portraiture maintained its viability throughout the modern period.

True, the first exhibit is dutiful to a fault. The octogenarian Queen Victoria, painted in 1900 by her favourite portraitist Heinrich von Angeli, looks weary and bored. Although von Angeli was supposed to be adept at keeping the old Queen amused, you would never guess from his dour effigy. In this instance, a photograph would have been just as effective. But as early as 1902, the Swiss artist Cuno Amiet proved that painting could still outstrip the camera. His tempera triptych called *Hope* started out as a portrait of Amiet's pregnant wife Anna, raising expectant hands in the direction of the unborn child depicted in a small panel above her. But the baby turned out to be stillborn, so Amiet added two gruesome flanking panels where male and female skeletons gaze blankly at the woman.

No photograph could have vied with the complex symbolism of this harrowing work. And by the time Picasso painted his mistress Madeleine in 1905, he was exploring pictorial possibilities that left the camera far behind. This extraordinarily delicate painting seems to have been washed on to the canvas, not applied with brushes. The thinness of Picasso's handling accentuates the emaciated quality of the young woman, wavering on a misty blue ground that reinforces her melancholy.

The fizziness of the society portrait had not gone entirely flat. Giovanni Boldini's shamelessly prettified portrait of Consuelo, Duchess of Marlborough has plenty of effervescence, while Sargent's *Sir Frank Swettenham*, sword slung from his colonial uniform, is filled with lordly swagger. But paintings as tough as Oskar Kokoschka's *William Wauer* proved that the emergent avant-garde wanted to pursue a more probing psychological approach. Wauer's inner anxiety seems to infect every inch of this nervous, hesitant image. The broken brushmarks promote a sense of instability.

When the Great War broke out, Otto Dix exposed the full, tormented disquiet of the Expressionist generation. Training as a machine-gunner in 1915, he painted himself as Mars setting out with wild, blood-red eyes for the battlefield. Everything around him tilts and sways with apocalyptic frenzy, and fear can also be detected in his haunted features. For all its martial bluster, Dix's self-portrait hints at the nightmare of defeat. And the aftermath of Germany's humiliation is reflected in Max Beckmann's *Family Picture* five years later. Crammed inside a claustrophobic interior, the artist reclines on a piano stool and seems alienated from his wife, son and other relatives. The entire room seems close to collapse, while the

86. Otto Dix, *Self Portrait as Mars*, 1915

candles introduce a note of privation suggesting the inflation-dogged austerity of the Weimar Republic.

Not all the portraits are grim. Léger depicts a cubist Charlie Chaplin with unaccustomed wit, using fragments of wood and rope to celebrate the acrobatic litheness of Chaplin's jerky movements. In the same year, though, Isaak Brodsky portrays Lenin standing with proprietorial satisfaction in Red Square. The style is tediously academic, just as the sitter would have wished. Brodsky makes Lenin look like a cloth-capped figure from the past rather than a harbinger of the future. Whereas the outrageous

Tamara de Lempicka presents herself as a helmeted machine-age goddess in 1929, resting one gloved hand on the steering-wheel of her gleaming green car.

Aeroplanes hurtle round the faceted head of Mussolini, painted in 1933 by Gerardo Dottori as a Futurist deity. The cold, pompous aggression of this monumental image heralds the violence to come, and in 1942 the young Lucian Freud portrayed an *Evacuee Boy* with precocious intensity. Naked against a black backdrop, the vulnerable sitter with his projecting ears and jagged teeth looks as bruised as a boxer after a fight. In this respect, he anticipates the greater exhaustion of Felix Nussbaum's *Self-portrait in the Camp*, where the pale and gaunt artist shows himself as a bewildered intern in France. He died at Auschwitz in 1944, the year that George Grosz attempted to paint *Hitler in Hell*. Seated wearily near a mound of pleading, protesting skeletons, the Führer is reduced to mopping his forehead. But Grosz's late style is no longer acid enough to convey powerful condemnation.

After the Second World War, the show reveals a waning intensity. Dubuffet's scarecrow-like portrait of the hallucinating artist Henri Michaux is as rough as a graffito scratched on a wall, while in Karel Appel's painting Michel Tapie and Stephane Lupasco loom from the large, wildly handled canvas like grotesque gargoyles. But too many of the post-1945 portraits seem tepid compared with the earlier exhibits. And by a paradox, the most memorable images shy away from presenting a fully identifiable sitter. Richard Hamilton shows Mick Jagger and Robert Fraser holding up their handcuffs inside a police van, thereby shielding their faces from photographers anxious to capture the moment of their arrest for drugs possession. The two young men in David Hockney's *Le Parc des Sources, Vichy* turn away from us, and stare enigmatically down the avenue of trees beyond. As for Frank Auerbach's *J.Y. M. Seated IV*, she is almost lost in the maelstrom of thick, agitated pigment heaped on to her features.

The more legible portraits become in this final section of the show, the weaker they are as works of art. And the paintings chosen for this final decade are, with the exception of Freud's magisterial *Leigh Bowery (Seated)* and Jenny Saville's corpulent *Branded*, inadequate in aesthetic terms. Their mediocrity is alleviated, in 1999, by Gary Hume's *Pauline K*, a strangely mask-like image where the sitter's identity is almost obliterated by creamy gloss paint. Perversely, though, Hume succeeds in defining the woman's character by bringing her to the very edge of effacement.

THE SCOTTISH COLOURISTS
11 July 2000

Nothing could be more dextrous than the still-life paintings commencing the Royal Academy's Scottish Colourists survey. The work of optimistic young men, these fluent studies of lobsters, roses, bottles and coffee-pots show how much J. D. Fergusson and S. J. Peploe had benefited from their early years in Paris. Both of them studied there during the 1890s, learning above all from the painterly flair and economy of Manet. And in the opening years of the twentieth century, they pitched their flowers, vases and gleaming utensils against the most dramatic of black grounds.

At this stage, Peploe's deftness of touch was more impressive than his friend's sturdier approach. But Fergusson soon proved more adventurous. His eruptive canvas of fireworks irradiating the Dieppe sky on 14 July 1905 is more than a homage to Whistler. Its loose, sensuous application of broken brushmarks announces a new freedom for Fergusson. Within a couple of years, his darting, on-the-spot oil sketches of the Paris streets showed how much he had learned from Fauvism. He was the first British painter to realise the importance of Derain, Matisse and the other French artists then revolutionizing European art. Fergusson's 1907 *Closerie des Lilas*, a fizzy little image of a lady in a broad hat, comes very close to Matisse paintings of the same period. But it is not a pastiche. Fergusson was driven by a very personal infatuation with women in general and young milliners in particular. By 1908 he had produced a tougher, more monumental portrait of his artist-friend Anne Estelle Rice, framing her strong, simplified features in a curved hat surmounted by deep blue feathers.

For a while, at least, Fergusson's art carried a potent erotic charge. In his large painting *La Terrasse, Café d'Harcourt*, he appears to salute the fashionable diners at a stylish Parisian restaurant. But the seductive milliner's assistant standing near the centre stares out at us through blank eyes, and her mask-like expression is as unsmiling as everyone else in the room. Fergusson's insouciant, almost slapdash handling of her pink dress adds to the sense of nocturnal danger. Women here are on the prowl, but a sinister man at a table seems quite capable of manipulating them in turn.

On the whole, though, Fergusson's art has no ominous undertones. He preferred to celebrate his favoured subjects with as much exuberance as possible. Stimulated by the experimental dancer Margaret Morris, his lifelong partner, he began to produce boldly outlined and thickly painted nudes. One of them, a beguiling seated figure holding an apple of temp-

87. J. D. Fergusson, *Les Eus*, 1910–11

tation in her open palm, became an icon when chosen for the cover of a new magazine called *Rhythm* in 1911. Edited by John Middleton Murry and Michael Sadler, its pages reflected a Fauve-aligned spirit of renewal in art and literature. Fergusson was brimming with assurance, and his colossal painting *Les Eus (The Healthy Ones)* made a frieze of dancing pneumatic nudes flaunt their well-being in a primitive landscape.

This boisterous image reflects Fergusson's admiration, not only for Derain and Matisse, but also for the liberated dance ideas explored by the Russian Ballet and the magnetic Isadora Duncan. Compared with the lithe dynamism of Matisse's earlier dance paintings, though, *Les Eus* looks heavy-handed. Roger Fry excluded Fergusson, Peploe and their Scottish allies from his hugely influential *Second Post-Impressionist Exhibition* in 1912. He found their work 'turgid and over-strained', and Peploe certainly became emphatic to a fault in his stridently Cézannesque still-life paintings of the period. They show an artist retreating from Fauvist abandon into a more controlled, ponderous way of working. Peploe stopped well short of involving himself with Cubism, Expressionism or Futurism, the three most powerful art movements in pre-1914 Europe.

But Fergusson maintained his old momentum for a while longer. Moving to London during the Great War, he and Morris founded a lively club in 1915 where her pupils performed their innovative dances. Fergusson also renewed himself by tackling the challenge of war art. In 1918 he visited Portsmouth Docks and painted battleships under construction. The vigour of these canvases demonstrate his new-found fascination with the machine age. Cranes, funnels and metallic hulls surge across his dockyard images, and an elegiac painting called *Damaged Destroyer* discloses his awareness of the war's tragic dimension. If Fergusson had become an official war artist, he might well have produced an impressive, large-scale painting worthy of comparison with the panoramic canvases commissioned from Wyndham Lewis and others. But government patronage failed to materialise, and his subsequent plans to collaborate with Charles Rennie Mackintosh were equally unsuccessful. Living near Morris's school in Chelsea, Mackintosh designed a new dance theatre for her in 1920. But the project sadly came to nothing, and Fergusson then decided to concentrate on Scottish and Mediterranean landscapes in a more cautious Post-Impressionist idiom.

It is a puzzle and a pity that Fergusson did not pursue his brief involvement with sculpture. In 1924 he produced a magisterial brass head of a Saxon goddess called *Eastre (Hymn to the Sun)*. With flat, helmet-like hair giving her the aspect of a warrior, she is a mesmeric, gleaming presence. Now on view at the Fine Art Society, along with paintings by the Colourists and the unfairly neglected Jessica Dismorr, this impressive head made me wonder why Fergusson failed to build on the success of his spellbinding idol.

By that time, the two other painters in the Royal Academy exhibition had also attracted attention. The earliest work produced by Leslie Hunter, who first went to Paris in 1904, cannot now be assessed. It was destroyed by the catastrophic 1906 earthquake in San Francisco, where Hunter was about to stage his first solo show. Plagued by ill-health and a persistent failure to sell enough of his paintings, he remained a marginal figure. But his art is cheerful enough. Self-taught, he met Fergusson in 1913 and painted some lively little beach scenes at Etaples in a fresh, Fauvist style. But the watercolours Hunter executed after the war are weaker, while his landscapes and still-life images of the 1920s are little more than tepid echoes of Cézanne.

The same verdict cannot be applied to the youngest of the Colourists, F. C. B. Cadell. Like Fergusson and Peploe, he had trained in Paris. But his earliest paintings in the RA survey owe more to Sargent and Whistler than French art. Their virtuosity is clear, especially in a spirited painting

called *The Black Hat*. A smart Edinburgh woman poses before her reflection in an overmantel mirror, a classic Whistlerian device. Another Cadell painting, *Afternoon*, shows a subtle awareness of psychological isolation in an interior where all three women seem strangely alienated from each other. But his flashy style still belongs to the late nineteenth century, and Cadell only developed a more audacious approach after the Great War.

It is announced, with commanding austerity, in *Portrait of a Lady in Black*. At first glance, the elegant woman holding a black fan with her impeccable white glove seems the quintessence of fashionable Edinburgh society. Cadell had recently moved to a new studio in Georgian Ainslie Place, and this painting appears calculated to appeal to a wealthy, style-conscious clientele. After a while, though, its mood grows more poignant. The funereal colours of her hat and dress might also signify the sitter's melancholy. After all, an overwhelming number of women lost husbands, fiancés and lovers during the war. So Cadell, the only Colourist who fought in the conflict, may well be harnessing his new-found severity to convey a mournful mood.

A witty and gregarious host, Cadell nevertheless favoured a sense of muted sadness in his art of the 1920s. The gold chair casting such a limpid reflection in the polished black floor is empty, save for a discarded white fan and drape. So is the red chair in several still-life paintings, one of them constructed with the heraldic clarity of Patrick Caulfield half a century later. Even when a figure finally occupies this chair, he turns out to be a naked black man slouched in a pensive, yearning posture.

The most disconcerting of all Cadell's paintings is the large *Interior: the Orange Blind*. Despite the glitter of a cut-crystal chandelier and the sumptuous oriental screen, the atmosphere in this lofty room is strained. The man playing a distant piano looks utterly removed from the woman on the jade-green *chaise-longue*. Her face is even more empty and mask-like than the woman dominating Fergusson's pre-war *La Terrasse*. Her glacial skin seems to have been drained of all its blood, and she stares forward without showing any interest in the silverware laid out on the tea-table. Veiled by the tall orange blind, this curiously sterile interior could hardly be more forlorn. In terms of the exhibition, it also acts as a swan-song. After Cadell completed it around 1927, neither he nor his fellow Colourists would ever regain the *élan* and gusto invigorating their finest earlier work.

BAUHAUS DESSAU
23 February 2000

Nothing could have been more ecstatic than the cover of the first Bauhaus Manifesto in 1919. Lyonel Feininger's jagged woodcut shows a cathedral surging into the sky with irresistible dynamism. Beams of light thrust outwards from the stars above three spires symbolizing the arts of painting, sculpture and architecture. Their unity would be proclaimed in this, the most influential art school of the twentieth century. And its founder, Walter Gropius, was not afraid to couch its aims in the most rousing, high-flown language. 'Let us together create the new building of the future, which will be everything in one form,' he declared, promising his prospective students that it 'will one day ascend towards heaven as a crystal symbol of a new faith that is to come'. Excited by the visionary words and the soaring avant-garde style of Feininger's woodcut, around 150 students soon enrolled. Almost half of them were women, and many came to the Bauhaus straight from active service. Exhausted and demoralised by the savagery of war, not to mention Germany's humiliating defeat, they responded eagerly to this clarion call for renewal. A new world had to emerge from the devastation, and optimism prevails at the beginning of the Design Museum's Bauhaus exhibition.

At Weimar, where the first Bauhaus began, an astonishingly talented team of teachers was appointed. Apart from Feininger, already a celebrated expressionist painter, they included Wassily Kandinsky, Paul Klee and Oskar Schlemmer. All three were at the forefront of modern art at its most innovative and liberated. But they agreed to work for a school led by the firm views of an architect, who insisted in his 1919 manifesto that 'the ultimate aim of all creative activity is the building!' From the outset, then, a creative tension can be detected at the Bauhaus. Both Klee and Kandinsky were happy to involve themselves in an idealistic enterprise bent on placing visual experiment at the centre of everyday life. But their own paintings were robustly individual, and could not easily be reconciled with Gropius's determination to 'raze the arrogant wall between artist and artisan'. Schlemmer noted that Klee's arrival in 1921 'appears to inspire the greatest shaking of heads, as a kind of *l'art pour l'art*, removed from any practical purpose'.

Against the odds, though, Klee managed to play an important role at the Bauhaus. His nimble drawings and watercolours are wonderfully unpredictable, and cannot be fitted into the programme Gropius envisaged. No grand theory about the unity of the visual arts is detectable in

88. Lyonel Feininger's woodcut in the *Bauhaus Manifesto*, 1919

Klee's little drawing called *The Protector*, where a screaming man tugs at the leash attached to a ferocious dog whose jaws stretch wide in a predatory bark. This cartoon-like image seems far removed from the diagrammatic exercises on colour theory that formed part of Klee's Bauhaus course. But he was a valued teacher, and when the school moved to Dessau in 1925 Gropius made sure that artists continued to assert their presence.

The Weimar years had ended in turmoil: right-wing politicians came to power and demanded the closure of a school they associated with Communist and Bolshevist tendencies. But Gropius found generous support at Dessau, a small industrial city more attuned to his progressive aims than tradition-haunted Weimar where the memory of Goethe and Schiller still held sway. The Dessau Bauhaus, erected in a surprisingly short time to Gropius's designs, had an enormous impact when it opened in December 1926. He wanted a free layout, quite distinct from the centralised approach of Renaissance and Baroque architecture. He believed that the 'spirit of our own times rejects the imposing model of the symmetrical façade'. So visitors were encouraged to walk right round the building's wings and appreciate the function of its different areas. But the most spectacular section was undoubtedly the street-facing frontage, an immense wall of luminous glass through which the staff and students could clearly be seen at work.

The lack of privacy did not suit everyone. Kandinsky lived in one of the Gropius-designed Masters' Houses, all built to impressive specifications in a small nearby pinewood. 'Anyone could look into the house from the street', recalled his wife Nina; 'that bothered Kandinsky, who would have preferred his private sphere to be private. Right away he painted the glass wall white on the inside.' On the whole, however, the artists entered into the functionalist spirit of the main Bauhaus building. The mural-painting class decorated the classrooms and library, employing an uncompromisingly abstract disposition of colours. Marcel Breuer directed the joinery workshop in the production of stripped furnishings for the canteen, the studios and, most strikingly, the auditorium where rank upon rank of his trademark tubular steel seats were displayed to a wide public for the first time. They rapidly became hailed as a breakthrough in furniture technology, just as the purged lamps designed by Marianne Brandt and Max Krajewski were pioneering classics in their field. Everything on view at the new Bauhaus, down to the sign-making made by the printing workshop, was in tune with the collaborative principle. It all amounted to a defining moment in the development of a bold, specifically twentieth-century language.

Not all the exhibits lent to the Design Museum show have lasted well. Some look doggedly utilitarian, and suffer from the proliferation of cheaper, later versions that turned vigorous innovation into tiresome clichés. But the best Bauhaus designs retain their freshness intact. Marianne Brandt's small teapot, a miracle of exquisitely pared-down refinement, stands out. The lid seems to be suspended on the flat, highly reflective surface of the pot, and the entire object gives off a

serenity well-attuned to the whole relaxing notion of sipping tea. Mies van der Rohe's armchair is equally outstanding, and far more comfortable than the sterner, bare-board furniture produced by puritanical designers.

Judging by a group photograph of the thirteen Bauhaus Masters, standing on the roof of the school building in their bow-ties and sober suits, they could be formidably severe. Overwhelmingly male – Gunta Stölzl is the only woman there – they look stern and pedagogic. So I was relieved to learn that life at the Bauhaus was enjoyable as well. Its themed parties became legendary, and Marianne Brandt caught the spirit of fun by photographing herself, on the way to the Metallic Party, sporting a bizarre, robot-like contraption clamped on her head and neck. It recalls the geometric costumes devised by Schlemmer for his renowned *Triadic Ballet*, where performers' bodies are encased in sculptural shells like automata in a science-fiction fantasy. The logical conclusion of such an approach can be found in Heinz Loew's model for a *Mechanical Stage Set*, where brilliantly coloured abstract forms in painted wood, brass and steel glide in silently from both sides and meet, interlock or pass each other like vessels manœuvring their way through a crowded sea. No space can be detected, here, for human performers: they have been ousted by these revolving denizens of the new machine age. But there is nothing menacing about these creatures. They look jaunty and curiously innocent, more suited to a carnival than a *danse macabre*.

All the same, internal conflicts at the Bauhaus could infuriate even its most dedicated supporters. Gropius's wife Ise, who described it in an exasperated moment as 'this eternal seething boiler', complained that 'spending a whole day with bauhaus people gets on your nerves'. Gropius himself resigned in 1928 to devote more energy to his own architecture. His departure caused bewilderment, and the increasingly hardline politics of his successor, Hannes Meyer, led to chronic unrest. Schlemmer, who became disenchanted with the new agit-prop direction of the stage workshop, left in 1929 after gloomily predicting that 'the Bauhaus will reorient itself in the direction of architecture, industrial production, and the intellectual aspect of technology. The painters are merely tolerated as a necessary evil now.'

Meyer himself was forced to resign only a year later. The growing opposition to his militant stance had been led by Kandinsky, whose experience in his native Russia left him with a deep mistrust of Communism. He feared that Meyer was guilty of sacrificing the necessary freedom of art to political imperatives, and Mies van der Rohe's appointment as the new Director promised to correct the imbalance. But

he went too far the other way, depoliticizing the Bauhaus and turning it into a narrow school of architecture lacking Gropius's original visionary fervour.

Not even the tenacious Mies could shut out the impact of larger social forces, however. The Nazis' accelerating power soon became trained on the Bauhaus. It was condemned for fostering sinister 'cosmopolitanism', and Fascist disapproval focused in particular on the school's advocacy of flat roofs. They were regarded as a poisonous heresy, originating in eastern countries and therefore suspiciously Semitic. After a doomed attempt to restart the Bauhaus in Berlin, it was finally forced to close by the Nazis in 1933. The great experiment was over, and Iwao Yamawaki's bitter collage shows jackbooted thugs marching over Gropius's collapsed flagship buildings.

The Bauhaus had the last laugh, though. As the ousted masters fled to other countries, its influence spread across the world. And UNESCO has now declared the original Dessau school a World Heritage site, in definitive acknowledgement of its far-reaching contribution to everyone's ideas about the shape of things to come.

PICASSO THE SCULPTOR
30 August 2000

With his black eyes focused in a mesmerizing stare, Picasso stretches out an arm and grips his sculpture of *The Orator* tightly round the neck. It could be a playful gesture, acted out as a mock-throttle by an artist who loved to perform for the camera. Or it might be a more instinctive move, revealing just how much Picasso loved to touch and handle the three-dimensional work he produced.

He certainly enjoyed hoarding it. For most of his long, protean career, Picasso ensured that sculpture was his best-kept secret. Occasionally, he would let the public have a glimpse of this hidden activity: at his 1932 exhibition in Paris, seven of the exhibits were sculptural. Even then, though, they were vastly outnumbered by the paintings on view. Picasso was never regarded as a significant sculptor until 1966, when Paris celebrated his eighty-fifth birthday with a barrage of exhibitions. I will never forget their overwhelming impact on my nineteen-year-old eyes, and the greatest revelation was provided by the first ever survey of his sculptural *œuvre* at the

Petit Palais. It proved, beyond all dispute, that he had made a prodigiously resourceful contribution to the language of modern sculpture.

Since then, the full extent of his prolific three-dimensional experiments has gradually become clear. We know today that Picasso produced around 700 sculptures, many of them deserving to be ranked among his major achievements. And now that the Pompidou Centre has mounted by far the largest retrospective of Picasso's three-dimensional work, he is hailed in the immense catalogue as 'the twentieth century's most important sculptor, proving perhaps more inventive in the latter role than as a painter'. Nobody would have been more surprised by such a rash, exaggerated claim than Picasso himself. A born draughtsman, this fundamentally linear artist regarded sculpture as a private activity compared with the marks he had made on paper or canvas. Many of the radical constructions he made during the cubist period were lost or destroyed, and nothing now remains of the towering structures he devised for Diaghilev's dancers in the 1917 ballet *Parade*. But over 300 hugely varied works have been brought together at the Pompidou, showing how brilliant and irrepressible his three-dimensional forays could be.

As a dextrous child of seven in Malaga, he astounded his family by cutting out animals, figures and flowers for a 'world theatre' with precocious aplomb. None of these boyhood feats has survived, and the earliest extant sculpture is a small *Seated Woman* he produced as a twenty-one-year-old in Barcelona. At first glance, this clay figure seems unassuming. But if we crouch and view it from below, the monumentalism inherent in her gentle form becomes clear. It looks forward to the imperturbable bulk of his neo-classical women twenty years later, just as the skull-like anguish in his 1903 *Mask of a Blind Singer* anticipates his wrenching images of pain during the late 1930s.

No suffering can be detected in the sculpture Picasso made as he moved towards Cubism, though. Bent on ever more severe simplification, he abandoned the lyrical sensuality of his 1906 ceramic *Woman Combing Her Hair* and started carving straight into wood. The cutting in *Nude with Raised Arms* is minimal, and much of the knotty surface left deliberately raw. Picasso is vying with the elemental force of tribal art, and its influence fuses with his love of medieval carving in a remarkable *Head of a Woman*. Cut direct in wood and partially painted during the winter of 1906–7, this small, mask-like work is a revolutionary sculpture. Intentionally crude, it jettisons all Picasso's formidable technical virtuosity in favour of a blunt assertion of tough, primal vigour.

The carved figures that follow, in the momentous year of 1907, are still more rugged. Their rough-hewn presence in his studio must have

encouraged Picasso to pursue a similar strength in his most innovative paintings, even if the act of carving frustrated him with its slowness. He returned to modelling, and by 1909 his assurance as a sculptor led him to arrive at the absolute finality of *Head of a Woman (Fernande)*. This angular, faceted and intensely muscular work combines a multitude of viewpoints without sacrificing anything in terms of overall impact. It adds up to a majestic act of synthesis, and Picasso could easily have gone on to make equally impressive sculpture over the next few years. But his first commitment in this heroic cubist period lay with painting: only in 1912 did he return to three-dimensional experiments with renewed energy.

By now, Picasso was ready to cast aside the traditional materials of sculpture altogether. Nor did he want to rely on modelling. Instead, he chose sheet metal and wire to build a construction called *Guitar*, flattening and opening out its lean planes so that the insides of the instrument are as visible as its exterior. In one sense, this austere masterpiece of cutting and folding marked a return to his childhood way of working. But it pointed forwards as well, opening up new approaches for other innovative sculptors to come. Most of the cubist constructions he went on to make astonished visitors to Picasso's studio, shocked by his readiness to incorporate objects as everyday as the silver-plated spoons lodged on top of all six versions of *Glass of Absinth*. Cast in bronze, they were then transformed by spattered paint into highly individual objects. The unclassifiable results, poised half-way between sculpture and painting, show how free Picasso had now become. Indeed, the most exhilarating aspect of this marvellous survey lies in his perpetual openness, refusing to rule out any possibility as he searches for new ways of meeting the challenge posed by sculptural expression.

Painting and drawing occupied much of his energy after the Diaghilev ballet, and for a while his three-dimensional urges seem to have been satisfied as he concentrated on painting all those heavy, highly sculptural neo-classical women. By 1928, though, he had begun working on an ambitious memorial to his old friend Apollinaire. Picasso's desire to erect a public monument was thwarted, but the wire figure he created in preparation survives. In defiance of sculpture's supposed preference for solidity, this delicate work is like a tensile drawing in space. It could not be more taut, infusing linear strength with a fragility that testifies to his sadness over Apollinaire's loss.

Picasso, however, thrived on reacting against the work he had just completed. Perpetually restless, he also produced in 1928 some small *Metamorphosis* pieces where extravagantly distorted figures twist themselves into a violent, greedy embrace. This surreal blend of lust and

89. Pablo Picasso, *Head of a Woman*,
1932

aggression marks much of his sculpture over the following years.
Working in collaboration with Julio González, he turned *Woman in the
Garden* into a flamboyant, spiky eruption of uninhibited forms. Then, as
if in penance for this excess, he focused on carving a sequence of pared-
down, attenuated figures in wood. Damien Hirst's fascination with but-
terflies is also anticipated in 1932, with a freewheeling *Composition* where
figures and leaves whirl through space while a real butterfly lies carefully
preserved beside them.

But the masterpieces of this fertile period are the colossal female heads
inspired by Picasso's infatuation with the young Marie-Thérèse Walter.
Working now in the seclusion of a studio at Boisgeloup, he excelled him-
self. These giant apparitions have their origins in the stillness and serenity
of his neo-classical phase. But they soon begin to bulge, sprouting
immense phallic noses, almond eyes and features provocatively swollen by
the fervency of Picasso's erotic involvement. Both the plaster and the
bronze versions of these spellbinding heads are displayed here, and they

seem to conduct a silent dialogue with one another across the room. Picasso limited each of the bronzes to a single cast, even though he could have sold many more if the editions had been larger. They are, in my view, his most powerful sculptures, and Francis Bacon once told me that he regarded the arresting 1932 *Head of a Woman*, sprouting so precariously out of her distended neck, as Picasso's finest work in any medium.

The rest of the show demonstrates that Picasso's engagement with sculpture remained intermittently rewarding for another thirty years. During the Second World War, when he was trapped in Nazi-occupied Paris, his mood darkened. The celebrated *Bull's Head*, made with triumphant directness from a bicycle saddle and handlebars, is usually hailed as a supreme example of Picasso's audacious wit. Here, however, it looks above all like a *memento mori*. As for the looming, full-length bronze *Man with a Sheep*, it frowns menacingly above an animal clasped in the figure's hands like a sacrificial victim. According to David Douglas Duncan, an incessant photographer of Picasso in later life, the artist would insist that *Man with a Sheep* arrived at each of his successive new homes several days before he moved in himself. But the bronze figure looks more vengeful than protective, and surely reflects Picasso's awareness of the war's annihilating tragedy.

Disappointingly few of his sculptures ever found their way into public locations. A cast of *Man with a Sheep* presides over the main square at Vallauris, the small town where Picasso made so many of his ceramics during the 1950s. And a later, welded steel colossus of a woman's head now surges sixty feet above a piazza in Chicago, showing how well his work lends itself to a monumental scale. But much of his sculpture is as intimate as the captivating little 1951–2 figure of a young woman reading, executed in three subtly varied versions all on view here.

The exhibition ends, appropriately enough, with an affectionate painted metal head of his last wife, Jacqueline. Lacking the savage distortions he so often inflicted on the human face, this final sculptural portrait is as tender as the small *Seated Woman* he had modelled sixty years before. Despite all the upheavals Picasso's sculpture had undergone in the intervening period, a fundamental continuity unites these two images of women at their most gentle, contemplative and loved.

WEEGEE

3 May 2000

Like a hard-boiled private eye in a film noir, Weegee drives off from police headquarters. The time is midnight, at some unspecified point in the 1940s. And Weegee, lit harshly from below with a cigar rammed in his mouth, frowns through the windscreen. His eyes are as piercing as the car headlamps, and the flash camera on the seat beside him is ready to blaze. In the caption for this darkly charged self-portrait, Weegee explains that he is leaving 'on my strange mission'. That was an understatement. He takes us, through his lacerating retrospective at MOMA Oxford, into a macabre nocturnal hell where corpses sprawl bleeding in gutters and crowds jostle round the bodies with voyeuristic relish. Night after night, Weegee penetrated the heart of New York's underworld with obsessive, unquenchable flair. His ability to arrive punctually at a crime scene was uncanny, inspiring the notion that clairvoyant powers led him there. His weird name 'Weegee' probably derives from the craze for Ouija boards, then at the height of their spooky popularity.

But there was, in truth, nothing supernatural about the energy and sheer visual power behind Weegee's urge to explore New York's night-life at its most lethal. He made sure that his car was equipped with a short-wave police radio, alerting him to murders, fires and other disasters at the same time as the cops. Once there, this resolute loner knew precisely how to react. His searing photographs sold for $5 each to mass-circulation newspapers and magazines hungry for raw, direct images of gangsterdom on the rampage. If Weegee had simply been a cunning pur-veyor of bloodsmeared sensationalism, he would not merit a full-scale exhibition today. But the work he produced at the zenith of his activi-ties, between 1935 and 1945, amounts to far more than flashlit gore. Born Usher Fellig to a Jewish family in Galicia, he emigrated to the US with his family in 1910. Growing up on Manhattan's Lower East Side, Weegee began using a camera at an early age to record the harshness of life on the streets. While identifying with the people struggling to survive in this rough, mean environment, he never lost the feeling of an outsider. Weegee was a lifelong itinerant. And after serving a rigorous apprentice-ship in the *New York Times* darkrooms, he became a photographer forever on the move. Formidable nerves were needed to confront the mayhem he witnessed, allowing him to look through his lens with analytical detachment. But there was nothing cold or ruthless about Weegee's unblinking approach. 'The trick is to be where the people are,' he

explained. 'One doesn't need a scenario or shooting script – all one needs to do is to be on the spot, alert and human.'

His fellow-feeling is at its most overt away from the crime scene. He turned his flash-gun on the interior of a segregated theatre in Washington, deserted save for a group of four young black men. Seated to one side of a barrier running up the central aisle, they gaze at the camera. One grins, the others look wary. But there can be no doubt about Weegee's true motive: the brutal slicing of the auditorium is painfully conveyed. Its wounding power provides a ready-made, visceral indictment of racism at its most divisive. More alarming still are the images of intolerance on the streets. In one, a black boy with a haunted expression stares out from the frontage of a food store where a notice has been taped on the glass. 'Negro Owned' announce the scrawled capitals, implying that no whites should ever give the shop their custom. Elsewhere in New York, the arrival of a black family in a white neighbourhood provokes an eruption outside their apartment, and a boarded-up window bears the message 'The Nigers [sic] Stink'. The white boys on the pavement may be play-acting combat with sticks and bare fists, but the seeds of adult violence are being sown throughout this agitated, half-blurred image of unrest.

Weegee was particularly alert to the grim significance of gun shops. He photographed himself perching on one of their window-sills in the dark, camera at the ready, waiting like a movie director for the action to begin. The immense pistol jutting out from the premises reappears in another, even more unsettling image, where its spectral whiteness dominates an otherwise empty, eerily expectant street.

Then the bodies start to appear. Sometimes Weegee closes in on the corpse alone. Neatly dressed, eyes still open and mouth parted in a rictus smile, one man lies next to his own impeccable hat. His right hand is bandaged, probably testifying to a recent fight. But Weegee refrains from identifying him, confining his caption to the terse words 'Shot and Killed on East Side Street'. Whenever the victim is known, though, Weegee does not hesitate to name him. 'Harry Maxwell Shot In Car' is the headline title of a picture taken from a distance. Another photographer's head and shoulders occupy most of the foreground, flash-bulb raised in his hands. The link between him and the man slumped at the steering wheel is the real subject of the image, for Weegee was fascinated by the relationship between victim and viewer.

In one horrifying shot, taken from high above, a photographer hidden beneath a clock turns his tripod lens on a decapitated head lying next to the cake-box where it was presumably found. No other faces are visible, although several men stand in an arc round the camera. The shadows cast

90. Weegee, *In the Paddy Wagon*, 27 January, 1942

by their bulky figures fill much of the space, giving it an air of unbear-
able sadness. But light does fall on the severed head, showing just how
hideously battered it really is.

As the show proceeds, Weegee becomes more and more fascinated by
the constant interplay between exposure and evasion. A couple of crooks
arrested for bribing basketball players hide their faces behind ample
handkerchiefs. Refusing to be discouraged by such tactics, Weegee
turned them to pictorial account. Peering into the metallic starkness of
a paddy wagon, he took one of his strongest pictures of the two men
huddled there on seats, both masking their features with dark hats. They
look as impersonal as robots, mere machines made for killing. But when
a criminal does stand revealed, the result is even more memorable. *Cop-
Killer* is the terse title of an outstanding image. With bandaged cheek and
torn shirt, the arrested man looks as if he has already suffered a beating
from the beefy policeman who grasps his lapel. He opens his right hand
in a gesture of helplessness, perhaps to plead for sympathy from Weegee
himself. But he makes no attempt to look at the camera, and his down-
cast eyes convey the wounded humiliation of defeat.

Plenty of Weegee's other pictures widen out to encompass the
reactions of the crowd. The most disturbing is *The First Murder*, where

children leer at the lens or struggle viciously with each other to gain a better view. In the centre of the maelstrom, an anguished middle-aged woman who clearly knows the victim opens her mouth to howl. But her distress is ignored by the kids surrounding her, hell-bent on savouring the novelty of a killing on their doorstep. Homicide, in the densely populated thoroughfares of New York, quickly becomes a spectacle. In *Murder at the Fiesta*, a man shot through the brain lies spreadeagled by a water-pump. Most of the former revellers, standing beneath carnivalesque banners, look subdued. Their holiday mood has been shattered by the sudden, wholly unpredicted invasion of death. But the policeman standing next to the corpse jokes with a colleague, and they both seem oblivious of the human mess at their feet.

On other occasions Weegee himself was keenly aware of humour, especially when words were involved. He must have enjoyed shooting the fire at a kitchen products building, where smoke failed to conceal the ironic impact of the slogan painted in giant capitals on the façade: 'Simply Add Boiling Water'. Nor did he turn his camera away from the corpse stretched in front of a cinema advertising Irene Dunne in a film called, unbelievably, *Joy of Living*. Weegee understood the potency of language, often typing out extended captions in the boot of a Chevrolet heaped with flash equipment, cigar boxes, salami, disguises, fireman's boots, a change of underwear and infra-red film for shooting in the dark. He could turn a picture-title into a short story, nowhere more poignantly than in the following caption: 'Fate's Little "Jokes": A Cop Off Duty And Going Home, Was Shot And Killed In Front Of A Funeral Chapel, A Casket Waits In The Doorway.' The image accompanying it is one of Weegee's most haunting, sombre achievements, entirely lacking in any suspect desire to exploit the bizarre aspects of this gruesome scene.

On rare occasions he could be exuberant, above all in a classic shot of New Yorkers relishing the heat of Coney Island in July 1940. The sand beneath the press of bodies is barely detectable. Semi-naked figures in their thousands cram the beach to a claustrophobic extent, most of them looking up at Weegee and waving. The result is a full-hearted, Whitmanesque celebration of America *en masse*, exulting in the sun. Even by the sea, though, he was ready to turn his camera towards tragedy. In *Drowning Victim*, a throng of sunbathers stare down helplessly at the lifeguards' frantic attempt to revive a young man prone on the sand. Everyone looks aghast, and the stillness of his body looks ominous. But a woman kneeling beside him catches sight of Weegee's lens. She looks up, forgets about the stricken swimmer, and grins.

FORCE FIELDS

19 July 2000

Even before the First World War, artists began toying with the heretical notion of setting their work in motion. At a notorious Futurist exhibition in Turin, one sculptor displayed a head that rolled its eyes from side to side. In London, after Jacob Epstein incorporated a real machine in his revolutionary *Rock Drill*, he 'thought of attaching pneumatic power' to the sculpture, 'thus completing every potentiality of form and movement in one single work'. His idea came to nothing, but the excitement of speed and dynamism would not go away. It resurfaced in the 1920s, the decade taken as the starting-point for the Hayward Gallery's refreshing *Force Fields: Phases of the Kinetic*. By then, however, the virile aggression of *Rock Drill* had given way to a far gentler, more abstract understanding of movement. The show's curator, Guy Brett, sets no limits on the artists' capacity to explore the possibilities opened up by expanded notions of space and time. He is in favour of out-and-out visionaries, unafraid to evoke the most dizzying cosmic perceptions as they search for ways of grasping our elusive place in the universe.

When motionless, some of the earliest exhibits have a rudimentary charm. Collaborating with Man Ray in 1920, Marcel Duchamp produced *Rotary Glass Plates (Precision Optics)* by mounting painted segments of glass on a revolving steel rod. The electric motor looks as if it belongs to a primitive automobile, with fan belt and wheel. But when in full motion, the blades are transformed into a whirling disc whose concentric lines rob the work of its heaviness. Laszlo Moholy-Nagy went further. Commenced in 1922 yet only finished eight years later, his ambitious *Light-Space Modulator* again uses metal and glass as well as an electric motor. The geometric structure retains its substance when revolving, but the lighting ensures that dramatic shadows of the work are thrown on to the surrounding walls. So although *Light-Space Modulator* has a potent presence, isolated in its own circular chamber, the presence of the shadows points towards a more mysterious, dematerialised alternative.

Fragility is another hallmark of the work in *Force Fields*. Alexander Calder, robust pioneer of the mobile and much else besides, is usually regarded as a puckish showman with a childlike love of circus manœuvres. Here, however, his untitled sculpture made in 1933 stresses vulnerability. The painted wood balls attached to both ends of a central bar are so delicate that we cannot touch them. And Calder suspends them from the most slender cord imaginable, itself dangling from a

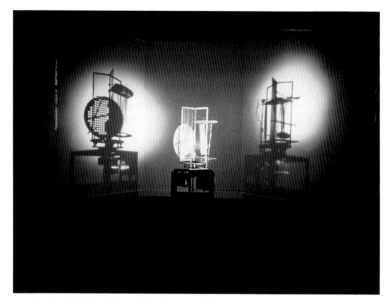

91. Laszlo Moholy-Nagy, *Light-Space Modulator*, 1922–30

piece of wire bent in a frail circle. When the balls begin to move, activated by air-currents from viewers walking past, they resemble planets floating in a cosmic void.

Calder was fascinated by astronomical references, and in this respect his work has unexpected links with the neglected Belgian artist Georges Vantongerloo. He proves one of the exhibition's most intriguing surprises, benefiting from a plentiful display of his post-1945 paintings and sculpture. Having started as a cubist-inspired artist in earlier decades, he forsook angles and became enraptured by curves. In an oil-painting called *Two Zones of Space: Action-Reaction*, Vantongerloo unleashes two multicoloured fireballs that collide in an emphatic shower of particles. But his sculpture is even more remarkable. Working with plastic, perspex and prisms, he bends his material like rubber into continually twisting, curving structures that celebrate infinite fluidity. He sees the universe in optimistic, almost playful terms, a place where energies can be unleashed and liberated to leap through space without limit.

Occasionally, the beneficent mood is disrupted by an image as alarming as Wols's watercolour *Untitled (Poet's Skull)*. Executed with great delicacy during the Second World War, it shows a decapitated head

marooned like a lost planet in the void. Undermined by fissures, it seems on the point of disintegration. But Wols's preoccupation with mortality is untypical of the show. Far more characteristic is Lucio Fontana's *Spatial Concept* series, where holes are punched through sheets of wallpaper or canvas while sand vies with oil-paint for pictorial attention. Fontana's urge to puncture the surface of his work is surprisingly free from aggression, and Yves Klein's scorched cardboard *Fire Painting* looks ethereal rather than damaged by flames.

Even when the act of piercing holes reappears in films by the little-known James Whitney, the result is far removed from violence. Backed by sitar music, *Yantra* uses dots punched into thousands of cards to make ever-shifting and dissolving patterns on the cinema screen. They reflect Whitney's interest in meditation and yoga, but the film also has a restlessness that links it with Henri Michaux's ink drawings produced under the hallucinogenic influence of the drug mescaline. But his work, in the end, is more haunted than Whitney's contemplative films. Michaux's obsessively intricate drawings might, we feel, explode with the force of Jean Tinguely's sculpture. Assembled from scavenged industrial fragments, his work looks melancholy when its electric motors are inactive. Once I pressed the scarlet button with my foot, though, *Baluba XIII* jerked into sudden, crazy activity. Capped by a shaking fur and feathers, it looked like a dancer in thrall to some wild, anarchic ritual. But then, just as abruptly, the demented forms lapsed into stillness once more.

The frenzied movements favoured by Tinguely are rare in the Hayward survey. Most of the contributors prefer a subtler way of working, and it pays beguiling dividends in Julio Le Parc's darkened room. Here, a shoal of small metal discs are suspended on wires. No motor is relied on to make them move. Instead, the heat generated by an electric light at the base seems responsible for setting these sequin-like elements into delicate motion. It is enough to activate a flurry of white shadows, hurtling across the emptiness like spacecraft thrusting their way through the cosmos. Other artists seem bent on challenging us to notice only the slightest spasms of movement in their work. Nothing appeared to animate Pol Bury's *Simulated Surface* when I first encountered it. The nylon threads projecting from its white-painted panel looked inert and forlorn, reminiscent of the few remaining tendrils of hair sprouting from a man's fast-balding scalp. Then, quite without warning, they are activated by a simple motor behind the board. Swaying and shuddering, they have the mysterious energy of unidentified plant life lurking on the ocean floor.

Not all the motorised wall-pieces are informed by the subtlety of Bury's approach. Gerhard von Graevenitz's *Kinetic Object with 37 White*

Discs on White performed sluggishly, and its gliding parts reminded me of giant aspirins caught up in a ponderous pill-manufacturer's advertisement. But the great merit of Guy Brett's selection lies in its variety and incessant changes of pace. He ensures that we never become bored with a predictable way of working, and plenty of his artists are virtually unknown in Britain. Take Gego, who was born Gertrud Goldschmidt in Hamburg and ended up living in Caracas. Most of her exhibits have been lent from Venezuela, and their clusters of elongated aluminium rods dangle from the ceiling like corpses swinging in the open after a public execution. Gego called many of them *Streams*, and may not have intended any pathos or figurative references to enter her work. The equally unfamiliar Hungarian artist Agnes Denes, on the other hand, must have intended to disconcert us with one of the photographs in her *Book of Dust*. Captioned as 'calcareous human remains', it called to mind a burial mound of bones from the Nazi Holocaust.

On the whole, though, vitality is the keynote of this show. In Len Lye's *Universe*, a great loop of undulating, wobbling steel lurches from side to side, occasionally rising to hit a ball above with an eerie, echoing clang. Foam surges out of David Medalla's *Cloud Gates* on one of the Hayward's outdoor courts, while bubbles are channelled through Hans Haacke's plastic tubes on the other court, where they flow across the concrete floor like blood surging through a body's circulation system. In common with Robert Smithson, whose early *Four-sided Vortex* confronts you with multiple reflections in its plunging fragments of mirrored glass, Haacke later went on to pursue a more powerful direction in his very different, non-kinetic art. But Gianni Colombo never surpassed his *Elastic Space*, a recent reconstruction of a large black room originally installed at the Venice Biennale in 1968. Entering it in the final section of the Hayward show, we find ourselves surrounded by a colossal linear grid of elastic threads. Their fluorescent whiteness seems about to enmesh us, but they carry no threat. After a time, our eyes end up gazing at their swaying movement. We feel diminished by their vastness, and yet strangely comforted as the gentle rhythms pulse through this lyrical, womb-like interior.

TWO NEW BIOGRAPHIES

CARAVAGGIO
January 2000

After Caravaggio, painting in Europe was never the same again. During a brief, astonishingly inventive and often violent career, this tenacious artist transformed the possibilities for adventurous painters to come. His own reputation suffered a dramatic decline after his mysterious death in 1610, and Poussin angrily declared fifty years later that Caravaggio had 'come into the world to destroy painting'. But Poussin's own art, with its solemn reliance on learned references to classical tradition, now looks far less revolutionary than Caravaggio's work. By relying above all on first-hand observation, brazen directness and extreme contrasts between radiance and shadow, he gave his paintings a stripped, disturbing and frankly erotic dynamism that still has the ability to transfix us.

Nobody has been more captivated by Caravaggio than Peter Robb, an Australian writer who established an international reputation with his previous book *Midnight in Sicily*. Its unflinching exploration of the mafia served as an apt preparation for his new book, a biographical study of Caravaggio's turbulent life and art. Robb calls it *M*, in terse, shorthand recognition of the fact that his subject's usual name was Michelangelo Merisi. But the terseness of the letter M also indicates how little we really know about Caravaggio the man. Our frustration reaches its climax with his death, at the age of only thirty-nine. For we do not know precisely when, where or how this proud, restless, quarrelsome and increasingly agitated individual met his premature end. Robb is prepared to speculate about the probable bloodiness of Caravaggio's death, but he is hampered at every turn by the lack of documentary evidence. Although Caravaggio was the most notorious and talked-about young artist of his time, hard facts about his life are difficult to pin down. Historians have been obliged to dig around in legal and criminal files, hoping that his habitual brushes with the police were recorded. Some of them are preserved in the archives, and Robb is assiduous in citing every mention of the elusive artist. But most of the references to Caravaggio prove only that he succeeded in evading the law, protected by high-ranking patrons who knew exactly how to exert influence and prevent their favourite painter from languishing in prison or receiving a sentence of execution.

Eventually, though, they were unable to shield him from exposure to public disgrace, banishment and death. Caravaggio's tempestuous life is undoubtedly driven by a tragic momentum, and Robb is well-equipped to tell the story with the vigour it deserves. He has also researched his

subject with extreme thoroughness, and at times the narrative flow suffers from the avalanche of detail he unleashes. This is an immensely long book, and it would have benefited from some sharp editing. There are plenty of moments when Robb, confronted by a dearth of factual evidence at crucial moments in his story, assails us with a fusillade of speculation. It is all well-informed, and sheds light on the cast of powerful, manipulative characters surrounding Caravaggio's meteor-like ascent as an artist. But I sometimes felt, during Robb's energetic attempts to fill the void, that nothing further had been learned about the enigmatic man lurking at the heart of his text. Just as the figures in Caravaggio's mature work threaten to disappear into impenetrable shadows, so the painter has a knack of vanishing in the darkness at the very moment when we need to find out precisely what happened to him.

On the whole, though, Robb does justice to his maddeningly elusive quarry. Unlike so many biographers of artists, who neglect to look hard at the objects themselves, he has scrutinised everything Caravaggio painted as well as many canvases whose attribution is insecure. If he has a tendency to accept disputed paintings as wholly autograph, it is a forgiveable weakness. For Robb responds passionately to Caravaggio's work, and he is able to communicate his excitement with an urgent eloquence that suits the images under discussion.

No wonder that such an artist succeeded in attracting discerning patronage at the very centre of Rome's cultural circles. Having grown up in the small town of Caravaggio, a quiet place thirty kilometres east of Milan, he was apprenticed at the age of twelve to the painter Simone Peterzano. Milan became Caravaggio's home for the next four years, but Rome was the Mecca to which any ambitious painter aspired. There, the Catholic church's supreme power meant that the greatest opportunities for artists lay waiting to be grasped.

When he arrived in Rome around the summer of 1592, aged about twenty, Caravaggio was unknown and virtually destitute. Within five years, however, he had attracted the acquisitive eye of Cardinal Del Monte, who took Caravaggio into his opulent household and gave him the time he needed to develop his burgeoning abilities. The toughness of an early painting like *Cheats*, where three men indulge in a tense game liable to erupt in violence at any instant, was tempered under Del Monte's guidance. Caravaggio had already developed an unsavoury reputation for picking fights, brawling and lashing out with his sword. Del Monte probably tried his best to bring the young firebrand under control, and a new vein of sweetness did enter Caravaggio's work for a while.

At the same time, though, he continued to be obsessed by the spectacle

92. Caravaggio, *Boy Bitten by a Lizard*, 1595–1600

of seductive young men, either plucking languorously at musical instruments or embroiled in more dangerous pursuits. By far the most arresting of these images is the painting of a boy with a rose tucked provocatively behind his ear. A moment before, he had surely been ready to tout

for sexual dalliance. His lips are as fleshy and beckoning as the cherries heaped beneath his outstretched hand. But this amorous figure, who combines the chubby innocence of a cherub with the knowingness of a homoerotic plaything, cannot concentrate on allure. His composure is annihilated by the teeth of a lizard, who emerges from the fruit-strewn table and administers a sharp bite to the libertine's middle finger. In this sense, the painting is strangely prophetic. For *Boy Bitten by a Lizard* is above all a pictorial warning, delivered by an artist who had already gained a reputation for executing slyly suggestive images of ambiguous sexual indulgence. Here, although the desirability of this effeminate youth is still temptingly depicted, he pays the price of perfumed permissiveness as well. The rose of love turns out to harbour a punitive thorn, and Caravaggio paints its viciousness with a foreboding that anticipates the pessimism of his later work, where desire and retribution are so tragically intertwined.

For the moment, at least, Caravaggio's career soared. Any ambitious Roman painter aimed above all at securing prominent patronage from the church, and he was delighted to be chosen for a major commission in the church of San Luigi dei Francesi. The two large canvases he produced, with characteristic swiftness, dealt with the life of St Matthew. But Caravaggio had no time for presenting the saint as a distant figure, loftily removed from present-day reality. He believed in painting what he saw, out there in front of him. He did not even have any patience with the idea of careful preliminary drawings, once considered the foundation of Renaissance art. He was prepared to make changes to the painting as he went along, and recent x-rays of his work have revealed just how extensive these alterations on canvas often were.

For Caravaggio was a young man in a hurry, eager to blow away the stereotyped piety of established church art and replace it with a raw, disconcerting vision. In *Matthew Called*, the first of his paintings for San Luigi, Christ appears in a dusty tavern and plucks out the future saint from a gaggle of extravagantly dressed roisterers who seem to have strayed from one of Caravaggio's early paintings of sexy revellers. Most of the scene is in darkness, but one shaft of light emanating from Christ's direction slices through the gloom, reinforcing the authoritative strength of his outflung, commanding arm. The painting of *Matthew Killed* is even more mesmeric. Sprawling on the ground, the bearded saint finds his wrist grabbed by an assailant who flaunts a muscular body while clasping his sword in readiness for the final, fatal thrust. Naked except for a loincloth, this yelling executioner occupies the centre of the stage. Everyone ranged round him recoils from the horror, and even the angel

perched on a cloud above appears unable to save Matthew. Darkness again envelops much of the scene, but Caravaggio ensures that the brutality at its heart is illuminated by a merciless clarity.

Although Robb describes this crucial painting with insight and eloquence, it is – amazingly – not reproduced in his book. Nor are most of the other paintings Robb discusses in great detail, and their absence mars the impact of his text. The publishers, Bloomsbury, claim in their press release that the book 'is lavishly illustrated with Caravaggio's paintings in full colour throughout'. But most of the plates are black and white: only eight are reproduced in colour. This meagre tally induces a sense of frustration in the reader, who naturally wants to turn from Robb's analyses to look at the paintings themselves. I was obliged to read his text with a weighty book on Caravaggio's art by my side, turning from one to the other with mounting irritation.

It is a pity, because Robb shows every sign of having looked hard and thoughtfully at all of the works he singles out. He is also good at setting Caravaggio's revolution in the full, repressive context of the Counter Reformation, which balked at any ideas smacking of Protestant unorthodoxy. Rome was bent on carrying out a return to order, away from Lutheran heresies. So Caravaggio's subversive insistence on seeing the Bible with the eyes of a Realist could hardly have been more risky, and he soon paid the price. Thousands flocked to see his paintings in San Luigi dei Francesi, where they were reviled and admired with extraordinary passion. Almost overnight, Caravaggio became the most talked-about painter in Italy, and other artists began adopting the approach he had pioneered.

But when he received another church commission, this time for a painting of *St Matthew and the Angel*, the authorities decided to punish his audacity. He depicted Matthew here as a wizened, balding and ungainly man, crossing one bare leg awkwardly over the other and exposing the grubby sole of his upturned foot. He peers down at his writing with difficulty, and seems heavily reliant on the ministrations of the winged messenger who guides his gnarled hand over the page. Caravaggio had been emboldened by his success at San Luigi, and the establishment reaction was severe. Deploring the supposed coarseness of his interpretation, the church banned the painting outright.

From then onwards, Caravaggio encountered hostility whenever he tackled a big religious commission. It probably generated an increasing sense of frustration, which erupted in the streets when his naturally fiery temperament made him lash out at anyone who taunted or challenged him. Plenty of rivalrous people in Rome were jealous of his success and

tried to mock his departure from the Counter-Reformation norm. The inevitable disaster occurred on 28 May 1606. Caravaggio was either attacked or goaded into fighting a young blade called Ranuccio Tomassoni. The initial cause may have been an argument over a tennis match, but it soon escalated into bloodshed. Tomassoni bled to death after being wounded by Caravaggio, who fled the scene and never returned to Rome again. He was sentenced to death, and anyone within the territory of the court's jurisdiction was allowed to kill him – even to the extent of severing his head, presenting it to the judge and claiming the offered reward.

The savagery of the edict guaranteed that Caravaggio was, henceforth, perpetually on the run. He ended up first in Naples. It must have seemed a grimly appropriate hiding place for an artist whose violent leanings had taken such a calamitous course. Positioned uncomfortably near a volcano still liable to explode, and seething with a feverish social unrest aggravated by famine, earthquakes and grotesque overcrowding, Naples was a brutal environment. But its chronic poverty coexisted with equally extreme wealth, and the powerful church authorities had an appetite for art that matched the insatiable collecting activities of the Spanish viceroys. A painter as celebrated as Caravaggio was therefore greeted with overwhelming enthusiasm. He found himself besieged by important commissions, and the enormous, complex canvases he carried out for major Neapolitan churches show how fiercely he responded to his belligerent new surroundings. In a monumental *Flagellation*, Christ's reeling body is raked by an angry spotlight, like the glare of a merciless torturer's lamp. Although the victim turns away from it and shuts his eyes, he cannot escape the pot-bellied thug who emerges from the gloom to kick him in the shins. Nor can he prevent his other assailant from yelling sadistically and wrenching his hair in readiness for a vicious flogging.

From painful experience, Caravaggio knew all about the perverted relish that impels men to commit appalling acts of aggression. His bullies are savouring their atrocities as much as the villains who lurked in the dark streets of Naples, ready to murder anyone for their money or clothes. The deputies in charge of the Monte della Misericordia church understood instinctively why his painting for the high altar turned out to be so thunderous and alarming. Although they asked him to depict the Seven Acts of Mercy – a subject that might have produced a suffocatingly pious interpretation – Caravaggio viewed it in terms of suffering, danger and desperate gestures. All the protagonists are forced to jostle with each other in a claustrophobic alleyway, where a corpse is carried hurriedly round a corner and unguessable perils fester within the

ink-black shadows. Even the saintly Martin appears reluctant to turn his face fully towards the grubby, naked man with whom he shares a cloak. As for the two angels hurtling down towards this furtive scene, they cannot bring the help conventionally expected of them. Arms and wings flailing with agitation, they are now more concerned to protect themselves and the Virgin above, who clasps her child as if fearful of contamination from the figures struggling on the street.

It is difficult, now, to appreciate how revolutionary Caravaggio's urgent art must have seemed in seventeenth-century Naples. He proved that Biblical themes could be invested with a dramatic directness that prevented his audience from taking the Bible for granted. The church was naturally delighted to find an artist capable of transfixing its congregations with awe, terror and pity. His eloquence helped Catholicism realise just how great a role art could play in the spreading of the Counter Reformation. But Caravaggio's Neapolitan pictures did not simply reflect his reactions to the city's turbulence and the propaganda requirements of its churches. These compelling canvases also convey the complex inner tensions afflicting a man who had killed in anger and now strove to come to terms with his folly. They are more profound and introspective than his earlier paintings, and by the time he returned to Naples after staying in Malta and Sicily his mood grew darker still.

After being attacked and wounded by sword-slashes so badly that his face was almost unrecognisable, he began painting even grimmer images of Salome carrying St John's severed head on a platter. Their mood was resigned, and Caravaggio became even more elegiac in a painting of *St Ursula Transfixed*, settling on the instant when she stares down at the fatal arrow puncturing her body. The startled young woman seems puzzled by her fate. She appears to accept the inevitability of death, but the self-portrait Caravaggio includes behind her looks, by contrast, eager and alert. He was still working hard, still renewing and deepening his art during the final year of 1610. Above all, he was still hopeful of receiving a pardon from Rome, and died in the summer while apparently on his way back to the holy city by sea.

More than that we do not really know. Robb is dismissive of retrospective accounts, recorded by writers after the event who relied on hearsay. They were all versions of the story that Caravaggio died of a sudden attack of fever on an unidentified, malaria-infested beach somewhere on the Tuscan coast. Robb scornfully declares that 'the oddest thing about this story...when you thought about it for a moment, was how it ever won credence in the first place, let alone unquestioned acceptance for nearly four centuries. The story, as it was handed down,

simply didn't make sense.' So the indefatigable Robb sets about constructing his own, densely argued alternative account, speculating that Caravaggio was murdered by a Knight of Malta who wanted revenge for an unspecified crime committed on the island. Nobody knows what Caravaggio did to arouse such fury, although Robb suggests that it involved a homosexual dalliance with the knight's page. But assassination does seem likely, in view of the grim fact that Caravaggio's body was never recovered, let alone buried.

The end, however it may have come, was undoubtedly wretched. It also deprived European painting of an innovator who might otherwise have gone on producing audacious work for several more decades. The loss to art was incalculable, but Robb's obsessive, occasionally maddening and always heartfelt book shows just how much emotional fervency Caravaggio can still arouse in his viewers today.

WYNDHAM LEWIS
October 2000

Painter, novelist, political theorist, editor, satirist, critic, pamphleteer and poet: Wyndham Lewis played all of these roles during his long, ceaselessly energetic career. The sheer multiplicity of the man makes him fascinating, and yet it also promotes bewilderment. How could one individual span so many diverse disciplines, especially in an age of increasing specialisation? Who was the real Wyndham Lewis, and did he feel as confused about the true nature of his talent as we do, struggling to grasp its hydra-headed complexity? Paul O'Keeffe, in his new biography of Lewis, acknowledges the problem in the title of his book: *Some Sort of Genius*. The words are taken from an article by the young Patrick Heron, who was puzzled enough to ask T. S. Eliot what he thought of Lewis during a walk through Welwyn Woods. Eliot had known Lewis since they were young rebels in the turbulent London art world of 1914. But his reply only compounded the mystery. 'A man of undoubted genius', Eliot told Heron, 'but genius for what precisely it would be remarkably difficult to say.'

Undeterred, O'Keeffe has produced a densely researched, highly detailed book which attempts to pin down, in almost 700 pages, the facts of Lewis's convoluted life. His task was not made any easier by Lewis's

notorious secrecy. Obsessive about hiding his private life away from public view, he consistently lied about his age, ignored his illegitimate children and did not even reveal his wife's identity to most of the people who thought they knew him. O'Keeffe begins his biography by casting doubt on Lewis's bizarre claim that he was born in his father's yacht off Amherst, Novia Scotia. His true birthplace will probably never be located for certain, but at least we do know that Lewis was the son of Captain Charles Edward Lewis, a West-Point educated soldier who fought in the American Civil War, and Anne Stuart Prickett, a British-born woman with Irish and Scottish ancestors. Captain Lewis came from a wealthy family in New York State, and could have provided his son with a comfortable inheritance. But Lewis's parents separated around 1893 when he was only eleven, leaving him to endure a far more precarious life with his mother. She moved back to England and became largely responsible for his upbringing. Lewis was sent to private schools and to Rugby. But his growing passion for drawing and painting then led him to study at the Slade School of Art in London between 1898 and 1901.

Lewis spent the next eight years in an oddly indecisive state. His interest in writing both poetry and prose was developing, and it probably prevented him from committing himself full-time to art. He travelled restlessly, visiting Madrid with his friend Spencer Gore and spending time in Munich. Above all, though, he stayed in Paris for several years. Here he started to paint more seriously, and heard the highly influential philosopher Henri Bergson lecture at the Collège de France. In 1907 his older friend and mentor Augustus John saw *Les Demoiselles d'Avignon* in Picasso's studio. Lewis probably heard about this seminal painting from John, but he was not yet ready to pursue a singlemindedly experimental path. John, already enjoying considerable acclaim in Britain, inhibited Lewis at this stage. He found more satisfaction in writing short stories about the itinerant acrobats and assorted eccentrics he encountered during his travels in Brittany.

Lewis's first success came in 1909, when he returned to London. Ford Madox Hueffer (who later became known as Ford Madox Ford) published several of his short stories in a new magazine called *The English Review*. They established his reputation as a promising young writer of fiction; but the drawings that survive from this period show Lewis caught uneasily between a growing involvement with so-called primitive art and an interest in Dürer and Leonardo's grotesque heads.

By 1912, however, Lewis had decided to devote more of his energies to art. He had already appeared in two exhibitions of the Camden Town Group, where his interest in harsh distortions marked him out from the

other members. But Lewis really began to define his own vision when Madame Frida Strindberg, ex-wife of the great Swedish playwright, commissioned him to make a monumental painting, a drop curtain and other designs for her adventurous Cabaret Club in London. It became known as the Cave of the Golden Calf, and other decorations were provided by Jacob Epstein, Eric Gill, Charles Ginner and Spencer Gore, who co-ordinated the scheme. But Lewis's contributions were outstanding, especially a large painting called *Kermesse*. Here his alert awareness of Cubism, Futurism and Expressionism was conveyed in an individual way – bleak, incisive and charged with ferocious energy. In this arresting canvas of three dancing figures Lewis became a mature painter, and he fortified his reputation when Roger Fry included his illustrations for Shakespeare's *Timon of Athens* in the 'Second Post-Impressionist Exhibition', a notorious survey of avant-garde art which scandalised London in 1912.

Like Timon, Lewis adopted an adversarial stance. Restless, satirical and capable of alarming coldness in his relationships with men and women alike, he had no patience with most of the art then produced in Britain. His ability as a draughtsman was already outstanding, with a distinctive emphasis on whiplash line. But O'Keeffe quotes very revealingly from Lewis's letters, and the correspondence of those who knew him, to build up a picture of a handsome, quarrelsome, fiercely intelligent, debt-ridden, arrogant yet insecure young man. In a perceptive letter to Lewis, Augustus John complained that 'you have never it seems to me given the idea of friendship a chance – it would appear that you live in fear of intrusion and can but dally with your fellows momentarily as Robinson Crusoe with his savages.'

Roger Fry enlisted Lewis's services when the Omega Workshops opened in the summer of 1913. He produced a painted screen, some lampshade designs and studies for rugs, but his dissatisfaction with the Omega soon developed into antagonism. Winifred Gill, one of his fellow-artists at the Workshops, witnessed an extraordinary display of Lewis's growing tendency to present a highly self-conscious, theatrical facade to the world. One day, she was resting on a bedstead in the back showroom, concealed by a shadow. It was late afternoon and getting dark. 'Suddenly', Gill recalled, 'the door burst open and in rushed Wyndham Lewis carrying a large paper bag which he threw onto a small table.' The bag contained an outsize cloth cap made in a large black and white check material: the height of fashion. 'Lewis . . . tried it on in front of the looking glass on the mantel piece. He cocked it slightly to one side to his satisfaction, then, taking a few steps backward, raised his hand as though to shake hands with someone and approached the mirror with

an ingratiating smile. He backed again and tried the effect of a sudden recognition with a look of surprised pleasure. Then, cocking the cap at a more dashing angle his face froze and he turned and glanced over his shoulder … with a look of scorn and disgust.' Throughout his embarrassing, would-be solitary play-acting, the reluctant spy feigned sleep, terrified at what he might do to her if he discovered he had been observed. Finally Lewis snatched the cap from his head, thrust it back into its paper bag and left.

This astonishing performance was the prelude to an eruption. In October 1913, no longer willing to be dominated by Fry, Lewis abruptly left the Omega with his new-found allies Edward Wadsworth, Cuthbert Hamilton and Frederick Etchells. They condemned Fry in an explosive, and probably libellous, document accusing him of outright deception. By the end of the year Lewis had begun to define an alternative to Fry's exclusive concentration on modern French art. In an essay for the catalogue of an exhibition in Brighton, Lewis announced the emergence of a more volcanic group of artists, far more involved with machine-age modernity than Fry would ever be. At the same time Lewis carried out a startling decorative scheme for Lady Drogheda's dining-room in Belgravia, shrouding the walls in black, mirrored panels and painting a semi-abstract frieze underneath the ceiling. Its fierce austerity challenged the more gentle mood of the Omega's interiors, and aroused a great deal of controversy.

Lewis was fast becoming the most hotly debated young painter in Britain. He established a rival to the Omega when the tersely named Rebel Art Centre was founded in March 1914. Many of the artists who allied themselves with the Vorticist movement attended the Rebel Art Centre, including Wadsworth, Hamilton, the precocious French sculptor Henri Gaudier-Brzeska and two women artists, Jessica Dismorr and Helen Saunders. Ezra Pound also supported it warmly, and he joined forces with Lewis to bring about the birth of Vorticism. The movement finally emerged in the rumbustious magazine *BLAST*, which Lewis edited with enormous flair. He wrote many of the essays it contained, and illustrated a wide selection of work by himself and his friends in the large, boldly designed pages. It was published on 1st July, which O'Keeffe points out 'was the hottest day of the year, with a temperature, recorded at Kensington Observatory, of 90 degrees in the shade. In the Home Counties violent thunderstorms provided an apt accompaniment to *BLAST*'s appearance.'

Many reviewers were bewildered by the magazine's brashness, and they couldn't even decide what colour the inflammatory cover was.

93. Wyndham Lewis, *Workshop*, 1914–15

O'Keeffe has fun with their confusion: 'Ford Madox Hueffer writing in *Outlook* observed that it was purple, and *The Times* agreed. *The Athenaeum*, *New Weekly* and *New Statesman*, on the other hand, thought it was magenta, while *The Little Review* described it as "something between magenta and lavender, about the colour of a sick headache." *The Egoist* was content to call it pink, while the *Pall Mall Gazette* attempted

even greater precision with "chill flannelette pink", adding that the colour "recalls the catalogue of some cheap Eastend draper, and its contents are of the shoddy sort that constitutes the Eastend draper's stock." ' Fearing scandal, the magazine's publisher John Lane insisted that certain lines of an erotic poem by Pound, including the line 'With minds still hovering above their testicles', be inked out by hand. Jessica Dismorr and Helen Saunders were assigned this arduous task, but Lewis still maintained that Pound's offending lines could still just be read through the ink.

For all its aggression, wit and audacity, *BLAST* soon found that its vigorous celebration of a revolutionary spirit in British art was overshadowed by the advent of the First World War. Lewis had hoped that Vorticism would develop an art that made people more aware of the rapidly changing dynamism of modern life, but the declaration of hostilities across Europe left him very little time to build on *BLAST*'s brilliant initiative. He was able to pursue his interest in large-scale schemes, decorating the study of Ford Madox Hueffer's London house with blazing red murals, and then devising a complete 'Vorticist Room' for the Restaurant de la Tour Eiffel in Percy Street. Despite suffering from a vicious bout of gonorrhoea, Lewis also organised London's only Vorticist Exhibition in June 1915 and produced a second issue of *BLAST* (a 'war number'). The young T. S. Eliot became a contributor, even though, as O'Keeffe wrily points out, Lewis had to reject Eliot's poem 'The Triumph of Bullshit' which included the refrain 'For Christ's sake stick it up your ass'. However much Lewis admired what he described as 'these excellent bits of scholarly ribaldry,' he was determined, as he put it, 'to have no "Words ending in -Uck, -Unt and -Ugger." '

But the entire country was being overtaken by the escalating war, and in 1916 Lewis joined the army as a gunner. His experiences at the Front, where he was lucky to escape death on many occasions, served him well as subjects for painting. After his appointment as an official war artist, he painted two enormous canvases based on his memories of life in a gun pit. One of them, *A Battery Shelled*, is among his finest achievements. The earth in this wide, almost cinematic painting has been pounded into an acid-green lunar landscape, furrowed with maze-like patterns of mud. These gouged channels make movement difficult and dangerous, for unexploded missiles may lurk unseen within the craters. So the rusty orange figures in *A Battery Shelled* display caution as they twist themselves into tortuous positions and search the pummelled ground. Throughout this principal area of the canvas an ingenious style, poised halfway between Vorticism and a more representational alternative, is incisively sustained. But Lewis juxtaposes it with three bulky figures on

the left, who contemplate the devastated scene. They are handled in a more naturalistic idiom than the rest of the picture. And the stylistic clash between the two parts of the painting is so incongruous that it must have been quite deliberate. By making the three figures stand apart from the rest of the scene, Lewis may have wanted them to signify his own post-war mood, newly awakened from the war and questioning the viability of the more geometrical idiom employed in the shell-wrecked land-scape. The three figures look as if they might be outside the canvas alto-gether, removed from a way of seeing that now belongs to a past beyond recovery.

Lewis was returning to a more representational style, leaving the most extreme of his Vorticist concerns behind. The destructive power of a war dominated by terrible mechanical weapons altered Lewis's attitude towards the machine age. He also felt, in common with many other artists, that he needed to submit himself to the discipline of drawing from life again. His first solo show, held at the Goupil Gallery in February 1919, contained many drawings of the war in a frankly figura-tive style. Lewis's move towards a more representational idiom was prompted, too, by his fast-developing interest in fiction. His first and most experimental novel, *Tarr*, was published in 1918, and from now on Lewis devoted an increasing amount of his formidable energy to writ-ing. The exhibition called 'Group X', held in 1920, brought together many of the artists formerly associated with Vorticism. But it was an end rather than a beginning. Lewis, the self-styled 'Enemy', was henceforth a man alone.

Collectors as eminent as the New York patron John Quinn continued to support him on a generous scale, and Lewis enjoyed travelling to the continent. During a trip to Paris in 1920 he was introduced by Eliot to James Joyce, with whom he became very drunk and ended up sitting in a gutter during a thunderstorm. But when he held an exhibition of 'Tyros and Portraits' in 1921, the strain of acid satire pervading the work belonged to Lewis alone. He saw the Tyros as elemental creatures, leer-ing embodiments of his harsh Comic vision. Nobody else in England was painting with this degree of peculiarly remorseless mirth. A feeling of isolation and retrenchment marks his *Portrait of the Artist as the Painter Raphael*, a redoubtable painting of a 38-year-old who has decided to remain resolute in the face of any attempt to undermine his defences. The rim of his hat has a blade-like sharpness, signifying Lewis's willing-ness to wield it against adversaries who came too close. William Rothenstein remembered his astonishment when, meeting Lewis again after several years, he 'now discovered a formidable figure, armed and

armoured, like a tank, ready to cross any country, however rough and hostile, to attack without formal declaration of war.' The metallic quality of this portrait recalls Tarr's declaration that 'the lines and masses of the statue are its soul. No restless, quick flame-like ego is imagined for the inside of it. It has no inside. This is another condition of art; to have no inside, nothing you cannot see.'

Lewis was ready, now, to engage with the physical world in a far more particularised way. Portraiture presented an especially stimulating challenge to an artist impelled by this new-found appetite for close observation. Iris Barry, who lived with Lewis for a few years and bore him two children, became a forbidding presence in a large canvas called *Praxitella*. Their relationship was riven with conflicts, and this steely painting reflects them. With the Sitwells – Edith, Osbert and Sacheverell – Lewis enjoyed at first a mutually admiring friendship. But when he began work on an ambitious portrait of Edith, she soon realised that she was dealing with a strangely unpredictable and multi-faceted personality, describing how 'this remarkable man had a habit of appearing in various roles, partly as a disguise . . . and partly in order to defy his own loneliness.' Edith became upset by his advances, probably because she was frightened: it was, after all, the only occasion on record when any man is alleged to have shown any sexual interest in her. The termination of their friendship did not, fortunately, prevent Lewis from completing the portrait later. The antagonism that prompted him to lampoon Edith as Lady Harriet in his sprawling satirical novel *The Apes of God* did not impair the painting's haughty poise.

By this time, Lewis's pictorial art had dwindled in quantity so much that he referred to his pictures as 'the fragments I amuse myself with in the intervals of my literary work.' After temporarily abandoning the Sitwell portrait in 1923 he did no oil painting for several years. Although Lewis did not publish any books between 1919 and 1926, he was increasingly absorbed in the researching, planning and execution of an enormous 'megalo-mastodonic masterwork' called *The Man of the World*. The projected book proved far too unwieldy, and he eventually split it up into half-a-dozen separate volumes: *The Art of Being Ruled, The Lion and the Fox, Time and Western Man, The Childermass, Paleface*, and *The Apes of God*. Lewis was permanently short of money, and he stupidly fell out with those most willing to be his patrons. O'Keeffe charts these petty yet bitter conflicts, most notably with publishers whose advances never lived up to Lewis's expectations. The accumulation of detail in these endless financial disputes makes for wearisome reading, and takes us too far away from the reasons why Lewis is still worth looking at today. His art makes

him memorable, not the fact that he was evicted from yet another lodging by landlords tired of waiting for him to pay his rent. But he had enough funds to travel abroad, journeying to New York in 1927 and four years later to Morocco and other parts of North Africa. This time, he was accompanied by Gladys Anne Hoskins, a young British art student whom he married in conditions of great secrecy. She remains a mystery throughout O'Keeffe's book, presumably because he failed to find out anything substantial about a woman whom Lewis insisted on hiding away. Her mother was German, and after visiting Germany in 1930 Lewis published a disastrously respectful book called *Hitler*. Although he repudiated his praise in a 1939 volume entitled *The Hitler Cult*, the damage was done. Lewis made even more enemies than before, and when the Royal Academy rejected his portrait of Eliot in 1938 his notoriety increased. Augustus John resigned from the Academy in protest at its hostility to Lewis's work. But for many years he remained an outsider in the eyes of the British art establishment.

Illness dogged him in the 1930s as well. He had a number of serious operations and periods of convalescence, but they did not prevent him from publishing one of his most outstanding novels, *Revenge for Love*, in 1937. Just before the Second World War was declared two years later, Lewis and his wife left England for six years. They stayed in New York, Buffalo and Toronto, where he remained until 1943. Then he accepted a year's lectureship at Assumption College, Windsor, Ontario. It was an intensely difficult, even humiliating period, when he was forced at times to produce mediocre, pot-boiling portraits. The once-notorious Lewis was in danger of being forgotten, and his reputation only revived after his return to London in 1945.

His appointment as art critic of *The Listener* the following year was felicitous. It enabled Lewis to demonstrate his remarkable responsiveness to emergent artists as well as his contemporaries. He exerted a wide influence again, and his *Listener* column was only terminated when blindness afflicted him in 1951. The most moving part of O'Keeffe's biography centres on Lewis's response to his loss of sight. He wrote an article called 'The Sea-Mists of Winter', explaining why no art criticism had appeared from his pen for four months. It began by deploring the weather, but then abruptly admitted: 'The truth is that there was no mist. The mist was in my eyes.' He described his day-to-day, often comic experience of near-blindness: standing on the pavement and hailing private cars and small vans as taxi-cabs or, having secured a cab, trying to enter the body of the vehicle at two or three places instead of through the space produced by the opened door. When friends visited him in the

evening, he saw them 'fragmentarily, obliquely, and spasmodically.' His central vision obliterated, he could no longer see anything directly in front of him. But he viewed the eventual advent of what he termed 'the absolute blackout' with courageous equanimity. 'Pushed into an unlighted room', he wrote, 'and locked for ever, I shall then have to light a lamp of aggressive voltage in my mind to keep at bay the night.'

Visitors to his exhibition at the Redfern Gallery two years before knew how much of a loss he was to British art. But Lewis was awarded a Civil List pension and forced himself to continue writing fiction. *Self Condemned*, one of his finest novels, appeared in 1954, and the following year his trilogy *The Human Age* was broadcast on the old Third Programme, uniting the earlier novel *The Childermass* with two succeeding parts commissioned by the BBC in 1951: *Monstre Gai* and *Malign Fiesta*. They were his literary swansong, and his achievements as an artist were celebrated in 1956 by a retrospective survey at the Tate Gallery called 'Wyndham Lewis and Vorticism.' The show was staged just in time: Lewis felt so feeble at the private view that, unable to negotiate the flight of steps to the main entrance from Millbank, he had to be taken up in a service lift from the rear.

But Lewis remained defiant, obstreperous and secretive to the very end. Suffering from a brain tumour, he was admitted in a semi-conscious state to Westminster Hospital the following year. Occasionally he would rally, and O'Keeffe relates that one question Lewis 'is alleged to have answered concerned the last occasion he had opened his bowels. The response is credited with containing his final words on this or any other subject: "Mind your own business!"'

AFTERWORD

GOODBYE TO ALL THAT
26 December 2000

Looking back over an extraordinary, frenetic and quite unrepeatable year, one development overrides everything else: the emergence in Britain of the public art gallery as a place where swaggering showmanship thrives unashamed. Up and down the nation, musty and wretchedly under-attended museums were either swept aside or transformed, with the help of Lottery funding, into glamorous alternatives. Far from alienating the potential visitor with institutional dullness, the abundance of siren-like new buildings proved impossible to resist. Whether rearing with indomitable conviction over Walsall, or opening up the British Museum's long-hidden heart in Bloomsbury, these enterprising *coups de théâtre* have already attracted prodigious numbers of visitors. The sheer profusion of people was exhilarating to begin with, and scotched the discredited notion that galleries are only good for a snooze or a lonely, melancholy stroll. When, as a student, I first visited the Barber Institute in Birmingham, one of the finest collections of paintings in the country, its galleries were deserted. Puzzled, I asked an attendant why. '*Aha*,' he said with a conspiratorial smile, 'the Director *likes* it that way.' But now, four decades on, museums have undergone a startling metamorphosis. In the twenty-first century, emptiness is banished. Hordes are the order of the day, nowhere more overwhelmingly than at Tate Modern.

Only a few years ago, nobody noticed Giles Gilbert Scott's grubby and disused power station lurking with embarrassed awkwardness on the edge of the Thames. Today, by contrast, it has become a cynosure. People from across the world find themselves drawn to the Titan of Bankside, and the press of bodies inside testifies to its magnetism. Even on a cold weekday morning I have been caught up, there, in crowds surging through the galleries. They impose their own urgent rhythm on everyone viewing the collection. And anybody gazing down from the windows on the Louise Bourgeois towers far below realises that lengthy queues have formed beside each of them. Tate Modern is without doubt a supremely successful 'visitor attraction'. Although austere and even sulky from the outside, the sheer scale of the emptied-out, excavated Turbine Hall within impresses anyone entering from the west side. The vastness could easily be intimidating, and make the individual feel daunted or crushed. But walking through this monumental space is an invigorating experience. It quickens the senses, thereby preparing us for the task of confronting the art in the north wing. And the *frisson* it provides also satisfies the require-

ments of the Construction Industry Council, whose breathless new set of 'performance indicators' will encourage architects and bodies commissioning new buildings to consider whether the planned building has 'the wow factor', as well as satisfying more traditional concerns about function and cost.

My only anxiety about Tate Modern, and every other museum that relies on a similar spectacle of immensity, centres on the amount of attention onlookers end up according to the work on display. If the architectural pyrotechnics are so diverting in their own right, how does the gallery ensure that its collection receives any serious attention? Whenever I ask people about their visits to Tate Modern, they discuss the merits of the building rather than the images it contains. And the same tendency will undoubtedly prevail even more alarmingly when Frank Gehry's major new Guggenheim Museum opens in New York later this decade. A few days ago, Mayor Giuliani announced that the city had given the project an unmissable pierside location on the East River. Gehry's preliminary plans indicate that his billowing and gleaming extravaganza will, if anything, be even more of a swashbuckling, neo-baroque showpiece than its predecessor at Bilbao. As well as transforming that prime stretch of Lower Manhattan, the $678 million mega-structure is bound to be a galvanic and, for many, irresistible landmark.

But will its interior dominate everyone's responses, to the exclusion of all else on view there? It may seem churlish to ask such a question when museums are bringing so many new visitors into first-hand contact with modern art. If these beguiling temples fail to encourage an intimate, prolonged awareness of particular images, however, they will not enlarge our understanding of art in any way. Architectural spectacle is easy to gawp at, especially when manipulated by a virtuoso as exuberant as Gehry. Serious looking, on the other hand, is much, much harder. But without learning how to focus on a single work, spend time with it and uncover its richness, we will never be able to approach the heart of the complex, demanding and inexhaustible nourishment art can provide. This is the principal challenge confronting Tate Modern and all the other flamboyant art institutions now springing up elsewhere in the world. I remain hopeful that their curators are conscious that no amount of visitor facilities, in the form of cafés, shops and delectable terraces with riverside views, should ever become a substitute for the tougher yet infinitely rewarding business of a full-blooded engagement with art itself.

Further down the Thames, though, no such imperative has guided the staff responsible for running the Millennium Dome. As a member of the 'Sculpture Group' who commissioned artists to produce work for the

94. Tony Cragg, *Life Time*, 2000, outside Millennium Dome, London

curving stretch of land between the Dome and the river, I feel betrayed. A number of outstanding sculptures and installations were made for this epic outdoor location, but they have been treated with an appalling lack of respect by Dome officials. On my last visit to the area, I was dismayed to find that Tony Cragg's superb *Life Time* was largely obscured by burger kiosks and yellow litter-bins. Tacita Dean's evocative sound sculpture, using as its base the round ventilation shaft of Blackwall Tunnel, was affected by the noise of a neighbouring fountain and treated as a stacking depot for plastic orange chairs. Worst of all, Anish Kapoor's audacious *Parabolic Waters*, where fifty tonnes of spinning coloured water once formed an immense concave mirror inside a crater-like basin eight metres in diameter, had been drained and boarded off with rudimentary metal fencing. It was a dismal sight, and profoundly insulting to the artist. The treatment of this inventive work, which extended our ideas about sculpture and inaugurated a potent new phase in Kapoor's development, proved that the Dome staff did not really care about the art they should have cherished.

I think back now in angry bewilderment to the morning in late March when *Parabolic Waters* was unveiled. Despite the inevitable downpour, it was an exciting and well-attended event. Many of the artists and their

95. Tacita Dean, *Friday/Saturday*, 2000, outside Millennium Dome, London

96. Anish Kapoor, *Parabolic Waters*, 2000, outside Millennium Dome, London

friends gathered there, to hear P.Y. Gerbeau, the recently appointed Chief Executive of the New Millennium Experience Company, declare with ebullient satisfaction that 'the Dome's got it all. We are privileged to have an amazing collection of specially commissioned art at the Dome – a "must see" for anyone interested in contemporary art by famous international artists.' I was heartened by his apparent enthusiasm, and even more gratified when we walked over to *Parabolic Waters* and stared down into its mesmeric, humming vortex of pure colour.

None of us involved in the venture ever imagined that such a notable work would soon be treated so disgracefully. Gerbeau and his team did not even bother to inform the 'Sculpture Group' of his decision to switch off Kapoor's whirling *pièce de resistance* and sully it with a makeshift barricade. We were left to make the discovery for ourselves, and no explanation or apology was offered to the selectors' group, who also included Lewis Biggs, Director of Tate Liverpool, Richard Calvocoressi, Keeper of the Scottish National Gallery of Modern Art in Edinburgh, Julia Peyton-Jones, Director of the Serpentine Gallery, Charles Saatchi and the project's valiant curator Andrea Schlieker. We all gave our services in good faith, believing that the artists we chose would be handled with the consideration they merit. And the ever-tenacious Schlieker negotiated with Gerbeau's team for months after they suddenly decided that *Parabolic Waters* was unsafe. She could not have fought harder, pointing out that Kapoor's sculpture had already satisfied the health and safety regulations before it was installed. But Gerbeau was adamant, and did not seem to care that Kapoor's sculpture, constructed at a cost of £250,000, would never be enjoyed by the public. Eventually the Dome staff forfeited any confidence we had in them. Over the course of the year, their behaviour was unforgivable.

Above all, they let down the artists by failing to promote the project with vigour. When Gerbeau unveiled Kapoor's *Parabolic Waters* in March, he also launched an illustrated leaflet describing the commissioned works and their locations. But copies ran out far too quickly, leaving many visitors with no inkling that art had been installed on the riverside site. Plenty of people who did encounter the work, often by accident, were enchanted by the discovery; and I am relieved that Rose Finn-Kelcey's inventive series of converted vending machines, called *It Pays to Pray*, continued to operate successfully throughout the year. I am also delighted to learn (from the sculptors themselves, not the Dome officials) that Antony Gormley's colossal *Quantum Cloud* and Richard Wilson's dramatically sliced dredger will remain as permanent images on and in the river. But the shameful handling of Cragg, Dean and Kapoor has

97. Rose Finn-Kelcey, *It Pays to Pray*, 2000, outside Millennium Dome, London

scarred my memories of an adventurous attempt to give contemporary sculptors the prominence they deserved in the millennial celebrations. Their mistreatment warns me that Britain's attitude to modern art can still degenerate, even on a site of such national significance, into callous and inexcusable philistinism.

INDEX

Page references in *italics* indicate illustra-
tions. Works are listed under artist and
subject.

Abramović, Marina, 95
Abstract Expressionism, 133, 299; *see also*
Expressionism
Africa, *see* Bamgboye; Ofili
Aguilera-Hellweg, Max, 38
Aitchison, Craigie, 140
Alÿs, Francis, 50–1
America, *see* museums; New York; Turrell
Amiet, Cuno, 309
Andre, Carl, *115*, 115–18, 175
Apocalypse, see Royal Academy
Apollinaire, Guillaume, 322
Appel, Karel, 311
archaeology, 254–6
architecture
architects, *see* Bramante; Caruso St
John; de Meuron; Dixon; Foster;
Gehry; Gropius; Herzog; Jones;
Libeskind; Mackintosh; Maltzan;
Mather; Piano; Robertson & Part-
ners; Rogers; Rundell; Safra;
Taniguchi; van der Rohe; Wilford
art/sculpture/architecture blurred,
216–19
galleries and museums, 5–10, 147–98
architecture too distracting? 353
see also Art Nouveau; Rome;
Victoria & Albert
Art2000, 216–19
Artangel, 240–4, 249–52
art colleges
Goldsmiths, 250
Royal College of Art, 66, 217
art criticism, *see* Ruskin
art history
Christian art, 258–62
gardens, 272–5

see also Abstract Expressionism; books,
biographies (Caravaggio, Lewis);
Bernini; Blake; Bramante; Chardin;
Constable; Cubism; Duchamp;
Expressionism; Futurism; Impres-
sionists; Matisse; Munch; Picasso;
Post-Impressionists; Pre-Raphaelites;
Raphael; retrospectives; Riemen-
schneider; Rodin; Rome; Sickert;
Sisley; Turner; van Gogh; Vorticists
artist's
house, 318
memorials: artists who died in 1997,
108–9
own body/person in art work, 31–5,
79, 103–5, 203
self-portraits, 77–8, *130*, 309, *310*, 311,
325
see also participatory art
poetry, 134
Art Nouveau, 300–4
art prizes
Art2000 sculpture prize, 216
Citibank Photography, 63–6
The Times/Artangel *Open*, 249; *see also*
Artangel
Turner Prize, *see* Turner
art/sculpture/architecture, blurred, 216–19
Aston, Paul, 238
audio/sound, 24–7, 47, 94–5; *see also* music
Auerbach, Frank, 16, *17*, 54, 122, 136, 138,
207, 311

Bacon, Francis, 57, 100, 151, 174, 203, 207, 324
Balla, Giacomo, 307
Balthus, 122
Baltic Flour Mills, 7
Bamgboye, Oladele Ajiboye, 45
Bankside, *see* Tate
Banner, Fiona, 153
Barney, Matthew, 175
Bauhaus, 175, 316–20

Beckett, Samuel, 32–3, 61, 90, 100
Beckmann, Max, 309
Beirut, *see* Hatoum
Belgium, *see* Fabre; Janssens; Vanmechelen;
 Vantongerloo
Bellini, Giovanni, 260, 268
Bergh, Richard, 306
Bernini, 268, 269
Berlin, *see* Germany
Berlin, Isaiah, 168
Bernini, *15*, 16, 268–9
Beuys, Joseph, 130, 174
Bevan, Tony, 10, 99–102, *100*, 140
Big Issue, 110
Billingham, Richard, 10, 35–9, *38*
Birmingham
 Barber Institute, 352
 Ikon Gallery, 35–9
Bismuth, Pierre, 48
black artists, *see* McQueen; Ofili;
 Shonibare
Blair, Tony, 213
Blake, Peter, 136, 139
Blake, William, 279–84, *283*
body, *see* artist's, own body in art
Boldini, Giovanni, 309
Boltanski, Christian, 176
Bomberg, David, 16, 138
books, 45, 228, *229*
 biographies
 Caravaggio, 334–41, *336*
 Wyndham Lewis, 341–50, *345*
 cover illustration, 57–8
Bosch, 122
Bouguereau, William-Adolphe, 308
Bourgeois, Louise, 17, *18*, 122, 133, 171,
 172, 352
Boyce, Martin, 50
Bramante, 271
Brandt, Marianne, 318–19
Braque, 297
Brett, Guy, 329, 332
British Art Show
 1995, 11
 2000, 11, 27–31, *29*
British Museum, *see* museums, London
Brodsky, Isaak, 310
Brown, Don, 71
Brown, Glenn, 54, 57–8
van Bruggen, Coosje, 121
Brzeska, *see* Gaudier
Burroughs, William, 109

Bury, Pol, 331
Button, Virginia, 43, 202

Cadell, F. C. B., 314–15
Cage, John, 266
Calder, Alexander, 329–30
Canada, *see* Graham (Rodney)
Caravaggio, 334–41, *336*
Caro, Anthony, 121, 156, 207
cartoons/ caricature, *see* satire
Caruso St John, 6, 7, 152–7, *156*
Cass, Wilfred, 216
Castle, James, 239
Catherine the Great, 187–92
Cattelan, Maurizio, 10, 80–1
Cattrell, Annie, 238
Caulfield, Patrick, 122, 173
Cézanne, Paul, 296, 306
Chabas, Paul, 306
Chadwick, Lynn, 239
Chapman, Jake and Dinos, 10, 19, 79–80,
 82–3, *83*
Chardin, Jean-Siméon, 275–9, *278*
Chodzko, Adam, 92
Christianity/Christian art, 14, 258–62
Clark, Lygia, 96
Clarke, Peter, *21*, 244–8
Coles, Pippa, 28
collectors
 Merians, Elaine and Melvin, 12,
 136–41
 public institutions, duty to collect,
 213; *see also* dealers
Colley, Linda, 246
Collings, Matthew, 48
Colombo, Gianni, 332
Coltrane, John, 39
competitions, *see* art prizes; Trafalgar Square
computer animation, 5
Constable, John, 161, 203, 274–5
consumerism, *see* protest
context for displaying/staging art
 beyond the gallery space, 219–23; *see*
 also public art; sculpture, outdoors
Cork, Richard, 11, 12, 14, 16, *21*, 22, 27,
 101, 151, 170, 182, 187, 244–8,
 267–72, 352–7
Cox, Stephen, 121
crafts, *see* folk art
Cragg, Tony, 25, 111–14, *112*, 156, 173, 207,
 354, 357
Craig-Martin, Michael, 44, 213

Creed, Martin, 11, *29*, 30, 43, 157, 159, 202
crime, *see* Weegee
Cuba, *see* Gonzalez-Torres
Cubism, 150, 297, 310
Cuevas, Minerva, 96
Cunningham, Chris, 82
Czechoslovakia, *see* Kupka

Dalí, Salvador, 54, 133, 173–4
David, J. L., 79
Deacon, Richard, 174
dealers, *see* Jopling; Logsdail; Schubert
Dean, Tacita, 354, *355*, 357
de Grey, Spencer, 193, 195
de Kooning, Willem, 109, 133
de Lempicka, Tamara, 311
Deller, Jeremy, 47, 110
de Meuron, Pierre, 173, 205
Denes, Agnes, 332
Denmark, *see* Lislegaard
Dennett, Terry, 109
destruction
 staged act of, by artist, 249–52
 of art, by 'philistines', 1, 357; *see also*
 London, Millennium Dome
 see also protest
Deuchar, Stephen, 200–4, *201*
Diana, Princess of Wales 22, 245
digital media, *see* computer animation;
 Internet
Dijkstra, Rineke, 10, 68–71, *70*
Dilworth, Steve, 239
Dix, Otto, 309, *310*
Dixon, Jeremy, 166–70, *169*
D. O. A., 41–3
documentary, 5, 44, 84; *see also* film;
 video
Doig, Peter, 12, 140, *141*
Dome, Millennium, 99, 223, 353–7
Dottori, Gerardo, 311
drawing, 11, 28, 46, 87, 331; *see also* Blake
dreams, 92–6
drugs, 93, 331
Dubuffet, 311
Duchamp, Marcel, 58, 163, 173, 207, 329
Dulwich Picture Gallery, *4*
Dumas, Marlene, 174
Duvivier, Eric, 93

Eakins, Thomas, 306
Edinburgh, 27–31; *see also* Doig
Emin, Tracey, 10, 28, 52, 76–8, *78*, 161

Epstein, Jacob, 116, 152–3, *154*, 155, 174,
 196, 236, 247, 329
Esche, Charles, 43, 202
Expo 2000, 110
Export, Valie, 108
Expressionism, 307

Fabre, Jan, 232–6, *234*
Fagen, Graham, 30
Fahlstrom, Oyvind, 108
Feininger, Lyonel, 316, *317*
Fellig, Usher, *see* Weegee
feminism
 gender divide/Muslim culture, 72–3
 see also women
Fergusson, J. D., 312–14, *313*
film, 31–5, 41–3, 44, 82, 93, 103–4, *104*,
 134, 176, 331; *see also*; Frampton;
 Hitchcock
Finland, *see* Gronlund; Nisunen
Finn-Kelcey, Rose, 356, *357*
First World War, 61, 165, 246, 297, 304, 314
Floyer, Ceal, 50
folk art, 47
Fontana, Lucio, 331
Foster, Norman, 1, 5, 7, 192–8, *194*
Frampton, Hollis, 116
France, *see* Bourgeois; Paris; Impressionists;
 Picasso
Francesca, Piero della, 121, 195
Freud, Lucian, 12, *13*, 122, 136, 138, 155,
 168, 203, 307, 311
Fry, Roger, 313, 343–4
Furlong, Bill, 47
Futurism, 119, 307, 311, 329

Gabie, Neville, 239
gardens, subject for art, 272–5, *274*
Garman, Kathleen, 152–3, 157
Gaudier-Brzeska, 174, 195, 236, 344
Gauguin, 306
Gego, 332
Gehry, Frank, 8, 153, 353
gender divide/Muslim culture, 72–73
Germany
 Berlin, *see* museums
 see also Bauhaus; Expressionism;
 Gego; Haacke; Holocaust; Kiefer;
 Nicolai; Nolde; Riemenschneider;
 Tillmans; Wols
Giacometti, Alberto, 175
Gibbons, John, 239

Gilbert & George, 10, 108, 162
Gilbert, Bruce, 24–5
Ginsberg, Allen, 109
Giuliani, Mayor, 67, 160
Glasgow, *see* Mackintosh
Gledhill, Jane, 239
Gloucester Cathedral, modern sculpture, 236–40, *237*
Goebbels, 177
van Gogh, Vincent, 12, 155, 256–8
Goldschmidt, Gertrud, *see* Gego
Gonzalez-Torres, Felix, 142–6, *145*
Gordon, Douglas, 10, 39–43, *42*, 44, 50, 176
Gormley, Antony, 10, 163, 175, 356
Graham, Dan, 95
Graham, Rodney, 10, 93, 103–6, *104*
Greer, Germaine, 173
Gronlund, Tommi, 27
Gropius, Walter, 316–20
Guevara, Che, 96, 163
Guggenheim, *see* museums (Bilbao; Las Vegas; New York)
Guston, Philip, 209, 299

Haacke, Hans, 332
hallucinations, 92–6, 132, 331
Hamilton, Richard, 107, 119, 311
Harris, Bob, *21*, 244–8
Harris, Mark, 94–5
Hartley, Alex, 216–19, *217*
Hatoum, Mona, 157–9, *158*, 202–3
Hayward Gallery, 123–9, 226, 329–32, *330*
Hermitage Rooms, 187–92
Herterich, Ludwig, 308
Herzog, Jacques, 173, 205
Hewison, Robert, 289
Higgs, Matthew, 11, 27, 48–9, 107–8
Hill, Gary, 175
Hiller, Susan, 30, 44, 92, 95–6, 240–2, *241*
Hirschhorn, Thomas, 107
Hirst, Damien, 3, 10, 28, 58, 75–6, 153, 160, 161, 162, 163–5, *164*, 212, 217, 250
Hitchcock, Alfred, 43
Hitler, Adolf, 177–8, 246
Hockney, David, 11, 28, 122, 136, 138, 139, 311
Hodgkin, Howard, 119–20
Hoffmann, Josef, 300, 303
Holbein, Hans, 167
Holland, *see* Netherlands

Höller, Carsten, 92–3
Hollist, Mike, 108
Holocaust, 19–20, 332
 exhibition, 176–82, *180*
Horn, Roni, 63–4
Houshiary, Shirazeh, 86–7, 95
Hue-Williams, Michael, 99
Hume, Gary, 79, 249, 250, 311
Hungary, *see* Denes
Hunter, Leslie, 314
Hussein, Saddam, 109–10

ICA, 59–63
Ikon, *see* Birmingham
Impressionists, 293–5
Innes, Callum, 156
Intelligence, 43–7
Internet, 5
inventor, *see* Panamarenko
Iran, *see* Houshiary; Neshat
Ireland, *see* Fagen; McFreely; Seawright; Timoney
Italy, *see* Rome

Janssens, Ann Veronica, 25, *26*
Japan, *see* Kusama; Maeda; Takahashi
Jenkinson, Peter, 152
Johns, Jasper, 122–3
Johnston, Alan, 46
Johnstone, Isobel, 216
Jones, Edward, 166–70, *169*
Jopling, Jay, 10, 161–3

Kabakov, Ilya and Emilia, 175
Kandinsky, Wassily, 308, 316, 318, 319
Kane, Alan, 47
Kapoor, Anish, 96–9, *97*, 156, 213, 354, *355*, 356, 357
Kelley, Mike, 81
Kiefer, Anselm, 17–19
Kinetic art, 329–32, *330*
Kitaj, R. B., 122, 136–7, 139
Klee, Paul, 128, 316–17
Koelewijn, Job, 95
Koons, Jeff, 82
Korea, *see* Paik
Kossoff, Leon, 136, 138–9, 168
Kupka, Frantisek, 306
Kusama, Yayoi, 10, 132–5, *135*

Lalique, René, 300
Lamin, Paul Joseph, 304

landscape, 65–6
Landy, Michael, 30, 31, 249–52, *251*
Laocoön, 111
Latham, John, 51
Léger, Fernand 310
Leith, Prue, 247
Leonardo, 124, 190, 198, 233
Le Parc, Julio, 331
Lewis, Graham, 24–5
Lewis, Wyndham, 175, 341–50, *345*
Libeskind, Daniel, 7–8, *8*, 19
Lichtenstein, Roy, 58, 109, 173
lighting, 24–7, 43
 neon 50
 see also Turrell (light sculpture)
Lislegaard, Ann, 26
Lisson Gallery, 33, 47–51, 86–7, 88–92,
 96–99, 103–6
Liverpool, *see* Tate
Livingstone, Ken, 248
Lloyd, Hilary, 46–7
Logsdail, Nicholas, 47
London
 Millennium Dome, 99, 223, 353, *354,*
 355, 356, *357*
 see also Art2000; art colleges; Dulwich
 Picture Gallery; Hayward; museums;
 National Gallery; Serpentine, Som-
 erset House; Tate, Trafalgar Square;
 Wallace Collection; Whitechapel;
 White Cube[2]
Lowe, Brighid, 45
Lowry Centre, *see* Manchester
Lowry, Glenn D., 10
Lucas, Sarah, 28, 45–6, *46*, 78, 160, 165,
 173, 250
Lye, Len, 332

MacGregor, Neil, 21, 228, 244–8, 259
Mackintosh, Charles Rennie, 302, *303*, 314
Maeda, Noriaki, 219–23, *222*
Magritte, Rene, 125, 174, 232
Maine, John, 237
Malevich, Kasimir, 86, 151
Maltzan, Michael, 10
Manchester
 Imperial War Museum, 8
 Lowry Centre, 7
Manet, Edouard, *12*, 122–3, 293, 298, 299
Man Ray, 329
Marcuse, Herbert, 95
Marinetti, 119

Martin, Jason, 156; *see also* Craig-Martin
Mason, Barry, 239–40
materials
 wood, 117, 238, 263–5
Mather, Rick, architects, *4*, 6, 182–6, *185*
Matisse, Henri, 36, 125, 136, 150, 156, 174,
 208, 297
McCaughey, Patrick, 137–8
McFeely, Conor, 30
Medalla, David, 332
van Meene, Hellen, *64*, 64–5
Mellon, Paul, 138
Merians, *see* collectors
Mexico, *see* Toledo
Meyer, Hannes, 319
Michaux, Henri, 93, 311, 331
Michelangelo, 57, 162, 210, 271, 280–1
Mik, Aernout, 10, 59–63, *60*
Mikhailov, Boris, 65
Millais, John Everett, 290, *291*
Millbank, *see* Tate Gallery
Millennium Dome, *see* London
Minimalism, 115, 116, 175
mobiles, 329–30
Moholy-Nagy, Laszlo, 175, 329, *330*
Monet, Claude, 120, 155, 225, 266, 293,
 294, 295, 296, *297*
Monk, Jonathan, 50
Moorman, Charlotte, 266
Mori, Mariko, 81
Morisot, Berthe, 295
Morphet, Richard, 17, 122
Mortimer, Sir John, *21*, 244–8
movie, *see* film; television; video
Mueck, Ron, 165
Munch, Edvard, 306
Murphy, John, 50
museums
 architecture, 5–10, 147–98
 Berlin
 Jewish Museum, 19
 Bilbao
 Guggenheim, 8, 353
 Copenhagen, Louisiana, 205, 207
 Edinburgh
 Scottish National Gallery of
 Modern Art, 213
 Las Vegas
 Guggenheim, 8
 London
 British Museum, 5, 6, 192–8, *194*,
 352

Imperial War Museum, 6, 19, 176–82
Natural History Museum, 232–6
see also Victoria & Albert
Manchester
Imperial War Museum, 8
New York
Brooklyn, 11
Guggenheim, 8, 12, 265–7, 353
Metropolitan, 12, 254–6, 263–5
Museum of Modern Art, 8, *9*
Philadelphia, 256–8
Pittsburgh
Warhol Museum, 205
Washington
Hirshhorn Museum, 224
Murillo, 260
music, 24–7, 39–40, 74–5, 142, 145, 160,
266

Naples, 339–40
National Gallery (London), 14, 16, 17,
119–23, 258–62
Sainsbury Wing, 119
see also Trafalgar Square
National Portrait Gallery, 6, 166–70, *169*,
308–15
Neshat, Shirin, 10, *11*, 71–5, *73*
Netherlands, *see* van Meene; Mik;
Panamarenko; Raedecker
Newman, Barnett, 175, 225
New York, 132, 133, 134, 143, 299, 325–8;
see also Horn (Roni); Kabakov;
museums; Neshat; Oursler
Nicolai, Carsten, 25
Nikolaev, Stefan, 48
Nisunen, Petteri, 27
Nittve, Lars, 205–9, *206*, 228
Noble, Paul, 107
Noble, Tim, 82
Noland, Kenneth, 67
Nolde, Emil, 307
Norway, *see* Munch
Norwich School, 161
Nussbaum, Felix, 311

Offerman, Jeroen, 51
Ofili, Chris, 67, 160, 165–6, 249
O'Keeffe, Paul, *see* Lewis, Wyndham
Oldenburg, Claes, 121–2, 133, *149*, 247
Opie, Julian, 44
Oursler, Tony, 88–92, *89*, 242–4, *243*
Owusu, Elsie, *21*, 244–8

Pacheco, Ana Maria, 238
painting, 4, 87, 99–102, 128–31, 308–15,
307–8; *see also* art history; Hockney;
Hodgkin; Saville
Paik, Nam June, 12, 265–7
Palmer-Tomkinson, Tara, 252
Panamarenko, 123–9, *126*
Paris, 11–12
exhibitions, 296–9
Exposition Universelle, 304–8
Pompidou Centre, 8, 11, *148*, 148–52,
299, 320–4
Parker, Cornelia, 176
participatory art, 95; *see also* artist's own
body in art
Patterson, Richard, 79
Pei, I. M., 193
Peploe, S. J., 312, 313
Perry, Grayson, 109
photography, 63–6, 116, 325–8, *327*, 332; *see
also* Billingham; art prizes, Citibank;
Tillmans
Piano, Renzo, 148
Picabia, Francis, 150, 173
Picasso, Pablo, 57, 136, 150, 156, 198, 297,
304, 307
sculpture, 320–4, *323*
Pissarro, Camille 295
Plath, Sylvia, 81
Pollock, Jackson, 299, 308
Pompidou Centre, *see* Paris
Poncelet, Jacqui, 28
portraiture, 11, 28, 110, 122, 308–15; *see
also* artists, self-portraits
Portugal, *see* Rego
Post-Impressionism, *see* Scottish Colourists
Pound, Ezra, 344–6
Poussin, Nicolas, 189, 334
Pre-Raphaelites, 290–2
printmaking, 79–80, 131
prizes, *see* art prizes; Turner Prize
protest, 107–10
anarchy, 107
art defaced in protest, 1
by artists, 44
anti-consumerism, 249–52
anti-racist
Klu Klux Klan, 299
see also Holocaust
see also destruction
public
art (sculpture), 20–2, 219, 227–52;

see also London, Millennium Dome; participatory art; sculpture, outdoors; Trafalgar Square

Quinn, Marc, 162

Raedecker, Michael, 29, 55–6
Rainbird, Sean, 216
Randall-Page, Peter, 239
Raphael, 57, 269, *270*; *see also* Pre-Raphaelites
Rego, Paula, 28, 122, 139–40
Reinhardt, Ad, 86, 225
Rembrandt, 182, 186, 190
Rendell, Ruth, *21*, 244–8
Renoir, Pierre-August 295
retrospectives, 14–18
 Blake, William, 279–84, *283*
 van Gogh, Vincent, 12, 256–8
 Gonzalez-Torres, Felix, 142–6, *145*
 Guston, Philip, 299
 Kusama, Yayoi, 132–5, *135*
 Paik, Nam June, 12, 265–7
 Picasso, Pablo 12
 Riemenschneider, Tilman, 12, 263–5, *264*
 Toledo, Francisco, 128–31
 Turner, J. M. W., 284–8
 Wearing, Gillian, 84–6; *see also* art history
Reynolds, Joshua, 281
Riemenschneider, Tilman, 12, 263–5, *264*
Riley, Bridget, 207
Robb, Peter, *see* Caravaggio
Robertson & Partners, 10
Rodin, Auguste, 304, *305*
Rogers, Richard, 148
van der Rohe, Mies, 217, 319, 320, 321
Rome, 14–16, 267–72, 335–9
Rondinone, Ugo, 67–8
Rosenthal, Norman, 80
Rough, Gary, 50
Royal Academy, 10, 16, 284–8, 304–8
 Apocalypse, 10, 19, 80–3
Royal College of Art, 66, 217
Royal Society of Arts, 21
Rubens, Peter Paul, 182, 190
Rundell, Mike, 162
Ruppersberg, Allen, 108–9
Ruskin, John, 288–9, *291*, 292
Russia
 antiquities, 254–6
 see also Kabakov; Kandinsky
Ryman, Robert, 87

Saatchi Gallery, 10, 58, 67–71, 75–80
 Ant Noises, 163–6
Safra, Edmond J., *4*
Sainsbury Wing, *see* National Gallery
satire, 204, 245–6
Savill, Rosalind, 182–6
Saville, Jenny, 78–9, 165, 311
Schlemmer, Oskar, 316
Schneider, Gregor, 10, 80
Schubert, Karsten, 250
Schulze, *see* Wols
Schwitters, Kurt, 94
science fiction, 57–8
Scottish Colourists, 312–15, 313
Scott Tuke, *see* Tuke
sculpture, 96–9, 236–40, *237*, 320–4, *323*, 352–5
 art/architecture/sculpture, blurred 216
 outdoors, 219–23, 223–7, 227–31, *229*
 prize, 216
 see also Andre; Cragg; Cox; Gormley; public art; Riemenschneider; Turrell (light sculpture); Whiteread; Woodrow
Seawright, Paul, 30
Second World War, 22, 299, 311
Sensation, 10–11, 67, 160, 250
Serota, Nicholas, 171, 209–14, *211*
Serpentine Gallery, 71–5, 84–6, 132–5, 142–6
Serra, Richard, 219, 247
Seurat, Georges, 36, 119
Shelley, Ozymandias, 230–1
Shonibare, Yinka, 45
Sickert, W. R. 306
Sisley, Alfred, 295
Smith, Bob & Roberta, 44
Smith, Charles Saumarez, 170
Smith, Chris, 244, 248
Smith, Keir, 239
Smith, Mike, 216–7
Smithson, Robert, 332
Somerset House, *4*, 6, 187–92, *188*, 224
Southam, Jem, 65–6
Spence, Jo, 109
Spencer, Stanley, 14, 208
Spies, Werner, 149
St John, *see* Caruso
Starkey, Hannah, 66
Stehli, Jemima, 48, *49*
Stein, Gertrude, 145
Stevenson, Robert Louis, 40

Stezaker, John, 29
Stonehenge, 116
Stonyer, Andrew, 240
Strindberg, August, 307, 343
Strong, Roy, 272
Surrealists, 90, 125, 134, 151, 173–4
Sweden, *see* Alÿs; von Hausswolff
Switzerland, *see* Amiet; Rondinone

Takahashi, Tomoko, 55
Taniguchi, Yoshio, *9*, 10
Tate Gallery
 Liverpool, 39–43, 111–14
 London
 Tate Britain (Millbank) 157–61, *160*,
 200–4, 288–92
 Tate Modern (Bankside Power
 Station), 1, *2*, 3–4, 205–9, 209–14,
 352–3
 opening, 170–6
 see also Intelligence; Turner Prize
Taylor-Wood, Sam, 162
technology, 5
television sets, 266–7
Thatcher, Margaret, 22, 107, 168, 245
Times, The, see art prizes
Tillmans, Wolfgang, 52, *53*, 81–2, 110
Timoney, Padraig, 30
Tinguely, Jean, 331
Titian, *14*, 15, 261–2, 268
Toledo, Francisco, 128–31, *130*
Tom of Finland, 108
Toulouse-Lautrec, 307
Trafalgar Square, 227–31, *229*, 244–8, *245*;
 see also National Gallery
Tuke, Henry Scott, 306
Turk, Gavin, 79, 163
Turner, J. M. W., 57, 284–8, *287*, 289, 290
Turner Prize, 1
 1999, 2–3, 31, 52
 2000, 2–3, 52–6, 110
Turrell, James, 156, 223–7, *225*
Tuymans, Luc, 81
Twombly, Cy, 122

Uglow, Euan, 120, 136–7
Ukraine, *see* Mikhailov
USA, *see* museums; New York; Turrell
Uslé, Juan, 68

vandalism, *see* destruction; protest, art
 destroyed in protest

Vanmechelen, Koen, 51
Vantongerloo, Georges, 330
Velázquez, Diego, 57, 182, 298, 307
Venice Biennale
 1968, 332
 1999, 25
Vermeer, Jan, 121–2
Victoria & Albert Museum, 16
 Libeskind Spiral, 7–8, *8*
video art, 5, 12, 16, 30, 33–4, 38–9, 41–2,
 46–7, 50, 59–63, 71–5, 82–6, 88–92,
 93, 96, 108, 122, 175, 203, 213,
 232–6
Vienna, 20
Viola, Bill, 122, 175
violence, *see* Weegee
von Angeli, Heinrich, 309
von Graevenitz, Gerhard 331–2
von Hausswolff, Carl Michael, 24
Vorticists, 175, 344–7
Vrubel, Mikhail, 307

Wall, Jeff, 120–1
Wallace Collection, 6, 182–6, *185*
Wallinger, Mark, 21–2, 213, 228, 244, *245*,
 247
Walpole, Sir Robert, 189
Walsall Art Gallery, 6, 7, 152–7, *156*, 352
war, 79; *see also* First World War; Second
 World War
Warhol, Andy, 168
watercolour, 284–8
Wearing, Gillian, 44–5, 84–6, *85*, 213,
 249
Webster, Sue, 82
Weegee, 325–8, *327*
Wentworth, Richard, 153
Whistler, 292
Whitechapel Art Gallery, 107–10, *115*,
 115–18, 128–31, 299
White Cube², 10, 161–6
Whiteread, Rachel, *20*, 21, 165, 176, 213,
 230, 247
Whitney, James, 331
Who, The, 39
Wilding, Alison, *237*, 238
Wilford, Michael, 7, 216
Williams, Glynn, 238
Wilson, Jane and Louise, 51, 93–4, *94*,
 232
Wilson, Richard, 274, 356
Wols, 330, 331

women
 gender divide/Muslim culture, 72–3
 female body as subject, 78–9; *see also*
 Saville
 Impressionist, *see* Morisot
Wonnacott, John, 140
Wood, Simon, 48
Woodrow, Bill, 22, 227–31, *229*, 247

Yalkut, Jud, 134
Yamawaki, Iwao, 320
Yass, Catherine, 153
Yorkshire Sculpture Park, 219–23, *222*

Zoffany, Johan, 160, 274
Zuloaga, Ignacio, 307
Zurbarán, 259, 261

CREDITS

The publisher has made every effort to contact the relevant copyright holder for the images reproduced. If, for any reason, the correct permission has been inadvertently missed, please contact the publisher who will correct the error in any reprint.

Polly Cork, Frontispiece; © Tate, London, 2002, 1, 15 (Courtesy The Artist, Courtesy Marlborough Fine Art, London, Ltd), 55 (Courtesy the artist), 60, 61, 62, 79; Dulwich Picture Gallery, London/photo: John Hammond, 2; Bolton & Quinn Ltd/© Nick Wood/Courtesy of Somerset House Trust, 3; British Museum, London/© Nigel Young, 4, 59; Baltic, Gateshead/photo: Elliott Young, 6; Victoria & Albert Museum, London/model: Millennium models/photo: Peter Mackinven, 7; Museum of Modern Art, New York/photo: Jock Pottle/ESTO, 8; Museum of Modern Art, Queens/photo: © 2001 Elizabeth Felicella, 9; Courtesy Barbara Gladstone Gallery, New York, 10, 31; Courtesy Goodman Derrick, London, 12 (Merians Collection) ; © The National Gallery, London, 13, 74, 82, 92; Courtesy the artist, 16; With permission of The Trustees of the Imperial War Museum, London, 17; Courtesy Anthony d'Offay Gallery, London, 18 (photo: Werner Kaligofsky); Courtesy the Department for Culture, Media and Sport, 19; Museum of Modern Art, Oxford, 20 (Courtesy the artist), 90 (Courtesy the International Centre of Photography, New York); Inverleith House, Royal Botanic Gardens, Edinburgh/photo: Alan Dimmick, 21; Courtesy the artist, Marian Goodman Gallery New York/Paris and Thomas Dane Ltd, London, 22; Ikon Gallery, Birmingham, 23; Courtesy Lisson Gallery, London, 24, 26, 35, 36, 37 (photo: Dave Morgan, London), 39 (photo: Dave Morgan), 96; Courtesy Maureen Paley, Interim Art, London, 27; Courtesy Carlier/Gebauer, Berlin, 28; Courtesy Sadie Coles HQ, London, 29; The Saatchi Gallery, London, 30 (Courtesy the artist), 32 (Courtesy White Cube, London), 33 (Courtesy White Cube, London/photo: Stephen White), 53 (Courtesy the artist/photo: Stephen White); Serpentine Gallery, London, 34 (Courtesy Maureen Paley, Interim Art, London), 46 (photo: John Charley), 48 (Courtesy Andrea Rosen Gallery, New York); Courtesy Michael Hue–Williams Fine Art, London, 38; Whitechapel Art Galley, London, 40 (photo: Clare Grafik), 42 (© Anthony Weller), 45 (Collection Galería Juan Martin), 47 (Courtesy the artist/Victoria Miro Gallery, London); Tate Liverpool/Courtesy Lisson Gallery, London, 41; Courtesy the artist, 43; Courtesy Galerie Christine and Isy Brachot, Brussels, 44; Courtesy Claes Oldenburg and Coosje van Bruggen/Collection Musée national d'art moderne, Centre Georges Pompidou, Paris, 50; Walsall Art Gallery, 51; Courtesy Jay Jopling/White Cube, London, 52 (photo: Stephen White); National Portrait Gallery, London, 54 (© Dennis Gilbert/VIEW); Imperial War Museum, London, 56 (Courtesy Auschwitz Museum/photo: BPK, Berlin); By kind permission of the Trustees of the Wallace Collection/© The Trustees of the Wallace Collection, London, 57; Courtesy Somerset House Trust, 58; Courtesy Victoria Miro Gallery, London, 63; Yorkshire Sculpture Park/photo: Jonty Wilde, 64; Florian Holzherr, 65 (Courtesy the artist); Courtesy the artist, 66; The Natural History Museum, London, 67; Karsten Schubert, London, 68 (Courtesy the artist); Susan Hiller/Witness/2000/Artangel/photo: Parisa Taghizadeh, 69; Tony Oursler/The Influence Machine/2000/Artangel/photo: Parisa Taghizadeh, 70; Artangel, London, 72; Victoria & Albert, Museum,

London, 75, 84; Ipswich Borough Council Museums and Galleries, 77; Birmingham Museums and Art Gallery, 80; By Courtesy of the National Portrait Gallery, London, 81; Courtauld Institute Gallery, Somerset House, London, 83; Collection Haus der Heimat, Freital (Dresden), 86; Hayward Galley, London, 91 (Collection Stedelijk Van Abbemuseum, Eindhoven); Frith Street Gallery, London, 95; Courtesy the artist, 97 (photo: Hermione Wiltshire)

COPYRIGHT LINES